FUTURISM
A MICROHISTORY

LEGENDA

LEGENDA is the Modern Humanities Research Association's book imprint for new research in the Humanities. Founded in 1995 by Malcolm Bowie and others within the University of Oxford, Legenda has always been a collaborative publishing enterprise, directly governed by scholars. The Modern Humanities Research Association (MHRA) joined this collaboration in 1998, became half-owner in 2004, in partnership with Maney Publishing and then Routledge, and has since 2016 been sole owner. Titles range from medieval texts to contemporary cinema and form a widely comparative view of the modern humanities, including works on Arabic, Catalan, English, French, German, Greek, Italian, Portuguese, Russian, Spanish, and Yiddish literature. Editorial boards and committees of more than 60 leading academic specialists work in collaboration with bodies such as the Society for French Studies, the British Comparative Literature Association and the Association of Hispanists of Great Britain & Ireland.

The MHRA encourages and promotes advanced study and research in the field of the modern humanities, especially modern European languages and literature, including English, and also cinema. It aims to break down the barriers between scholars working in different disciplines and to maintain the unity of humanistic scholarship. The Association fulfils this purpose through the publication of journals, bibliographies, monographs, critical editions, and the MHRA Style Guide, and by making grants in support of research. Membership is open to all who work in the Humanities, whether independent or in a University post, and the participation of younger colleagues entering the field is especially welcomed.

ALSO PUBLISHED BY THE ASSOCIATION

Critical Texts
Tudor and Stuart Translations • *New Translations* • *European Translations*
MHRA Library of Medieval Welsh Literature

MHRA Bibliographies
Publications of the Modern Humanities Research Association

The Annual Bibliography of English Language & Literature
Austrian Studies
Modern Language Review
Portuguese Studies
The Slavonic and East European Review
Working Papers in the Humanities
The Yearbook of English Studies

www.mhra.org.uk
www.legendabooks.com

ITALIAN PERSPECTIVES

Editorial Committee
Professor Simon Gilson, University of Warwick (General Editor)
Dr Francesca Billiani, University of Manchester
Professor Manuele Gragnolati, Université Paris-Sorbonne
Dr Catherine Keen, University College London
Professor Martin McLaughlin, Magdalen College, Oxford

Founding Editors
Professor Zygmunt Barański and Professor Anna Laura Lepschy

In the light of growing academic interest in Italy and the reorganization of many university courses in Italian along interdisciplinary lines, this book series, founded by Maney Publishing under the imprint of the Northern Universities Press and now continuing under the Legenda imprint, aims to bring together different scholarly perspectives on Italy and its culture. *Italian Perspectives* publishes books and collections of essays on any period of Italian literature, language, history, culture, politics, art, and media, as well as studies which take an interdisciplinary approach and are methodologically innovative.

APPEARING IN THIS SERIES

20. *Ugo Foscolo and English Culture*, by Sandra Parmegiani
21. *The Printed Media in Fin-de-siècle Italy: Publishers, Writers, and Readers*, ed. by Ann Hallamore Caesar, Gabriella Romani, and Jennifer Burns
22. *Giraffes in the Garden of Italian Literature: Modernist Embodiment in Italo Svevo, Federigo Tozzi and Carlo Emilio Gadda*, by Deborah Amberson
23. *Remembering Aldo Moro: The Cultural Legacy of the 1978 Kidnapping and Murder*, ed. by Ruth Glynn and Giancarlo Lombardi
24. *Disrupted Narratives: Illness, Silence and Identity in Svevo, Pressburger and Morandini*, by Emma Bond
25. *Dante and Epicurus: A Dualistic Vision of Secular and Spiritual Fulfilment*, by George Corbett
26. *Edoardo Sanguineti: Literature, Ideology and the Avant-Garde*, ed. by Paolo Chirumbolo and John Picchione
27. *The Tradition of the Actor-Author in Italian Theatre*, ed. by Donatella Fischer
28. *Leopardi's Nymphs: Grace, Melancholy, and the Uncanny*, by Fabio A. Camilletti
29. *Gadda and Beckett: Storytelling, Subjectivity and Fracture*, by Katrin Wehling-Giorgi
30. *Caravaggio in Film and Literature: Popular Culture's Appropriation of a Baroque Genius*, by Laura Rorato
31. *The Italian Academies 1525-1700: Networks of Culture, Innovation and Dissent*, ed. by Jane E. Everson, Denis V. Reidy and Lisa Sampson
32. *Rome Eternal: The City As Fatherland*, by Guy Lanoue
33. *The Somali Within: Language, Race and Belonging in 'Minor' Italian Literature*, by Simone Brioni
34. *Laughter from Realism to Modernism: Misfits and Humorists in Pirandello, Svevo, Palazzeschi, and Gadda*, by Alberto Godioli
35. *Pasolini after Dante: The 'Divine Mimesis' and the Politics of Representation*, by Emanuela Patti

Managing Editor
Dr Graham Nelson, 41 Wellington Square, Oxford OX1 2JF, UK
www.legendabooks.com

Futurism
A Microhistory

❖

Edited by Sascha Bru,
Luca Somigli, and Bart Van den Bossche

LEGENDA
Italian Perspectives 36
Modern Humanities Research Association
2017

*Published by Legenda
an imprint of the Modern Humanities Research Association
Salisbury House, Station Road, Cambridge CB1 2LA*

ISBN 978-1-781884-85-0 (HB)
ISBN 978-1-78188-486-7 (PB)

First published 2017

All rights reserved. No part of this publication may be reproduced or disseminated or transmitted in any form or by any means, electronic, mechanical, photocopying, recording or otherwise, or stored in any retrieval system, or otherwise used in any manner whatsoever without written permission of the copyright owner, except in accordance with the provisions of the Copyright, Designs and Patents Act 1988, or under the terms of a licence permitting restricted copying issued in the UK by the Copyright Licensing Agency Ltd, Saffron House, 6–10 Kirby Street, London EC1N 8TS, England, or in the USA by the Copyright Clearance Center, 222 Rosewood Drive, Danvers MA 01923. Application for the written permission of the copyright owner to reproduce any part of this publication must be made by email to legenda@mhra.org.uk.

Disclaimer: Statements of fact and opinion contained in this book are those of the author and not of the editors or the Modern Humanities Research Association. The publisher makes no representation, express or implied, in respect of the accuracy of the material in this book and cannot accept any legal responsibility or liability for any errors or omissions that may be made.

Trademark notice: Product or corporate names may be trademarks or registered trademarks, and are used only for identification and explanation without intent to infringe.

© Modern Humanities Research Association 2017

Copy-Editor: Dr Nigel Hope

CONTENTS

	Acknowledgements	ix
	List of Contributors	x
	A Note on Translations	xi
	List of Illustrations	xii
	Futurism from Below: By Way of Introduction SASCHA BRU, LUCA SOMIGLI, AND BART VAN DEN BOSSCHE	1
1	The New Man ROGER GRIFFIN	13
2	The Church MONICA JANSEN AND LUCA SOMIGLI	29
3	The Automobile SAMUELE F. S. PARDINI	48
4	London JOHN J. WHITE	59
5	The Skyscraper FRANCESCA BILLIANI	69
6	The Letterhead MARIA ELENA VERSARI	91
7	Numbers MATTEO D'AMBROSIO	116
8	Football PRZEMYSŁAW STROŻEK	130
9	Gymnastics MICHAEL SYRIMIS	142
10	The Café ERNESTO LIVORNI	153
11	The Cocktail MARJA HÄRMÄNMAA	167
13	Seduction BARBARA MEAZZI	183

13 Doubles
 SIMONA CIGLIANA 192

14 Puppets
 SHIRLEY VINALL 213

15 The Bed
 SILVIA CONTARINI 223

 An Afterword with Günter Berghaus 234

 Index 249

ACKNOWLEDGEMENTS

We are very grateful to the staff of Legenda, whose support proved indispensable to make this book. Thanks to Simon Gilson for going along with our somewhat unusual experiment, and to managing editor Graham Nelson and copy-editor Nigel Hope for their formidable help. We further thank our assistants Valentina Fulginiti, Kathleen Gaudet, Wout Gevaert, and Wanda Santini. Their work on translations, the index and other aspects of this book has helped make this volume into what it is. Our gratitude also goes to the MDRN team at the University of Leuven. Its experimental gusto and brash support has contributed a great deal to this book as well.

Our deepest gratitude goes to Ann White, whose husband John passed away in the process of making this book. Ann's warm and helpful input proved essential, and it is with pride that we include John's contribution here—his work in Futurism studies remains of such value and his absence touches us all.

<div style="text-align: right;">S.B., L.S., B.V.B., Leuven and Toronto, 2017</div>

LIST OF CONTRIBUTORS

Sascha Bru is Professor of General and Comparative Literature at KU Leuven.

Luca Somigli is Professor of Italian Studies at the University of Toronto.

Bart Van den Bossche is Professor of Italian Literature at KU Leuven.

Roger Griffin is Professor of Modern History at Oxford Brookes University.

Monica Jansen is Lecturer in Italian Literature at Utrecht University.

Samuele F. S. Pardini is Assistant Professor of Italian at Elon University.

John J. White (d. 2015) was Emeritus Professor of German and Comparative Literature at King's College London.

Francesca Billiani is Senior Lecturer in Italian at the University of Manchester.

Maria Elena Versari is Visiting Assistant Professor of Art History at Carnegie Mellon University.

Matteo D'Ambrosio is Professor of History of Literary Criticism at the Università Federico II, Naples.

Przemysław Strożek is a Lecturer at the Academy of Fine Arts in Warsaw and Assistant Professor at the Institute of Art of the Polish Academy of Sciences.

Michael Syrimis is Associate Professor of Italian at Tulane University

Ernesto Livorni is Professor of Italian at the University of Wisconsin — Madison.

Marja Härmänmaa is Senior Lecturer in Italian at the University of Helsinki.

Barbara Meazzi is Professor of Italian Literature and Culture at the Université de Nice Sophia Antipolis.

Simona Cigliana is Professor of Militant Criticism at the Università di Roma La Sapienza.

Shirley Vinall is Visiting Fellow at the Department of Modern Languages and European Studies at the University of Reading.

Silvia Contarini is Professor of Italian Literature at the Université Paris Ouest Nanterre La Défense.

A NOTE ON TRANSLATIONS

Works by Marinetti and other Futurists that have been published in easily accessible translations are quoted directly in English translation without the original. Works that are not or not easily available in translation as well as sources that need to be quoted in the original version for scientific purposes are quoted in the original language, followed by an English translation. Unless otherwise indicated, the translations are by the author of the chapter in question.

LIST OF ILLUSTRATIONS

[Introduction]

FIG. 1. Umberto Boccioni, *Visioni simultanee* (Simultaneous Visions), 1911; Wuppertal, Von der Heydt Museum.

[Chapter 5: Francesca Billiani]

FIG. 1. Sant'Elia, *La città nuova* (The New City), 1914. Collection of Consuelo Accetti, *Casa a gradinata con ascensori dai quattro piani stradali* (Terraced House with Lifts from the Four Street Levels), Milan.
FIG. 2. Sant'Elia, *Stazione d'aereoplani e treni ferroviari con funicolari e ascensori su tre piani stradali* (Station of Airplanes and Trains with Funiculars and Lifts on Three Street Levels), 1913–14, pencil on paper; Como, Musei Civici.
FIG. 3. *La città nuova, casamento con ascensori esterni, galleria, passaggio coperto, su tre piani stradali (linea tramviaria, strada per automobili, passerella metallica), fari e telegrafia senza fili* (The New City, Block of Flats with External Lifts, Gallery, Converted Walkway, on Three Street Levels (Tram line, Road for Motor Vehicles, Metal Gangway), and Streetlighting and Wireless Telegraph), signed and inscribed *La città nuova*, detail, 1914, Como, Musei Civici.
FIG. 4. Mario Chiattone, *Per una cattedrale IV* (For a Cathedral IV), Ink, Pencil and Gouache on Paper, 1914, 15 × 15.5 cm.
FIG. 5. Fortunato Depero, *Grattacieli e Tunnel* (Skyscrapers and Tunnels), Tempera on paper, 68 × 102 cm; Mart, Museo di arte moderna e contemporanea di Trento e Rovereto.
FIG. 6. Fillìa and Prampolini, The Futurist Pavillion at the exhibition held at the Parco Valentino in Turin (1928) (photo).
FIG. 7. Guido Fiorini, *Grattacielo con tensitruttura: base* (Skyscraper with Tensile Structure: Base), 1931.
FIG. 8. *Grattacielo con tensitruttura* (Skyscraper with Tensile Structure), 1931.

[Chapter 6: Maria Elena Versari]

FIG. 1. *Manifeste du futurisme* in letter format (first page of 4), January 1909, Private Collection.
FIG. 2. Letter by Filippo Tommaso Marinetti to Francesco Balilla Pratella, 24 January 1911 on the stationery for *Poesia*, Fondo Pratella — Biblioteca Comunale 'F. Trisi' — Lugo (Ravenna).
FIG. 3. First page of *Il Futurismo*, 15 February 1910, F. T. Marinetti Libroni, Beinecke Rare Books and Manuscript Library, New Haven, CT.
FIG. 4. Alberto Martini, cover of *Poesia*, 1, n. 4, May-June 1905, Beinecke Rare Books and Manuscript Library, New Haven, CT.
FIG. 5. The First Futurist Letterhead, Beinecke Rare Books and Manuscript Library, New Haven, CT.
FIG. 6. Map of Milan, 1910, Artaria Publisher (detail), showing Marinetti's residences in Via

Senato (A) and in Corso Venezia (B), and the location of the shops of Poligrafia Italiana (C), Tipolitografia Ripalta (B) and Tipografia Taveggia (E).

FIG. 7. Letter by Renzo Provinciali to F.T. Marinetti with letterhead for *L'Incendiario. Periodico Futurista*, 9 May 1911, The Getty Research Institute, Los Angeles.

FIG. 8. Incipit of *A note by William Morris on his aims in founding the Kelmscott Press* (London: Kelmscott Press, 1898).

FIG. 9. First page of *La musica futurista. Manifesto tecnico*, dated 11 March 1911, Fondo Pratella — Biblioteca Comunale 'F. Trisi' — Lugo (Ravenna).

FIG. 10. Umberto Boccioni, *Still Life: Glass and Siphon*, collage, gouache, pen and ink, 1914, Yale University Art Gallery, New Haven, CT.

[Chapter 7: Matteo D'Ambrosio]

FIG. 1. Filippo Tommaso Marinetti, [number poem], s.d. [usually 1915; date proposed by the author 1914]; Filippo Tommaso Marinetti Papers, Beinecke Rare Book and Manuscript Library, New Haven, CT.

FIG. 2. Filippo Tommaso Marinetti, *La splendeur géométrique et mécanique et la sensibilité numérique. Manifeste futuriste*, Milan, Direction du Mouvement Futuriste, 11 March 1914, p. 1. Leaflet.

FIG. 3. Filippo Tommaso Marinetti, *La splendeur géométrique et mécanique et la sensibilité numérique. Manifeste futuriste*, Milan, Direction du Mouvement Futuriste, 11 March 1914, p. 4. Leaflet.

FIG. 4. Filippo Tommaso Marinetti, *Zang Tumb Tumb* (Milan: Edizioni futuriste di *Poesia*, 1914), p. 139.

FIG. 5. Filippo Tommaso Marinetti, *Une assemblée tumultueuse (Sensibilité numérique)*, s.d. [1918].

FIG. 6. Filippo Tommaso Marinetti, 'Poema preciso', in *Parole in libertà futuriste tattili termiche olfattive* (Savona-Roma: Lito-Latta & Edizioni futuriste di *Poesia*, 1932) (pages in tin are unnumbered).

FIG. 7. Filippo Tommaso Marinetti, 'Poema preciso', in *Parole in libertà futuriste tattili termiche olfattive* (Savona-Roma: Lito-Latta & Edizioni futuriste di *Poesia*, 1932) (pages are unnumbered).

[Chapter 12: Barbara Meazzi]

FIGS. 1–3. The three different covers of *Gli amori futuristi* (Cremona: Ghelfi, 1922). Collection Libreria Pontremoli.

[Chapter 13: Simona Cigliana]

FIG. 1. Luigi Russolo, *Autoritratto (con doppio eterico)* (Self-Portrait [with Etherical Double]), 1910.

FIG. 2. Filippo Tommaso Marinetti, *Decalogo della sensibilità motrice* (Decalogue of Motor Sensitivity), in *Dune*, 1914.

FIG. 3. Benedetta, *Spicologia di 1 uomo* (Spychology of 1 Man), 1919.

[An afterword with Günter Berghaus]

FIG. 1. Police file from the *Carteggio Riservato*.

FIG. 2. The Aviatrix — Dance performance inspired by Giannina Censi's *Aerodanze* (1935). Presented as part of a programme of four mechanical dances, *Metal Monsters and Mechanical Mayhem* (Bristol, 1996).

Fig. 3. Fortunato Depero, *Motolampade* (The Moving Lampshades, 1925). Presented as part of a programme of four mechanical dances, *Metal Monsters and Mechanical Mayhem* (Bristol, 1996).

Fig. 4. Maria Sideri, *It Comes in Waves* (Dance performance, 2014).

Fig. 5. *Vuoto totalo*, no. 1 (Paris & Pozzuoli: Pesce Nero Editore [Napoli: Tip. Fratelli Mazzanti], 1987).

INTRODUCTION

Futurism from Below:
By Way of Introduction

Sascha Bru, University of Leuven
Luca Somigli, University of Toronto
Bart Van den Bossche, University of Leuven

This book began when we stumbled upon an essay by Italian historian Carlo Ginzburg in which he explains the notion and practice of microhistory.[1] Ginzburg concludes his essay by stating (without explanation) that his work and that of other Italian microhistorians such as Giovanni Levi, Pietro Redondi, Franco Ramella, Osvaldo Raggio, and Alberto Banti is best represented by the paintings of Futurist Umberto Boccioni, most notably his *La strada entra nella casa* [*The Street Enters the House*, 1911, see cover image] and *Visioni simultanee* [*Simultaneous Visions*, 1911, see fig. 1]. It initially struck us as strange that a historian of the European Renaissance, known today still perhaps above all for his classic study of a sixteenth-century Italian miller and heretic, *Il formaggio e i vermi* [*The Cheese and the Worms*, 1976], would compare his work and method to the exploits of one of the most renowned antipasséist art movements of the twentieth century. Indeed, *microstoria*, a trend in history that flourished in Italy especially during the 1970s and 1980s, and Italian Futurism, one of the most famous movements of the so-called 'historical' avant-gardes, do not appear to have much in common. Yet we soon found that it was rather apt of Ginzburg to isolate Boccioni's painting *The Street Enters the House* to show what microhistory is about.

Boccioni's *The Street Enters the House* famously depicts the artist's mother leaning over the balcony while observing a large group of workers laying the foundation of a building. While the phallic poles of the workers eroticise the portrayed act of labour, it is above all the act of witnessing this labour that is thematised by Boccioni. For his mother does not just passively digest the scene. Her act of observation is an active intervention in the action further depicted; the ongoing work in turn quite literally enwraps her. As she watches on she changes the world around her and the world around her in turn transforms her. The far-off buildings and houses surrounding the construction site fracture in Cubist-like geometric planes leaning towards the central square, which appears to act as centre of gravity. The sway of the construction work, too, suggests a whirlwind-like set of events unfolding around this centre. Workers and their horses, as well as staircases and other construction

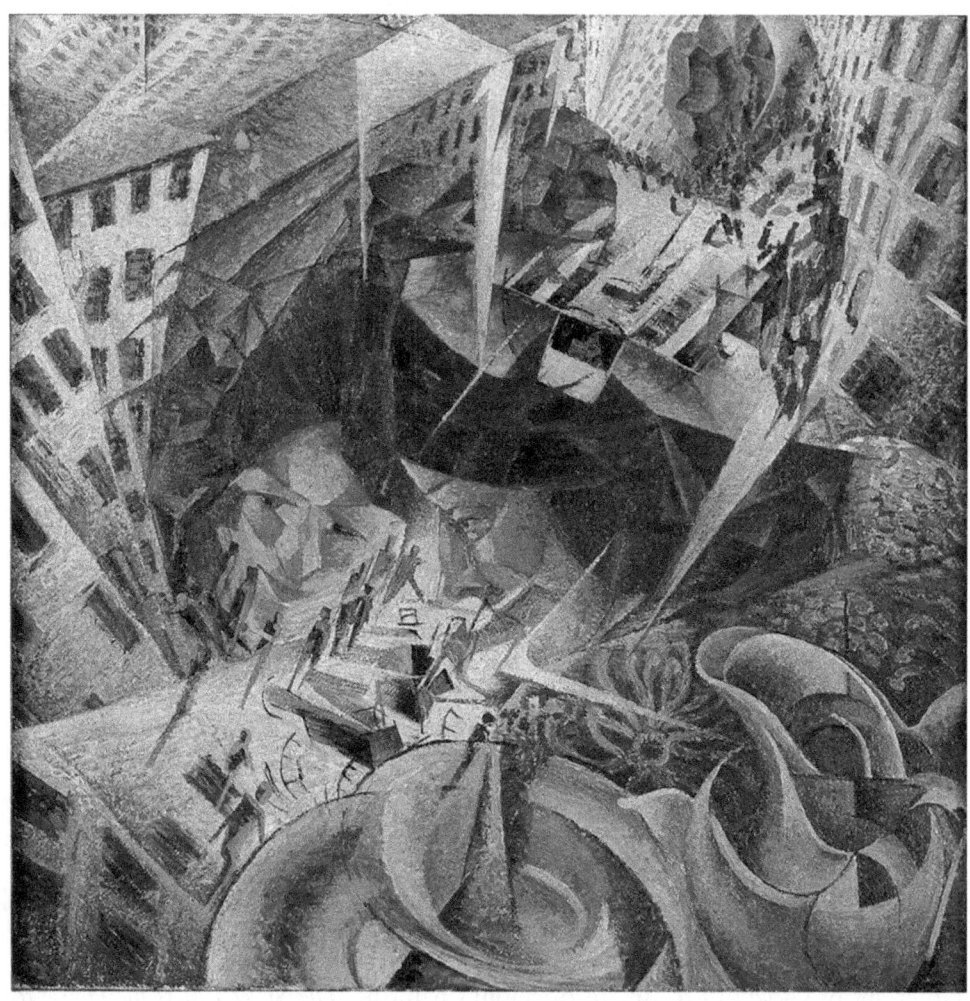

Fig. 1. Umberto Boccioni, *Visioni simultanee* (Simultaneous Visions), 1911; Wuppertal, Von der Heydt Museum.

materials, find themselves not in front but moving behind the observing mother's back, over whose shoulders we too come to observe the action. As a result, we as viewers also end up being placed right in the middle of the vortex, our gaze drawn to the centre of the canvas before we start looking at the outer regions of the painting to decode the larger whole.

Boccioni's aesthetics of course would change before he died in the Great War, and his work is not to be equated with Futurism as such. Yet, the fact that Ginzburg singled out *La strada entra nella casa* and the comparable *Visioni simultanee* does establish a thought-provoking connection between microhistory and Futurism, and in particular between the ways both Futurist painters such as Boccioni and historians inspired by microhistory approach the singular and the modest. Microhistory is the intensive historical investigation of a well-defined smaller unit of research (most often an event, an object, a small community, or a village). It does not simply involve case studies, however, but explores 'large questions in small places', as Charles Joyner put it.[2] Although different from the French *histoire des mentalités* and the German *Alltagsgeschichte*, microhistory thus focuses on smaller everyday practices within more modest constellations to unearth larger, frequently contradictory patterns, most often scrutinising little narratives developed to make sense of events and the world. This attitude or orientation, too, is encountered in Boccioni's painting. It is from the fractured point of view of the mother focusing on the small centre of the canvas that we move outward to the larger and more comprehensive context of modernity and modernisation. Rather than a well-defined 'method', Ginzburg and other microhistorians such as Giovanni Levi stress, microhistory is much like Boccioni's painting: a way of looking, a mode of observation.

Having encountered Ginzburg's small comparison between Futurism and microhistory, we began wondering how a microhistory of Futurism itself would look like. Could a 'method' designed to study early modern phenomena in cultural history and anthropology not also be used to scrutinise a distinctly modern art and literary historical phenomenon like Futurism? Could microhistory, scarcely employed within the field of modern art and literary history, not also cast a different light on Futurism? And with these questions the project for this book was born.

Between the celebration of the centenary of the foundation of Italian Futurism in 2009 and the renewed attention for it in North America after the major and comprehensive exhibition mounted by the Guggenheim Museum in 2014, there is at present no dearth of studies and books on the movement. Again the centre of attention in international scholarship, the movement, which from the late 1900s onward has been the object of an interdisciplinary aesthetic, cultural, and political investigation, hardly requires an introduction. The names of writers such as F. T. Marinetti and Aldo Palazzeschi, of plastic artists such as Boccioni, Giacomo Balla, or Fortunato Depero, of composers such as Luigi Russolo, and of dozens of other creative minds are now inextricably tied to Futurism and modernism at large. Recognising the substantial advances by Futurism studies in mapping the significance of the movement abroad and in historicist archival research, this book aims to take Futurism studies a step further by reading its exploits through the prism of

microstoria. For, indeed, studying Futurism with *microstoria* is a timely endeavour for at least three reasons.

First and most generally, exploring new modes of writing the history of Futurism and the modernist avant-gardes in general feeds into a wider trend of historiographical shifts of recent years in modernism studies. From the 1980s to the turn of the millennium, scholars tended to rub avant-garde texts and artworks up against their most immediate contexts — understood in institutional, ideological, social, or cultural terms. More recently, however, new approaches have called this procedure into question: digital humanities appear to bookend all avant-garde history by questioning the traditional modes of presenting textual and artistic sources;[3] cognitive approaches substitute 'the human brain' for 'context' and so often view the history of the modernist avant-gardes on an evolutionary rather than a political or cultural scale;[4] and ecological and other approaches regard the history of modernist art and literature as a blip on the screen of planetary history, or 'deep time', radically expanding the reach of a term like 'context'.[5] These recent approaches have led to what could be called an 'excess' of context. This excess has thoroughly complicated our historical understanding of modernism and its avant-gardes. Yet it has also created a situation in which the trees are often no longer seen for the forest. For what, then, is the context in which to situate Futurism? It is here that the 'method' of microhistory, despite its less conspicuous presence today, comes to us as both fresh and, in a way, comforting. As Ginzburg stresses amply, what all Italian microhistorians have 'in common programmatically is the insistence on context',[6] understood in a more conventional, historicist sense. Not unlike Fredric Jameson, microhistory persists to 'always historicise'.[7] Yet, while taking us back to a more familiar notion of context, microhistory also comes with a sense of freshness. For unlike more rigid systems for historical analysis and large-scale and generalizing tendencies as encountered in Jameson and much other historical research within the humanities and social sciences, microhistory does not so much take off with a system. Rather, it simply follows the historical material, and, as Levi argues, 'microhistorians [. . .] concentrate on the contradictions of normative systems and therefore on the fragmentation, contradictions and plurality of viewpoints which make all systems fluid and open'.[8]

This stress on singular agency rather than structural social or cultural determination is no doubt a second reason why a microhistorical study of Futurism in particular proves a timely one. While an enormous amount of ink has been spilled over the conditions that led to the emergence of Italian Futurism, it is worth recalling that the birth of Futurism in Italy was by no means self-evident. Quite the opposite, in fact. Looking back, Futurism could perhaps best be called, with microhistorian Edoardo Grendi, the 'exceptional normal',[9] an anomalous and highly improbable sort of event, at least seemingly. As is well known, when in 1909 Marinetti's 'Fondation et manifeste du Futurisme' [Foundation and Manifesto of Futurism] was published in *Le Figaro*, the movement of Futurism existed only on paper, in this highly performative manifesto itself.[10] By no means was the movement destined to become such a large, brash, and internationally visible phenomenon

in the following years. There were as yet no structures in place that allow us to account for the form the movement took or for its fast and loud rise.

Stressing agency over structure, and the more improbable type of historical documentation, *microstoria* therefore, thirdly, comes with the promise of casting a new light on the 'improbable' phenomenon of Futurism itself. Indeed, a brief look at the table of contents already suggests that this book presents an alternative 'little narrative' about Futurism, one that singles out a male protagonist whose every move during a single day is carefully monitored and documented. The table of contents suggests this book is about a New Man who in the morning goes to church, gets into his car, and drives into the city to work in the office, afterwards to enjoy sports, women, and (perhaps too much) alcohol before, finally, going to bed. As such, the narrative of the table of contents projects a rather mundane and bourgeois tale. Yet this is of course one of the many contradictory aspects of the anti-bourgeois phenomenon of Italian Futurism. It, too, proved bourgeois in many respects.

Each of the individual chapters in the book bends or enriches our understanding of Futurism by focusing on an object, a place, an episode selected from the movement's long and winding history. Whereas some of the items selected could be seen as nothing short of indispensable in a book on Futurism, other topics have less obvious or less specific connections with Futurism, at least at first sight. What most contributions have in common is that the microhistorical scope allows them to develop particular and at times puzzling perspectives on various aspects of Futurism. Close-up analyses of topical and iconic artefacts or situations of Futurism bring to the fore implications, associations, tensions, and contradictions that in a larger perspective are easily missed or covered up, whereas the careful scrutiny of places and objects usually associated to the historical avant-gardes in general helps to shed light on the transformations of Futurism and of its position within the context of the historical avant-gardes and of Italian culture at large. Microhistory is of course not a constant exercise in dismantling preconceptions and assumptions. Microhistorical perspectives on objects and events do not of necessity challenge what is commonly assumed about Futurism's representational policies, but will definitely help to lay bare the twists and turns in the way Futurist representations have come about. Close-up perspectives help to reveal (in some cases once again, and with more conviction) patterns of inclusion, exclusion, association, and manipulation in Futurism's representational strategies.

Commonplaces

Right from the first lines of its founding manifesto, Futurism was outspoken about its fascination with **cars and speed**. In recounting a car accident that happened in the autumn of 1908, Marinetti even bestowed upon the car the honour of opening up unprecedented ways of experiencing reality and of allowing man to enter an era of omnipresent speed. Samuele Pardini in his chapter confronts the Futurist interpretation of the car with the function of the car as a text-generating device in Marcel Proust. This comparison permits us not only to grasp the common view

of the car as an accelerator of time and history, but also to highlight some striking differences. In fact, whereas Proust saw the car first of all as a material object, focusing on the specific connections between the material and social aspects of the car and the subjective experiences it enforces, Marinetti and his fellow Futurists were inclined almost completely to dematerialise the car. Futurist texts tend to evoke the pure experience of speed and keep the technical, commercial, and social features of the car largely out of sight. For Proust, the materiality of the modern car allowed for some kind of negotiation between past and present, resulting in a new sense of historical and artistic memory. By contrast, for Marinetti the omnipresence of speed and motion erased any historical experience, and in the process the car itself became intangible as well.

As can be seen in Umberto Boccioni's 1913 triptych on sports, Futurists saw sports as an expression and celebration of dynamism, energy, antagonism. Przemysław Strożek argues in his chapter that **football** here stood out because of its large popularity. The sport was to become an icon of national pride and modernisation, with the Fascist regime sponsoring the construction of new stadia and hosting major international tournaments. Therefore Futurism's interest in football (or in sports in general for that matter) went beyond the topical celebration of energy, vigour, and dynamism with which it is commonly associated. The celebration of football was inextricably connected with the public sphere, becoming one of the main ways to make Futurist art interact with Italian society, as is also illustrated by Marinetti's attempts to combine sports with public performances.

If a sport like football clearly functioned as an interface between Futurist art and Italian society, gymnastics fascinated Futurists for reasons that are quite different in nature but certainly no less crucial for Futurist poetics. As is stressed by Michael Syrimis, Futurism's constant interest in **gymnastics** can be ascribed only to a limited extent to apparently obvious connections with education, war, agility, and performance. Rather, what made gymnastics so appealing to Futurists was its inherent tension between order and chaos, method and hazard, discipline and confusion. This also accounts for the rich variety of references and associations surrounding the term, ranging from swiftness and flexibility over military education and national pride to precision and discipline. The frequent and contradictory references to gymnastics certainly highlight how strongly Futurism was imbued with ideas on the constant struggle between opposing forces, including the tension in its own poetics and practices between disorder and disruption on the one hand and a desire for order and clarity on the other.

A similar set of entangled associations characterises the bed. As Silvia Contarini shows, the **bed**, with its obvious associations with sleep and sex, immediately became a *lieu* of antipasséism (refusing sleep and conventional sex) and of affirmation of typically Futurist values of energy, masculinity, and vigour. These representations turned the bed into a place of reinstated stereotypes about the male predator and the female 'prey', contradicting the attacks on other romantic stereotypes and ideas of gender equality in some of Futurism's political programmes. In this sense, the bed really is a 'microplace' that illustrates Futurism's aporias and the contradictions between some of its general intentions and the actual behaviours.

Aporias and contradictions also characterised Futurism's attitude towards the Catholic **Church**, discussed by Monica Jansen and Luca Somigli. As is well known, the first fifteen years of Futurism, and in particular its political proclamations, were marked by a strong anticlerical and anti-Vatican stance. The programme of Italy's *svaticanamento* (devaticanisation) was linked to the association between the Church and a number of typically Italian moral and political vices as well as to Futurism's overall antipasséist and anti-institutional iconoclasm. Yet the polemical attitude vis-à-vis the Vatican also points to a much deeper tendency in many instances of literary and artistic modernism to deal with the secularisation of Western societies. In probing for spiritual answers to this secularisation, Futurism can be seen as a competitor of institutionalised religions, and this common ground also explains why in the course of the thirties there was room for converging interests, especially in the realm of art and spirituality, with the 1931 'Manifesto dell'arte sacra futurista' [Manifesto of Futurist Sacred Art] as the most direct attempt to reconcile Futurism and Catholic spirituality.

The meaning of detail

The long history of Futurism is full of negligible details: places where Futurists hardly ever went or where they received a rather unfriendly welcome, events that were too ephemeral or too unsuccessful to be registered, artefacts that pop up on rare occasions. In a microhistorical perspective, similar details are likely to be turned into a looking-glass that uncovers patterns of major significance. This seems to be the case in particular with Marinetti's visits to **London**, which, measured by the mostly negative and even openly hostile reactions to Marinetti's performances, can hardly be deemed a success. The rare positive responses to the Futurist programme rapidly gave way to the birth of an autonomous group who, although influenced by Marinetti's ideas, quickly chose a different direction. From that point of view, the London episodes of Italian Futurism are at best an illustration of Marinetti's ability astutely to turn any sort of attention from the press, however negative and derisory, into some kind of *succès de scandale*. Yet, as John White demonstrates, Marinetti's visits to London contributed in a decisive way to a shift in Futurist representations of the metropolis. On several occasions, Marinetti hailed London as a city that not only embodied the modern city life evoked in early Futurist paintings, but that in turn could inspire new visions of what the Futurist city should look like. It is not a coincidence, as White stresses, that in the 1916 manifesto 'La nuova religione-morale della velocità' [The New Ethical Religion of Speed] the images associated with the modern metropolis bear striking resemblances to London, showing how the city for Marinetti represented an authentic epiphany of the modern city of speed.

Futurism's fascination with the metropolis was of course also central in Futurist architecture. Architecture was rarely at the forefront of Futurist activities, yet it is possible to highlight a set of recurrent preoccupations and interests in building and urban planning throughout Futurism's history that signal important shifts in the way Futurism envisaged modern urban life. A notorious icon of the modern metropolis, the **skyscraper** (*grattacielo*, or *grattanuvole* — 'cloudscraper' — as it was

also called) was the focus of various ways of shaping and interpreting life in that metropolis, as demonstrated here by Francesca Billiani. In the period immediately before the First World War, an urban landscape dominated by the skyscraper was considered to be the ideal setting for the self-fashioning of the dynamic modern individual wanting to get rid of the old historical categories of time and space. As such, rather than being a specific type of building, the skyscraper was a crucial element in the reconfiguration of urban and social space. In the thirties, Fortunato Depero's stay in the United States gave way to a different reading of skyscrapers. As is clear from his *Grattacieli e tunnel* [*Skyscrapers and Tunnels*, 1930], Fortunato Depero saw skyscrapers as part of an urban landscape of clashing forces and rotating circular movements associated with everyday life. In the same years, various Futurist artists took up Sant'Elia's drawings and rephrased them in a more static and less aerial architectural language. Futurist architecture became substantially aligned with rationalist architecture and eventually dismissed the skyscraper as an obsolete concept, because speed and transport allowed the modern city to be conceived as a horizontal space.

As the previous examples show, a microhistorical reading of minor events and artefacts can improve our understanding of gradual developments and shifts in Futurism, but in other cases a close look at secondary or even hardly noticed episodes can bring us to the heart of complicated and even existential questions Futurism's protagonists had to face at certain stages of its history. In the opening chapter of this book, for instance, Roger Griffin examines Marinetti's short afterword to Antonio Beltramelli's 1923 portrayal of Mussolini as *L'uomo nuovo* [*The New Man*]. This 1923 text brings us to the heart of the vexed problem of the relations between Futurism and Fascism, and Roger Griffin's reading of this text foregrounds some vital questions for the study of both Futurism and early Fascism. In spite of all the megalomania and the egocentric distortions, a careful reading of Marinetti's views in his short afterword to Beltramelli's *L'uomo nuovo* shows not only how Marinetti focuses on aspects of Fascism that were instrumental to his search for a Futurist-Fascist *modus vivendi*, but also offers an occasion to consider some of the main factors in the rise of Fascism, such as early Fascism's emphasis on production and transformation, the role of Interventionism and the Fasci di combattimento — enough arguments for Marinetti (but maybe not only for him) to highlight the Futurist connections in the rise of Fascism.

A striking example of how a minor topic can invite us to reconsider Futurism's internal history is Maria Elena Versari's close examination of the Futurist letterhead. Regardless of the movement's ambitious and all-encompassing programme of radical reform, Marinetti continued to use the red letterhead of the *Poesia* review until the end of 1911. He only gradually started to use specific letterheads and datelines in the movement's communication, and for a certain period employed various fonts and formats for Futurist publications. The fluctuating choices can be connected to the intention to transform Futurism from a group still loosely associated with *Poesia* and its network into an autonomous movement. This transformation is reflected in the creation of a new letterhead, used for the first time in the second half of 1911, and

in the decision to have a second print run of the Futurist manifestos with a different caption. Yet despite the will to create a 'new' letterhead necessary for the branding of Futurism as a movement, this letterhead utilised the same typeface as the first manifestos, in a move clearly intended to assure visual coherence to the movement and connect the new phase to the Futurist group's previous endeavours. In the course of 1912, shortly after moving to a different printing office, a new typeface was introduced for the manifestos, yet the red Futurist letterhead would continue to be used well into the twenties and was, tellingly, treated (for instance in a collage by Boccioni) as an icon of the movement's distinctive identity.

Futurism and cultural repertoires

As one of the most active, long-lived, and spectacular movements within the historical avant-garde, Futurism stands out for the variety and width of its cultural politics. Within the context of the historical avant-gardes, Futurist cultural politics can be described in terms of the transformation and rewriting of broader cultural repertoires present in other cultural movements and trends of the first decades of the twentieth century. As various chapters in this book illustrate, a reading inspired by *microstoria* applied to artefacts, motifs, and places of these cultural repertoires allows us to highlight how Futurism's strategies of appropriation and rearrangement contributed to the movement's specific position and evolution within the broader cultural context of the avant-gardes.

In early twentieth-century literary culture, **puppets** were a rather common presence, packed with diverging and contradictory meanings. Puppets did not just embody freedom, fantasy, and anticomformist rebellion but also fear of mechanisation and loss of control. Marinetti, steeled in Symbolism, fully embraced the connotations of the marionettes in symbolist theatre and poetry, using puppets to criticise inauthentic and conventional bourgeois behaviour but also to stress the importance of the irrational and the fantastic. In subsequent years, puppets became more and more linked to the Futurists' interest in the treatment of objects as living creatures and in machine-like performances (such as the *balli meccanici*). All in all, as Shirley Vinall persuasively argues, Futurism's interest in puppets remained closely connected to the fundamental ambiguity between the human and non-human represented by puppets in many artworks of the period.

Just as in the case of puppets, Futurism's interpretation of **doubles** was also indebted to the artistic repertoires and the psychological culture of previous decades. In the case of the double, however, the transformations operated by Futurism were more radical. Simona Cigliana highlights how appearances of the double in Futurist practices were no longer associated with bewilderingly uncanny experiences, but rather expressed the richness and energy of the individual's inner mental forces and desires. As symbols of dynamic mental life, instances of the double were inextricably linked with Futurism's cult of dynamism as the basic cosmic force, and reflected the intention of Futurist artists to trigger and accelerate processes of intellectual and aesthetic dynamism for themselves and for their audience. Eventually, Futurism's

use of the double fits into a broader pattern of dispersion of the 'I' through the multiplication of connections and associations on different levels of consciousness.

Experiments with poetry that transcend natural language are present in various avant-garde movements. The Russian Futurists' experiments with the transrational qualities of *zaum* paradoxically tied in with the dream of a universal language (or at least of identifying a universal dimension of language). It is no wonder that Velimir Khlebnikov at a certain stage started to work with **numbers** as a resource for immediate and universal communication. A letter from Roman Jakobson to Khlebnikov suggests that Marinetti's visit to Russia in 1914 may have played an important role in Khlebnikov's choice to pursue number poems. Yet, Matteo D'Ambrosio highlights the complex nature of Marinetti's interest in numbers. As is illustrated by his manifesto 'Lo splendore geometrico e meccanico e la sensibilità numerica' [Geometrical and Mechanical Splendour and Numerical Sensibility], published shortly after his visit to Russia, and by a number of other texts (including unpublished materials), for Marinetti 'sensitivity towards numbers' comprised highly different and even contradictory interests, ranging from ways of exploring the fourth dimension to applications of geometrical and mathematical precision to the hazardous dynamism of life.

It is not rare to see avant-garde movements combine an elitist self-consciousness with a desire to reach out to a wider audience (or even to an audience as wide as possible), and Marinetti in particular is notorious for the ways in which he tried to bring Futurism to the attention of the public. In the course of the 1920s, Marinetti also envisaged the possibility of producing types of literature that, while remaining faithful to Futurist poetics, would be able to extend Futurism's readership through the use of literary techniques and motifs from popular fiction. Barbara Meazzi's interpretation of *Gli amori futuristi* [*Futurist Loves*] shows nonetheless that these attempts of **literary seduction** were rather unsuccessful, and that the combination of sentimental fiction and narratological experimentation at least from that point of view turned out to be a failure.

A somewhat different story is told by Marja Härmänmaa in the chapter on **the cocktail**. Far from sharing the fascination for alcohol or drugs that could be found in some other avant-garde movements, Marinetti adopted a negative attitude towards drinking, as it went against the ideals of health and virility hailed by Futurism. Alcohol abuse brought a serious risk of degeneration and was to be seen as an authentic threat to the nation, an attitude that would change only in the final years of Futurism, when wine (provided it was locally produced) became associated with Italy's national heritage and with a *joie de vivre* capable of bolstering the Futurists' creative energy.

Despite this attitude towards alcohol, **cafés** occupied an important place in Futurism's history and poetics. As with other artistic groups and movements of the same period, for Futurism cafés were important places for meeting and organising Futurism as a movement, and also played a stimulating role in different artistic practices. In particular the café-chantant and the music-hall were decisive for Futurist approaches of theatre and performance. Yet, as can be seen in the work

of Carrà, Severini, or Boccioni, cafés were also highly attractive because of their atmosphere and bustling social life, including the *risse* between rival artistic groups. In fact, as Ernesto Livorni argues, Futurism's development in the first years of its existence can be described by tracing its associations with cafés in Milan, Florence, and various other places in Italy. The cafés they chose as venues for their meetings were far from being exclusively associated with literary and artistic circles, as they also met in cafés that did not host concerts or performances and that had a predominantly bourgeois and passéist clientele. For Futurists, a café was and ought to be a place where they could experience and boost the so often celebrated energy and dynamism of modern life, including the clashes between opposing forces. As cafés in the course of the 1920s no longer seemed to offer attractive occasions for similar experiences, the Futurists simply abandoned them.

Futurism and (micro)history, again

The microhistorical readings in this book quite often highlight transformations and shifts in Futurism's poetics, its self-organisation or its relations with wider cultural frames and developments. Many of these close-up readings fit well into the larger periodisations in the history of Futurism, such as the aesthetic institutionalisation in the second half of the twenties, or the compromises with more traditional political and cultural agendas in the course of the thirties. Yet they further highlight — precisely by focusing on specific episodes or events — the tensions that surrounded some of these large-scale transformations, the tactical choices they sometimes required and the side-effects they generated. In the course of the thirties Futurism shifted to traditional representations of seduction and sex and concentrated its efforts in this field more on commodities such as drinks and food appropriate for lovers (the *polibibita Guerrainletto* being the most obvious example), which in turn fitted into Futurism's refashioning of everyday life of which *La cucina futurista* [*The Futurist Cookbook*] is perhaps the best-known example. *Microstoria* further helps to unearth different and easily overlooked twists and turns in Futurism's history. The introduction of a Futurist letterhead for instance is a telling episode in the self-fashioning of Futurism as a 'movement' and the different temporalities connected to Marinetti's choices in this sense.

In the afterword with Günter Berghaus that closes this book, we attempt to take stock of the vast amount of histories of Futurism to which this book can also be added. Again favouring the small rather than the large we turn, among other things, to factual errors in some of those histories — small errors that on occasion had big consequences as they long distorted our historical understanding of the movement. These and other aspects of Futurism's historiography discussed in the afterword of course also remind us of that other issue microhistorians such as Ginzburg and Levi returned to time and again: *microstoria*, as history in general, is not only about getting the facts right; it is also about form and about the presentation of those facts in apt narratives that ideally manage to grab and fascinate readers to the point of immersing them in the past — just as Boccioni does today still in *The Street Enters the House*.

In the afterword Günter Berghaus, as always, proves most generous in sharing his tremendous knowledge and wisdom. It is to him, in honour of his sixty-fourth birthday and out of respect for his many feats in Futurism studies, that we dedicate this book.

Notes to the Introduction

1. Carlo Ginzburg, 'Microhistory: Two or Three Things that I Know about It', *Critical Inquiry*, 20.1 (1993), 10–35.
2. Charles W. Joyner, *Shared Traditions: Southern History and Folk Culture* (Urbana, IL: University of Illinois Press, 1999), p. 1.
3. The volume of material that has been digitally edited in recent decades has thoroughly affected historical research in modernism studies, and has given rise to new modes of editing modernist historical sources. See, among others, collaborative digital humanities initiatives such as the Modernist Journals Project (http://library.brown.edu/cds/mjp/), Editing Modernism in Canada (http://editingmodernism.ca/), and the Blue Mountain Project (http://library.princeton.edu/projects/bluemountain/).
4. Consider Peter Stockwell's analysis of avant-garde poetry and Jesse Matz's reading of modernist prose: Peter Stockwell, *Cognitive Poetics* (London: Routledge, 2002), pp. 112–17; Jesse Matz, 'The Art of Time, Theory to Practice', *Narrative*, 19.3 (2011), 273–94.
5. See, for instance, Wai Chee Dimock, *Through Other Continents: American Literature across Deep Time* (Princeton, NJ: Princeton University Press, 2006).
6. Ginzburg, p. 33.
7. This is, of course, the famous opening slogan of Fredric Jameson's *The Political Unconscious: Narrative as a Socially Symbolic Act* (Ithaca, NY: Cornell University Press, 1981).
8. Giovanni Levi, 'On Microhistory', in *New Perspectives on Historical Writing*, ed. by Peter Burke (Cambridge: Polity Press, 1991), pp. 97–119 (p. 107).
9. Edoardo Grendi, 'Micro-analisi e storia sociale', *Quaderni storici*, 35 (1977), 506–20 (p. 512).
10. Luca Somigli, *Legitimizing the Artist: Manifesto Writing and European Modernism 1885–1915* (Toronto: Toronto University Press, 2003).

CHAPTER 1

The New Man
Marinetti's Appendix to Antonio Beltramelli's *L'uomo nuovo* (Benito Mussolini)

Roger Griffin, Oxford Brookes University

The New Sigismondo

The specimen of Futurism chosen for analysis in this microstudy is Marinetti's twelve-page paean to Italy's new Prime Minister, Benito Mussolini, and to Futurism's (allegedly) crucial role in the spectacular rise of power of his movement, published as an appendix to Antonio Beltramelli's *L'uomo nuovo* [*The New Man*] in 1923, a few months after the 'March on Rome'. Beltramelli introduced it with the laconic words that 'ogni presentazione sarebbe ingiuriosa' [any presentation would be injurious], and limited himself to thanking 'l'amico mio carissimo F. T. Marinetti, per aver voluto concorrere a far più compiuta l'opera mia' ['my dearest friend F. T. Marinetti for having agreed to make my work more complete].[1]

Despite its brevity, the eulogy offers insights into aspects both of Marinetti's conception of Futurism's political agenda and of the deep personal kinship he felt with Mussolini, which are easily obscured by orthodox art history's tendency to focus narrowly on Italian Futurism as an aesthetic phenomenon, reducing the high-profile commitment to Fascism of some of its most significant artists to an epiphenomenon. When this relationship is foregrounded by historians, its nature has all too often been obfuscated by a failure to recognise the deep affinity between, but separate identity of, radical experiments in creativity, innovation, and regeneration in both the artistic and socio-political spheres in the early twentieth century, and the need to expand our understanding of 'modernism' to embrace both.

L'uomo nuovo was written some two years before the Fascist dictatorship was declared in January 1925 and well before the '*duce* cult' and 'cult of the *littorio*' took off in earnest as a popular phenomenon.[2] It represents the very first of the numerous bibliographies of Mussolini that have continued to appear to this day. Antonio Beltramelli was a prolific man of letters: travel writer, novelist, poet, journalist, cultural commentator, and, with the rise of Fascism, a political pundit. In this role he was a typical representative of the crisis of Italian identity and culture that from the turn of the century had produced not just the Communist avant-garde hoped

for by Gramsci, but an *anti*-Communist avant-garde imbued with an insistence on the need for a total revolution in the national spirit and the Italian character, combined with the ardent embrace of modernity's dynamism and technological innovation so that a new Italy could emerge.[3]

Writers such as D'Annunzio, Prezzolini, the *Voce* Circle, Beltramelli, and Marinetti himself saw the primary function of literature and art as forging the cultural and mythic premises needed for Italy to complete the spiritual and political mission of the Risorgimento to bring about not just geographical and political, but spiritual and national unity. They were convinced that only when the shackles of a corrupt and spiritually bankrupt liberalism had been removed would Italy be able to fulfil its potential for national greatness that had been thwarted time after time by different constellations of historical and political circumstances ever since the Middle Ages.[4]

In this context both Beltramelli and Marinetti can be seen in Gramscian terms as 'organic intellectuals' representing a counter-hegemonic, nationalist intelligentsia in Giolittian Italy. Though made up of a highly disparate group of individuals, this self-appointed elite was destined to play a key role in supplying the ideological legitimacy of the Fascist regime, and in guaranteeing the impressive outpouring of highly variegated cultural production in all creative spheres which promoted the Fascist Revolution for the next twenty years.

In 1908 Beltramelli had written the Nietzschean *I canti di Fauno* [*The Songs of Faunus*] and in 1912 *Un tempio d'amore* [*A Temple of Love*], a brief and highly mythicised narration of the life of the fifteenth-century *condottiere* Sigismondo Malatesta which focused on his reconstruction of Rimini's Church of San Francesco in Isotta's honour. His account, rather than emphasise the lyrical, emotional aspect of their relationship, lionised instead Sigismondo's dominating willpower and the charismatic qualities he displayed as a freelance warrior that won him the reputation of the 'wolf of Rimini'. Hence such assertions as 'The mere presence of Sigismondo was enough to impose subjection, and in this lay the secret of his fascination over the masses', and that 'If Sigismondo failed in his effort to kill Pope Paul II, it was hardly for lack of will.'[5] The Ezra Pound critic Lawrence Rainey comments that in Beltramelli's hands:

> [T]he salient characteristic of Sigismondo became a ruthless, indomitable will — which also signalled the arrival of a new ethical and cultural order, turning him into an exemplary figure *for the imagining of a new man who would address the pervasive sense of crisis that marked the early twentieth century and modernity itself.*[6]

Beltramelli's interpretation of Sigismondo as embodying the Renaissance's nascent heroic individualism, and thereby prefiguring both Italy's imminent rebirth and the Nietzschean 'superman' who would bring it about, was to fire the imagination of one of the leading lights of American literary modernism, Ezra Pound. He encountered Beltramelli's work when he travelled to Italy in 1924 to do research for what became the 'Malatesta Cantos' sections 8–11 of his life's work, *The Cantos*. Impressed by Fascism's proclaimed dynamism and genius, Pound, now in permanent self-imposed European exile from the United States, was soon to become an ardent

supporter of Mussolini as the incarnation of the spirit of innovation, which the poet summed up in the famous exhortation 'Make it new'. This was an appeal for a decisive response to the alleged atrophy of the spirit of creativity in Europe not just in art, but in society, politics, economics, and Western civilisation as a whole. Later that year Pound moved permanently to Rapallo with his wife, and it was from there that he was to become one of the Fascist regime's most ardent and notorious English-language propagandists.

Beltramelli himself had been one of the 'first Fascists', and wrote a brief essay 'La nascita del Fascismo' [The Birth of Fascism] as a first-hand witness of events.[7] It already refers to Mussolini as 'l'uomo nuovo', and includes the declaration: 'Date una fede e un canto al popolo di questa terra nostra magnifica e lo condurrete più lontano che mai, fin oltre alla morte. Questa è stata la divina intuizione del Duce' [Give a faith and a song to the people of our magnificent land and you will lead them further than ever, even beyond death. That has been the divine intuition of Mussolini in the aftermath of the war].[8] Mussolini's appointment as Head of Government at the King's bidding in 1922 was for anti-Giolittian organic intellectuals such as Beltramelli the long-awaited fulfilment of their palingenetic myth of the imminent creation of a new Italy through a charismatic individual. In contrast to what they saw as the parliamentary road to anarchy and weakness promoted by Cavour, Giolitti, and Nitti, Italy was to be modernised and turned into a 'Great Power' by a leader who combined the amoral individualism of a Renaissance *condottiere* with the heroic will to power of the Nietzschean superman, selflessly dedicating both qualities to the cause of the reborn Italy.

Beltramelli's reaction to what he thus saw as the dawning of a new age in the history of Italy's greatness, signalled by the outcome of the March on Rome, was to write *L'uomo nuovo*. He went on to sign Giovanni Gentile's 'Manifesto degli intellettuali fascisti' [Manifesto of Fascist Intellectuals, 1925], and to be one of the first to be elected to the regime's newly created Accademia d'Italia. He died in 1930. Thus when he invited Marinetti to publish his Futurist eulogy of Mussolini as the completion of his book, he did so consciously as a kindred spirit of the author of the poem *Zang Tumb Tumb*, even if his own literary modernism had taken him on a different aesthetic path.

Marinetti's 'Futurisation' of Fascism's Rise to Power

The essay opens with a bombastic declaration, practically its author's trademark, claiming that both the victory of the Italian army over the Austrians at Vittorio Veneto and Fascism's breakthrough 'costituiscono la realizzazione del programma minimo futurista' [constitute the realisation of the minimum Futurist programme] first promulgated fourteen years earlier, namely in the first Futurist Manifesto of 1909. He alludes cryptically to a 'programma massimo non ancora raggiunto' [maximum programme that has not yet been fulfilled]. This would presumably be a fully-fledged Futurist state with all traces of Italy's artistic and historical legacy surgically removed to expunge all traces of 'passatismo'. The practical implications of such a programme once rhetoric turned into actions are illustrated by the cultural

destruction carried out with such relish by the Conquistadores in their genocidal onslaught against Amerindian societies, though what Marinetti was proposing (at least on paper) was a systematic 'culture-cide' to be carried out by Italians on their own culture.

Yet such eagerness to take the credit for Fascism was far from predictable at the time of writing, given that Marinetti penned the piece in the period of Futurism's profound estrangement from the movement. He and other notable Futurists had distanced themselves when, following the crushing electoral defeats of 1919, Mussolini had used the Fascist Congress of Milan of May 1920 as an opportunity to reject the radically anti-clerical and republican stand of San Sepolcro Fascism, adopting instead a more moderate anti-systemic position which edged his movement towards extensive compromise with the Church, the monarchy, the bourgeoisie, and the entire Giolittian parliamentary system, all detested by Marinetti's faction. However, Mussolini's unexpected success in gaining power seems to have aroused irrepressible enthusiasm in Marinetti for the prospect of a 'genuine' revolution, while also giving this irrepressible self-promoter the opportunity to claim the victory as his own and bathe his movement in the reflected glory of Mussolini's growing personality cult.

Having laid out his stall, Marinetti proceeds to offer readers a succinct summary of what the 'minimum programme' was as set forth in the 1909 Manifesto, but somewhat re-edited for the occasion:

> l'orgoglio italiano, la fiducia illimitata nell'avvenire degli italiani, la distruzione dell'impero austro-ungarico, l'eroismo quotidiano, l'amore del pericolo, la violenza riabilitata come argomento decisivo, la glorificazione della guerra, sola igiene del mondo, la religione della velocità, della novità, dell'ottimismo e dell'originalità, l'avvento dei giovani al potere contro lo spirito parlamentare, burocratico, accademico e pessimista.
>
> [Italian pride, unlimited faith in the future of Italians, the destruction of the Austro-Hungarian Empire, everyday heroism, love of danger, violence rehabilitated as a decisive argument, the glorification of war, the only hygiene of the world, the religion of speed, of novelty, of optimism and originality, the rise to power of young men opposed to the parliamentary, bureaucratic, academic, and pessimist spirit.][9]

So far Marinetti's appendix to a biography on Mussolini has talked only of his own brainchild, and he continues unashamedly in this vein. Futurism, he boasts, has spawned many Futurisms (he scornfully dissociates himself from Russian Futurism as a 'state art'), but as a movement of art and ideas it only assumes an overtly political character when the nation is in an hour of need. One such moment was the Interventionist Crisis, led by the Futurists (he claims), high points of which for Marinetti were being imprisoned with Mussolini in Milan after the demonstrations during the Battle of the Marne (5–9 September 1914), and again on 12 April 1915 in Rome. He pointedly reminds the reader that Futurists created the first Arditi associations, were among the first Fascists, and both he and Mussolini were sent to prison in Milan in November 1919 (after the police had found explosives in Marinetti's apartment, a detail he omits to mention). Thus as 'divinatori e lontani

preparatori della grande Italia d'oggi' [the seers and distant precursors of the great Italy of today], Futurists are delighted to find in the not yet forty-year-old Prime Minister 'un formidabile temperamento futurista' [a marvellous Futurist temperament].[10]

A Futurist Portrait of Mussolini

This is the rhetorical preamble to the crucial passage in the appendix that links it to the core theme of Beltramelli's book: Mussolini as the 'new man'. The 'new man' is a primordial image in human mythopoeia whenever it seeks to capture in words and images the process of regeneration and renewal. It is central to Pauline theology, Nietzschean philosophy, and the revolutionary fantasies of all 'totalitarian' Fascist and Communist movements, their project of bringing about an anthropological revolution setting them apart from tyrannies and authoritarian or military dictatorships that have no such aspiration.[11]

However in the context of the Mussolini cult it also acquires the associations of another 'new man', the *homo novus* first encountered in the works of the classical Roman writers Seneca and Boethius, and subsequently taken up by Dante, Petrarch, and Chaucer. This is an individual who rises from obscure humble origins to eminence and influence because of his outstanding personal talents and courage. Having established itself as a topos in the late Middle Ages, it then became of central significance to a number of Renaissance humanists in Italy, who saw the modern state which was emerging from Italy's feudal order as deeply dependent on a caste of highly educated and literate *homines novi* to be run efficiently. It was the hybrid ideal type of the *homo novus* in both the Renaissance and Nietzschean sense that Beltramelli had seen incarnated in Sigismondo.

It was with the connotations both of a new anthropological type of man (like Ernst Jünger's 'worker') and of the 'man who has risen from the people' (an essential ingredient of the Hitler myth as well), that *La Voce*, the main publication of political modernism in pre-war Italy, called for an elite of 'new men' to emerge to save Italy from decadence. It has a significance still widely overlooked by more pedestrian historians and biographers of Mussolini that, long before the demise of his 'socialist' phase, he was reading *La Voce* — from its first publication, in fact.[12] In 1935 he was openly to acknowledge his debt to the journal for crystallising his sense of mission: 'La sensazione di essere chiamato ad annunciare una nuova epoca, l'ho avuta per la prima volta allorché mi avvicinai — epistolarmente — al gruppo de *La Voce*' [I first had the feeling of being called to announce a new era when I started corresponding with the *La Voce* group].[13]

So what does Marinetti see as the defining traits of the 'new man', Benito Mussolini, who had so dramatically catapulted himself into the role of Italy's head of state? For one thing, he is not an ideologue 'incatenato dalle idee' [trapped in ideas]. Instead he is 'libero, scatenatissimo' [free, completely unfettered]. Hence, he was 'socialista e internazionalista, ma soltanto in teoria. Rivoluzionario sì, ma pacifista mai' [a socialist and an internationalist, but only in theory. He was a revolutionary, but never a pacifist]. Finally he had given in to the compulsion of

his special form of patriotism, which Marinetti calls 'physiological'. What he means by this is that his love for Italy is corporeally constructed *all'italiana*, in an angular body, 'scolpito dalle asprezze rocciose della nostra penisola' [sculpted by the rugged rocks of our peninsula]:

> Labbra sprezzanti, prominenti, per spavalderia, aggressività che sputano su tutto ciò che è vano, lento, ingombrante, inutile. Testa massiccia, ma occhi ultradinamici che gareggiano con la velocità delle automobile nelle pianure lombarde. La bombetta rincalcata giù sugli occhi come le nuvole nere che pesano sul buio intenso dei burroni appenninici. Il bavero del cappotto sempre alzato per un istintivo camuffamento di complotto romagnolo.
>
> [Contemptuous lips that protrude out of sheer conceitedness, full of an aggression which spits on all that is pointless, slow, bothersome, futile. A massive head, but ultra-dynamic eyes which rival the speed of cars hurtling down the plains of Lombardy. The bowler hat [he was yet to don the extravagant uniforms of *il duce*] pressed down over his eyes like the dark clouds that hang over the intense dark of ravines in the Apennines. The collar of the grey-coat is always instinctively raised as if he is covering up a conspiracy hatched in the Romagna countryside.][14]

Moreover, when Mussolini's arms lean on the writing desk they look like 'leve per balzare al di là, sullo scocciatore o il nemico' [levers ready to hurl him down with all his weight on a fool or an enemy]. His body is in a constant state of agitation to shake off everything that is superfluous. But perhaps his most prominent Futurist feature is his angular head, resembling a 'nuovo proiettile o scatola piena di buon esplosivo, o semplicemente cubica volontà di Stato, testa pronta a colpire nel petto come un toro' [a new type of cannon shell, a box of powerful explosive, or simply a cube brim-full with the will of the State, a head ready to strike you in the chest like a bull].[15]

Marinetti then turns to Mussolini's rhetorical powers. The new Prime Minister is no run-of-the-mill parliamentarian, but an '[o]ratore futurista che sfronda, incide, trapana, strangola l'argomento avversario, taglia metodicamente tutti gl'intrichi delle obiezioni, fende la folla come un *mas*, come un siluro' [Futurist orator who prunes, cuts into, drills, or strangles the opponent's argument, who whittles away methodically the intricacies of the objections, who cleaves the crowd like a navy speedboat, a torpedo]. He then quotes two recent examples of Mussolini's Futurist rhetoric in action, one contained in a speech attacking the museum mentality of the old Italy and celebrating the creative spirit of a young people, the other calling for Italy to become a race of producers and not of parasites so that it can create the glories of the present and the future, and not just live off the artistic triumphs of the past. The second passage quoted from Mussolini ends:

> Noi samo la generazione dei costruttori che col lavoro e con la disciplina del braccio e intellettuale vogliono raggiungere il punto estremo, la meta agognata della grandezza della Nazione di domani, la quale sarà la Nazione di tutti i produttori e non dei parassiti.
>
> [We are the generation of constructors who with the work and discipline of brawn and brain want to reach the extreme point, the goal so ardently fought

for, the greatness of the Nation of tomorrow, which will be the Nation of all the producers and not of its parasites.][16]

With a few deft strokes of the pen Mussolini has been portrayed as a champion of the Futurist vision of a reborn Italy as effectively as Gerardo Dottori's well-known painting of Mussolini blending Cubist and Futurist compositional elements, *Il Duce*, of 1933. This presents him with an imperious sneer as aeroplanes gyrate around his chiselled head like the halo of a modernist icon of the technological age, the dominant colour blue emphasising the liberating effect of charismatic leadership from the thralls of the past. By presenting the future *Duce* as his own kindred spirit, it is as if Marinetti has turned himself into a secular John the Baptist of the political redeemer now at the helm of the state. (Perhaps Jesus Christ, son of a humble carpenter, was the ultimate *homo novus*.)

The Birth of Fascism and the Battle of *Avanti!*

Having firmly established the new prime minister historically and ideologically as one of his own with his broad-brush Futurist portrait, Marinetti then offers his own account of the birth of Fascism in which he emerges unequivocally as its principal mid-wife. In real terms, he declares, it was born immediately after the Italian army's victory at Vittorio Veneto, which caused the disparate elements which had made up the Interventionist movement in 1914 — 'ex-socialisti, repubblicani, giovani monarchici, artisti futuristi, sindacalisti, anarchici, rivoluzionari di ogni genere'[17] [ex-socialists, Republicans, young monarchists, Futurist artists, [national] syndicalists, anarchists, revolutionaries of every kind] — to reform as a movement fired with renewed passion to defend the victorious army from the counter-attack mounted by the socialists, and to channel into revolutionary change the wave of patriotism it had inspired. Incensed at not having been able to stop Italy's participation and eventual triumph, these were subversive forces bent on exploiting the inevitable post-war chaos for their own ends. Urged on by the politician Francesco Nitti, they thus mounted a campaign against the Interventionists, accusing them of responsibility for the mess the country was in to a point where war heroes and war-wounded were physically threatened. Instead of victory celebrations, a wave of strikes was unleashed undermining industrial recovery and sparking an unsustainable surge in wages.

It was this threat to the country that brought Fascism into being, according to Marinetti. To stop the nation plunging into socialist anarchy, the first Fasci were founded in a theatre in Milan's San Sepolcro Square by Mussolini, Marinetti, and two other Futurists, Mario Carli and Ferruccio Vecchi, the head of the Arditi, all men determined to incite a patriotic revolution based on the spirit of the war veterans. They were first called into action by the attempted socialist uprising in April 1919 in Milan, which they successfully resisted with a few revolver shots.

However, despite this victory, the Fascist breakthrough was a long time coming. D'Annunzio's occupation of Fiume, supported by Fascist and Futurist legionaries, did not end in a great Italian revolution as hoped. Socialists and supporters of Nitti

were in the ascendant, and it was Marinetti and Vecchi who had to organise a celebration of Vittorio Veneto in Milan to keep the flame of the veteran movement burning. In the elections of 20 November the Fascist List, which included Mussolini, Marinetti, and two other Futurists, Bolzon and Macchi, was heavily defeated by the socialists, who secured the imprisonment of Mussolini, Marinetti, Vecchi, and fifteen other Arditi 'accusati di attentato alla sicurezza dello stato e di organizzazione di bande armate' [accused of an attack on the security of the state and the organisation of armed gangs][18] (again no mention of the cache of arms found at Marinetti's apartment which prompted the arrest). On 20 May, Marinetti and other Futurist leaders left the Fascist movement because of their failure to 'imporre alla maggioranza fascista la loro tendenza antimonarchica e anticlericale' [impose anti-monarchist and anti-clerical principles],[19] but many Futurists continued the struggle as Fascists, notably Balbo, Bottai, Bolzon, Steiner, Masnata, Castelli.

Significantly, Marinetti truncates his account of the genesis of Fascism so that it ends at the point where he and his followers left the movement, juggling away not just Mussolini's massive ideological and tactical input to the rise of his own movement, but also the entire episode of regional *squadrismo* in the *biennio rosso*, without which the transformation of Fascism into a significant paramilitary movement in Northern and Central Italy and the March on Rome itself would have been unthinkable. Building on the fleeting reference made earlier, he instead devotes the final section of the appendix to a blow-by-blow account of 'the Battle of 15 April 1919', one which graphically brings alive the Futurists' goal of 'la violenza riabilitata come argomento decisivo' [violence rehabilitated as the decisive argument] declared in the highly Fascistised summary of their minimal programme on the first page.[20]

The section opens in melodramatic vein: '[i]l *15 aprile 1919* rimarrà memorabile nella storia d'Italia' [15 April will ever be remembered in the history of Italy][21] — an assertion that would be quickly refuted by any survey of public opinion held in Italy after 1945. Thirty thousand left-wing 'subversives' had decided to mount an uprising on that day, counting on the non-intervention of the forces of order of an allegedly pro-Communist government. Even though the day before Mussolini in a meeting held at the offices of his own newspaper *Il Popolo d'Italia* had decided not to oppose the insurrection, some diehard Arditi, Fascists, and Futurists turned up in the Piazza del Duomo about two o'clock ready to use revolvers to keep the enemy at bay. Marinetti, accompanied by Ferruccio Vecchi and the Futurist poet Pinna, also an artillery lieutenant, went into a *pasticceria* in the Gallery (Milan's famous arcades), where they were soon joined by other militant anti-Communists. Grouped into a small column headed by Vecchi, they proceeded to the Polytechnic, where another 300 students swelled the ranks of the ramshackle column, sweeping aside the Communist activists trying to close off the Gallery. By now Marinetti was with three other Futurists at the head of an improvised, poorly armed, and vastly outnumbered 'army', which proceeded to throng around the monument of Vittorio Emanuele. Here, inflamed nationalist speeches were made, with Marinetti surveying the scene while perched histrionically on the neck of one of the monumental lions.

Suddenly the column of Bolsheviks arrived, singing the Red Flag and carrying the portrait of Lenin. As the Futurists rushed at the policemen defending the Communist march, truncheons started flying, one of which landed at Marinetti's feet. As if this was a prearranged signal, the cry 'A noi, a noi, Arditi!' [Victory to the Arditi!] went up, and the anti-Communists now launched a counter-attack with clubs, stones, and bullets. Two of their number fell dead, but undeterred they continued the assault on the enemy, who suddenly broke up and ran in all directions. Some cowered on the stone steps of the monument, others ran away in terror. As for Marinetti: '[c]azzotto un giovane socialista che cade e al quale urlo, afferrandolo pel collo: "Grida almeno *viva Serrati!*[22] E non *viva Lenin!* Imbecille!"' [I punch a young socialist who falls down, and I seize him by the collar and yell 'At least shout *Long Live Serrati!*, and not *Long Live Lenin!*, you imbecile!'].[23] The socialists are chased away, and Marinetti's column, having won the day, comes to a halt in front of the Eden Theatre. The battle had lasted an hour.

It was then that one of the most historic, not to say mythic, events in the early history of Fascism took place. Reformed as a column, Marinetti's jubilant men marched to the editorial offices of the socialist periodical *Avanti!*, once famously edited by Mussolini himself, and sacked the building before setting fire to it. Despite a number of gunshot wounds suffered by his men, the column led by Vecchi and Marinetti then returned to Piazza del Duomo, now masters of Milan, shouting '*L'Avanti* non è più' [*Avanti!* is no more]. They delivered to Mussolini in the offices of *Il Popolo d'Italia* the charred sign of the journal as a trophy. The next day a notice written by Vecchi and Marinetti was posted on the walls of Milan explaining their version of events. The verdict of General Caviglia, who led the troops at Vittorio Veneto, on what had been achieved at the Battle of 15 April, was that their battle had been 'decisive' in crushing the threat of a socialist revolution.

In fact, Marinetti declares, Milan was transformed from that day on. The back of the Bolshevik Revolution had been broken, and even when the Communists moved the focus of their attack on the state to Bologna, Futurists such as Leone Castelli fought with great distinction to put down the uprising. Soon Fascist squads were overrunning Emilia and Romagna, and, so Marinetti implies, it was this wave of anti-Communist resistance, to be seen as a continuation of 'the Battle of Milan', which set in train the events that were to lead to the March on Rome, not D'Annunzio's Fiume adventure which had come to nought. The last line of the appendix once more highlights the crucial role played by Futurists in assuring victory for the antisocialist right: 'Da *Roma Futurista*[24] alla *Testa di Ferro*,[25] il nostro gruppo Futurista-Ardito-Fascista non diede mai tregua agli anti-italiani' [From *Roma Futurista* till *Testa di Ferro*, our group, a mixture of Futurists, Arditi, and Fascists, never gave quarter to anti-Italians], a claim even more remarkable given the fact that some accounts of the arson attack make no reference to the involvement of Futurists at all.[26]

The wider significance of the appendix for Futurism studies

We have seen how Marinetti offers a highly Futurism-centric, not to say egomaniacal, view of early Fascism. Indeed, Mussolini is conspicuous by his absence from most of Marinetti's account: Futurists led the Interventionists, the formation of the Arditi, co-founded the *Fasci*, and played a leading role in the Battle of Milan, without the help of Mussolini, who had decided (by implication wrongly) not to intervene against the socialists. Somewhat humiliatingly, he is delivered a memento of the *Avanti!* offices, once his work place, only after the battle.

Yet what this one-sided futurisation of Fascism accurately pinpoints is an essential but widely misunderstood element of its history: the central role played by first the Interventionist spirit and then the veteran spirit in its genesis. It is remarkable how often historians have assumed that Fascism derives its name from the Roman *Fasces* and not from the Interventionist *Fasci*, or leagues. (Though *il fascio* was a general word for association or league at the time, Mussolini used it specifically with the connotations of Interventionism, an attitude which, whether from the left or the right, despised what Giolittian Italy stood for and fought for a 'new Italy'.[27])

Even so, the poet still drastically underplays the significance of Mussolini's independent tactical ability in seeing the Interventionist campaign as a catalyst to the release of revolutionary energies in Italy. Even more outrageous is that he takes credit for seeing the Arditi, the front-line soldiers, and the veterans as the nucleus of a new Italy. Mussolini's article 'Trincerocrazia' [Trenchocracy], which appeared on 15 December 1917 in *Il Popolo d'Italia* (which incidentally makes no reference to the Futurists), shows he had no need for the inspiration of Marinetti's 'minimal programme' to conceive the *Fasci di combattimento* as the nucleus of a popular revolutionary movement building on the army's success at Vittorio Veneto. Despite this, Marinetti has managed to highlight without megalomaniacal distortion several major components of Fascism which have escaped the attention of generations of conventional historians who deny Fascism and generic fascism an authentic, ideologically driven, revolutionary dynamic.

One is Fascism's productivist dimension. The transformative power of productive, manual, and industrial work in realising the goals of a national state was one of the leitmotifs of the interwar period,[28] whether we think of Bolshevism, for whom the Soviet worker (both industrial and agricultural) became a mythicised, heroised figure, of Nazism, which celebrated the beauty of work in an organisation such as *Schönheit der Arbeit*, or of the American New Deal, for which the construction of the Hoover Dam became the supreme emblem. The myth of the emergence of a new man fully adapted to an age of 'total mobilisation' is the theme not just of the Stakhanovite movement in Russia,[29] but also of Ernst Jünger's *Der Arbeiter* [*The Worker*, 1932]. It was no less central to the Fascist cult of modern industry, technology, new civil architectural projects, and public works expressed in the building of new towns and the draining of the marshes.[30] A mythicisation of the fruits of the industrial revolution which have filled the modern world with technologies of speed lies, of course, at the heart of the Futurist Manifesto.

This last point connects directly to an even more important insight about the nature of Fascism which was for decades ignored or denied by many historians, whether Marxist or liberal, namely the *revolutionary* spirit of early Fascism. Marinetti's whole piece, reinforced by the context of Beltramelli's book, celebrates Mussolini as the leader of a movement which, far from being reactionary, represents a decisive, futural, and even *Futurist* rupture with Italy's past, despite its tactical compromises with conservative, establishment forces. In particular, the appendix forcibly highlights the centrality to Fascism, even before it established the single-party state, not just of a mythic *élan* towards the future, but of a palingenetic reading of the present as a decadent status quo ripe for transformation and rebirth, one which resonated with the project of renewal that Marinetti had repeatedly announced in all his poems and manifestos.

In stressing this aspect of 'his' version of Mussolini and his movement, Marinetti perceptively uses his Futurist description of the new Prime Minister to emphasise graphically the need to see Fascism as generically different from the entire world of liberal-rational forms of power and legitimation. For its followers it embodied a Nietzschean, charismatic mode of politics based on action not words, on the vitalistic force of an outstanding, explosive personality destined to *make* history[31] and not just discuss it while negotiating policies and reforms. As we have seen, this was precisely how Mussolini himself had envisaged his mission ever since 1908 when his revolutionary socialism was first blended with an admixture of Nietzschean and Vocean vitalism.

As for students of Futurism itself, perhaps the main value of 'microstudying' the appendix to Beltramelli's biography of Mussolini is that it invites us to reflect further on the intimate relationship between Marinetti's artistic movement and Fascism. In her 1991 essay 'Politics as Art: Italian Futurism and Fascism', Anne Bowler criticised two wrong-headed critical strategies to this problem. The first of these 'in the tradition of aesthetics more generally, has been to ignore the issue through implicit assumptions about the absolute separation of art and politics'.[32] In practice this has meant concentrating exclusively on Futurist aesthetics as an episode in the history of modernist art, or making minimal reference to the political context, let alone analysing the love–hate relationship of Futurism's founder to the movement and regime. A second has been 'to displace the significance of the political dimension of Futurism by relegating it to a later, less aesthetically important phase of the movement',[33] namely to what is known as 'Second Futurism' after the heady escapades of the Milanese period.

One could add two more wrong-headed approaches. One of them, frequent among left-wing art historians, was to equate Futurism with Fascism so much that it became practically taboo to dedicate serious research to its history as a movement in its own right because of its identification with and contamination by Mussolini's regime. Another, particularly popular among the more 'intellectual' Marxist art critics, was to see it through the lens of Walter Benjamin's pronouncement that, in contrast to Communism's drive to politicise art, Fascism allegedly set out to 'aestheticise politics' in an entirely reactionary spirit, diverting the healthy revolutionary

energies of the people into the cultic celebration of national power, charismatic leadership and war, and so neutralising its revolutionary energies.[34]

A sophisticated version of this is to see the Fascist sympathies of the likes of Gottfried Benn, Ezra Pound, Ernst Jünger, Salvador Dalí, and Marinetti as unholy alliances between avant-garde art and anti-modern politics, thus producing aesthetic equivalents of the 'reactionary modernism' explored by Jeffrey Herf,[35] Andrew Hewitt,[36] and Charles Ferrall,[37] whose books offer outstanding examples of this convoluted approach. The premise of all these strategies is that there can be no natural kinship between Fascism and aesthetic modernism, as a result of a fundamental incompatibility between Fascism's essentially 'anti-progressive' nature and modernism's essentially progressive (i.e. left-wing) dynamic. It is an assumption that even seems to inform the subtitle to Günter Berghaus's magisterial book on Futurism and politics 'Between Anarchist Rebellion and Fascist Reaction'.

One of the more obvious inferences from Marinetti's text is to realise the nonsense of denying the inextricable relationship, at least in Marinetti's own head, between the aesthetics of his own current of Futurism and early Fascism. Moreover, this phrase clearly refers not just to San Sepolcro Fascism, but to Fascism's new party-political guise which it cynically adopted after the electoral setbacks of 1919, a strategy which led Futurist support to be officially withdrawn in 1921. (The guise was to be dropped melodramatically in January 1925 when, after the parliamentary inertia that followed the assassination of Matteotti, Mussolini declared the establishment of a totalitarian regime.) It is thus simply wishful thinking on the part of those who want to preserve the aesthetic 'purity' of First Futurism's original vision to postdate its involvement with Fascism until after the first flush of creativity associated with the 'Milan phase' (1909–19), since Marinetti and Mussolini were already (literally) as thick as thieves in Milan in the first year of Fascism.

It also flies in the face of the empirical evidence provided by this appendix uncritically to adopt Walter Benjamin's distinction between a Fascism that aestheticises politics and a Communism that politicises the aesthetic. It is clear that in 1923 Marinetti looked to Mussolini to become the vehicle for the systematic political realisation of his aesthetic vision, and proudly claimed to be a Fascist *avant la lettre* in terms that seem to suggest the relationship of John the Baptist to the Messiah. Moreover, under Mussolini's totalitarian leadership aesthetics were comprehensively politicised no less than under Stalin, who was also a paramount aestheticiser of politics.

Furthermore, the piece articulately demonstrates the porous membranes that existed between art and politics for some modernists in the interwar period, a fact widely accepted in the cases of the *left-wing* espousal of aesthetic experimentation, such as the architectural visions of Tatlin or Gropius, but till fairly recently generally denied in the case of Nazism and Fascism, or even with respect to such right-wing modernists as Le Corbusier, Adalberto Libera, or Albert Speer. It is a fallacy that I have extensively attempted to refute in *Modernism and Fascism*, which argues that both aesthetic and political modernism, left and right, were rooted in the intense nomic crisis that Europe had entered even before 1914, and hence in

the need for a new totalising vision or *Weltanschauung* which would offer a panacea to the prevailing sense of disenchantment, anomie, and civilisational decay. Once historians break out of the tunnel vision of an exclusively aesthetic approach to modernism, it can be recognised that while some modernist artists were concerned with exploring new ways of expressing the anomic experience of modernity and momentary escapes from it (the 'epiphanic modernism' of Baudelaire, Kafka, or Joyce), others saw their artistic vision as supplying modernity's lost nomos and represented various forms of 'programmatic modernism' as a creed of liberation for society as a whole (e.g. Wassily Kandinsky, Tristan Tzara, and Marinetti himself). The truly original utopian projects of social reformers, eugenicists, revolutionaries, and totalitarian leaders in the nineteenth and twentieth centuries can all be seen as expressions of social or political modernism, including Fascism itself. Marinetti's appendix expresses the utopian belief in a possible fusion of his own programmatic aesthetic modernism with Mussolini's programmatic political modernism, both futural projects without a trace of 'reaction', unless judged by the essentialist criteria of the left about what constitutes 'progressive'.

In this context it should be no surprise if two of Italy's modernist nationalists,[38] Beltramelli and Marinetti, could both create 'their' Mussolini, the perpetual Rorschach test of Italian political affiliations of the day, in their own image. He was thus turned by them into the long-awaited 'new man' at the height of a profoundly liminal period in Italian history which bred hundreds of other personal longings and utopias of a new Italy which could be projected onto the future *Duce*, and indeed would be projected onto him *en masse* by the late thirties. For tactical reasons, it was essential that Mussolini himself did *not* resolve the persistent ambivalence generated by so many alternative Mussolinis in circulation. He remained aloof, ambiguous, imperious in the spirit of 'hegemonic pluralism',[39] and thus could continue to appeal to all the anti-Communist dreamers of a new Italy of modernity, dynamism, and greatness.[40] Certainly Fascism wanted to 'explode the continuum of history'[41] in a futuristic spirit, but without burning the nation's bridges with traditional or historical Italy to indulge Marinetti's fantasies of a total cultural cleansing of the past.

If the underlying purpose of both Beltramelli's book and its Futurist appendix was to reveal the political Superman's cloak hidden under the bourgeois dress of the new Prime Minister, then they certainly succeeded in capturing the palingenetic longings which would form the mythic substratum of the *ventennio fascista*. Thanks to a crisis in Italian and European civilisation that was not just structural but ontological, Marinetti and Mussolini both thrived in an age of 'fantasy politics'. Modris Ekstein's *Solar Dance: Genius, Forgery and the Crisis of Truth in the Modern Age* convincingly explores the proposition that the liminal state into which the phenomenological world had sunk for millions of Europeans after 1918 blurred the boundaries between pose and authenticity, play acting, and achievement, confidence trick and the 'real thing' in the interwar period, thus creating an entire political class of false prophets and redeemers while promoting extravagantly utopian artistic manifestos of social transformations to the status of revelations and epiphanies. Stalin, the father of his people, Hitler, the saviour of Germany;

Goebbels, the director of a nation's cultural renaissance; Mussolini, the 'new man' leading a 'new Italy'; Marinetti, the would-be orchestrator of the purge of Italy's pastism, pacifism, and feminism: all can be seen as fantasists who would have been ignored or marginalised in a more grounded, sustainable age, but who prospered in an age of collective self-delusion whose spirit is captured better by Woody Allen's *Zelig* than by any historical documentary.

Perhaps the culmination of the encounter between political regimes ungrounded in pandemics of social *angst* and wishful thinking, and art based on megalomaniacal overestimations of its liberating revolutionary potential, was when Marinetti joined Gottfried Benn in giving the opening addresses at the Berlin exhibition of Italian Futurist art held in March 1934. The event was sponsored by Joseph Goebbels, a fervent admirer of Vincent Van Gogh and Edvard Munch, and displayed several examples of the *aeropittura* that had so obviously influenced Dottori's portrait of Mussolini. It was a style that within three years would not be given houseroom in the Third Reich once the wind of Nazi cultural politics had become a fierce anti-modernist gale.

Yet, however rhetorical and utopian the energies that made such surreal juxtapositions possible, the death and destruction that followed from the cult of the hygienic properties of war and violence celebrated in Marinetti's appendix were made horrifically real in blood and suffering on the plains of Ethiopia and the battle fronts of Operation Barbarossa. But the escalating horrors of modern conflict after 1935 could do nothing to deter Marinetti from glorifying war, at least rhetorically, as demonstrated by his offer to serve as volunteer in Italy's conquest of an 'African Empire' and later with Italian soldiers on the Russian Front, even though he was by now over 60 years old. His appendix can be seen as vivid testimony to Marinetti's profound and culpable misreading of history in an age when not just art but death could be subjected to a process of mechanical reproduction, and where the rhetoric of violence and destruction would soon be lived out in blood and steel, transforming vast areas of Europe and Asia into killing fields. It invites contemporary historians not to burn the academies and university libraries, but instead to use our historical imagination and methodological empathy to realise the profound nomic crisis of the post-war era in Italy, which reconfigured the relationship between poetic imagination and politics, and made infantile, male chauvinist daydreams of national rebirth through violence the basis of government for two decades, with such catastrophic consequences.

Notes to Chapter 1

1. Antonio Beltramelli, *L'uomo nuovo* (Rome and Milan: Mondadori, 1923). Marinetti's 'Appendice' is separately numbered (pp. i–xvii).
2. The best book on this topic by far is Emilio Gentile, *The Sacralisation of Politics in Fascist Italy* (Cambridge, MA: Harvard University Press, 1997).
3. See Emilio Gentile, *Il mito dello stato nuovo. Dall'antigiolittismo al fascismo* (Bari: Laterza, 1982).
4. Essential background on this topic is provided by Walter Adamson, *Avant-Garde Florence: From Modernism to Fascism* (Cambridge, MA: Harvard University Press, 1993); Emilio Gentile, 'The Myth of National Regeneration in Italy: From Modernist Avant-garde to Fascism', in *Fascist Visions*, ed. by Matthew Affron and Mark Antliff (Princeton, NJ: Princeton University Press, 1997), pp. 25–45.

5. Quoted in Lawrence Rainey, 'On Pound and Sigismondo Malatesta', <http://www.english.illinois.edu/maps/poets/m_r/pound/poundandmalatesta.htm> [accessed 12 March 2012].
6. Ibid. (my emphasis).
7. The publication details of this piece, which seems to be identical to 'La genesi del Fascismo' referred to as another of his publications in *L'uomo nuovo*, are elusive. The text is published with no further information at <http://italpag.altervista.org/9_b_storia/storia6.htm> [accessed 29 March 2012].
8. Ibid.
9. Marinetti, 'Appendice', pp. iii–iv.
10. Ibid., p. v.
11. This thesis is explored fully in Emilio Gentile, 'The Sacralisation of Politics: Definitions, Interpretations and Reflections on the Question of Secular Religion and Totalitarianism', *Totalitarian Movements and Political Religion*, 1.1 (2000), 18–55.
12. Roger Griffin, *Modernism and Fascism: The Sense of a Beginning under Mussolini and Hitler* (London: Palgrave, 2007), p. 205.
13. Cited in Gentile, *Il mito dello stato nuovo*, p. 105.
14. Marinetti, 'Appendice', p. iv.
15. Ibid., p. vi.
16. Ibid., p. viii.
17. Ibid.
18. Ibid., p. xi.
19. Ibid.
20. For the account of the 'battle', see ibid., pp. xi–xvii. Futurism's minimal programme is summarized on pp. iii–iv.
21. Ibid., p. xi.
22. Giacinto Serrati was the leader of the most pro-Bolshevik faction of the Italian Socialists.
23. Ibid., p. xiv.
24. The journal *Roma futurista* was founded in September 1918 by Marinetti, and after the crushing electoral defeats of his Partito Politico Futurista in November 1919, turned into a cultural periodical.
25. *La Testa di Ferro* [*Iron Head*] was the journal of the legionaries of Fiume founded in February 1920 by Mario Carli, another demonstration of some Futurists' attempt to play a major role in shaping the political events of the day.
26. Scholarly recognition of the Futurist contribution to the attack is confirmed by Francesca Villanti in 'La plastica murale. Completamento "costruttivo" dell'architettura futurista', her thesis for the PhD awarded by the Università degli Studi di Tuscia (March 2010), on pp. 138–48 <http://www.scribd.com/doc/62711406/Francesca-Villanti-La-plastica-murale-Completamento> [accessed 14 March 2012]. The section contains a plate of Prampolini's vast canvas entitled *La battaglia di Via Mercanti a Milano e l'incendio dell'Avanti e Arditismo e Futurismo* which was exhibited in 1919. However, the Italian Wikipedia entry on the event has somehow airbrushed the Futurists from the official history of the event, claiming that it 'was nationalist squads, officer cadets and Arditi' who burnt the journal's offices without any assistance from modernist artists; <http://it.wikipedia.org/wiki/Avanti!> [accessed 14 March 2012].
27. See Griffin, p. 209.
28. Stefan Johannes, 'From Taylorism to Human Relations: American, German, and Soviet' (March 2011) <http://harvard.academia.edu/StefanLink/Papers/583663/From_Taylorism_to_Human_Relations_American_German_and_Soviet_Trajectories> [accessed 14 March 2012].
29. Andrzej Wajda's film *Man of Marble* explores the myth-making process behind a fictional Polish Stakhanovite, telling the story of his rise and eventual fall from grace, and bitterly satirising the Communist worker cult and the myth of the Soviet New Man.
30. See Jeffrey Schnapp, 'Between Fascism and Democracy: Gaetano Ciocca — Builder, Inventor, Farmer, Engineer', *Modernism/Modernity*, 2.3 (1995), 117–57; 'The Fabric of Modern Times', *Critical Inquiry*, 24.1 (1997), 191–245.
31. See Claudio Fogu, *The Historic Imaginary: Politics of History in Fascist Italy* (Buffalo, NY: University of Toronto Press, 2003).

32. Anne Bowler, 'Politics as Art: Italian Futurism and Fascism', *Theory and Society*, 20.6 (1991), 763–94 (p. 765).
33. Ibid.
34. Benjamin introduced this highly undeveloped concept in his ground-breaking essay *The Work of Art in the Age of Mechanical Reproduction* (1936) available at <http://www.marxists.org/reference/subject/philosophy/works/ge/benjamin.htm> (accessed 11 February 2014).
35. Jeffrey Herf, *Reactionary Modernism: Technology, Culture, and Politics in Weimar and the Third Reich* (New York: Cambridge University Press, 1984).
36. Andrew Hewitt, *Fascist Modernism: Aesthetics, Politics, and the Avant-Garde* (Stanford, CA: Stanford University Press, 1993).
37. Charles Ferrall, *Modernist Writing and Reactionary Politics* (New York: Cambridge University Press, 2001).
38. A term used by Adamson and Gentile (see notes 3 and 4), and explored at length in Griffin, chs 7–8.
39. The key concept used in Marla Stone's *The Patron State: Art and Politics in Fascist Italy* (Princeton, NJ: Princeton University Press, 1998) to explain the regime's rampant aesthetic pluralism.
40. See Emilio Gentile, *The Struggle for Modernity* (Westport, CT: Praeger, 2003); *La Grande Italia: ascesa e declino del mito della nazione nel ventesimo secolo* (Milan: Mondadori, 1997).
41. The phrase is Walter Benjamin's. See Roger Griffin, 'Exploding the Continuum of History: A Marxist Model of Fascism's Revolutionary Dynamics', in *A Fascist Century: Essays by Roger Griffin*, ed. by Matthew Feldman and Roger Griffin (London: Palgrave, 2008), pp. 46–68.

CHAPTER 2

The Church

The Politics and Aesthetics of 'Svaticanamento'[1]

Monica Jansen, Utrecht University, and
Luca Somigli, University of Toronto

In 1919 Count Vincenzo Fani Ciotti, better known by his Futurist pseudonym of Volt, opened and closed his proto-science-fiction novel *La fine del mondo* [*The End of the World*], set in 2247, with Pope Sylvester (no number given) wandering the Roman countryside after his expulsion from the Vatican, now transformed by a Masonic-Communist alliance into the seat of the Parliament of the United States of Europe.[2] Returning the Church to its roots of poverty and prayer, Sylvester witnesses both the departure of a few brave men to conquer the stars and the destruction of the planet plagued by both what we might nowadays call environmental disasters and the degeneration of the moral fibre of humanity. Written by an eccentric 'Future-Fascist' figure — as Gianfranco De Turris has labelled him — who simultaneously cultivated the revolutionary aesthetics of *parole in libertà* and the anti-modernist and aristocratic politics of the right wing of the Fascist movement, the novel is nonetheless a rare attempt to imagine and narrativise one of the symbolic actions that underlie the Futurist imaginary: the 'svaticanamento' [de-vaticanisation] of Italy.

To be sure, Volt, a conservative Catholic as well as an anticlerical, can hardly be said to summarise the positions of the movement in regard to the dominant religion of Italy — indeed, he and most of his fellow Futurists parted ways precisely on the question of the recognition of the status of the Vatican[3] — and yet he provides a good example of the ambivalence that throughout the history of the movement oriented its relationship with Catholicism. For if the Vatican offered an ideal target through which to attack what the Futurists perceived as a series of Italian vices, religion itself was another, more complex, matter that was dealt with in different, even contradictory, ways. Not long before Ciotti published *La fine del mondo*, Marinetti, the most vocal proponent of 'svaticanamento', attempted to recruit Jesus himself to the Futurist cause as an early proponent of free love and an adversary of the indissolubility of marriage in the 1919 manifesto 'Contro il Papato e la mentalità cattolica, serbatoi di ogni passatismo' [Against the Papacy and the Catholic Mentality,

Repositories of Every Kind of Traditionalism]. This apparently contradictory stance has been explained in the light of Marinetti's mystical inclinations, especially in the later phase of his career, and of the fact that, even at his most polemical, the Futurist leader attempted to distinguish between clericalism and the Christian message.[4] Indeed, as Gianni Eugenio Viola has pointed out, 'svaticanamento' should not be read simply in an antireligious key, but mainly as an expression of anticlericalism, and, as such, as yet another form of the anti-institutional spirit that characterises Futurism.[5]

In this chapter, we attempt to map some of the twists and turns of the fraught relationship between Marinetti's movement and the Catholic Church. At once an institution to rail against, a storehouse of myths and symbols to ransack at will, and an ideological foil against which to articulate the Futurist vision of the 'new man', the Church loomed large over the movement. On a macro level, the history of Futurist anticlericalism should be considered as part of modernism's answer to Western secularisation at the turn of the twentieth century.[6] Delegitimised as an institution by the secularism that dominated nineteenth-century political, scientific, and philosophical thought, the Church appeared as a relic that needed to be discarded in order for the nation to free itself of its backwardness and become modern. Christian spiritual values, in the eyes of the avant-garde, had to be substituted with other means of transcendence mediated by Art itself. Ultimately, this would result in the theorisation, in 1931, of Futurist 'Sacred Art', which at first sight seems to contradict the avowed anticlericalism of the movement. On a micro level, anticlericalism is only one aspect of the complex relationship between Futurism and religious faith. Previous scholarship has pointed out the apparent contradiction between on the one hand Futurist anticlericalism, and on the other a spiritual tension that would eventually lead to an engagement with sacred art and even to Marinetti's conversion.[7] However, it can also be argued that this contradiction is inherent in the ambivalence that Walter Adamson has identified as a constitutive element of the avant-garde: the dialogue with Catholicism in the thirties is an example of the 'alliance-oriented strategies'[8] that distinguish the later avant-garde from its earlier, more autonomous and antagonistic manifestations. Thus, we will see that, for instance, in the 'Manifesto of Sacred Art' Marinetti could simultaneously affirm his anticlericalism and the essentially Futurist nature of Catholicism. This ambivalence should be kept in mind also when assuming the Fascist nature of these alliance-oriented strategies, as Ernest Ialongo has done pointing out the concomitance of the 1931 manifesto on Sacred Art with Mussolini's strengthening his direct contacts with Italian Catholics by reducing the autonomy of the Vatican as intermediary.[9]

Marinetti's Anticlericalism and Notari's Example of 'Svaticanamento'

If we can take Marinetti's own words at face value, his anticlericalism dated back to his early days as a student in the Jesuit college 'Saint François Xavier' in Alexandria, where in 1894 he founded and edited the magazine *Papyrus*, 'brimful of Romantic poetry and anti-clerical invectives against the Jesuits'.[10] There is however little evidence in Marinetti's writing over the next decade of any particular interest in

political matters — anticlerical or otherwise — and when Marinetti did intervene in them, he openly displayed that contempt for political activity that characterised *fin-de-siècle* decadentism. This is the case of the 1905 play *Le Roi Bombance* [*King Revelry*], easily his most political pre-Futurist work, where the anti-socialist diatribe concealed behind the thin allegorical veil of the story of Roi Bombance and his subjects offers no positive alternative, if not the sterile consolation offered by poetry, to the materialism of modern bourgeois life. Even Père Bedain, the fat court chaplain of Roi Bombance, is more a re-proposition of the stock figure of the gluttonous and pleasure-seeking cleric whose origins can be traced back at least to Boccaccio's *Decameron* than an indictment of the contemporary Catholic Church. It is perhaps also significant that there is no mention of the Church among the institutions representing *passatismo* that Futurism aims to demolish in the founding manifesto of Futurism, published on 20 February 1909. Even though Marinetti was becoming increasingly involved in political matters, as the studies of Günter Berghaus have shown,[11] at the turn of 1908, when the manifesto was ready for launch, he seemed to be still trying to keep politics and aesthetics separate, so that the attack on the past in the manifesto is configured specifically as an attack on and within the institutional sites of art (libraries, museums, etc.).

An important role in the political development of the founder of Futurism was played by the novelist and journalist Umberto Notari, one of his closest associates within the Milanese intellectual milieu at the beginning of the century. Best known as the author of *Quelle signore* (1905), the fictional diary of a prostitute that garnered him a much-publicised trial for obscenity (Marinetti was a witness for the defence), Notari was also a vigorous cultural organiser and promoter, and in January 1909 he launched the first issue of the monthly (then weekly) periodical *La Giovane Italia* [*The Young Italy*], subtitled *Rivista di combattimento sociale-politico-letterario* [a journal of social-political-literary struggle]. With its obvious reference to the clandestine political movement (and the periodical of the same name) founded in 1831 by the patriot in exile Giuseppe Mazzini that had as its programme the liberation of Lombardy and the Veneto from Austrian rule and the political unification of the peninsula, *La Giovane Italia* situated itself within the political lineage of the Risorgimento and oriented its nationalist agenda along two main directives: on the one hand, a ferocious critique of the government of Giovanni Giolitti and especially of the politics of friendly relations with Austria promoted by his foreign minister Tommaso Tittoni, and on the other, a violent anticlericalism bent on denouncing the encroachment of the Church on Italian institutions. Such concerns came on the heels of a growing presence and visibility of Catholics in Italian political life. In 1868, just a few years after Italian unification, the papal decree *Non Expedit* (from the Latin 'it is not convenient') prohibited the participation of Catholics in the politics of the young kingdom, but this policy became increasingly relaxed under Pope Pius X, beginning with the general elections of 1904. Indeed, after that date 'clericalism' changed its meaning: if before it had referred to the intransigent faction that denied the legitimacy of the Italian state and of political action within it, now it indicated an organised Catholic party working within the state itself.[12]

This gradual relaxation of Mazzinian laicism was realised by Catholics primarily on a local level — the *Non Expedit* did not prevent Catholics from participating in local administrative elections — and by the early years of the new century resulted in the end of the long wave of secularisation and anticlericalism begun with the Enlightenment.

The fear of a block uniting Catholics and conservatives led to a resurgence of anticlerical sentiments within the parties on the left — socialists, republicans, radicals — a late manifestation of which was precisely *La Giovane Italia*.[13] According to Notari, the Vatican had become the safety raft of the Italian bourgeoisie that had found in its social conservatism a bulwark against the socialist threat. This in turn had allowed the Church, on the defensive after the annexation of Rome to the Kingdom of Italy in 1870 and the resulting end of the secular authority of the Pope, to turn the tables and infiltrate all civic institutions, from schools and charitable organisations to banks and cooperatives. Anticipating Marinetti's public call in his 1919 address to the Fascist Congress of Florence, to 'svaticanare l'Italia' [getting rid of the Vatican],[14] in January 1909 *La Giovane Italia* proposed an international survey for 'the 'translation' [*traslazione*] of the Vatican outside Italian borders', the responses to which were published in a column featured regularly until June of the same year and collected in the volume *Il Papa alla porta! Inchiesta e conclusioni per l'abolizione del Papato* [*Sack the Pope! Inquiry and Conclusions on the Abolition of Papacy*].[15] In 1910 Notari attempted to translate his programme into practice by founding the 'Associazione italiana d'avanguardia', a short-lived political movement that held its first and, apparently, only meeting in San Marino on 18–20 September. In its programmatic document endorsed by Marinetti, the pamphlet *Noi* [*We*], Notari's familiar anticlericalism is articulated in terms that recall the rhetoric of Futurism, especially in its opposition between an old, sclerotic order — the Catholic Church — stunting the whole of Italian culture, and the youth of the nation as the agents of its renewal.[16]

From the beginning, Marinetti was involved in and supportive of Notari's initiatives, publishing one of his first political articles in the inaugural issue of *La Giovane Italia* — 'Trieste, polveriera d'Italia' [Trieste, Powder Keg of Italy], where he celebrated the Italian irredentist Guglielmo Oberdan[17] — and financing Notari's Associazione to the tune of 100 lira (the highest subvention after the 500 lira of *La Giovane Italia*).[18] In his turn, Notari, while lukewarm towards Futurism, reprinted manifestos and reported on his friend's activities, especially when the Italian translation of Marinetti's novel *Mafarka le futuriste* was tried for obscenity in 1910. The results of this relationship, however, go well beyond such occasional collaborations, and there are further and more suggestive parallels between the two writers' activities in the period between late 1908 and 1910: in manifestos and editorials, they both provided the theoretical basis for the formation of an avant-garde in the political or aesthetic domain in which the youth of the nation was called to take charge of a popular revolution to come.[19]

As Futurism moved from the aesthetic into the political domain, Marinetti, following Notari, identified in the Church a political counterpart to the cultural

institutions blasted in the founding manifesto of the movement, and easily adapted the rhetorical structures of his artistic proclamations to the new target. Thus, if the 'First Political Manifesto', issued on the occasion of the General Elections of 7 and 14 March 1909, was as vague as it was evocative in describing the programme of the movement 'Noi futuristi, avendo per unico programma politico l'orgoglio, l'energia e l'espansione nazionale' [We Futurists have as our only programme national pride, energy, and national expansion], it showed no doubts when it came to identifying its adversaries, 'i candidati che patteggiano coi vecchi e coi preti' [the candidates that make deals with the old and the priests].[20] Notari's influence is also evident in Marinetti's concern with the pervasive presence of Catholicism in the education system, which he described as 'inquinata dalla morale cristiana' [poisoned by Christian morality] in an article published — not surprisingly — in *La Giovane Italia* on 10 July 1910, 'La necessità della violenza' [The Necessity of Violence].[21]

In these early writings, clericalism thus joins a whole set of traditional values responsible for the state of decadence of Italian social life that renders urgent a wholesale cultural and political renewal. Indeed, Marinetti was able to reconcile his otherwise rather incompatible nationalist and anarchist sympathies by identifying a series of 'common enemies', to quote the title of an article published in 1910 in the syndicalist journal *La demolizione*, among which the Church featured prominently. 'Is it indeed necessary to rehearse their banal, doom-laden names: clericalism, moralism, commercialism, academicism, pedantry, pacifism, and mediocrity?',[22] he asked rhetorically, bringing together the various cultural and political *bêtes noires* of the movement. Moreover, the struggle against the Catholic Church became also an instrument in Marinetti's Europe-wide campaign of publicity for the movement, playing for instance a central role in the rhetorical strategy of the 'Proclama futurista agli Spagnoli' [Futurist Proclamation to the Spaniards, 1910] commissioned by Ramón Gómez de la Serna, the Spanish translator of the founding manifesto.[23]

Imagining 'Svaticanamento': Futurist Anticlericalism and the Great War

In the early 1910s, anticlericalism also provided a bridge between aesthetics and politics in Marinetti's poetic production. Returning to poetry in 1911 after a relatively long hiatus — his previous volume of poetry, *La ville charnelle* [*The Carnal City*], had appeared in 1908 — he composed *Le monoplane du Pape* [*The Pope's Monoplane*], published early the following year.[24] Significantly subtitled 'roman politique en vers libres' [political novel in free verse] — then changed to the more topical 'romanzo profetico in versi liberi' [prophetic novel in verse] when Decio Cinti translated it into Italian as *L'aeroplano del Papa* in 1914 — the poem presaged a war between Austria and Italian volunteers, a new army of *camicie rosse* in the spirit of Risorgimento hero Giuseppe Garibaldi, for the liberation of the 'unredeemed' Italian territory of Trieste. Divided into eleven cantos of unequal length in Marinetti's characteristic emphatic verse — for this is very much a transitional work, stylistically closer to his early symbolist poetry than to the a-syntactic writing that he began to theorise in May 1912 with the 'Manifesto tecnico della letteratura

futurista' [Technical Manifesto of Futurist Literature] — the poem relates the journey of a clearly autobiographical narrator on his aeroplane along the length of the peninsula, from Sicily to the Austrian front, where he provides air support for the Italian soldiers. En route, he passes over the Vatican, where he captures the Pope — the 'great varnished seal' — whom he ties, dangling like a grotesque appendage, to his aeroplane. This turns into a secret weapon of sorts, as the ultra-Catholic Austrians are forced to retreat rather than risk firing upon the Pontiff. His mission accomplished, the poet drops his prey into the Adriatic Sea, then turns towards his next target, Vienna. What makes this work particularly interesting is that here clericalism becomes the element that binds together the internal and external enemies of the nation — the Church on the one hand, and the Austro-Hungarian empire on the other — so that the fulfilment of the project of the Risorgimento entails the overcoming of the ideological and political yoke represented by them. Opposed to the superstitious Austrians, the young Italian fighters become the agents of a secular modernity represented by the hyper-technological war machines with which they conduct their assault.

The outbreak of actual war in 1914 and the ensuing appeals for peace on the part of the newly elected Pontiff Benedict XV exacerbated the antagonistic, anticlerical rhetoric of the Futurists. Initially, the Vatican was accused of playing a role in Italian neutrality (Italy, as is well known, did not enter the war until May 1915). In an editorial in *Lacerba*, a journal with impeccable anticlerical credentials, as we will see below, Giovanni Papini argued that the pacifism of what he called 'papal clericals' was due to their very practical concern over 'il disfacimento dell'Austria, unica ed ultima terra promessa dei chiericati europei' [the dissolution of Austria, sole and last promised land of the European clergy].[25] Such anticlerical rhetoric, whether justified or not,[26] did not abate after Italian intervention, as witnessed for instance by the sarcastic references to Catholic pacifism and German religious piety in the 'parole in libertà' compositions published in *L'Italia futurista*, the foremost magazine of the movement during the war. Examples include: Ugo Cantucci's 'Italia' ('Intervento contro Germania — Austria — Turchia / Neutralità dei Socialisti — Preti') [Intervention against Germany — Austria — Turkey / Neutrality of Socialists-Priests],[27] Mario Betuda's 'Cane + buoi' [Dog + Oxen] ('FRONDISMO + ATEISMO + Forza crescente + GENIALITÀ = LATINITÀ' [REBELLION + ATHEISM + growing Strength + GENIALITY = LATINITY],[28] and Vieri Nannetti's 'Vignetta umoristica', whose caption reads: 'I tedeschi per ottenere intiero l'aiuto d'Iddio hanno pensato di prolungare all'infinito i digiuni quaresimali' [In order to secure God's help for themselves, the Germans decided to extend the Lent fasting period].[29] Similar sentiments were expressed by Marinetti, for instance in his *8 anime in una bomba. Romanzo esplosivo* [*8 Souls in a Bomb. Explosive Novel*, 1919]:

> Cuore cristiano!... Cuore clericale!.... Cuore gesuita!... Bigotto!...
> CUORE PURULENTO!....
> MALEDETTO CUORE!... Ingordo!... Ingordo!...
> Fetido fetido CUORE!... Sacrestia! Catacomba!
> TE LO SPACCO! TE LO SPACCO!
> **TE LO SPACCO!**

[Christian Heart!... Clerical heart!... Jesuit heart!... Bigot!....
 FESTERING HEART!...
DAMNED HEART!... Glutton!... Glutton!...
 Filthy filthy HEART!.. Sacristy! Catacomb!
 I WILL BREAK IT! I WILL BREAK IT!
I WILL BREAK IT!.....][30]

All these literary examples thus fit within Marinetti's political vision, characterised by a modern nationalism which is clearly anticlerical and antimonarchic, and which traces its roots back to the Risorgimento and was radicalised during and after the Great War as a result of the pacifist position of the Church.[31]

Culture Wars: *Lacerba's* Anticlericalism and the Catholic Response

However, Futurism, as an avant-garde movement, also had a more immediate goal with its incendiary rhetoric: to generate propaganda, and to establish its own autonomy within mass popular culture. In this context, a polemical engagement with institutions such as the Catholic Church provided far greater opportunities for (self-)promotion than the more traditional diatribes against rival literary movements. A particularly telling example is provided by the Florentine journal *Lacerba*, whose frequent attacks against middle-class morality brought it to the attention of the Church hierarchy as well as of Catholic intellectuals. Shortly after 1900, Florence had become the centre of a lively debate on Italian cultural renewal that in turn entailed the elaboration of 'a new secular religion' that would overcome traditional Christianity.[32] Launched in January 1913 by Giovanni Papini and Ardengo Soffici, *Lacerba* was the latest in a string of journals — *Leonardo* (1903–07) and *La Voce* (1908–14) in particular — characterised by, among other things, a pronouncedly negative attitude towards Catholicism. *Lacerba* differentiated itself from its predecessors — and quickly acquired a reputation and a certain degree of popularity — for its iconoclastic opinions often expressed in outrageous and aggressive terms. Initially anti-Futurist, it came into the orbit of the movement by the spring of 1913, and in December of that year sponsored a *serata* at the Teatro Verdi in Florence where Marinetti reiterated his position against internationalist clericalism:

> We are Futurist nationalists and therefore fiercely opposed to that other great, ever-present danger of clericalism, with all its layers of reactionary moralizing, police repression, antediluvian academicism, and self-interested pacifism or commercialism.[33]

Marinetti's targets here were the expected ones, and yet the close connection between clericalism and pacifism — one of the central aims of Marinetti's speech was to defend the legitimacy of the Italian conquest of Libya in the Italo-Turkish war (1911–12), which, however, Catholic nationalists had in fact also supported as a 'crociata religiosa contro gli infedeli turchi' [religious crusade against the infidel Turks][34] — anticipated the new ground on which Marinetti continued his anticlerical campaign, namely the opposition of the Vatican to Italian intervention in the Great War, as discussed above.

By this time, however, the journal had already come under the close scrutiny of the Catholic Church in Florence. Two articles in particular attracted the attention and the ire of Catholics: Italo Tavolato's salacious 'Elogio della prostituzione' [Praise of Prostitution, 1 May 1913], and Papini's blasphemous 'Gesù peccatore' [Jesus the Sinner, 1 June 1913], a commercial success with some 10,000 copies of the journal sold. Tavolato was tried (and acquitted) for indecency, and Papini was threatened with a lawsuit for indecency and defamation of the State religion that never actually went to court. Naturally, *Lacerba* did not waste the opportunity of using the journal's legal troubles, real and potential, for its publicity machine. On 15 June, an unsigned editorial note informed readers that 'le nostre prime scaramucce contro la moralità borghese e lo spirito cristianuccio hanno cominciato a produrre i loro effetti' [our skirmishes against petty bourgeois morality and niggling Christian spirit are having their first results],[35] while on 1 July Papini published the article 'Lacerba sotto processo' [Lacerba on Trial] which opens with: 'Sicchè *Lacerba* è sotto processo. Doppio processo: civile ed ecclesiastico. La Morale e la Religione, lo Stato e la Chiesa sono in arme' [So *Lacerba* is on trial. A double trial, both civic and ecclesiastical. Moral and Religion, State and Church are taking up arms].[36]

While Papini's customary bombastic rhetoric implied a direct confrontation between the Church and the Futurists, the situation was perhaps more complex, and the scandals were motivated more by self-promotional than by intellectual or political concerns. Two rivalling groups of intellectual 'dissidents' — on the one hand the reactionary Catholic circle of Domenico Giuliotti and Ferdinando Paolieri and their newly founded journal *La torre* [The Tower, 1913–14], and on the other the Florentine Futurists — fought their culture war[37] in the courts of law and in the court of public opinion.[38] On 8 June 1913, Paolieri took upon himself the task of defending Catholic sensibility on the Florentine daily *La Nazione*, writing in reaction to Papini's 'Gesù peccatore' and calling for legal prosecution:

> In Italia, la religione dominante è la cattolica: quel signor Papini non ha offeso Gesù [. . .]; quel signor Papini ha semplicemente oltraggiati e percossi nelle loro credenze molti milioni di fedeli; il codice vigente contempla cotesto reato e lo punisce; io domando soltanto che il nominato Giovanni Papini sia denunciato al Procuratore del Re per oltraggio alla Religione dominante dello Stato e, per conseguenza, sia rinviato davanti alla Corte d'Assise.
>
> [In Italy, the dominant religion is Catholicism: Signor Papini did not insult Jesus [. . .]; Signor Papini simply offended and affronted the faith of millions of believers. The law of the land punishes this type of offences. Now I simply demand that the above-mentioned Giovanni Papini be reported to the Prosecuting Magistrate for defamation of the dominant State religion, and that, as a consequence, he be brought before the Court of Assizes.][39]

In their turn, the Futurists incorporated the trials into their propaganda strategy. As late as 1918, Bruno Corra and Emilio Settimelli, co-editors of *L'Italia futurista*, published the records of the Tavolato trial, along with those of the trial for indecency against Marinetti's *Mafarka il futurista* [Mafarka the Futurist, 1910] in the self-described 'propaganda book' *I processi al Futurismo per oltraggio al pudore* [*The Trials of Futurism for Offence against Morality*].[40]

Yet the Church decided not to interfere directly. In his narrativised account of the events, Sebastiano Vassalli reports that, according to the examining magistrate on the Tavolato case Oscar Muzi, the Archbishop of Florence, who on 8 June 1913, during Mass, had forbidden the congregation to buy and read *Lacerba*, did not want to proceed legally against Papini for his 'Jesus the Sinner' in the belief that questions of faith should not be judged by a State Tribunal. Vassalli has Muzi observe that although legal measures for the protection of religion did exist, these were not recognised by the Church, and that there was no formal institutional relationship between the State and the Church.[41] The Church, in its turn, had its own ways of warning believers against blasphemous writings and behaviours. One instrument in this cultural war against laicism was the Jesuit journal *La Civiltà Cattolica*, which, since its foundation in 1850 by Father Carlo Maria Curci, was closely linked to the Papal court and was conceived, as Jan Nelis has put it, as a type of Catholic 'think tank'.[42] Confronted with the growing threat of liberal anti-clericalism, the Church actively sought to utilise 'modern' media such as the press in order to diffuse its message. *La Civiltà Cattolica*'s 'college of writers', reporting to the Pope on a regular basis, 'was widely regarded as an "unofficial spokesperson" for the Holy Father'.[43]

The spectacle of the Tavolato trial in 1913 was not much different from that of a Futurist *serata*.[44] The goliardic attitude and youthful vigour celebrated by the Futurists in order to create a new kind of horizontal participatory culture was stressed by *La Civiltà Cattolica*, but with the intention of rendering innocuous their attacks on Christian morals. In the pre-war period, the Vatican journal appeared to be concerned with modern art in general, as is suggested by a 1911 article aiming to explain the recent inclusion in the Index Librorum Prohibitorum of the complete works of D'Annunzio as well as of *Leila*, by the Catholic author Antonio Fogazzaro. The general tenor of the article is relevant to understand the reception of the writings of the Futurists:

> Ma qui appunto in questo oscuro e indefinito concetto filosofico, in questo fluttuare frequente di sentimenti, di aspirazioni, di desiderii, di ogni cosa, sopra tutto in questo *vago, inafferrabile e contraddittorio* sta il veleno di siffatte opere; [. . .] sta il pericolo della loro lettura e propaganda; sta infine la ragione del reato di chi alla loro notorietà e propaganda concorre con l'esorbitanza delle lodi o con l'indulgenza della critica.

> [But it is precisely in this obscurity and indefiniteness of their philosophical concept, in the frequent shifts in sentiments, aspirations, desires, and everything else, above all in this *vagueness, ungraspability, contradictoriness*, that lies the poison of these works; [. . .] the danger of their reading and propaganda; finally, the complicity in their crimes on the part of those who contribute to their fame and propaganda through their exaggerated praise or the indulgence of their critique.][45]

As this quotation suggests, propaganda is feared more than the perverting potential of the works discussed.

On 26 July 1913, *La Civiltà Cattolica* dedicated an entire article to 'Il Futurismo' and its growing popularity in Italy and abroad, and mentioned the 'oscenità sopra

oscenità' [bestial obscenities] that got 'un giornalettaccio futurista che si pubblica in Firenze' [a cheap little Futurist magazine published in Florence] banned by the ecclesiastical authorities. The emphasis is reversed: more attention is paid to Papini's blasphemy than to Tavolato's (ignored) indecency. The Florence trial is not mentioned at all, and the rhetoric of the article is that these are episodes and characters that are not worth remembering. The Futurists, with their 'furore', their rage, are nothing more than 'ragazzacci insolenti [. . .] Ecco tutto' [insolent brats [. . .] That's all].[46] However, a final note is added as a coda to the article to answer the question of whether Futurist works should be put on the Index or in other ways banned. The answer is that for their obscene and sordid nature, they fall under the general prohibitions of the Index, confirmed by Leo XIII in the Constitution *Officiorum ac munerum* (1897), and this should suffice to protect those who are young against cultural corruption.[47] This makes it possible to conclude that even though the Futurists were not directly banned by the Vatican, their literature was certainly discouraged, and silence should not be explained as indifference, but as an antidote against Futurist propaganda.[48]

Futurist 'Svaticanamento' and Fascism: From War to Conciliation

The subordination of politics to aesthetic performance prevalent in the pre-war years changed into an Interventionist poetics during the Great War and was modified between 1918 and 1920 into a Futurist politics when Marinetti sought to turn Futurism into a political party leading a Futurist-Fascist alliance.[49] However this alliance was not without frictions, and anticlericalism was one of the major sources of disagreement between the Futurists and the Fascists. Indeed, anticlericalism traverses Marinetti's political writings of the late tens and early twenties as a veritable *fil rouge*. The 'Manifesto del partito politico futurista' [Manifesto of the Futurist Political Party, 1918] even dedicates one entire programmatic point to it:

> 5. Substitution of the present rhetorical, quiescent anticlericalism by an actively violent and resolute anticlericalism, so as to rid Italy and Rome of their medieval theocracy, which can find an appropriate country in which to go and slowly wither away. Our clericalism is total and uncompromising and constitutes the basis of our political program.[50]

Berghaus has noted that, after the 1919 assembly in Piazza San Sepolcro, the Futurist leader voiced his concern over the reactionary tendency of the rally to act against Socialism, and pointed to a list of enemies against which to launch instead an 'Italian revolution'. This list included not only the institutions of the Italian state — the government, the monarchy, and parliament — but also the Vatican, seen as perfectly complicitous with these institutions in maintaining bourgeois order.[51] In the 'Discorso di Firenze', delivered at the 1919 Fascist Congress and then published in *Roma futurista* but also in *L'Ardito*, the organ of so-called 'Arditismo', it becomes clear that Marinetti did not accept any compromises on this point:

> Fascists! There is no greater danger to Italy than the black peril. The Italian people [. . .] would fail in their mission if they did not strive to liberate our peninsula [. . .] from the filthy plague of the Papacy. We must desire, demand,

and carry out the expulsion of the papacy, or put more precisely, we must 'devaticanize' Italy. (*Applause, ovation*)[52]

Notari's 'svaticanamento' had thus become a central component of the Futurist political plank, to the point that 'insufficient anti-clericalism' was one of the three points of divergence with the Fasci di Combattimento that would lead Marinetti to resign from Mussolini's political movement on 29 May 1920.[53] Indeed, Marinetti had already used anti-clericalism to mark his territory within the rather crowded nationalist camp of post-war Italy in his already mentioned and most outspoken manifesto against the Vatican, 'Contro il Papato e la mentalità cattolica, serbatoi di ogni passatismo', first published on *L'Ardito* in 1919, and afterwards reprinted not only in the volume *Democrazia futurista* (1919) but also in *Futurismo e Fascismo* (1924), a fundamental text in Marinetti's attempt to reposition himself and his artistic movement in relation to Fascism between 1923 and 1924. In this essay, described by Berghaus as a response to 'Mussolini's turn to the Right and his overtures toward traditionalist forces such as monarchists and Catholics',[54] Marinetti demanded again 'the expulsion of the Papacy so as to rid Italy of the Catholic mentality'.[55]

However, revisionism was already around the corner: at the First Futurist Congress in 1924 Marinetti accepted the monarchy as a possible sign of national unity[56] and the honours bestowed on Marinetti 'were a clear sign that the movement was ready to enter into a dialogue with the Fascist régime and was keen to claim its place within the predominantly conservative artistic establishment'.[57] Salaris, in *Artecrazia: l'avanguardia futurista negli anni del Fascismo*, takes the concept of 'artecrazia' [artocracy] from Marinetti's 1922 manifesto 'Ad ogni uomo, ogni giorno un mestiere diverso! Inegualitarismo e Artecrazia' [To Every Man, a New Task Every Day! Inequality and the Artocracy] to characterise Second Futurism's turn towards a renewed aestheticisation of artistic engagement.[58]

This appeal to the primacy of art caused frictions with intransigent, dissident Futurists and Fascists Mario Carli and Emilio Settimelli, founders in March 1923 of *L'Impero*, a daily newspaper that professed to be 'antisocialista, anticlericale, antitradizionale' [antisocialist, anticlerical, antitraditionalist], according to a programmatic manifesto signed by Marinetti, Carli, and Settimelli,[59] and that was supported by Mussolini, who chose its title. The project of *L'Impero* was to establish a Fascist culture with the help of a group of intellectuals of indisputable Fascist credentials and of Futurist formation.[60] In fact, the only cultural proposition to remain constant in its ten years of life was Futurism, both as an aesthetic proposal and as a guarantee of moderate opposition toward official Fascism, although this never became an effective potential.[61] In practice the paper, to which Paolieri[62] and Volt also collaborated, had a double agenda and was monarchic, imperialist, reactionary, and sometimes even clerical as well.[63] A curious episode, noted even by *La Civiltà Cattolica*, was the scandal provoked by Marinetti's reiterated invectives against the papacy during a banquet organised by *L'Impero* at the Cabaret del Diavolo in the Hôtel Élite on 1 March 1925 to welcome the poet's move to Rome. In a speech then published in *L'Impero* (3 March 1925), Marinetti stated that '[v]i sono in Italia purtroppo forze italiane che osteggiano l'idea imperiale. Combattiamole pure,

non dimenticando però fra queste la più segreta e la più antiitaliana: il Vaticano' [unfortunately, in Italy there are forces that oppose our imperial idea; let us fight them, but let us not forget the most secret and most anti-Italian among them: The Vatican].[64] *La Civiltà Cattolica*, in the section 'Cose italiane', reported that '[f]ece anche parlare di sè il futurista F. T. Marinetti, il quale, durante un banchetto offertogli, il 1° marzo, dall'*Impero*, in uno sproloquio da folle, pronunciato in fin di tavola, espresse sentimenti tutt'altro che sinceramente monarchici, e punto rispettosi della Santa Sede' [the Futurist F. T. Marinetti drew much attention when, during a banquet in his honour sponsored by *L'Impero* on 1 March, he launched into a crazy rant at the end of the dinner, expressing opinions that were anything but sincerely monarchist and not at all respectful of the Holy See].[65] Meanwhile, in response to critical articles in the mainstream press, including *Il Popolo* and the *Corriere della Sera*, *L'Impero* was forced to reassert its monarchist and Catholic credentials with a rectification, published on 5 March, declaring that 'le onoranze tributate a Marinetti dal gruppo degli scrittori dell'*Impero* [. . .] non implicavano affatto un'adesione incondizionata e completa alle sue particolari concezioni politiche, in materia di religione e di regime' [the homage paid to Marinetti by a group of writers of *L'Impero* [. . .] in no way implied an unconditional and full support of his political ideas in regard to the regime and to religion].[66]

Marinetti's overt anticlericalism changed after his movement's realignment with the Fascist regime, and especially after the ratification of the Lateran Pacts on 11 February 1929, which granted Catholicism the status of State religion in Italy and introduced Catholic education as a subject in the public school system. Marinetti, who was appointed a founding member of the Accademia d'Italia just a month later, was notably silent on the issue, whatever private misgiving he might have had about it.[67] Other members of the movement were not so acquiescent. The case of Emilio Settimelli is especially instructive regarding the complex relationship of the Futurist movement with the Fascist regime and the Vatican. In 1931, Settimelli, who had become a reference point for extremist, independent Futurists within the movement,[68] published a brochure through his own 'Edizioni fiorentine' that in its very title evoked the old Marinettian battle-cry: *Svaticanamento. Dichiarazione agli italiani* [*Devaticanisation: Declaration to the Italians*]. Also signed by other Tuscan Futurists from the times of *L'Italia futurista* — Ottone Rosai, here joined by his young nephew Bruno, Remo Chiti and Alberto Maurizio — the pamphlet was a reaction to the perceived anti-Fascism of the encyclical *Non abbiamo bisogno* [*We Are in no Need*], in which Pope Pius XI protested against Mussolini's closing of the Catholic organisation Azione Cattolica, and urged the Duce to denounce the Concordat. Its anticlerical attitude harked back to the spirit of the Risorgimento, even though its signatories professed to be not only '[f]edeli al giuramento fascista' [faithful to the Fascist oath], but also '[c]redenti in Dio' [believers in God].[69] Although *Svaticanamento* was confiscated and its author taken to court, the regime did not always interfere with such displays of anti-clericalism, as they also served Mussolini's purposes at moments when he entered into conflict with the Holy See — by 1931 the Concordat was already in crisis — without having to expose

himself.⁷⁰ This could have been the case with another of Settimelli's brochures, *Aclericalismo* (1929), expanded and more broadly distributed as *Preti, adagio!* [*Calm Down, Priests!*] in 1931, before *Svaticanamento*. Here the Fascist-Futurist formulated the curious compromise notion of Fascist 'aclericalism', distinguished from traditional anticlericalism and thus not in open conflict with Catholicism, but rather vigilant of the borders between the Church and the State:

> Niente anticlericalismo podrecchiano ma, sì, aclericalismo fascista. Esatta visione dei confini fra Regno d'Italia e Città del Vaticano, fra Religione e Stato. Esattissima visione del Duce, unico Maestro e Capo della gioventù italiana.
>
> [No anticlericalism à la Podrecca,⁷¹ but rather Fascist aclericalism. A precise vision of the boundary between Kingdom of Italy and Vatican City, between Religion and State. A very precise vision of the Duce, the only Teacher and Leader of Italian Youth.]⁷²

Settimelli's critical attitude towards the Futurist movement and the Fascist regime thus placed him on the margins of both. His censure of what he perceived as Marinetti's compromising attitude towards Fascist culture resulted in his 'excommunication' from the movement during the Second Futurist Congress in 1933,⁷³ while his intransigent condemnation of the compromises of the regime and the corruption of the Fascist 'gerarchi' landed him a sentence to five years confinement on the island of Lipari in 1939.⁷⁴

Conclusion: Towards a 'Futurist Sacred Art'

The debate over the Concordat was the last notable resurgence of the anticlerical spirit that had characterised much of the history of Futurism. Quite significantly, this final, ineffectual call for 'svaticanamento' was left to independent figures within the movement whose opposition did not disrupt the integration of the leadership — Marinetti in particular — into the institutions of the regime. In 1931, the same year in which Settimelli theorised 'Fascist aclericalism' in *Preti, adagio!*, Marinetti issued for the first time in Turin, in the *Gazzetta del Popolo*, the 'Manifesto dell'arte sacra futurista' [Manifesto of Futurist Sacred Art], authored with the painter Fillìa who added some programmatic points to it. While still describing the movement as anticlerical (and, in parallel, anti-masonic), here Marinetti in effect sought to reconcile Futurist principles and Catholic dogma, as witnessed for instance by point 5:

> Only Futurist artists, who for twenty years have addressed the complex matter of simultaneity, are able to express clearly, with suitable interpenetrations of time and space, the simultaneous dogmas of the Catholic faith, such as the Holy Trinity, the Immaculate Conception and Christ's Calvary.⁷⁵

In 1931 Marinetti also organised a Futurist room at the 'Mostra internazionale di arte sacra' (International Exhibition of Sacred Art) in Padua that enjoyed a degree of appreciation even in the Catholic press.⁷⁶ The following year, in a piece entitled 'Spiritualità nuova' published in the journal *La città nuova* [*The New City*], Fillìa further articulated the spiritual dimension of Futurism, writing:

> Vogliamo entrare in queste forze intuite e scoprirne i simboli da tradurre in arte: simboli rappresentativi del nuovo spirito religioso che fascierà questo secolo e al quale nessuno potrà sottrarsi, perché universale e duraturo.
>
> [We aim to enter these intuited forces and to discover their symbols, to be translated into art — symbols that represent the new religious spirit that will envelop this century and which no one will be able to avoid, as it will be universal and enduring.][77]

This embryonic state of a new spiritual élan captures well the debate on sacred art in the thirties that followed Pius XI's speech for the inauguration of the Nuova Pinacoteca Vaticana on 28 October 1932. His condemnation of 'certe altre così dette opere d'arte sacra, che il sacro non sembrano richiamare e far presente se non perché lo sfigurano fino alla caricatura, e bene spesso fino a vera e propria profanazione' [certain so-called works of sacred art that do not relate to and make present the sacred except than by defacing it to the point of caricature and even blasphemy],[78] and of a new art that neglects the quality of the old masters,[79] was read internationally by the Catholic press as a dogma and a verdict.[80] However, except for an explicit reference to the Code of Canon Law,[81] the Pope did not provide specific criteria on the basis of which artistic currents should be banned by the Church. This opened a lively discussion within those organs, such as the journals *Arte Cristiana* and *Arte sacra*, which attempted to play a role of mediation between the Church and the Fascist State in regard to the commission of sacred art.[82]

As Marja Härmänmaa has noted, on the occasion of the 25th anniversary of the foundation of Futurism in 1934 Marinetti complained about the ferocious criticism of his movement by the Catholic youth, which, tellingly, he also described as 'afascisti o antifascisti' [afascist or antifascist].[83] The Futurists further protested against the exclusion of Futurist 'arte sacra' from the 'Mostra Internazionale d'Arte Sacra' in Rome in 1934.[84] In practice, Catholic intellectuals seemed to remain rather lukewarm towards Futurism, and references to the movement remained few and oblique. Pius XI's opposition to modern sacred art — 'quella inconsulta e indiscreta ricerca del "nuovo"' [that ill-advised and impertinent search for the 'new'][85] — was quite open and had as its target a range of tendencies, including rationalism. Giovanni Battista Montini (the future Paul VI) assumed a more nuanced position in a programmatic article in the first issue of *Arte sacra*, where he distinguished between a positive artistic 'modernity' and a negative 'modernism', but dismissed in passing 'il demone agitato del futurismo' [the agitated demon of Futurism] as merely a form of 'assillante attualismo' [insistent actualism].[86] This near silence is consonant with the strategy of ignoring Futurist provocations that we have already seen carried out by *La Civiltà Cattolica* in the tens, but it also confirms the limited ability of Futurism to establish itself in the growing market of for-profit cultural production.

It would be easy to suggest that the most immediate — and, in the end, ineffectual — aim of Futurist sacred art was to support Futurist artists in obtaining commissions from the Catholic Church, but this interest in sacred art may also be a symptom of a broader shift in alliances.[87] If the pacifism of the Church had

made it a target of Futurist scorn during the Great War,[88] its support of imperialist intervention during the Ethiopian campaign, which would inspire Marinetti's religious poem *L'aeropoema di Gesù* [*The Aeropoem of Jesus*], written in 1943–44 but published posthumously in 1991, clearly made it an ally of sorts. Catholicism, from being seen as 'anti-Italian' in the first decades of Italian unification, became a typical element of 'Italian character', as a long-converted Papini put it in 1942 at the first meeting of the European Union of Writers founded by Goebbels.[89] Even Settimelli, once the scourge of the priesthood, would be 'touched by the Grace of God' and become 'an observing Catholic' during his confinement in Lipari.[90] As early as 1934, in the above-mentioned article on the 25th anniversary of the movement, Marinetti himself did not hesitate to state that 'i futuristi sono cattolici' [Futurists are Catholics].[91] Indeed, in the thirties and forties, the Futurist leader would turn more and more frequently to religious imagery, with a special fondness for the figure of Jesus, not only in the already mentioned *Aeropoema di Gesù*, but in several other works, such as *Il poema africano della divisione '28 ottobre'* [*The African Poem on the Division '28 October'*, 1937] or *Originalità russa di masse distanze radio cuori* [*Russian Originality of Masses Distances Radios Hearts*, 1942, published 1996].

There is no reason to doubt the honesty of Marinetti's very personal blend of Catholicism and Futurism. And yet, this return to the Church — like that to Art and to the Academy in the twenties and thirties — is another, perhaps the last, indication of the failure of the overambitious project of a 'Futurist reconstruction of the universe' and of the resilience of the institutions against which the movement had initially unleashed its iconoclastic fury. Indeed, the modern sacred art envisioned by Montini seemed to accept many of the values defended by Futurism — essentiality, anti-rhetoricity, vitality[92] — while at the same time taking the movement as exemplary of the excesses of *modernolatria*, the worship of modernity. Instead of a 'svaticanamento' of Italy on the part of Futurism, in effect the end result of the long and difficult history of the relationship between the Church and the movement was a call for a 'smarinettimento' (and normalisation) of the avant-garde, which, upon the death of its founder, would come to rest in the House of God. On 5 December 1944 Marinetti was buried in Milan in the Church of the San Sepolcro with the following banner on the pediment: 'Accogli Dio nel tuo Regno | la grande anima | di | Filippo Tommaso Marinetti | Poeta soldato sansepolcrista | che tutto diede alla patria | dalla quale invoca con noi | la vittoria e la gloria.' [God, welcome into your kingdom | the great soul | of | Filippo Tommaso Marinetti | Poet soldier Fascist of the first hour | who gave everything to the Motherland | from which he demands with us | victory and glory.][93]

Notes to Chapter 2

1. We would like to thank Matteo Brera, Adele Dei, and Jan Nelis for their advice.
2. Volt [Fani Ciotti, Vincenzo], *La fine del mondo* (Florence: Vallecchi, 2003). As Gianfranco De Turris notes in his introduction to the 2003 reprint of the novel, there seem to be no extant copies of the 1919 edition that a number of authorities cite as the first. The supposedly second edition, by the publishing house 'Modernissima', appeared in 1921, and was dedicated to Mussolini.

3. On Volt, in addition to De Turris's introduction, see also Giuseppe Pardini, 'Alla destra del fascismo. L'itinerario intellettuale di Vincenzo Fani Ciotti (Volt)', *Nuova storia contemporanea* 4.4 (2000), 79–104 (for his positions on the Church, see especially pp. 92–93). On Volt's *La fine del mondo* see also Kyle Hall, 'Love, Politics, and the Explosive Future: Volt's *La fine del mondo*', in *The History of Futurism: The Precursors, Protagonists, and Legacies*, ed. by Geert Buelens, Harald Hendrix, and Monica Jansen (Lanham: Lexington Books, 2012), pp. 213–32.
4. Claudia Salaris, 'Il futurismo dalla religione della velocità alla velocità della religione', in *Beyond Futurism: Filippo Tommaso Marinetti, Writer*, ed. by Gino Tellini and Paolo Valesio (Florence: Società Editrice Fiorentina, 2011), pp. 179–207 (p. 185).
5. Gianni Eugenio Viola, *L'utopia futurista. Contributo alla storia delle avanguardie* (Ravenna: Longo, 1994), p. 67.
6. See Roger Griffin, 'The "Holy Storm": "Clerical Fascism" through the Lens of Modernism', *Totalitarian Movements and Political Religions*, 8.2 (2007), 213–27 (p. 222).
7. Claudia Salaris, 'Il futurismo e il sacro', in Filippo Tommaso Marinetti, *L'aeropoema di Gesù* (Montepulciano: Editori del Grifo, 1991), pp. 79–102; Claudia Salaris, 'Il futurismo dalla religione della velocità alla velocità della religione', pp. 179–207; Marja Härmänmaa, *Un patriota che sfidò la decadenza. F. T. Marinetti e l'idea dell'uomo nuovo fascista, 1929–1944* (Helsinki: Academia Scientiarum Finnica, 2000), pp. 306–28; *Piety and Pragmatism: Spiritualism in Futurist Art / Arte sacra futurista: spiritualità e pragmatismo*, catalogue of the exhibition at the Estorick Collection of Modern Italian Art, 26 Sept.–23 Dec. 2007, curated by Massimo Duranti and others (Rome: Gangemi, 2007).
8. Walter Adamson, *Embattled Avant-Gardes: Modernism's Resistance to Commodity Culture in Europe* (Berkeley, Los Angeles, and London: University of California Press, 2007), p. 4.
9. Ernest Ialongo, 'Filippo Tommaso Marinetti: The Futurist as Fascist, 1929–37', *Journal of Modern Italian Studies*, 18.4 (2013), 393–418 (p. 404). See also Ialongo's *Filippo Tommaso Marinetti: The Artist and His Politics* (Madison: Farleigh Dickinson University Press, 2015), p. 219: 'Marinetti recognized, as would Mussolini, that a true totalitarian state in Italy required both a limitation of this autonomy and the support of the Catholics directly. As such, when Mussolini moved against the Church's autonomy in the summer of 1931, Marinetti followed with *arte sacra*'.
10. Filippo Tommaso Marinetti, *Critical Writings*, ed. by Günter Berghaus, trans. by Doug Thompson (New York: Farrar, Straus and Giroux, 2006), p. 7. The rarity of *Le Papyrus* makes it difficult to establish the veracity of Marinetti's statement. There are few obvious traces of anticlericalism in the extracts signed 'Hesperus' and republished by Jean-Pierre de Villers in 'Documents pour servir à une biographie de F. T. Marinetti', *Etudes sur le futurisme et les avant-gardes*, 1.1 (1990), 37–158. On his expulsion from the *collège*, see also Giovanni Lista, *F. T. Marinetti* (Paris: Séguier, 1995), p. 18 and Viola, pp. 21–25. According to Viola, the correspondence between Father Cottin and Marinetti shows that the Jesuits tried hard to keep him in the school. However, Marinetti's poor results together with the libertarian provocations of *Le Papyrus* could not be overlooked and Marinetti was removed from the College in 1894, after which he set off for Paris.
11. Günter Berghaus, *Futurism and Politics: Between Anarchist Rebellion and Fascist Reaction, 1909–1944* (Providence and Oxford: Berghahn Books, 1996); Günter Berghaus, 'Violence, War, Revolution: Marinetti's Concept of a Futurist Cleanser of the World', *Annali d'Italianistica*, 27 (2009), 23–43.
12. Adrian Lyttelton, 'An Old Church and a New State: Italian Anticlericalism 1876–1915', *European Studies Review*, 13 (1983), 225–48 (p. 233).
13. On anticlericalism in early twentieth-century Italian political life, see Enrico Decleva's essays 'Anticlericalismo e lotta politica nell'Italia Giolittiana. I: L'"esempio della Francia" e i partiti popolari (1901–1904)', *Nuova rivista storica*, 52 (1968), 291–354, and 'Anticlericalismo e lotta politica nell'Italia giolittiana. II: L'estrema sinistra e la formazione dei blocchi popolari (1905–1909)', *Nuova rivista storica*, 53 (1969), 541–617.
14. Filippo Tommaso Marinetti, 'Address to the Fascist Congress of Florence', in *Critical Writings*, pp. 330–38 (p. 330).
15. As Adamson has pointed out in *Embattled Avant-Gardes* (Cambridge, MA, and London: Harvard University Press, 1993), p. 373, n. 25). Notari's proposal to expel the Vatican was first made in his

journal *Verde e Azzurro*; see for example the article 'Lo sport in Vaticano' (14–15 March 1904).
16. The appeal to youth was already present in the programmatic editorial that opened the first issue of *La Giovane Italia*, where Notari described the journal as directed at 'the most evolved and selected social groups, and the youth in particular' ('Un grido nella nebbia', *La Giovane Italia*, 1 (1909), 5–11 (p. 5)).
17. This is an entirely different text from his better-known 1909 manifesto 'Trieste, la nostra bella polveriera', first published in French in *Le futurisme* (1911), then in *Guerra sola igiene del mondo* (1915).
18. Marinetti also endorsed Notari's proposal to expel the Vatican, which, in a letter now held at the Beinecke Library and addressed to Notari himself, he described as 'odioso avanzo di medio evo, custode di tutti i passatismi più dannosi' [a nasty leftover of the Middle Ages, keeper of all the most dangerous *passatismi*] (quoted in Härmänmaa, p. 306).
19. For an interpretation of Notari's project in terms of economic profit rather than aesthetic-political engagement, see Adamson, *Embattled Avant-Gardes*, p. 87.
20. *Manifesti, proclami, interventi e documenti teorici del futurismo*, ed. by Luciano Caruso (Florence: SPES, 1990), item 4.
21. Filippo Tommaso Marinetti, 'La necessità della violenza', *La giovane Italia*, 43 (1910), 16–18 (p. 17). On the complex history of the speech from which this article was drawn and of its piecemeal publication, see Berghaus's notes to his critical edition of the text in Filippo Tommaso Marinetti, 'La necessità e bellezza della violenza', *Annali d'Italianistica*, 27 (2009), 44–71.
22. Marinetti, *Critical Writings*, p. 52.
23. In 'La necessità della violenza' Marinetti referenced the case of the Spanish anarchist Francisco Ferrer y Guàrdia, whose execution for his supposed role in the anticlerical violence during the riots of 'Tragic Week' in Barcelona in July 1909 sparked international protests (Marinetti himself took part in demonstrations in Milan). See Marinetti, *Critical Writings*, note 12, pp. 437–38.
24. Domenico Cammarota gives 12 January 1912 as the publication date, but notes that it was only distributed from 1 July. The translation, published by the Edizioni futuriste di *Poesia*, is dated 1914, but Cammarota suggests that it might in fact not have been distributed until May 1916 (see *Filippo Tommaso Marinetti: Bibliografia* (Milan: Skira, 2002), p. 54 and p. 57).
25. Giovanni Papini, 'Chi non la vuole', *Lacerba*, 2.21 (15 October 1914), 282.
26. According to Verucci the majority of Catholics and bishops was in favour of intervention, except for the lower clergy and the Pope (cf. *Idealisti all'Indice. Croce, Gentile e la condanna del Sant'Uffizio* (Rome and Bari: Laterza, 2006), pp. 23–25). Furthermore, one should also keep in mind of the large number of chaplains who took service in the First World War.
27. *L'Italia futurista*, 1.1 (1916); in *L'Italia futurista (1916–1918)*, ed. by Maria Carla Papini (Rome: Edizioni dell'Ateneo & Bizzarri, 1977), p. 71. Here and in the following text we do not reproduce the layout of the 'parole in libertà'.
28. *L'Italia futurista*, 1.4 (1916) (now in *L'Italia futurista*, ed. by Papini, p. 103).
29. *L'Italia futurista*, 2.7 (1917) (now in *L'Italia futurista*, ed. by Papini, p. 228).
30. Filippo Tommaso Marinetti, *8 anime in una bomba* (Milan: Edizioni futuriste di *Poesia*, 1919), p. 82.
31. See Salaris, 'Il futurismo dalla religione', p. 182.
32. Walter Adamson, 'Modernism in Florence: The Politics of Avant-Garde Culture in the Early Twentieth Century', in *Italian Modernism*, ed. by Luca Somigli and Mario Moroni (Toronto: University of Toronto Press, 2004), pp. 221–42.
33. Marinetti, *Critical Writings*, p. 177.
34. Verucci, p. 20.
35. 'Primi scontri', *Lacerba*, 1.12 (15 August 1913), p. 131.
36. Giovanni Papini, '"Lacerba" sotto processo', *Lacerba*, 1.13 (1 July 1913), 133–35 (p. 133).
37. In *Avant-Garde Florence: From Modernism to Futurism* (Cambridge, MA and London: Harvard University Press, 1993), Walter Adamson entitles his chapter on Florentine Futurism: 'Culture Wars and War for Culture' (p. 153).
38. See the sixth 'polemic' in Giovanni Papini's *Polemiche religiose* (Lanciano: Carabba, 1919), pp. 96–116.
39. Ferdinando Paolieri, 'In difesa di Gesù', *La Nazione*, 8 June 1913, 2.

40. *I processi al Futurismo per oltraggio al pudore*, ed. by Bruno Corra and Emilio Settimelli (Rocca S. Casciano: Cappelli, 1918). The expression 'libro di propaganda' is on p. 147.
41. Sebastiano Vassalli, *L'alcova elettrica. 1913: Il Futurismo processato per oltraggio al pudore* (Milan: Calypso, 2009), pp. 83–84.
42. Jan Nelis, 'The Clerical Response to a Totalitarian Political Religion: *La Civiltà Cattolica* and Italian Fascism', *Journal of Contemporary History*, 46.2 (2011), 245–70 (p. 254).
43. Ibid., p. 254.
44. As Adamson writes, 'Upon the announcement of the verdict, the largely Futurist audience shook the courtroom with chants of "viva il futurismo!"' (*Avant-Garde Florence*, p. 177).
45. 'Il recente decreto dell'Indice e la nostra letteratura contemporanea', *La Civiltà Cattolica*, 2 (1911), 547–62 (p. 555). Until 1933, all articles in *La Civiltà Cattolica* were unsigned.
46. 'Il Futurismo', *La Civiltà Cattolica*, 3 (1913), 321–30 (pp. 328–29).
47. Ibid., p. 330.
48. This practice of silencing the impact of these obscene and blasphemous works is confirmed by a letter dated 21 June 1913, by Father Rosa, a collaborator of *La Civiltà Cattolica*, to the Holy Office. After reading the publications of these 'pazzi e corrotti futuristi' [mad and immoral Futurists] together with those of the 'morti veristi' [dead *veristi*] and the 'viventi dannunziani' [living disciples of D'Annunzio], Father Rosa proposes to condemn them altogether by not honouring them or their works with any further mention. Rosa's proposal, however, was never put into practice by the Index (Father Rosa's letter is discussed by Matteo Brera in his *Novecento all'Indice. Gabriele d'Annunzio, i libri proibiti e i rapporti Stato–Chiesa all'ombra del Concordato* (Rome: Edizioni di Storia e Letteratura, 2016). Futurist books were indeed banished from Catholic circulating libraries; cf. Domenico Cammarota, *Futurismo. Bibliografia di 500 scrittori italiani* (Milan: Skira, 2006), p. 32.
49. Adamson, *Embattled Avant-Gardes*, p. 234.
50. Marinetti, *Critical Writings*, p. 272.
51. Günter Berghaus, 'Introduction: F. T. Marinetti (1876–1944): A Life between Art and Politics', in Marinetti, *Critical Writings*, pp. xvii–xxix (pp. xxii–xxiii).
52. Marinetti, *Critical Writings*, p. 331.
53. See the entry for 20 May 1920 in Filippo Tommaso Marinetti, *Taccuini 1915–1921*, ed. by Alberto Bertoni (Bologna: Il Mulino, 1987), p. 486.
54. Marinetti, *Critical Writings*, p. 486.
55. Ibid., p. 323.
56. Berghaus, *Futurism and Politics*, p. 245.
57. Ibid., pp. 223–24.
58. Claudia Salaris, *Artecrazia: l'avanguardia futurista negli anni del fascismo* (Scandicci: Nuova Italia, 1992), p. 3.
59. Filippo Tommaso Marinetti, Mario Carli, Emilio Settimelli, 'Manifesto dell'Impero Italiano', *L'Impero*, 25 April 1923.
60. Anna Scarantino, *L'Impero. Un quotidiano 'reazionario-futurista' degli anni Venti* (Rome: Bonacci, 1981), p. 118.
61. Ibid., pp. 136–37.
62. In 'Fascismo e Cattolicesimo. Le tenebre', published in *L'Impero* on 4 April 1924, Paolieri reflected on his 'espulsione' [expulsion] in 1913 from the Italian press organs as a result of his collaboration in what he called the 'ultra imperialista-cattolico foglio' [ultraimperialist-Catholic journal] *La Torre*.
63. Scarantino, *L'Impero*, p. 68.
64. Filippo Tommaso Marinetti, 'Il discorso di Marinetti', *L'Impero*, 3 March 1925, p. 2.
65. *La Civiltà Cattolica*, 1 (1925), p. 559.
66. 'A proposito del discorso di F. T. Marinetti', *L'Impero*, 5 March 1925 [the article, pasted in Marinetti's "Libroni", is available online through the Beinecke Rare Book and Manuscript Library at <http://brbl-dl.library.yale.edu/vufind/Record/4149640?image_id=14687022>, consulted 7 April 2016]
67. Berghaus has described Marinetti's position on the Catholic Church after 1929 as 'blatant

revisionism'. He writes: 'Following Mussolini's "historic compromise" with the Vatican, he [Marinetti] relinquished his emphatic anti-clericalism and publicly confessed his Catholic faith' (*Futurism and Politics*, p. 245). On Marinetti's private misgivings regarding the Concordat, see Giordano Bruno Guerri, *Filippo Tommaso Marinetti. Invenzioni, avventure e passioni di un rivoluzionario* (Milan: Mondadori, 2009), p. 225.
68. See Salaris, *Artecrazia*, p. 127.
69. Emilio Settimelli, Ottone Rosai, Remo Chiti, Alberto Maurizio, and Bruno Rosai, *Svaticanamento. Dichiarazione agli italiani* (Florence: Edizione Fiorentine, s.d. [1931]).
70. John Pollard, *The Vatican and Italian Fascism, 1929–1932: A Study in Conflict* (Cambridge: Cambridge University Press, 1985), pp. 182–92.
71. Giulio Podrecca was the founder of the anticlerical journal *L'Asino* (1892–1925).
72. Emilio Settimelli, *Preti, Adagio!* (Florence: Giannini & Giovannelli, [1931?]), p. 2.
73. Officially, Settimelli was expelled because of *L'Impero*'s favourable attitude towards 'xenophile critics' (see Salaris, *Artecrazia*, p. 129).
74. In 1934, Settimelli was also the target of a curious pamphlet by Fernando Gori entitled *Emilio Settimelli ovverosia l'eroe di stoppa* (Rome: Edizioni di 'Pattuglia Nera', 1934), where he was taken to task for his shifting allegiances.
75. Filippo Tommaso Marinetti [and Fillìa], 'Manifesto of Futurist Sacred Art', in *Piety and Pragmatism*, pp. 90–93 (p. 91).
76. See Pia Vivarelli, 'Dibattito sull'arte sacra in Italia nel primo Novecento', in *E.42. Utopia e scenario del regime. Urbanistica, architettura, arte e decorazione*, ed. by Tullio Gregory, Achille Tartaro, and Maurizio Calvesi, 2 vols (Venice: Marsilio, 1987), II, 249–60 (p. 256).
77. Quoted in Salaris, *Artecrazia*, p. 113.
78. Pius XI, 'La parola del Santo Padre sull'arte sacra', *Arte sacra*, 3–4 (1932), 291–99 (p. 293).
79. Ibid., pp. 293–94.
80. The journal *Arte sacra* observed that these declarations of the Pontiff on art were in effect law ('fanno legge', p. 298), the more so because they were also included in the *Acta Apostolicae Sedis*, the official gazette of the Holy See.
81. Pius XI, p. 294.
82. See Vivarelli, p. 258.
83. Filippo Tommaso Marinetti, 'Il 25. del futurismo festeggiato dai futuristi venticinquenni', *Sant'Elia*, 1.3 (1934), quoted in Härmänmaa, pp. 311–12.
84. See Vivarelli, p. 256.
85. Pius XI, p. 296.
86. Giovanni Battista Montini, 'Su l'arte sacra futura', *Arte sacra*, 1 (1931), 39–45 (p. 39).
87. On the 'air of opportunism' of Futurist sacred art, see Christopher Adams, 'A Leap of Faith: Futurism, Fascism and the "Manifesto of Futurist Sacred Art"/Uno slancio di fede: futurism, fascismo e il "Manifesto dell'arte sacra futurista"', in *Piety and Pragmatism*, pp. 41–46 (pp. 44–45).
88. The attack on Vatican pacifism remained a weapon in the rhetorical arsenal of the anti-clerical intellectuals close to Futurism. For instance, in *Svaticanamento*, Settimelli and his co-signatories wrote 'Pius XI becomes a Pius IX [. . .] with the burden of the defeatist legacy of Benedict XV who popularised, thus shamefully erasing himself from the history of the world, the matricidal sentence: "The World War is a useless slaughter"' (p. 6).
89. Härmänmaa, p. 318.
90. Günter Berghaus, 'Review Article: New Research on Futurism and its Relations with the Fascist Regime', *Journal of Contemporary History*, 1 (2007), 149–60 (p. 159).
91. Marinetti, 'Il 25. del futurismo', quoted in Härmänmaa, p. 312.
92. Montini, p. 43.
93. Quoted in Viola, p. 149.

CHAPTER 3

The Automobile

Samuele F. S. Pardini, Elon University

A minor automobile accident occasioned the writing of 'Fondazione e manifesto del Futurismo' [The Founding and Manifesto of Futurism]. On the morning of 15 October 1908, just before noon, Marinetti, then thirty-one years old, drove his four-cylinder Fiat on the streets of Milan, accompanied by his mechanic Ettore Angelini. The sudden appearance of a cyclist forced Marinetti into an acrobatic manoeuvre that resulted in the classic accident of motoring during its initial age: the automobile, with Marinetti and Angelini, fell into a ditch. From the nearby car factory, Isotta e Fraschini, two racing drivers rushed up with their cars to rescue the two mildly injured men. Later that afternoon, the vehicle was taken out of the ditch under the eyes of a group of curious bystanders.[1]

Marinetti incorporated this accident in the manifesto, which appeared on the front page of the French daily *Le Figaro* on 20 February 1909. In contrast to the real accident, this time Marinetti is alone in the car, upon which he stretches 'like a corpse on its bier',[2] a metaphor that immediately associates the automobile with death. Yet, the steering wheel, similar to 'a guillotine blade' threatening his stomach, revives him. Once symbolically reborn, Marinetti is ready to race through the streets of Milan with his fellow poets, chasing death. Suddenly, two cyclists appear in front of Marinetti's car, forcing him to break hard and, as in the real accident, fall into a ditch: 'to my disgust the wheels left the ground and I flew into a ditch'.[3] After the crash, Marinetti gets up from underneath his capsized car, followed by the automobile. As he is resurrected from under the steering wheel, so is the car from out of the ditch:

> Slowly the car's frame emerged [. . .]. They thought it was dead, that gorgeous shark of mine, but a caress was all it needed to revive it, and there it was, back from the dead, darting along with its powerful fins![4]

After this second resurrection, Marinetti is ready to announce that

> [T]his wonderful world has been further enriched by a new beauty: the beauty of speed. A racing car, its bonnet decked out with exhaust pipes like serpents with galvanic breath [. . .] a roaring motorcar, which seems to race on like machine-gun fire, is more beautiful than the Winged Victory of Samothrace.[5]

The fusion of machine and speed is the manifesto's signature mark, what defines it, because the beautiful racing car occasions, embodies, and conveys the essential

elements of the Futurist poetics, social vision, and political economy. It represents three simultaneous stages of Futurist politics: the seeming rebirth as a figure of duplication that substitutes for the materiality of the real; the self-sufficiency of the machine; and the supposedly omnipresent but intangible new beauty that for Marinetti is superior to and displaces the solid, tangible, lasting beauty of the ancient Greek sculpture, the product of human labour and work, of human energy and skills. Speed and the automobile are two sides of the same inward-oriented mirror that reflects these three moments.

In order to gain a sharper insight into this politics, it may be helpful to start first of all with a close reading of another significant piece of car literature. In fact, in spite of its historical centrality in the cultural territory that the automobile has created ever since its first appearance, Marinetti's Futurist manifesto 'Foundation and Manifesto of Futurism' was neither the first piece to signal the irruption of this relatively new vehicle of transportation in literature nor the first car-occasioned literary piece worthy of remembrance to appear in *Le Figaro*. On 17 November 1907, the newspaper had welcomed an article by a young French writer named Marcel Proust, titled 'Impressions de route en automobile' [Impressions of the Road while Seated in an Automobile], later collected in the section 'En mémoire des églises assassinées' in *Pastiches et mélanges* as 'Les églises sauvées. Les clochers de Caen. La cathédrale de Lisieux. Journées en automobile' [The Churches Saved. The Towers of Caen. The Cathedral of Lisieux. Days on the Road]. In this article, Proust presents the automobile as a new writing tool, *thematically* anticipating the Futurist manifesto along with more recognised influences such as Mario Morasso's *La nuova arma (La macchina)* [The New Weapon (The Car)] and, as I have argued elsewhere, Luigi Barzini's *Da Pechino a Parigi* [From Peking to Paris].[6] In both Marinetti and Proust, the car enters the written page and connects writing, literature, and history, but in Proust it is the automobile, not speed, that induces an act of writing and stimulates the *experience* of writing. The car remains a concrete object, and it is the use of the automobile that generates new experiences of time and space, new modes of perception that writing translates into artistic and historical memory and, by so doing, points out the possibilities that twentieth-century modernity might be able to offer. In Proust, the car enlarges the vision of the modern world that Marinetti's automobile reduces mainly to speed.

'Impressions of the Road' chronicles Proust's visit to the steeples of Saint-Etienne on his way to his parents' house in the company of his faithful driver-mechanic Agostinelli. The article was not unique in Proust's career. The automobile returns in *À la recherche du temps perdu* [In Search of Lost Time], where Proust often juxtaposes it to the train to highlight the qualities of the former, as he had already done in the piece published in *Le Figaro*. In the newspaper article, he writes that the automobile has resuscitated the figure of the traveller, 'that traveler who ceased to exist when railways became general, and has now been resuscitated by the motor-car'.[7] The automobile, the material object, produced the rebirth of a subject — the traveller — that another technology of motion — the train — had terminated. Although Proust's language fashions the traveller in sublime garments, the reason of the latter's resurrection is solely factual. The automobile has given back to the traveller

what the train had taken away: independence from time, in the form of control over its schedule: 'the most splendid gift bestowed by the automobile on this modern traveller is that of a splendid independence, by virtue of which he can set out at any hour he pleases, and stop when and where he will'.[8] The traveller, whom the train had reduced to an acted-upon object, is turned again into an active subject by the automobile, because he has regained control over time and space, the two notions that the speeding car of the first Futurist manifesto announces dead and replaces with omnipresent speed: 'Time and Space died yesterday. We are already living in the realm of the Absolute, for we have already created infinite, omnipresent speed'.[9] For Proust, such a re-inversion is what opens up new writing opportunities and triggers the initiation of processes of literary creation, as is illustrated by the fact that his newspaper article on his 'Impressions de route' eventually was turned into a brief, but rather significant, part of À la recherche du temps perdu.

'Impressions of the Road' returns almost in its entirety in *Du côté de chez Swann* [*Swann's Way*], more precisely in the Martinville episode, which rounds off 'Combray', the beginning of the novel. The one significant difference between the article as it appeared in the newspaper and its incorporation in the novel is the vehicle itself. In *Du côté de chez Swann*, an old carriage substitutes for the car. One would think that the reason for this change would be purely historical. In the early eighteen-eighties, the decade during which the episode narrated in *Du côté de chez Swann* occurs, the automobile was a brand-new invention. And yet, there seem to be more important implications than a strict chronological one, because the absence of cars signals the central position of the Martinville episode in the general economy of the novel. It is at this point in the narration that Proust introduces the motif of his recognition and success as a writer, an obsession that pervades the whole book, and establishes a link between his public literary status, writing as textual performance, and technology as accelerator of the historical process, the same connection that is at the roots of the Futurist poetic revolution, as Proust acknowledges in *À l'ombre des jeunes filles en fleurs* [*Within a Budding Grove*].[10]

It may as well be the recognition of this connection that led him to change the title of the article into 'Journées en automobile' [Days on the Road] when he collected it in *Pastiches et mélanges*. The change is of great importance because it indicates a shift in his thematic priorities that repositions the automobile within the process of writing. From the senses (*impressions*) we are transported (we may as well use this verb) into time (*journées*). The writing process that the automobile occasions seems to modify the essence of the piece, as it assigns time a position of dominance over the senses. However, though time, space, and impressions are the three motifs with which Proust opens his article, it is the automobile that 'produces' them, beginning when it is not moving,

> Because I had started fairly late in the afternoon, there was no time to be lost if I wanted to reach, before nightfall, the house of my parents which stood half-way between Lisieux and Louviers. To right, to left, and ahead, the car windows, which I kept closed, produced the effect of, as it were, displaying under glass the lovely September day which, even to the gazer in the open air, showed as something seen through a kind of translucent substance.[11]

Before beginning what is supposed to be a car trip to view some artistic monuments and visit his parents, Proust has already made of his automobile something other than a vehicle of transport. He has turned it into a writing tool, an instrument to see and discover, like a new lens to read, even a strategy to read. The windshield (*vitrage*) of the car allows him to freeze the beautiful September day and capture a material sense of the lovely day as it appears to his eyes; the windshield allows him to grasp its loveliness. It does so because the automobile provides him with the necessary physical distance to appreciate such a day by way of establishing a frame, a moment of articulation of the natural view. Without the windshield, this view would not be possible. The automobile's windshield works as a screen: it serves to bring to view something that is otherwise absent. It brings to the surface an absence or, which is the same, it gives birth to something, like the whole car gives (re) birth to the traveller. Conversely, in this way the vehicle has materially entered the page, to the point that it will return in several volumes of his novel. It has become a constitutive part of Proust's writing. Without the automobile, the novelty would neither be manifest nor could it (and the novel) be written.

This pairing of the automobile and the idea of 'birth' returns twice in the article when Proust and Agostinelli stop in Lisieux because of a mechanical problem. While waiting for the car to be fixed, he decides to observe the town's cathedral. When the night begins to fall, he steps closer to the door of the cathedral to touch it with his hands, as if he wants to materialise a concrete presence, an illustrious physical reminder of the past: 'I walked forward, wishing at least to touch the famous trees of stone'.[12] Exactly at this moment, his mechanic illuminates the old sculptures with the automobile's headlights, a gesture that symbolically sends the salute of the present to the past and, by so doing, connects the cathedral and the automobile, making the modern machine a reading tool:

> My driver, the resourceful Agostinelli, paying to ancient stones the tribute of the present, whose gift of life served to make easy the *reading* of old lessons, was focusing upon each section in turn of the porch I wished to see, the bright beams of his headlights.

As if this was not enough, when Proust turns around towards the car, he sees near the vehicle, attracted by 'the unearthly glare', a group of children who resemble a Nativity, 'some little nativity scene of angels'.[13]

Proust positions the car within the text in such a way that the reader comprehends two births. The first is a new way of seeing that Proust associates with the intellectual capabilities of the worker, almost anticipating Gramsci's theories of the intellectual. A mechanic, 'mon mécanicien' as Proust defines Agostinelli, obviously mindful of the distinction between the latter and a chauffeur, and one of the symbols of the bourgeoisie of the early twentieth century, illuminates the cathedral, shedding the light of the present upon the past. He does so by using one component of the machine that *he* operates: the automobile's headlights. The combination between the creativity of the worker and the use that he makes of a fairly new technology of individual locomotion allows Proust, the traveller and writer, to see the cathedral and see it in a different way because Agostinelli's act changes the way Proust can

view and then write about the old monument. Technology does not change things. The way the worker uses it does.

In addition, this particular technology multiplies the ways of seeing things, thus making the present itself a reading tool of the past, a past that is therefore made anew, as it were. As the windshield had previously allowed Proust to frame the picture of a lovely September day, now the use of the headlights permits him to see the cathedral. In turn, this illumination generates the picture resembling a Nativity, the children near the automobile, as if Proust wanted to indicate, in his typically subtle fashion, the link between work — including the work of the traveller-writer, which is writing, which in turn we may define as the materialisation of the labour of the mind and of the hands that transfer it on the page after the car's trip is over — and beauty, birth, the Nativity, a secular celebration of the sacredness of life, of love. It is this solidity that Proust celebrates, as it represents the possibility of a lasting presence made perceivable by a possible crash. Despite the trip in the car, the steeples seem to remain 'unattainable, resisting every effort of our mechanised advance to break through the separating distance', writes Proust. It is only 'in the last few seconds that we had realised to the full how fast we had been moving'. Yet the danger is not speed, it is the steeples, the concrete buildings, which, 'like giants [over]whelming us with the vastness of their height, [. . .] flung themselves so recklessly before us, that we had only just enough time to keep ourselves from crashing into the porch'. Here, to paraphrase the 'Foundation and Manifesto of Futurism', time and space seem to (temporarily) die, but what's left is not 'omnipresent speed'.[14] It is the beautiful towers of Saint-Etienne in all their frightening solidity, in which history too is stored.

In Proust the automobile connects writing and something solid, touchable, that represents artistic beauty, historical memory, the spiritual dimension of life, and that intertwines present and past, the now and history. In Marinetti's first manifesto (and subsequent Futurist works), the car exemplifies the superiority of speed over the real, historical sculpture, the *Victory of Samothrace*. Fast motion, the transient, the immaterial, prevails over stability, the durable and the material, making it disappear along with the present, whereas what is represented is the speeding car itself and its representation: 'We created omnipresent speed'. In contrast to Proust's approach, however, such creation is not the result of a new way of looking at the past enabled by the arrival of the automobile. It is not an addition. It is a subtraction, the result of an act of exchange, something similar to the (ex)change of the little accident of Via Domodossola into the fictional accident of the first manifesto. The addition of the beauty of speed has meant the subtraction of Time and Space, which 'died yesterday' and in whose place is now 'omnipresent speed'. In other words, omnipresent speed is the complete unfolding of history, that is to say, its end. No wonder that one of the subsequent points of the manifesto invokes the destruction of museums, one of the places where history is physically stored. In this sense, in terms of history, Futurist speed must be intended exclusively as acceleration so swift that what is accelerated cannot last at all. History is neither dying nor dead. It is erased.

This is the governing principle of the Futurist project that informs the Futurists' idea of the literary text, which must be disrupted starting with linear narration,

which is nothing but the correlative of historical sequence — and there is nothing that Marinetti hates more than historical sequence. As the car disappeared in the ditch of Via Domodossola, so must most elements of the literary text. According to the 'Manifesto tecnico della letteratura futurista' [Technical Manifesto of Futurist Literature], a large number of traditional components of the literary text (or of language as such) must disappear from literary writing: the adjective, the adverb, punctuation, the subject, syntax, but especially the 'I' with its psychological depth and its fondness for memory, that is, for its self-recollection, one of the preconditions, if not *the* precondition, of history. This is the reason why poetry is defined as the art of listening to motors, of *duplicating* their conversations, a constant flux of images. The way to achieve this poetic goal is the doubling of the noun, the so-called Futurist 'sostantivo doppio' [double noun]. The results of this technique of analogy are spatially dislocated over the page through a typographical revolution consisting in a reduplication of the expressive power of words, making this power mobile and unfixable, while at the same time expressing less tangible qualities of reality such as noise, weight, and smell. An act of linguistic expression is the Futurist technology of choice, one, however, that is nothing but a moment to be performed, consumed, exhausted in the famous, chaotic, and reportedly quite hilarious, *soirées futuristes*.

It may seem paradoxical, but in a literature in which there are, so to speak, more cars than in the Detroit area, in the end there is only one *macchina*, the machine-text that condenses and maximises its production-in-motion (since it can never last), that the free dislocation of the words on the page represents visually. As in Luciano Folgore's 'Automobile quasi te' [Automobile Almost as You]:

> D'intorno tutto il mondo è in moto,
> d'intorno città non più immobile,
> ma giro
> corsa
> capitombolo
> di fogliecaseparapettifanali
> di uomini stanchi di marce a piedi
> e di polvere
> sulla gomma
> nella folata.
>
> [All around me the world is in motion
> All around me the city no longer immobile
> my trip
> moving
> headlong
> ofleaveshousesparapetsstreetlamps
> of tired men travelling on foot
> and of dust
> from the tires
> flurrying.][15]

Or as in Auro d'Alba's 'Battute d'automobile' [Automobile Beats], where the 'battute' are strokes rather than heartbeats, as the unfortunate translation has it:

> Satollo di rossa benzina
> scalpito
> sussulto
> mi sferro
> m'apro tra colonnati d'atmosfera
> portici di libertà.
>
> Le strade, inebrianti sanguisughe
> arroventate,
> mi succhiano mi succhiano
> sfettucciandomi alle calcagna
> i cadaveri dei chilometri
> divorati dal cannibale motore.
>
> [Saturated with red gas
> pawing
> trembling
> I break loose
> I open up columns of atmosphere
> doors of liberty.
>
> The streets-intoxicated bloodsuckers
> they suck me suck me
> At the heels
> the cadavers of miles
> devoured by the cannibal motor.][16]

On the one hand, the text is reduced through the disappearance of most of its formal elements; on the other, this subtraction doubles the nouns *and* its productive capacity, therefore avoiding a possible moment of stasis: 'We should fuse the object directly with the image that it evokes', writes Marinetti.[17] The machine-text becomes an all-inclusive process through a language that is at the same time referential, self-referential, and a system to produce images. This explains the choice of the automobile as a figurative device of motion. It gives the Futurists the possibility to represent the dynamism of objects in motion, beginning and ending with its own dynamism, thus making it manifest and expressing it. It enacts that (forward) movement that, through a multitude of images, makes visible the act of production itself, the moment Marinetti defines as 'dynamism'.

An especially exemplary text in this respect is *Dunes*, one of Marinetti's creative works, written in 1914, where the actual motif is travelling through the African desert. Traditionally, a travelogue is set in a landscape; on the road people meet and things happen. At the end of the journey, those who undertook it also recollect it. In the case of Futurism there is no such act. Here the attempt is to reproduce the moment and the act of travelling. The 'poem' begins with an onomatopoeia originating from the automobile already in motion, since apparently Futurist cars do not need to be turned on ('Karazuc — zuczuc'), and with the rotating noise of the African sun ('dum dumdumdumdumdum'). The narration (if this is an appropriate term for Futurist texts of this kind) goes on with the ten moments of the 'sensibilità motrice' [propelling sensibility] represented by ten different dunes, the

reproduction of other noises ('tlac tlac cic-cioc') and of the yellow colour through the deployment of typographically expanded and analogically doubled words, which allow Marinetti to avoid any possibility of fixation or rest at the moment of the performance of the text ('giallooogiallooo' [yelloooowyellooow]). Travelling means 'andare senza scopo FARE VIVERE CORRERE ESSERE' [going without a goal just DOING LIVING RUNNING BEING]. The text continues with the shortening of a sentence, which we can think of as the extreme act of condensation, through the elimination of the letter 'o' and of the typographical spaces between the words in the sentence 'seistatuneroe' [youwereahero], and ends with the technical parataxis of the printed words that generates spatial interpenetrations of the different temporal levels in 'acciecato di lagrime' [blinded with tears] and 'acciecante di lagrime rosse' [blinding with red tears].[18] This is at once a writing technique and a poetics of continuous movement that elides any moment of stasis, any mediation, and any articulation. As Futurist painter Umberto Boccioni would write in 'Moto assoluto + moto relativo = dinamismo' [Absolute Motion + Relative Motion = Dynamism]: 'there is not such a thing as rest, only motion'.[19]

Yet one wonders where all this motion comes from. Or, to put it in another way, one wonders why, in spite of all this motion and the Futurist passion for making things manifest, the engine of their cars is never visible, as if it never existed. In fact, the engine is not even mentioned in these Futurist writings. The Futurist cars do not seem to need an engine and gasoline to transform energy into movement, or production into representation. In 'L'uomo moltiplicato e il regno della macchina' [Extended Man and the Reign of the Machine], published a year after the founding manifesto of the movement, in 1910, Marinetti proposed an over-productive view of the machine, but one that does not (re)present an engine, let alone the workers that build the cars. The one thing that does (re)present, however, is a self-sufficient and self-generated economic principle:

> You will undoubtedly have heard the comments that car owners and car workshop managers habitually make: 'Motorcars, they say, are truly mysterious . . . They have their foibles, they do unexpected things; they seem to have personalities, souls and wills of their own. You have to stroke them, treat them respectfully, never mishandle nor overtire them. If you follow this advice, this machine made of cast iron and steel, this motor constructed according to precise calculations, will give you not only its due, but double and triple, considerably more and a whole lot better than the calculations of its creator, its father, ever dreamed of!'[20]

This is the ideal picture of a social and economic hierarchical order. There are private owners of automobiles, managers, and unlimited, self-generated overproduction, but there are not actual makers of the machines. One wonders who actually 'constructed' these machines and who made the precise calculations. Even the reproductive metaphor is asymmetric. There is the father but not the mother of the machine. There is, instead, an invitation to respect the machine and follow such an advice, without questioning it. The uncalculated overproduction of the machine is the result of the economisation of the terms of the process in an act that contains them both. On the one hand, this economic self-sufficiency

of the automobile resembles the presumed self-sufficiency of a rigidly disciplined corporate economy, that is to say, a model of controlled order and productivity. On the other, these are the principles of a scientific management taken to its extreme. It is no coincidence that along with the lack of engines and workers, the Futurist texts also present the lack of social status. Despite the obsessive, almost annoying presence of the automobile, we never know what kind of automobile any of these writers drives. The classic dimension of the automobile as an indicator of social status is non-existent in the Futurists. Likewise, the Futurist cars are possibly the only literary cars that never go backwards. They have neither a reverse gear nor a rear-view mirror.

The final stage of this discourse appears in what may be considered *the* manifesto of Futurism, 'La nuova religione-morale della velocità' [The New Ethical Religion of Speed, 1916]. Marinetti begins by tracing a brief history of motion, which, tellingly, also represents three different historical moments seen by Marinetti as conquest. From his own feet, man passed on to horses 'through [*mediante*] an increase in speed'.[21] Then, as a novel Prometheus, he stole electricity and the fuels to create the motor, forged the metals with fire, and built the automobile to carry him around the world, of course swiftly. After having delineated this final, absolute stage, Marinetti draws a Manichean division between speed (which identifies the self-produced acceleration necessary to keep everything in motion) and slowness (which is its opposite). Such a division reflects an entire system of *values*. On the side of speed, Marinetti poses the synthesis of all the forces in movement: intuition, purity, aggressiveness, war, and modernity. Slowness, instead, is characterised by immobility, filthy (*immonda*) morality, stagnation, pacifism, and romanticism. The same dichotomy applies to the landscape that Marinetti glorifies: an urban, mechanised territory made of automobile tracks, tires, internal combustion engines, gases, in which joy is the result of an acceleration, of a (ex)change, the switch from 'third to fourth gear'. The same displacing binarism is reiterated in the two kinds of speed that Marinetti links to the structure of language, which properly returns at the end of the essay to close the circle, so to speak. On the one hand, Marinetti places 'active speed', the one identifiable with 'writing, sculpturing' and with 'speed that carries different speeds' reproduced in the figure of the chauffeur (*volantista*); on the other, he places 'controlled speed', the one identifiable with 'what is written or sculptured', and 'speed that is borne by different speeds'. It is to the first type, to the mobile, empty, and deferring signifier, that Marinetti assigns primacy: 'Our life must always be a carrying speed'.[22]

This preference testifies once again to a rejection of everything that is fixed, of stability, durability, and materiality. Conversely, such rejection signals a love for destruction, that is to say, for consumption and disappearance, and for becoming, what is about to become but is not yet, a short circuit that never ends. An endless chain that only the semblance provided by the machine-metaphor can justify, '[l]a macchina prodotto e conseguenza che produce a sua volta infinite conseguenze' [the machine product and consequence that in turn produces infinite consequences], as Marinetti reaffirms in his introduction to a collection of Futurist poetry in 1925.[23] When these terms are translated into history, they ignite a process that postpones

the present, which is posited as a past that must disappear, like the automobile in the ditch of Via Domodossola and in the first manifesto. In this deadly logic, unlike Proust's article, what is real — beginning with the materiality of the modern world and the opportunities it might be able to offer — vanishes and becomes meaningless.

In Proust's vision the automobile can produce a new experience of writing and translate it into a renovated sense of artistic and historical memory by linking the present to the past evoked by the cathedrals of Lisieux; to identify and bring into the world a renewed beauty; to pay tribute to the worker; to present, in the picture of the children near the automobile that he calls a Nativity, modernity as a possibility of a new beginning. It is an enlarged and enlarging vision of both literature and modernity, of the possibilities they might be able to present. There is no such sentiment in Futurism. In a classic process of inversion whereby the subject becomes the object, the Futurist speeding automobile leads to what Marinetti chased at the steering wheel of his automobile in the streets of Milan, to the end of any possibility of new experiences. His speeding car is a weapon that reduces the poetic text to an efficient machine, erases work, and expels workers from economic production and the social sphere. The Futurist automobile extinguishes any historical experience by way of duplication and cancels any possibility of historical memory by declaring the end of time and space, the end of history. In short, as exemplified by this microstudy, which took off with a depiction of the historical car crash that set Futurism in motion, the new beginning that Marinetti's roaring and speeding car announced was its own negation, its own end, its death.

Notes to Chapter 3

1. Claudia Salaris, *Filippo Tommaso Marinetti* (Milan: La Nuova Italia, 1988).
2. Filippo Tommaso Marinetti, 'The Foundation and Manifesto of Futurism', in *Critical Writings*, ed. by Günter Berghaus, trans. by Doug Thompson (New York: Farrar, Strauss and Giroux, 2006), pp. 12–16 (p. 12).
3. Ibid.
4. Ibid., p. 13.
5. Ibid.
6. See Mario Morasso, *La nuova arma (La macchina)*, with an introduction by Carlo Ossola (Turin: Centro Studi Piemontesi, 1994); see also Samuele F. S. Pardini, 'Before the Future/ists: Luigi Barzini's *La metà del mondo vista da un'automobile. Da Pechino a Parigi in sessanta giorni*', *Annali d'Italianistica*, 27 (2009), 209–23.
7. Marcel Proust, 'In Memory of a Massacre of Churches. 1. The Churches Saved. The Towers of Caen. The Cathedral of Lisieux. Days on the Road', in *A Selection from His Miscellaneous Writings*, chosen and translated by Gerald Hopkins (London: Allan Wingate, 1948), pp. 11–17 (p. 15).
8. Ibid., p. 16.
9. Marinetti, 'The Founding and Manifesto of Futurism', p. 14.
10. The article is mentioned at various points in three other volumes: in *The Guermantes Way*, in *The Captive*, and in the next to the last volume, *The Fugitive*, when we are (finally!) told that the piece has been published and the author has thus achieved his long-pursued literary status. For Proust's reference to Futurism, see *Within a Budding Grove* (New York: The Modern Library, 1998), p. 143.
11. Proust, 'In Memory of a Massacre of Churches', p. 11.
12. Ibid., p. 14

13. Ibid.; my emphasis.
14. Ibid., p. 12, p. 13.
15. Luciano Folgore, 'Automobile quasi te', quoted from *I poeti del futurismo 1909–1944*, ed. by Glauco Viazzi (Milan: Longanesi, 1978), p. 203; translation quoted from *Automobile and Culture*, ed. by Gerald Silk (New York: Abrams, 1984), p. 83.
16. Auro d'Alba, 'Battute d'automobile', quoted from *I poeti del futurismo 1909–1944*, ed. by Glauco Viazzi (Milan: Longanesi, 1978), p. 227; translation quoted from *Automobile and Culture*, p. 83.
17. Filippo Tommaso Marinetti, 'Technical Manifesto of Futurist Literature', in *Critical Writings*, pp. 107–19 (p. 108).
18. Marinetti, 'Dune', in *Teoria e invenzione futurista*, pp. 783–90 (p. 789).
19. Umberto Boccioni, 'Absolute Motion+ Relative Motion = Dynamism', in *Futurist Manifestos*, ed. by Umberto Apollonio (London: Thames and Hudson, 1973), pp. 150–54 (p. 150).
20. Filippo Tommaso Marinetti, 'Extended Man and the Reign of the Machine', in *Critical Writings*, pp. 85–88 (p. 86).
21. Filippo Tommaso Marinetti, 'The New Ethical Religion of Speed', in *Critical Writings*, pp. 253–59 (p. 253).
22. Ibid., pp. 254, 256, 257. The Italian reads: 'velocità maneggiante, modellante, scrivente, portante diverse velocità [. . .] velocità maneggiata, scritta, portata da diverse velocità [. . .] La nostra vita deve sempre essere una velocità portante', in *Teoria e invenzione futurista*, p. 132, p. 134, p. 135.
23. Filippo Tommaso Marinetti, *I nuovi poeti futuristi* (Rome: Edizioni futuriste di *Poesia*, 1925), p. 14.

CHAPTER 4

London

John J. White, King's College London

This chapter takes Marinetti's visits to the city of London as a starting point so as to reconstruct how he experienced the British capital. Pasting all the historical evidence together, its shows that London may well have been one of the most significant cities in the development of Futurism's aesthetic of speed. Three key figures are vital to an understanding of Marinetti's London visits between 1910 and 1916: Gino Severini, who, having staged a one-man exhibition at the Marlborough Gallery in Duke Street in 1913, continued to monitor the London press's responses to Italian Futurism; C. R. W. Nevinson, England's only Futurist painter, as well as Marinetti's guide to London in general; and the painter Umberto Boccioni, whose city images, street paintings, theories of speed, and views about London were vital to Marinetti's experience of the city and its artistic circles.

Writing on 15 March 1912 to Vico Baer, Boccioni sang the city's praises: 'A Londra con Marinetti sono andato a insultare, in casa, un giornalista inglese. Che magnifica gita in automobile fino a sessanta chilometri da Londra! Ho assistito a tutti i disordini delle suffragette, incoraggiandole e acclamandole' [In London I went with Marinetti to insult a journalist at his home. What a wonderful car trip, sixty kilometres out of London! I witnessed all the riots of the suffragettes, encouraging and cheering them on].[1] Yet Boccioni's attitude to London was relatively ambivalent:

> Londra, bella, mostruosa, elegante, ben pasciuta, ben vestita, ma cervelli pesanti come bistecche. Interni di case magnifici; pulizia, onestà, calma, ordine ma in fondo un popolo idiota o semi. [. . .] Cosa conta se un giorno si scaveranno sotto le macerie di Londra degl'impermeabili intatti e dei libri mastri senza macchie d'inchiostro?
>
> [London, beautiful, monstrous, elegant, well-fed, well-dressed, but with brains as heavy as steaks. Inside the houses are magnificent: cleanliness, honesty, calm, order, but fundamentally these people are idiots or semi-idiots. [. . .] What does it matter if some day under the ruins of London raincoats will be excavated intact, and account books without ink spots?][2]

'London in the years immediately prior to the Great War was the perfect destination for Futurism', according to C. R. W. Nevinson's biographer.[3] In his preface to 'The Futurist Manifesto against English Art' (published in English and Italian in *Lacerba*), Marinetti declared: 'I am an Italian Futurist poet and I love England

passionately'.[4] 'Vital English Art', an abridged version of the manifesto, appeared in *The Observer* of 7 June 1914, one of Marinetti's many attempts to exploit Fleet Street on Futurism's behalf.[5] That Marinetti loved an England beyond the South-East's borders seems highly unlikely. According to D'Harnoncourt and Celant, 'the Futurists were fascinated by London, a modern metropolis which took them to its heart with a warmth that Paris never displayed'.[6] The chapter relating to London in Gino Severini's autobiography speaks of 'the erroneous Futurist feeling of antagonism, of competing with Paris and Cubism', suggesting 'it would have been more advantageous for them to function harmoniously'.[7] As we shall see, a comparable feeling of 'competing with London and Vorticism' showed the Italian Futurist painters' determination to define their relationship to London, above all when interviewed by, or submitting articles to, London newspapers.

The Journey from Paris to London

Marinetti was ill-prepared for the reaction to his 'Discours futuriste aux Anglais' [Lecture to the English on Futurism] delivered at the Lyceum Club, Piccadilly, in December 1910. He found himself addressing an audience consisting largely of suffragettes concerned with weightier matters. Continually provoking and patronising his audience, he failed to find the right tone. His introduction did not help, beginning with:

> I'll tell you straightaway what we think of you. I shall express myself with total frankness, refraining absolutely from flattery toward you, that all-too-common practice of international speakers who crush foreign audiences with their encomiums to then stuff them full of all sorts of banalities.[8]

Marinetti evidently needed to reconsider his approach to London audiences and newspaper readers, if Futurism was to avoid ridicule. As if to deflect attention from his experience at the hands of the London audience,[9] Marinetti pronounced the exhibition of Futurist Painters at the Bernheim-Jeune Gallery in Paris a great success.[10] However, the verdict was not shared by Severini, who saw in the exhibition's reception 'a severe and well-deserved lesson, despite its repercussions in Paris'.[11] While Marinetti and Carrà found comments made by Apollinaire 'flattering', Severini was aware how damaging such attacks might be to the Sackville Gallery 'Exhibition of Works by the Italian Futurist Painters' scheduled for March 1912. However, Severini's misgivings were confined to his autobiography:

> My friends insisted on treating [Apollinaire's] kicks in the seat of their pants [. . .] as praise. Well-acquainted with the art circles in Paris, I knew that they were anything but complimentary. Blinded by the momentary celebrity, [the Futurists] actually believed themselves in possession of all aesthetic verities. The only positive aspects of the exhibition were its air of youth and a decisive orientation towards innovation, which, at least, were real.[12]

Untroubled by what Severini called Apollinaire's 'severe and well-deserved lesson', the Futurists geared their presentational strategy to the familiar set of artistic exhibitions, declamations, soirées, and events supported by manifesto statements

judged appropriate to English audiences.[13] For Italian home-consumption Marinetti produced the flyer *Futurism Triumphs in London*, although claiming personal responsibility for Futurism's 'colossal success' in the city. In a letter to Francesco Pratella of 12 April 1912, Marinetti declared that more than 350 articles had been written about the [Sackville Gallery] exhibition 'in un mese e quattro giorni' [in a month and four days].[14] Unfortunately, Marinetti failed to register Italian Futurism's mixed reception at the hands of the English press. On occasions when he did, he behaved as if immune to the cocktail of hostility and derision to be found in newspapers peddling what one Futurist dismissed as 'gossip by journalists or amateur critics'.[15]

To raise the spirits of Marinetti and the Futurist painters about to embark for London, Severini wrote on 19 April 1913:

> Qui a Londra va meravigliosamente bene [. . .]; ogni giorni escono articoli seri e riproduzioni di quadri. Ti mando pel momento lo Sckeck [*The Sketch*] e il *Graphic*, ma ce ne sono moltissimi, tutti importanti [. . .]. Occorre anche procurare per gli archivi del Futurismo tutti i giornali e Riviste che riguardano il movimento.

> [Here in London things are going marvellously well [. . .]; every day there are serious articles and reproductions of [Futurist] paintings [in the papers]. I am sending you *The Sketch* and *The Graphic*, but there are many more, all important [. . .]. It is also necessary to procure all the newspapers and journals that concern the movement for the archives of Futurism.][16]

Tactfully emphasising the archival value of newspaper articles and expressions of public opinion, Severini noted in a letter to Marinetti of 7 April 1913 that 'the press is starting out well, as you can see from the newspapers I am sending, I will keep you informed', adding in a postscript: 'Two important journalists [sic!] *Daily Chronicle* and *Academy* have demonstrated great sympathy for Futurism, which they have been following since its beginnings'.[17]

The London Press and Marinetti

The London *Evening News* of 17 January 1914 contained the challenging headline '"Some of the Manifestoes of Futurism": Amazing, Absurd, Amusing — As You Like It'. Given the content and satirical tone of the publications cited in Cork, Walsh, and Wees,[18] Nevinson was unlikely to have drawn Marinetti's attention to a hostile claim doing the rounds at the time, according to which 'The Futurist is the super-joke of the century' (*Town Topics*, 20 June 1914).[19] Marinetti would also not have known that *The Observer* had published a spoof letter from someone signing himself 'Marionetto Bomblewis', of The Only Art Centre, announcing the formation of a new movement called 'Infinitism' (5 July 1914) or that on 18 June 1914 the *New Age* had published a satirical essay on 'Futile-ism' using the *nom-de-plume* Charles Brookfarmer (pseudonym for Carl Bechhöfer). The *Western Mail* joined in the fun, publishing a photographic reproduction of Nevinson's painting *Tum-Tiddly-Um-Tum-Pom-Pom* of 1914,[20] sarcastically hailing it 'A Futurist masterpiece'. When the

Daily Mail of 21 November 1913 published 'The Meaning of the Music-Hall' (an abridged version of Marinetti's manifesto 'The Variety Theatre'), it was subtitled 'By the Only Intelligible Futurist F. T. Marinetti'. *The New Statesman* asked its readers on 2 May 1914 'Would you allow a Futurist to marry your daughter?', but we do not hear how many responses were received. In comparable lampooning mood, the *Manchester Guardian* printed a photograph of Nevinson's painting *The Strand*,[21] commenting 'The London streets are indeed perilous', while then adding the further caption 'A Futurist's Conception of a London Street'.[22] As Cork, Walsh, and Wees indicate, the London press was awash with satirical claims, spoof articles and hostile interpretations during the Futurists' visit. Cork observes, 'Marinetti was providing perfect copy for the London press, and he knew it'.[23] 'In England', according to Wees, 'the major exhibitions of Futurist work [. . .] probably made no greater impact on the avant-garde or the public in general than did the visits of Marinetti between 1910 and 1914'.[24] This was in no small part attributable to the combination of Marinetti's appeal to Fleet Street and the connections of the journalist H. W. Nevinson (C. R. W. Nevinson's father) with the publishing world.

Given that The Strand, one of London's principal thoroughfares running eastwards from Trafalgar Square, played an important role in Marinetti's conception of London, it is worth bearing in mind that upon arrival at the City of London it becomes Fleet Street, at the time the home of the London press. Marinetti, 'a master of manipulating the press',[25] must have been aware of such happy proximity, although his uncharacteristically positive picture of The Strand may have been coloured by associating it with Jacob Epstein's Strand Statues. However, the extent to which Marinetti manipulated the London press while Fleet Street exploited Italian Futurism for its own satirical purposes remains unclear. Be that as it may, the tables would soon be turned, although not until a barrage of jibes at the Futurists' obsession with speed had gone into print.

In the *Daily Express* of 11 April 1913, Severini declared London to be 'a city where movement and order reign', adding that, in conjunction with England's 'essentially masculine spirit', these qualities would help the English appreciate Futurism. Others were less charitable. In *The Observer* of 8 March 1914, P. G. Konody declared Nevinson to be 'obsessed with the idea of speed':

> [he] devotes himself to conveying by pictorial means the sensation of speed in railway trains and other means of locomotion, and gives the idea of movement by displacing objects, making them penetrate each other, in fact, making several successive moments simultaneous. The result would be intolerable confusion if it were not for the artist's fine sense of rhythm, which saves his utterance from absolute incoherence.[26]

Wyndham Lewis expressed his impatience with 'the café-philosopher, Marinetti, with his epileptic outpourings in praise of *speed* and *force*'[27] and such acoustic works as Russolo's *Incontro d'automobili e aeroplani* [*A Meeting of Motor-Cars and Aeroplanes*, 1914]. He criticised the Futurists' 'careful choice of motor omnibuses, cars [. . .], aeroplanes, etc.', finding the Automobilist pictures 'too "picturesque", melodramatic and spectacular'. 'AUTOMOBILISM (Marinetteism) bores us', he wrote. 'We don't

want to go about making a hullo-bulloo about motor cars, anymore than about knives and forks, elephants or gas-pipes'. 'Cannot Marinetti, sensible and energetic man that he is, be induced to throw over this sentimental rubbish about Automobiles and Aeroplanes, and follow his friend Balla into a purer region of art?'[28]

Marinetti's *Volte-Face*

In the wake of Vorticism's and Fleet Street's orchestrated attacks on the Futurist cult of speed, a radical turning point can be detected in Marinetti's relationship to London, one that would eventually lead to a paradigm-shift in his conception of the pre-war metropolis. In some respects, of course, it was by and large Severini who drew Marinetti's attention to what the Italian movement's leader owed to London. He did so, not by pointing to the implications of Apollinaire's hostile attacks on the Futurists' artistic programme and aggressive manifesto policies, but by sending on-the-spot reports from London itself in an attempt to emphasise the powerful role of the media and public opinion in showing the Futurists that a different tone of address was a more effective way of recruiting fresh allies in the underlying struggle between Futurism and Vorticism.

For a while, Marinetti remained content to provoke London audiences and manifesto readers with the provocative claim that 'every good Futurist should be discourteous twenty times a day'.[29] Yet rather than basking in what he called 'the pleasures of being booed',[30] Marinetti appears to have undergone a pronounced change in attitude to London as well as to British audiences. To appreciate the significance of this *volte-face*, one only needs to compare the dismissive tone of Marinetti's 'Lecture to the English on Futurism', 'The Futurist Manifesto Against English Art', or even 'The Exhibitors to the Public', with the new approach he began to adopt towards London and the city's avid newspaper readers and cultural pundits. This often underestimated change of attitude on the part of Italian Futurism's leader is captured in one particular newspaper article, an article that deliberately addressed Londoners, either in their capacity as visitors at Futurist exhibitions and lectures or as newspaper consumers. Rather than repeatedly telling his readers *what Italian Futurism represented*, Marinetti now concentrates on contemporary *London's enviable virtues*. In the wake of this *volte-face*, one sees a new Marinetti emerging from a city that arguably had a greater impact on his thinking than Paris, Berlin, St. Petersburg, or Moscow had on the Futurist perception.

The article in question, published on 4 March 1912 as the result of an interview for the London *Evening News*, shows Marinetti changing his previously provocative posture by making positive claims to the paper's correspondent as well as its London readership. Evidently conscious that he was no longer addressing a hostile-cum-sceptical British press, Marinetti departs from his usual obsession with Futurism's superiority over *passéism* in order to offer a glowing description of modern London as experienced from the perspective of the visiting Futurist painters and their Milanese spokesman. According to the new Marinetti, London is already 'a Futurist city!'.[31] In support of this claim, he draws his readers' attention to the city's 'brilliant

hued motor buses', its 'enormous glaring posters', the 'coloured electric lights that flash advertisements in the night' and the Underground, from which, Marinetti specifically declared, 'I got what I wanted [. . .], not enjoyment, but a totally new idea, of motion, of speed'. These models evidently served as inspiration for the Futurist artists' further urban images. It is clear from the above change of approach that Marinetti's claims in the *Evening News* about London already being a Futurist city are not 'flattery' in the spirit of his early 'Lecture to the English on Futurism'. Instead, they represent a new, well-intentioned mode of delivery, which is far more genuine than the Italian Futurists' earlier deliberatively provocative boasts. The evidence in this case is largely stylistic.

As if he and his fellow Futurists had happened upon a new discovery, Marinetti exclaims 'Why, London itself is a Futurist city!', suggesting a sense of discovery designed to give the impression that he and the accompanying Futurist painters had undergone some form of epiphany as a consequence of their London experiences. By passing on their reactions to the *Evening News*'s readership, they are in fact now offering London a similar insight into what makes it a Futurist city in the making. But the story does not stop here.

In connection with the Doré Galleries' new 'Exhibition of Works of the Italian Futurist Painters and Sculptors' in early summer 1914, Marinetti gave an interview to the London *Daily Mirror* on 6 May. On this occasion, he attempted to modify his earlier opinion of London's importance as a vibrant Futurist city with a great deal to teach its citizens:

> While I like London very much because it is the most Futurist city in Europe, it is not yet completely Futurist [. . .]. The streets are still not sufficiently lighted, and the traffic is too slow. You should have more electric light, more noise, and the traffic must be much quicker. Light, noise, speed — you can never have too much of these.[32]

As we shall see, the features of London praised in the earlier *Evening News* article in many cases appear either derived from — or in tune with — iconic Futurist city-paintings of the time. However, there is no reference now to double-decker buses, the Underground or the role of advertisements on London's main streets. What was allegedly the most Futurist city in Europe is now grudgingly charged with not being completely Futurist. In this context, it is debatable to what extent Londoners themselves would have been happy with more noise or urban demonstrations of the Italian Futurist mantra that noise and speed were by definition 'good things'. One wonders how Londoners would have reacted to Nevinson's painting *The Non–Stop*, described in the *Westminster Gazette* as creating the impression of straphangers on the Underground. But trains, railway stations, abundant street traffic, crowds, accompanying pavement-noise, and the hurly-burly of Underground transport were among the principal attractions of London life for the Italian Futurists.

The New Ethical Religion of Speed

On 1 June 1916, no doubt in response to the London press's constant jibes about Italian Futurism's 'obsession with speed', *L'Italia futurista* published a new Futurist manifesto entitled 'La nuova religione-morale della velocità' [The New Ethical Religion of Speed].[33] The manifesto appears to have received little attention either among London readers or within the literary avant-garde in general.[34] The work offers a new dimension to Marinetti's relationship to London, a city, like Interventionist Italy and Britain itself, preoccupied with the Great War. Having reminded his readers that he had declared the splendour of the world to have been enriched by a new beauty, 'the beauty of speed',[35] Marinetti enumerates a series of metaphors, ex cathedra announcements, and dubious connections between speed and the divine. 'In this Futurist year of our great liberating war', he declares, 'the new ethical religion of speed is born'; 'but today it no longer has any purpose, since the Divine is utterly finished',[36] a claim arguably chosen by Marinetti to justify the manifesto's use of the replacement adjective 'ethical' in lieu of the adjective 'divine', which is only sparingly used. The argument in favour of speed's advantages proceeds via a mixture of metaphors, allegorical statements, and in many cases non-sequiturs.

The unquestioning re-designation of speed (repeatedly praised in various Italian Futurist manifestos from the Founding Manifesto onwards) as part of a New Ethical Religion invites many questions, though no eyebrows appear to have been raised at the time, that is, more than four years after Marinetti's keystone article in the *Evening News*, where he had declared 'London itself is a Futurist city!'. The implication is that more had been learnt about speed from London than from any other place that the Futurists had visited.

The most intriguing section of the new manifesto is headed 'Places inhabited by the divine'. Listed are:

> trains with restaurant cars for dining at high speed; railway stations, especially those in the American West, where trains speed along at 140 kilometers per hour, taking in the water they need (without stopping) together with the mailbags. Bridges and tunnels. The Place d'Opéra in Paris. The Strand in London. Racing-car circuits. Cinemas. Radio-telegraphic stations. The huge pipes conducting mountain water to snatch electrical power from the atmosphere. [. . .] The hypermodern, industrial cities like Milan [. . .].[37]

While some of the places itemised are familiar from earlier manifestos, readers may wonder what the Place d'Opéra and The Strand have to do with the much-proclaimed 'New Ethical Religion of Speed', apart from the fact that Paris and London loom large as important centres of hypermodernity and sources of key topics of Futurist urban painting. Admittedly, while the London Underground had stations at both ends of The Strand, the street has little that can compete with high-speed railway stations, the pace of travel at surface level, or the glamour often associated with London's 'brilliant hued motor buses'. Underground railway systems were part of Futurist mythology: for example, *Nord-Sud Métro (velocità + rumore)*

[*North-South Underground (Speed + Noise)*], the title of an urban transport painting by Severini,[38] was the name of a famous underground train in Paris. C. W. R. Nevinson, whom Severini singled out as the Futurist to whom he felt close, was known both for his picture *The Strand* and for an urban travel painting entitled *The Circular Railway*, no doubt an allusion to the Circle Line. In addition, his *Non–Stop* seemed designed, as the *Westminster Gazette* claimed, to evoke the experience of a London tube journey. Marinetti's London has much in common with Severini's depictions of the metropolis in *Souvenirs de voyage* [*Memories of a Journey*, 1910] and *Le train dans la ville* [*The Train in the City*, 1915], Carrà's *Quel che mi ha detto il tram* [*What I Was Told by the Tramcar*, 1911], and Nevinson's *The Departure of the Train de Luxe* (c. 1913). These Futurist works reflect various images of metropolitan life. Marinetti's declared indebtedness to The Strand for 'a totally new idea, of motion, of speed' has hitherto unexplained implications for an adequate understanding of the movement's relatively complex taxonomy of its various functions and connotations. While Boccioni's *Pittura e scultura futuriste (dinamismo plastico)* [*Futurist Painting and Sculpture (Plastic Dynamism)*, 1914] theorised the concept at great length, Severini had little sympathy for the movement's typology of dynamism.[39]

In some respects Marinetti appears to have learnt as much about parts of London from Nevinson's and Severini's paintings as from exchanges with Wyndham Lewis and Boccioni. He repaid what he had learnt to the host metropolis by drawing attention to the fact that he, the first Futurist, was able to direct his *Evening News* London readers' to the possibility that their world was a Futurist city, a harbinger of a world to come. He had praised such institutions as a well-integrated transport system, the music hall, the country's industrial advances, heroism, shared love of speed, and what Margaret Nevinson reported, with regard to his lecture 'Discours futuriste aux Anglais', Marinetti called other elements of Englishness: Ernest Shackleton, Charles Rolls, the Dreadnought, and the courage and fighting spirit of the English soldier in the Boer War.[40] It may have taken him some time to learn that the English did not take Futurism as seriously as he had wanted, and that he needed to follow Severini's advice and reconsider just how to address an English audience.

Postscript

By the time Nevinson told the *Daily Graphic* on 11 March 1915, 'I am firmly convinced that all artists should enlist and go to the Front, no matter how little they owe to England for her contempt of modern art, but to strengthen their art by a fearless desire for adventure, risk and daring', what I have called 'Marinetti's London' no longer felt like Marinetti's London. Nevinson had joined the Red Cross Ambulance Corps and had told the Press on 22 January 1919: 'I have now given up Futurism' (*The Newcastle-on-Tyne Illustrated Chronicle*). Later, as his biographer shows,[41] he was to leave his mark as an officially commissioned war painter, remembered for his *Bursting Shell*, *Night Arrival of the Wounded*, *Road from Arras*, and *Harvest of Battle*. Among the Italian Futurists, Boccioni and Sant'Elia had been killed during the war. But it was *Lacerba* — not Fleet Street — that recorded their loss. 'This war

will be a violent incentive to Futurism, for we believe there is no beauty except in strife, no masterpiece without aggressiveness', Nevinson told the *Daily Express* of 25 February 1915 — sentiments not uncommon among patriotic Londoners at this time, even though the enemy might be a different one and the goals based on different sentiments.

Appendix: newspapers containing comments on the Futurists' London visit

The Academy, The Daily Chronicle, The Daily Express, The Daily Graphic, The Daily Herald, The Daily Mail, The Daily Mirror, The Daily News and Leader, The Daily Telegraph, The Egoist, The English Review, The Evening News, The Evening Standard and St. James Gazette, The Illustrated London News, The Manchester Courier, The Manchester Guardian, The Morning Post, The Nation, The New Age, The New Freewoman, The New Statesman, The New Weekly, The New Witness, The Newcastle-on-Tyne Illustrated Chronicle, The Nottingham Guardian, The Observer, The Pall Mall Gazette, The Saturday Review, The Sketch, The Star, The Sunday Times, The Times, Town Topics, The Tramp, The Western Mail, The Westminster Gazette, The Yorkshire Observer.

Notes to Chapter 4

1. *Archivi del Futurismo*, ed. by Maria Drudi Gambillo and Teresa Fiori, 2 vols (Rome: De Luca Editore, 1958–62), II (1962), pp. 42–43.
2. Ibid., p. 43.
3. Michael J. K. Walsh, *C. R. W. Nevinson: This Cult of Violence* (New Haven, CT and London: Yale University Press, 2002), p. 43.
4. Filippo Tommaso Marinetti, *Critical Writings*, ed. by Günter Berghaus, trans. by Doug Thompson (New York: Farrar, Strauss and Giroux, 2006), p. 94.
5. The manifesto 'Vital English Art' was delivered in the same month at Cambridge University.
6. Anne D'Harnoncourt and Germano Celant, *Futurism and the International Avant-Garde*, Exhibition Catalogue (Philadelphia: Philadelphia Museum of Art, 1980), p. 2.
7. Gino Severini, *The Life of a Painter: The Autobiography of Gino Severini*, trans. by Jennifer Francina (Princeton, NJ: Princeton University Press, 1995), p. 143.
8. Marinetti, *Critical Writings*, p. 89.
9. The review of a similar Futurist event published by P. G. Konody in the *Pall Mall Gazette* bore the caption 'Nightmare Exhibition at the Sackville Gallery', and the *Daily Express* summed up the occasion with a series of cartoons entitled 'The New Terror'.
10. Severini, p. 88.
11. Ibid., p. 91. The allusion is to two unambiguously critical pieces published by Guillaume Apollinaire in *L'Intransigeant* (7 February 1912) and *Le Petit Bleu* (9 February 1912).
12. Severini, p. 92.
13. The manifestoes in question are: 'The Manifesto of the Futurist Painters' (1910), 'Futurist Painting: Technical Manifesto' (1910), 'The Exhibitors to the Public' (1912), 'Lecture to the English on Futurism' (1910), and 'The Futurist Manifesto Against English Art' (1914).
14. *Archivi del futurismo*, I (1958), p. 237.
15. Severini, p. 91.
16. Anne Coffin Hanson, *Severini futurista: 1912–1917* (New Haven, CT: Yale University Art Gallery, 1995), pp. 149-50.
17. Ibid., p. 148.
18. Richard Cork, *Vorticism and Abstract Art in the First Machine Age*, I: *Origins and Development* (London: Gordon Fraser, 1975); Walsh; William C. Wees, *Vorticism and the English Avant-Garde* (Manchester: Manchester University Press, 1972).

19. The London Tate Gallery's Archive 75 contains fourteen volumes of Nevinson's press cuttings concerning the Futurists' reception at the hands of the English press, covering the period 1910–47.
20. The painting is reproduced in monochrome as Fig. 20 in Walsh, p. 70.
21. The *Manchester Guardian*'s reproduction of Nevinson's painting appears as Fig. 18 in Walsh, p. 68.
22. Ibid., p. 83.
23. Cork, p. 26.
24. Wees, p. 92.
25. Walsh, p. 79.
26. P. G. Konody, "Art and Artists. The London Group', *The Observer*, 8 March 1914, p. 8.
27. Wyndham Lewis, *The Letters of Wyndham Lewis*, ed. by W. K. Rose (London: Methuen, 1963), p. 310.
28. Manifesto comments from *Blast No. 1* (1914), p. 144. Cited from Cork, pp. 251–52.
29. Marinetti, *Critical Writings*, p. 89.
30. Ibid., p. 183.
31. The London *Evening News* interview is not reproduced in any of the main anthologies of Marinetti's writings. However, it is quoted in full in Wees, p. 96.
32. Wees, p. 102.
33. Marinetti, *Critical Writings*, pp. 253–59.
34. The gloss in ibid., p. 473 is admirably diplomatic in its endnotes to 'The New Ethical Religion of Speed'. An emollient postscript notes that the manifesto was reissued in the 'beautifully designed' volume *Lussuria-velocità* of 1921.
35. Ibid., p. 13.
36. Ibid., p. 253.
37. Ibid., p. 255.
38. The painting is reproduced in Cork, p. 109.
39. On this disagreement, see Severini, p. 165.
40. Walsh, p. 46.
41. Ibid., pp. 105–18.

CHAPTER 5

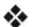

The Skyscraper

Francesca Billiani, University of Manchester

> Let's not deceive ourselves, in our European arrogance, that the wretched buildings of *our* era could alter the overall picture. (Gropius/Taut/Behne)

'An epoch creates its own architecture, and this is the clear image of a system of thought', wrote Le Corbusier famously in his 1923 pioneering work *Towards a New Architecture*.[1] Largely in agreement with Le Corbusier's observation, some ten years earlier the Italian Futurists had directed their creative and theoretical efforts towards building a new architecture. From 1914 Marinetti and his followers began to publish manifestos on architecture, most notably for us Antonio Sant'Elia's 'Architettura futurista. Manifesto', published in the magazine *Lacerba* in 1914 on the initiative of Marinetti (and with a number of passages that were probably added by Marinetti and Decio Cinti),[2] which prominently featured the so-called *grattanuvole* [cloudscrapers] or skyscrapers. All this happened in the context of the emerging discipline of urban planning.[3] Yet by 1923, the year in which Le Corbusier published the book just cited, the cultural and political landscape of Europe had changed dramatically, especially in Italy with the fast rise of Fascism. After the First World War, architectural developments across Europe meant metaphorically as well as practically ('rationalist') 'reconstruction' rather than the 'disintegration' of forms that had characterised Futurist pre-war experiments in architecture. Indeed, if the Futurists had voiced their most radical proclamations mainly during a period in which the disintegration of forms reigned supreme, by the twenties and thirties their experimental freedom had come to an end. Symbolically, the year 1916 closed the first phase in the history of Futurist architecture: its leading figure, Antonio Sant'Elia, died in Monfalcone (Gorizia) fighting on the Italian front, while Umberto Boccioni encountered a similar fate during a training exercise in Verona.

The Futurists' contributions to architecture remained largely at the level of discourse, since they were hardly ever put into practice. This has led to a partial neglect of their importance in the history of Italian architecture. Furthermore, their designs' political orientations implied a further marginalisation in post-Second World War Italian academic research. Eminent architect Bruno Zevi, for example, dismissed Futurist architecture by claiming that Sant'Elia's 'scatti geniali e profetici [. . .] non riescono però a traslare in chiave edilizia il "dinamismo plastico" di Boccioni' [brilliant and prophetical leaps [. . .] cannot however translate into construction Boccioni's 'plastic dynamism'].[4] Similarly, Manfredi Tafuri and Francesco

Dal Co were not very generous with the Futurists. If Cesare De Seta was one of the few to give his support early on to the idea of a distinct Futurist architecture, more recently Iain Boyd Whyte championed its significance in the general development of the Italian avant-garde movement, both aesthetically and politically.[5] To date, however, only two monographs, by Esther da Costa Meyer and Enzo Godoli, have been devoted to the importance of Futurist architecture by placing it in the wider contexts of both the Italian and European debates. Da Costa Meyer points out how the novelty of Sant'Elia's Futurist drawings of the *Città nuova* with its embryonic skyscrapers rests particularly with their use 'of post-and-lintel tectonics, the thinness of the facades reduced to a membrane, the high degree of abstraction, and a total rejection of history in urbanism as well as in architecture'.[6]

To complete and supplement existing research, this chapter charts the history of Futurist architecture across two decades, from the early, pioneering 1914 manifestos and drawings to the fascisticised (or tamed) 'second Futurism' in the thirties. It does so by zooming in on the microhistory of one of the landmarks of the Futurists' forays into this field of action: the *grattanuvole*.[7] To recount this history, we start with the Futurist architecture manifestos written by Marinetti and Sant'Elia and finish with Fortunato Depero's famous painting *Grattacieli e tunnel* [*Skyscrapers and Tunnels*, 1930] and the 1933 'Manifesto dell'architettura futurista' by Cesare Augusto Poggi.[8] Both these narratives will be set against the 'grand narrative' of Futurist ideas on modernity, defined as the explosion of speed and chance, for the Italian avant-garde movement often and unreservedly subscribed to these ideas for much of its existence.[9] In a nutshell, modernity was a multifaceted concern for both the first and the second wave of Futurism, since it simultaneously represented a breakaway from tradition and an innovative investigation of geometrical form itself. In political terms too, the *grattacieli* or skyscrapers were the embodiment of a brand of modernity, which, in the thirties, embraced innovation as well as conservatism and played a significant role in the Fascist construction of the *arte di stato*.[10] Moreover, because of their relationship with urban planning and new technologies as well as their foreign origin, the *grattacieli* were one of the most inventive experiments in modernity and the 'new architecture'. As Claudia Salaris notes:

> Il grattacielo, o 'grattanuvole' (come all'epoca viene chiamato), una vera sfida alle leggi di gravità, è il simbolo stesso della scalata al cielo tentata dall'uomo nell'era moderna. Gli illustratori che disegnano o sognano i grattacieli newyorkesi alimentano l'immaginario degli europei con la visione della metropoli moderna, dotata di sopraelevate che s'innalzano a diversi metri dal suolo e di metropolitane sprofondate nel ventre della città.
>
> [The skyscraper, or 'cloudscraper' (as it was called at the time), posed a real challenge to the laws of gravity; it was the symbol of modern Man's attempt to reach the sky. The illustrators who designed, or dreamt of, designing the New York skyscrapers fuelled the Europeans' imaginary with their vision of the modern metropolis, filled with flyovers which stood metres high from the ground and with subways falling deep into the womb of the city.][11]

In writing the microhistory of the Futurist skyscraper and in view of its significance for Futurist architectural aesthetics and politics, we need to focus on the idea of

form rather than on style, seen both as an aesthetic-theoretical endeavour and as an architectural realisation *in fieri*.[12] We understand form, as Marinetti himself framed it when discussing the essence of modern architecture, as an 'expression and synthesis' in which the former stands for visual or verbal patterns and the latter for conceptual reach.[13] In other words, for the Futurists, skyscrapers were yet another structural embodiment of their rejection of traditional aesthetics as well as a political avowal of the individual's position within the public space. We argue that, if skyscrapers were seen as an expression of the avant-garde ambition of giving art a transformative power over society in order to enhance what Boccioni had termed 'pan-dynamism' and spiral architecture, they also embodied Futurist aspirations of building a vertical, far-reaching social space for the individual of the liberal economies with their rationalising, conquering ethos. It is our main contention that Futurist architectural projects and projections, like many others elsewhere in Europe, were expressions of a perceived need to reframe the space for the individual; the *grattacielo*, as a form, responded to an unfulfilled aspiration for speed, change, and individual freedom.[14] A similar yet collectivised aspiration resurfaced later under the Italian, German, and Soviet totalitarian regimes in their conquest of civil society. Our microhistory thus demonstrates how Futurist architecture, and the Futurist skyscraper in particular, evolved from symbolising a moment of experimentalism and individualism typical of a liberal state apparatus, to a more static moment, which voiced the collective social aspirations of the Italian regime, the latter being a reflection of totalitarianisms in the thirties, which needed to accommodate and transform the demands of the individual on a collective scale, with public spectacle, displays, and gatherings.

The 1914 Manifesto(s) in Context

As Bernard Tschumi observes, architecture around the turn of the century

> was, first and foremost, the adaptation of space to the existing socioeconomic structure. It would serve the powers in place, and, even in the case of more socially oriented policies, its programmes would reflect the prevalent views of [the] existing political framework.[15]

Tschumi here establishes a connection between architecture and power, and crucially between architectural orientations and aspirations, and the political powers in place at any given time. Architecture, he concludes, was a political statement and the nexus between space and socio-economic factors was not an easy one to ignore; or better still the nexus 'between an urban framework and social movements' was unavoidable.[16] This connection was undoubtedly at work, and very powerfully so, in Futurist architecture. Yet what differentiated the avant-gardes from our (and Tschumi's) contemporary ideas about architecture is that 'the disjunction between space and event, together with their inevitable cohabitation, is characteristic of our contemporary condition'.[17] Our contemporary condition is indeed different from that of Futurism in that the movement did not envisage a disjunction between event and space, and promoted instead their mutual interaction in the formation

of the individual Self. The theoretical writings on and drawings of skyscrapers clearly illustrate this point, and elucidate this significant turn towards an abstract conceptualisation of the relationship between the individual and space in terms of aspirations and competition, and not of disjunction. Such connectedness is crucial to a proper understanding and appreciation of what architecture meant for the Futurists, since it largely existed in the realm of their imagination. The aspirational quality of skyscrapers is also indicated by their original name: *grattanuvole*. The *grattanuvole* did not aim to reach the sky but the clouds, which are ephemeral and transient *par excellence*. As such, the *grattanuvole* reflects the avant-garde ambition to reach new heights combined with the awareness of their precarious and unstable dimension. As Umberto Boccioni put it in his 'Manifesto' (published for the first time only in 1972):

> Oggi cominciamo ad avere intorno a noi un ambiente architettonico che si sviluppa in tutti i sensi: dai luminosi sotterranei dei grandi magazzini ai diversi piani di tunnel delle ferrovie metropolitane alla salita gigantesca dei grattanuvole americani. L'avvenire farà sempre più progredire le possibilità architettoniche in altezza e in profondità. La vita taglierà così la secolare linea orizzontale della superficie terrestre la perpendicolare infinita in altezza e profondità dell'ascensore e le spirali dell'aeroplano e del dirigibile. Il futuro ci prepara un cielo sconfinato di armature architettoniche.[18]
>
> [Today we finally start gathering around us an architectural environment, developing in all directions: from the luminous undergrounds of the departments' stores and the multi-levelled tunnels in the urban railway stations through to the colossal rise of the American cloudscrapers. The future will make current architectural potentials progress. Life will cut: the centennial horizontal line of the globe, the infinite, high, and deep perpendicular line of the lift as well as the spirals of the aeroplane and the zeppelin. The future is preparing for us a boundless sky of architectonical scaffoldings.]

The history of skyscrapers dates back to urban development in the United States at the end of the nineteenth century, when they flourished most notably in Chicago and New York in a context of rampant financial speculation.[19] From the eighteen-eighties onwards, skyscrapers opened up new possibilities for shaping and planning cities, and allowed in particular for the massive expansion of cities, which could accommodate and shape the private and public lives of individuals according to a radically different perspective that was no longer horizontal but vertical. The skyscraper represented a new economic configuration, thereby catering to the needs of the emerging industrial classes and rationalising space in terms of efficiency and profit.[20]

The first to theorise the skyscraper was Louis Sullivan, a Chicago-based architect, who in his *The Tall Office Artistically Considered* (1896) analysed the skyscraper from the point of view of its composition.[21] Skyscrapers were the expression of a new syntax of architecture, since they rejected the traditional architectural language based on an outdated understanding of linear continuity and proportions, linked to an idea of horizontal organisation of space. Such architectural reconfigurations, now understood as powerful ways of rethinking the individual in the real or lived

space condition, soon also took hold in Europe. Around the same time when Futurist drawings and manifestos were issued, the architecture of skyscrapers in New York moved from Gothic features (still clearly present, for instance, in Cass Gilbert's realisation of the Woolworth Building in 1913) to a design closer to the Viennese Secession (with William Van Alen's Chrysler Building in 1930 as the most famous example). The first European competition for a skyscraper took place in Germany in 1921 and involved a team of young architects — the oldest being forty years of age — Hans Poelzig, Hugo Häring, Ludwig Mies van der Rohe, and Hans Scharoun. In 1920–21, Ludwig Mies van der Rohe realised the *Glass Skyscraper* in Berlin and published the project in the last issue of *Frülicht*. The design was based on a continuous vertical line without interruption, which moved from the bottom to the flat roof in a continuum of reflected light. Hitler's rise to power silenced all these initiatives and in the thirties the spotlight was back on the United States, reaching its fulfilment in 1931 in the Empire State Building.

The first 'Manifesto dell'architettura futurista' was officially released on 11 July 1914 and was published on 1 August 1914 in *Lacerba*. This appeared five and a half years after Marinetti's first manifesto, 'Le futurisme', published in French in *Le Figaro* and in Italian in a number of (mostly local) newspapers. The manifesto on architecture appeared four years after the manifestos on painting (1910), and two years after Boccioni's manifesto on sculpture, 'La scultura futurista' [Futurist Sculpture, 1912], and Marinetti's manifesto on literature, 'Manifesto tecnico della letteratura futurista' [Technical Manifesto of Futurist Literature, 1912]. In the same year, on 29–30 January 1914, Enrico Prampolini had already published a proto-manifesto, 'Anche l'architettura futurista: E che è?' [Futurist Architecture as Well: So, What's That?], in the *Piccolo giornale d'Italia*. All things considered, then, it is safe to say that architecture was a late arrival in Futurist theorisation. For the key ideas on architecture were only sparked in 1914, when two young Futurist architects, Antonio Sant'Elia and Mario Chiattone,[22] took the opportunity presented by the exhibition of the 'Nuove Tendenze' group, held in Milan in May–June 1914, to show the drawings of more or less disguised skyscrapers, equipped with a multilevel road system, lifts, aeroplane slip-ways, as well as their plans for a 'New City'. Sant'Elia's six drawings, exhibited on this occasion and entitled *La città nuova*,[23] were accompanied by a text, a 'Messaggio', which was reworked by Marinetti and published between July and August of 1914 in *Lacerba*. This piece of writing, enriched with a polemical introduction and some insertions, would become known as the 'Manifesto dell'architettura futurista'.[24] (It is worth noting that in the same year Marinetti had produced other technical manifestos, thereby following a new trajectory in his enquiry on form, and the transformation and rationalisation of the formal dynamics of expression.) Various ideas developed here would be taken up elsewhere in post-war Europe by the likes of Le Corbusier and adherents of De Stijl and the Bauhaus.[25]

In 1914, in provincial Umbertine Italy, skyscrapers were not only modern but they also represented an unavoidable tension between the possible and the unachievable, which necessarily informed Futurist avant-garde practice. In his 1914–15 *L'atmosfera-*

struttura futurista. Basi per un'architettura [*The Futurist Atmosphere-Structure: Foundations of an Architecture*], Prampolini[26] strongly advocated light and aerial constructions as the basic elements and principles for Italy's architectural renewal, for 'L'architettura futurista deve avere una genesi atmosferica, perché rispecchia la vita intensa di *moto, luce, aria* di cui l'uomo futurista è nutrito' [Futurist architecture must have an atmospheric genesis, since it reflects the life full of movement, light, and air that feeds the Futurist man].[27] A further development of the concept of overall regeneration resurfaced in the manifesto for the 'Ricostruzione futurista dell'universo' [Futurist Reconstruction of the Universe], published in 1915 by Giacomo Balla and Fortunato Depero. By means of what they called the '"complesso plastico", polimaterico e moto-rumorista' ['Plastic Complex', with various materials and a combination of motion and noise], they pursued a totally artificial, yet playful and joyful, reconstruction of reality, which would dismantle any causal-deterministic relationship between subject and object, in so far as, to paraphrase Le Corbusier, reality would become a machine to inhabit.[28]

Despite its late arrival on the Futurist scene, architecture was not an occasional or in any way insignificant art form for the Futurists to tackle. Architecture was in fact crucial in the development of the Futurist vision of modernity and the Futurist inquiry into the concepts of event and space as well as into the consistency of the individual. And, although not formalised or much discussed before, as a technical discipline it also represented an area that was an inherent part of the movement's aesthetic and philosophy of active involvement: 'The problem of *Futurist* architecture is not a problem of linear rearrangements', as is claimed in the 1914 manifesto. 'This [Futurist] architecture cannot be subject to any law of historical continuity. It must be as new as our frame of mind is new'.[29]

Of course, architecture also figured within a more general move of the historical avant-gardes in the direction of investigating form, not exclusively from the perspective of speed, but also as a powerful transformative force, which acted on the idea of space. In Finland, Germany, and Catalonia, for example, albeit with different aesthetic outcomes, experimental architectural modernisms had been used as a political means of reaffirming each country's cultural and political identity. In a similar way, around the same time experiments in urban planning and in skyscraper construction in the United States were a direct response to the changes in urban design and life brought about by rapid industrialisation. The German Werkbund, in turn, with its connection of artisanal practice and big industry in the name of linear simplicity and efficiency, reflected a relationship similar to what could be seen at work in the Italian economic context with its artisanal structural base and incumbent industrialisation.

While Futurism thus drew inspiration from both European architectural propositions (Henard, Wagner, Sauvage, Sitte, Garnier, Perret) and the construction of skyscrapers and stations in the United States (Corbett, Reed, Wetmore, Warren, Stem), Umberto Boccioni above all laid the theoretical foundations of Futurist architecture. Boccioni elaborated the idea of the 'oggetto-ambiente' [object-setting], which was not only shaped by centripetal and centrifugal forces, but

which was always in a dynamic relationship with the objects (*ambiente*) surrounding it: a static and a dynamic entity, just like a skyscraper.[30] Like all Futurist projects, architecture too had to break away from any form of linearity, any sense of teleological development or historical progress and, more importantly, from the superimposition of futile decoration, which only had the purpose and function of obfuscating and violating the modern beauty of concrete and iron.

Here, again, the question is: what was peculiar and unique to Futurist architecture? Marinetti's answer was succinct, if not innovative: new materials. 'The calculation of the strength of material, the use of reinforced concrete, rule out "architecture" in the classical and conventional sense' for

> [m]aterial possibilities and attitudes of mind have come into being that have had a thousand repercussions, first and foremost of which is the creation of a new idea of beauty, still obscure and embryonic, but whose fascination is already being felt even by the masses.[31]

Mindsets and materials were the basic elements of the new architecture that sought to be a modern way of constructing spaces to accommodate the masses. The new architecture had to concern itself with the design of buildings that had a public function and were not for the exclusive use of certain groups of individuals: hotels, railway stations, huge roads, colossal ports, covered markets, brightly lit galleries, freeways, demolition, and rebuilding schemes with connecting aerial and terrestrial paths. In this new-world scenario, Marinetti narcissistically believed in parting ways with Austrian, Hungarian, German, and American architectural experimentations — while in actual fact their influences clearly resounded in the works of the Italians, filled as they were with stations, railways, factories, skyscrapers, and Bauhaus volumetric shapes and lines built with new materials.[32]

Indeed, across the whole of Europe, contemporary architectural structures and declarations put the individual (and, later, the collective) as envisaged by the Futurists in new spaces. In the June 1914 congress of the German Werkbund held in Cologne, for instance, Muthesius challenged the accepted idea of architecture and transformed it into a synthesis à la Marinetti of material and spirit, and championed it as an economic means of sustaining the nation. The congress also introduced to the wider world the new rising stars of Walter Gropius and Adolf Meyer. As in Futurist drawings, the city itself had to become the place where to realise this synergy between economic and aesthetic pressures, and thus encapsulate the totality of individuals and crowds. Planning and standardisation of taste were the guiding principles for Muthesius; creativity and individuality those supported by Henry Van de Velde, who was very critical of the damage capitalism had caused to the development of architecture, especially vis-à-vis the environment, with which people had lost all connection. Futurist architecture was greatly indebted to the German architectural movement in particular for its negotiations of the relationship between the artisanal/industrial sphere and that of man/environment within inter-war capitalist society and city space. In fact, in the June 1914 Futurist manifestos the central theoretical contention on architecture as a whole[33] and on the *grattacielo* in particular was intrinsically linked to their wider interest in the topography of

urban space. They superimposed this interest onto their desire to create a rational (though abstract) space/home for modern Man, in which it would be possible to achieve harmony between the environment and mankind in order to 'render the world of things a direct projection of the spirit'.[34] In all this, and in dialogue with their theories on architecture itself, the city with its cartography of individuals acting mechanically as crowds[35] surfaced both as the collective and cerebral symbol of this reformulation of the concept of subjectivity and objectivity and as the principal de-humanised protagonist. But, as we shall see, it was not and could never be a reflection or embodiment of the real Italian city, with its provincial, often somnolent mentality; it was the international and transatlantic metropolis, with its convulsive dynamism and the frenetic activity of its inhabitants that they had in mind.

The Disintegration of Form: Sant'Elia and Chiattone

If architecture was not the chief preoccupation of Futurism at the beginning of its glory days, after 1914 it became one of its main concerns and remained so well into the thirties. Antonio Sant'Elia's drawings forming *La città nuova* and Fortunato Depero *Grattacieli e tunnel* [*Skyscrapers and Tunnels*] from 1930 (to which we return further on) are crucial to our discussion.[36] In Sant'Elia's own words, the city had a new, rapid rhythm of fast communication and transitions for which new architecture had to account:

> We have lost our predilection for the monumental, the heavy, the static, and we have enriched our sensibility with a taste for the light, the practical, *the ephemeral and the swift*. We feel that we are no longer the men of the cathedrals, *the palaces*, the assembly halls, the podiums; but of big hotels, railway stations, immense streets, colossal ports, covered markets, brilliantly lit galleries, freeways, demolition and rebuilding schemes.
>
> We must invent and rebuild the *Futurist* city, it must be like an immense, tumultuous, lively, noble work site, dynamic in all its parts, and the *Futurist* house must be like a gigantic machine. The lifts must not hide like lonely worms in the stair wells; the stairs, become useless, must be done away with and the lifts must climb like serpents of iron and glass up the housefronts. The house of glass, concrete and iron, *without painting* and without sculpture, [. . .] must rise on the edge of a tumultuous abyss; the street, which will no longer stretch like a foot-mat level with the porters' lodges, but will descend into the earth on several levels, will receive the metropolitan traffic and will be linked, for the necessary passage from one to the other, by metal walkways and immensely fast escalators.[37]

Like all Futurists, Sant'Elia sought to design a new industrial city, which had to be made magnificently heroic by the power of the machines. In his drawings, we see how he conceived, for example, a solution to the modern problem of traffic with raised bridges and layered tunnels. As is clear from fig. 1, the skyscraper played a central role in the composition of the new city, with its large steps (*a gradini*) and vertical, straight system of elevation.[38] Here, the sky can be reached either via a gradual, medieval-like ascendance or through a launch or catapult sliding through

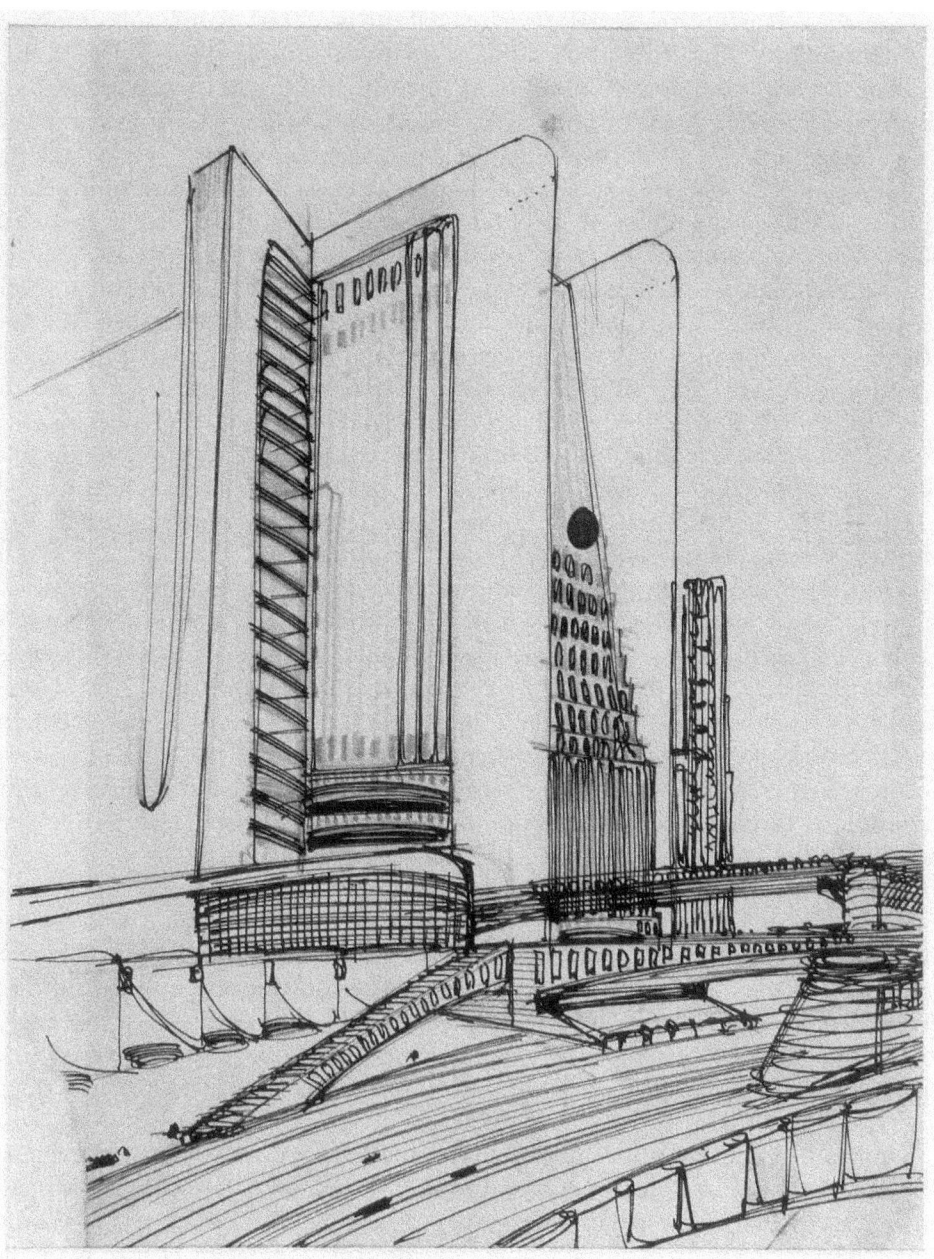

Fig. 1. Sant'Elia, *La città nuova* (The New City), 1914. Collection of Consuelo Accetti, *Casa a gradinata con ascensori dai quattro piani stradali* (Terraced House with Lifts from the Four Street Levels), Milan.

the smooth surfaces of the tower-*grattacielo*, all the way to the top.³⁹ This drawing also exemplifies Sant'Elia's plans on how to solve future, metropolitan traffic problems.⁴⁰ For it shows a distribution of surfaces (like bridges and balconies) on several levels and a system of bridges for pedestrian passages which, in an almost Benjaminesque fashion, ideally united two modernities: that of the twentieth-century passers-by gathered in crowds on one hand, and that of the nineteenth-century *flâneur* on the other. As da Costa Meyer observes, 'the streets of the Città Nuova are not narrow, as in New York, but are stretched out like broad valleys between the high-rise buildings on either side'.⁴¹ In Sant'Elia's arrangement, both the *grattacielo*'s ascending compositional rhythm and that of the pedestrians and cars in the lower part is that of pan-dynamism and simultaneity, which Boccioni described as 'l'esaltazione lirica, la plastica manifestazione di un nuovo assoluto: la velocità; di un nuovo e meraviglioso spettacolo: la vita moderna; di una nuova febbre: la scoperta scientifica' [the lyrical exaltation and plastic manifestation of a new absolute: speed; of a new and marvellous spectacle: modern life; of a new fever: scientific discovery].⁴² Crowds could thus move across three superimposed layers of overpasses: one of streets for pedestrians, one of roads for automobiles, and one of tracks for trams. If metropolitan life took place at the higher, less visible, levels of this ideal city, traffic flows absorbed all the remaining space of this composition, thereby emphasising the idea of modernity embodied in the form of the skyscraper and characterised by speed and the call for social transformation. As Umbro Apollonio remarked about this specific drawing: 'Le case di abitazione diventano così strutture che si agitano costantemente verso l'alto, legate da affusolate torri nelle quali gli ascensori trovano la strada per la salita e la discesa'⁴³ [Houses thus became structures constantly aiming at the sky, bound together by tapered towers in which lifts find both their ways up and down]. Other examples proposing a similar pattern of urban planning and modern social organisation could be found in many of Sant'Elia's drawings, for example in *Stazione d'aeroplani e treni ferroviari con funicolari e ascensori su tre piani stradali* [*Station of Airplanes and Trains with Funiculars and Lifts on Three Street Levels*, 1913–14, fig. 2]. The pan-dynamism of the Futurist skyscraper was also guaranteed by the principle of the new architecture laid out in the 1914 manifesto: strong materials to be used for the buildings (iron, concrete, and glass) as well as the synthesis of symmetrical forces constructed by bridges, steps, lifts, and passages, which could carry the crowds high up into the sky.⁴⁴

Stations had to accommodate several systems of motion as well as to function according to the same principle of pan-dynamism, which did not work horizontally but vertically. Funiculars and lifts were not only vehicles, but were, metaphorically, the architectural pillars modern architecture needed in order to elevate man and to foster social transformation through increased variety and availability of means of transport. Sant'Elia's pharaonic and monumental vision, with its stereometric and proto-rationalist forms, portrayed the city as a complex, which in this case was framed by planes and trains spread over three floors and superimposed traffic networks. In line with Futurist reflections on social modernisation, this urban complex functioned primarily because of the mechanics of intersection of its parts

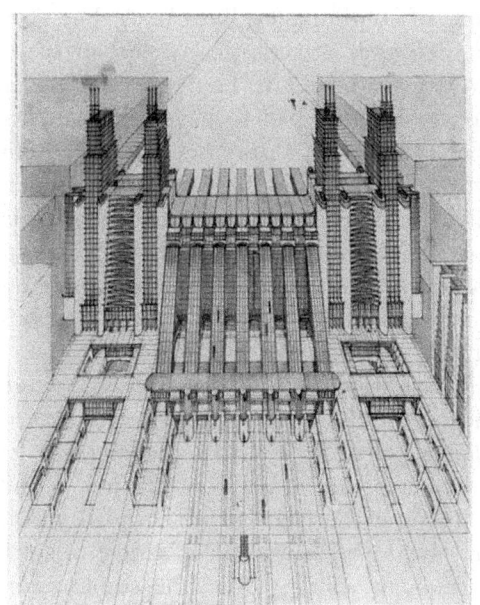

Fig. 2 (left). Sant'Elia, *Stazione d'aereoplani e treni ferroviari con funicolari e ascensori su tre piani stradali* (Station of Airplanes and Trains with Funiculars and Lifts on Three Street Levels), 1913–14, pencil on paper; Como, Musei Civici.

Fig. 3 (right). *La città nuova, casamento con ascensori esterni, galleria, passaggio coperto, su tre piani stradali (linea tramviaria, strada per automobili, passerella metallica), fari e telegrafia senza fili* (The New City, Block of Flats with External Lifts, Gallery, Converted Walkway, on Three Street Levels (Tram line, Road for Motor Vehicles, Metal Gangway), and Streetlighting and Wireless Telegraph), signed and inscribed *La città nuova*, detail, 1914, Como, Musei Civici.

and not because of any teleological principle of continuity or linearity.[45] The skyscraper was not only a revolutionary architectural organisation of urban space but also a house for the distribution of crowds, and for Sant'Elia, who had never visited the United States, the Futurist house-*grattacielo* had to have external lifts and bridges, galleried and covered passages over eleven floors (see fig. 3).[46] Like Sant'Elia's multifunctional station, it had to be constructed on three levels, which again could guarantee regular or modulated (through steps) vertical elevation. As clear even from the basement, the city was an all-connected utopian mechanism and the house-skyscraper was to be perceived as a composite apparatus vertically aligned, which re-proposed and re-enacted the principles of synergy and dynamism with a stronger sense of energising vigour.

As da Costa Mayer explained, the *grattacieli* were unusual for Italy and were often derogatorily associated with American culture's lack of historical tradition. But this is precisely the point of the *grattacielo* and the key to understanding its role. Sant'Elia never considered the skyscraper as an actual construction — he never fully planned it; rather the *grattacielo* was at the heart of his utopian vision for a new urban configuration.[47] The city was to be a rational ensemble of solid materials, carefully and symmetrically positioned, which blessed the composition with linearity and internal rhythm. The unmentioned reference could be traced back to Tony Garnier's utopias, such as his *Cité industrielle* (1901–14) and his *blast furnaces*, which divided the space into three levels and modulated an effect of energy towards the sky, embracing the revolutionary power of the new technology. But in Sant'Elia's designs there is no sign of anthropomorphic life anywhere, no parks and no fountains as in Garnier's. The skyscraper existed in a space where organic life could not be produced and where sources of life were missing.

Sant'Elia's visions were also stimulated by the examples produced by the Viennese Secession of Otto Wagner and his school, with its abstracting, antinaturalistic, ahistorical and half-mythical spirit manifested in Loos's Stein house (Vienna, 1910), Emil Hoppe's drawing for a Monumental Building (1902), and Walter Gropius and Adolf Meyer's Fagus Factory at Alfeld (1910–14). But there are also marked differences from their perhaps more famous predecessors that gave the Futurist designs a sense of originality. Such compositional and figurative originality was to become evident in, for example, the intermedial references to the Italian avant-garde in the works of the Soviet Union Constructivist movement, with the *Monument to the Third Communist International* in Moscow (1919–20) by Vladimir Tatlin, the *Restaurant that Juts out of a Cliff* (1922) by Nikolai Ladovsky, or the *Horizontal Skyscraper* by El Lissitzky (1923–25). Like Futurist drawings, however, these projects were all drafted between 1923 and 1927 to be left unmade. Moreover, unlike those of the Viennese Secession and Art Nouveau as well as the US skyscrapers, these buildings were not thought of as elements in themselves, but as grafted onto their urban tissue, to create interconnectedness of volumes and juxtapositions of materials. Not unlike the utopia of the proto-rationalists, such as Tony Garnier, Sant'Elia's merits and limitations are perfectly consistent with self-consciously avant-gardist town design rather than with architectural design. As Guido Cannella remarks, Sant'Elia's

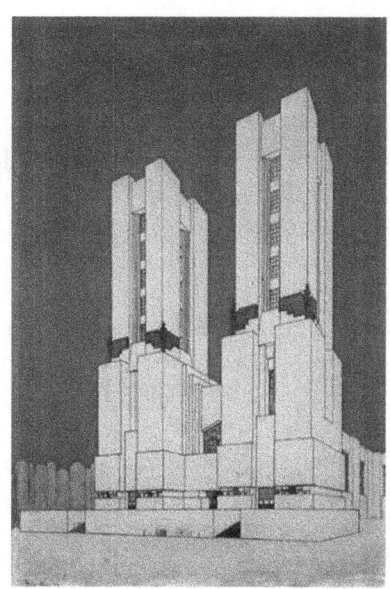

FIG. 4. Mario Chiattone, *Per una cattedrale IV* (For a Cathedral IV), Ink, Pencil and Gouache on Paper, 1914, 15 × 15.5 cm.

city lacked a centre and indicated a state of crisis of the liberal state, unable to accommodate its citizens.[48] In Sant'Elia's Futuristic utopia, skyscrapers remained a sign of enthusiastic, yet overly dynamic, rejection of the past with the aim of freeing Italy from the panopticon control of *passéists* and sleeping technocrats. What distinguishes Sant'Elia's visions from the real skyscrapers is that they are made to be part of a whole complex of buildings, while the US skyscraper was often an isolated instalment.

In the 1914 exhibition 'Nuove Tendenze', Mario Chiattone, a catholic and therefore perhaps an eccentric figure within Futurism but also an unexpected friend of Sant'Elia, also presented a series of drawings entitled *Costruzione di una metropoli moderna* [*Construction of a Modern Metropolis*, 1914]. Chiattone's drawings were overshadowed by those of Sant'Elia and to date have not received the critical attention they deserve. Despite the overly simplistic parallel with Fritz Lang's skyscrapers and high-rise roads in *Metropolis* (1925–26), Chiattone's Cathedral IV in particular (see fig. 4), while resembling the Notre-Dame in Paris, also recalls a *grattacielo* with square towers, which could symbolically bridge the gap with the USA. Like his Italian colleague, Hugh Ferris, the architect who had theorised the myth of the skyscraper more extensively than his contemporaries, imagined it in the shape of a cathedral and placed great emphasis on its spiritual qualities. Moreover, with his cathedral-cum-*grattacielo* chromatically defined, Chiattone introduced a further element of originality into the debate on social modernity. For he problematised a sense of limitation exercised by the irrationality of any religious belief offset by the control of an institutional power, like that of the Church, over individuals' terrestrial life. The shortcoming was that Chiattone's volumetric disposition was inevitably static, and thus lacked the aspirational tension of Sant'Elia's *grattanuvole*. In other words, Chiattone's volumetric qualities with their

sober disposition preceded rationalist architectural developments and accounted for the technological, modern control by the architect displayed later by buildings such as Terragni's Casa del Fascio in Como, Adalberto Libera's houses in Ostia, and Le Corbusier's aerodynamic Cité d'Alger.

Within Futurist architectural discourse, skyscrapers had multiple, interchangeable and productive meanings. Aesthetically they were a manifestation of the desire to break free from traditional composition in order to suggest an unconventional view on the relationship between the individual and its surroundings. Sant'Elia's inadequate and abstract social analysis, however, undermined his justified preoccupation with contemporary needs; just as his drawings were projections and visions, his architectural statements did not mean to have, or even could not have had, any realistic appeal. Chiattone, a professional architect, instead indicated the direction for further development in the chromatography and volumetry of the skyscraper. In both cases, however, skyscrapers performed a social function in so far as they proposed change and progress but they certainly did not call for any present-day building on Italian territory.

Lyrical Reconstruction: Depero

Across the Atlantic, it was the Rovereto-born artisan and illustrator Fortunato Depero who favoured aerial pan-dynamism through the *grattacieli*. In his imagination figured 'Bar giranti — monumenti danzanti parlanti volanti — Passeggi serpeggianti nello spazio in vortici luminosissimi coloratissimi — Fontane giroplastiche. Piazze — Parchi aerei — Stazioni per aeroplani — Ville volanti — Caffè su pali altissimi a 100, 200, 300, 1000 metri d'altezza' [Rotating bars — dancing, talking, flying monuments — Promenades snaking in colourful and luminous vortexes — Gyroplastic fountains. Squares — Aerial parks — Stations for airplanes — Flying villas — Coffeehouses on very high poles at 100, 200, 300, 1000 metres from the ground].[49] Compared to Sant'Elia's earlier statements, Depero's projects of the late twenties fleshed out the relationship between space and the self less in technological and more in lyrical terms, in an attempt to capture the aerial and fantastic expressions of city life. But city life was also imbued with popular culture, which featured prominently in Depero's work of the late twenties and thirties.

Unlike Sant'Elia and Chiattone, Fortunato Depero had lived in the USA from November 1928 until October 1930, during the Great Depression. Under such circumstances it is not at all surprising that his stay in New York with his wife Rosetta was not successful. Depero loved New York and established *Depero's Futurist House* there (resembling the one in Rovereto), but the reception of his works was at best lukewarm. Depero wrote in his diary *Un futurista a New York* [*A Futurist in New York*]:

> I grattacieli offrono prospettive audacissime, solo ingombre di meccanismi pubblicitari e luminosi nei centri più animati. Reclame esuberanti ed enormi. Luci che piovono, scoppiano e girano vertiginosamente, trascinando le fiumane di folla in un ritmico flusso e riflusso di mille colori.

[The skyscrapers offer audacious perspectives, cluttered with luminous advertisements in the liveliest centres. Full of exuberant and colossal appeal. Lights that pour down, crackle, and turn spiralling down, dragging streams of crowds in a rhythmic ebb and flow of thousands of colours.]

The crowds are 'una marea di insetti che brulicano, mordono, penetrano, vanno e vengono a processioni' [a tide of swarming, biting, penetrating insects. They come and go in processions].[50] For Depero, too, skyscrapers were in essence the symbol of otherness as well as a link between the avant-gardes and popular culture, a link still missing in Europe and even more so in Italy.

In *Grattacieli e tunnel* (New York, 1930, fig. 5), Sant'Elia's tensions and elevations have been replaced by a striking chromatographic play and a more organic distribution of circular spaces and volumes upon naked facades. The composition does not have a central protagonist but only elements that clash together and, simultaneously, remain aerially suspended and intact in an anti-naturalistic rendering of reality. The viewer is given a preferred entry point through the tunnels (the arrow in the left-hand tunnel) to the mystery of the construction, a mystery perhaps hidden in any social apparatus. The *grattacieli* themselves are not linear, because the idea of unlimited progress in the thirties was vanishing rapidly, leaving behind traces of a force that seems to sustain the overall composition of the elements encapsulated in the painting. The symmetry, on this occasion, is linear (see the circles at the bottom repeated on the top) and, more importantly, follows a vertical trajectory. This vertical symmetry is what controls the image, which has at its centre a spiralling 'chaos'. The chaos of the avant-gardes is still there in the unstable, centre-bending skyscrapers, but it is channelled by underground mysterious tunnels across clear pathways and captivating wheels rotating in circular movements.

Depero's rendering of skyscrapers in the thirties shows that there was a clear transition in the special aesthetics and politics of crowd management. In the thirties the *grattacielo* was a less tall, less powerful building, since it was no longer moving towards the sky but towards a collective representation of the everyday. The freedom of the aerial pan-dynamism and of the *oggetto-ambiente* was no longer there, for it had been replaced by a rotating, circular routine, spiralling into what was soon to become chaos. In other words, in the thirties the avant-garde had to come to terms with popular culture in both aesthetic and political matters and it did so by re-employing Futurist aesthetics of modernity to enact a more popular and less elitist process of social modernisation. Thus the novelty of Depero's skyscraper is not to be found in any architectural sedimentation, but rather in how he borrowed elements from popular culture (chromatisms and general diagonal lines and perspective which he had used in advertising) to reflect the social practices of individual and cultural industries, which were not previously part of the Futurists' sphere of intervention.[51]

The Politicisation of Form: the Thirties

Skyscrapers were political statements, especially during the second phase of Futur-

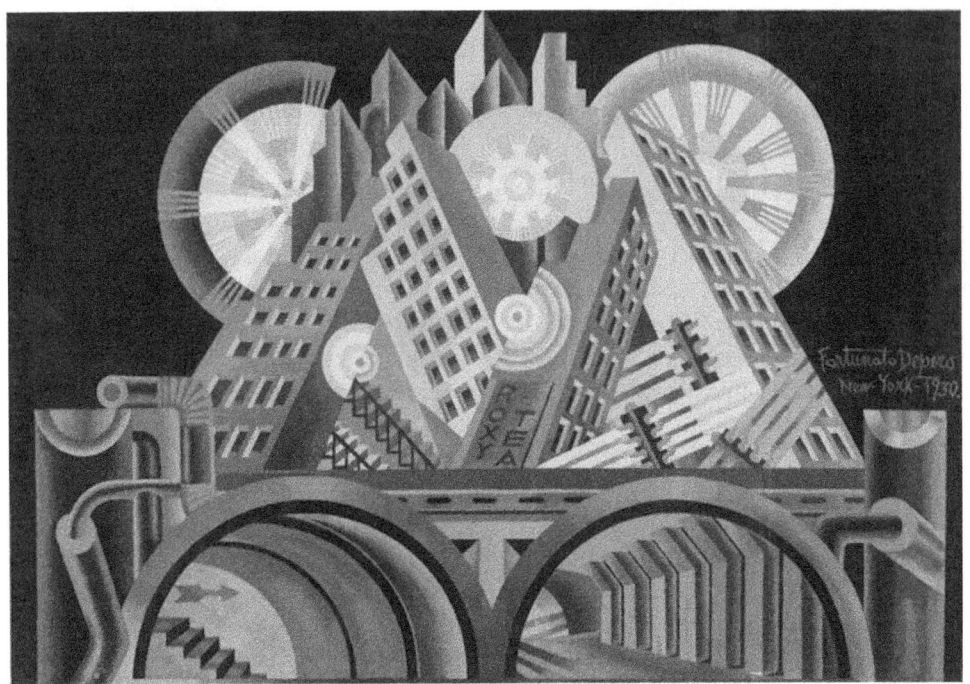

Fig. 5. Fortunato Depero, *Grattacieli e Tunnel* (Skyscrapers and Tunnels), Tempera on paper, 68 × 102 cm; Mart, Museo di arte moderna e contemporanea di Trento e

ism.[52] The thirties drawings of Crali, Rancati, Fiorini, Somenzi, and Spiridigliozzi replicated Sant'Elia's themes of multi-purpose and multi-level stations, of pyramidal houses, of skyscrapers and of air transport; but by the thirties, architecture was required to be more technical and less intuitive and visionary. With his Le Corbusier-like programme *La nuova architettura* in 1931, Fillìa took a strong position with regard to the professionalisation of architecture in Italy and aligned himself with the rationalists.[53] In so doing, he also positioned Futurist architecture within the regime's *arte di stato*.

In the broader context of the consolidation of Fascist architecture, at the 'Padiglione Futurista all'Esposizione del Valentino a Torino' (1928), Fillia organised, with Mussolini's patronage, a retrospective of Sant'Elia, Chiattone, Marchi, and Balla, and a display of the most recent works by Prampolini, Depero, Balla, Panaggi, and the Turinese Futurists Ugo Pozzo, Diulgheroff, Beppe Ferdinando, and Mino Rosso, along with those of Fillìa himself. Here, the pre-First World War skyscraper also returned to architecture, albeit less aerial and more imposing, with clearly defined volumes in the style of the early Chiattone but with some experimental vigour remaining.

In the Turin pavilion (see fig. 6), Prampolini and Fillìa brought together the geometry of the sphere, typical of the former, with the oneiric lyricism of the latter, in a sort of pan-space as discussed by Prampolini himself in *Nascita della simultaneità* [*Birth of Simultaneity*, 1932] and *Divinizzazione dello spazio* [*Divine Transformation of*

Space, 1931]. Built by the Turin Futurist architects following Prampolini's drawings, the pavilion presents an original Futurist type of architecture, characterised by a brilliant polychromatism, volumetric spherical contrasts, striking supergraphics, and well-defined orchestrations of volumes and proportions. The overall composition is more static, however: it needed to express the solidity of the state's design as well as the rationalisation of forms as a trademark of modernity. The lightness of Sant'Elia's early drawings vanished in favour of Chiattone's earthbound forms. In a similar vein, the *Grattacieli 'a radiatore'* by Guido Fiorini [*Radiator-Shaped Skyscrapers*, 1930–31; see fig. 7][54] are perhaps the most remarkable examples of late Futurist architecture. These skyscrapers are built in such a way as to allow air and light to penetrate through the different floors and parts of the construction, without any limitations and in equal quantity. The urban plan for these skyscrapers positioned them equidistantly (225 metres) from each other and connected them via pedestrian super-elevated walkways. The skyscrapers only host offices and not houses, but everyday life drifts at the ground level with the vehicular traffic and shops. The *grattacielo* stood on two pillars positioned at the centre of its square base to allow traffic to flow at its sides. At an international level, this scheme resembles the *Ville contemporaine de trois millions d'habitants* (1922) and *Plan voisin* (1925) for Paris by Le Corbusier that similarly comprised cruciform tower constructions and clear separations between pedestrian and vehicular traffic.[55] In 1938 Le Corbusier would bring to the fore the project for the *Gratte-ciel Cartésien* shaped like an open Y.[56]

Fiorini's innovative 'tensistruttura' [tensile structure; see fig. 8] proposed as one of its guiding principles the use of iron for construction instead of reinforced concrete in order to be able to have buildings in which every floor was independent from all others.[57] The other guiding principle of his innovative architectural project was the idea that all levels had to be similar and that buildings ought to be constructed in series. If in the traditional skyscraper every floor had to support the one(s) above it, in the mass-oriented skyscraper,

> la possibilità della costruzione in serie costituisce il principio basamentale per la industrializzazione degli edifici. L'impiego di tiranti, in sostituzione dei pilastri ordinati, ha in massima parte ridotto gli effetti della pressoflessione. Tutto l'edificio è sospeso. L'abolizione specialmente dei pilastri alle estremità del perimetro è particolarmente interessante agli effetti della realizzazione del traffico entro il perimetro dell'edificio.
>
> [the possibility of construction in series embodies the basic principle for the industrialisation of buildings. The use of tie-rods to replace ordinary pillars has largely reduced the effects of the bending stress. The whole building is suspended. The removal especially of the pillars at the extremities of the perimeter is of particular interest for its consequences for the realisation of the traffic inside the circumference of the building.][58]

Times had most certainly changed and there was no need for individualism or heroic pioneers and the skyscraper followed suit. In the last Futurist manifesto actually to mention the word *grattacielo* explicitly, the term was pronounced only to put it to rest. Poggi argues that the *grattacielo* was no longer needed: 'Domani il grattacielo non avrà più ragione di esistere. Il cemento armato sta già tramontando,

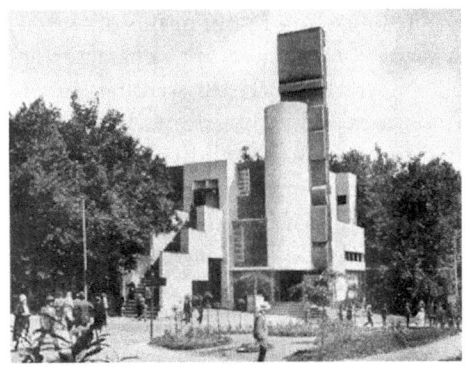

FIG. 6 (left). Fillìa and Prampolini, The Futurist Pavillion at the exhibition held at the Parco Valentino in Turin (1928) (photo).
FIG. 7 (right). Guido Fiorini, *Grattacielo con tensitruttura: base* (Skyscraper with Tensile Structure: Base), 1931.

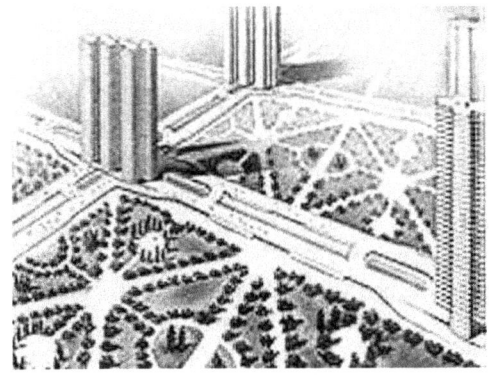

FIG. 8. *Grattacielo con tensitruttura* (Skyscraper with Tensile Structure), 1931.

e con esso necessariamente anche la sua fisonomia, la sua estetica' [Tomorrow the skyscraper will have no reason to exist. Concrete is already declining and, with it, necessarily its appearance, its aesthetics].[59] The *grattacielo* had been caused to vanish by 'la sempre crescente diffusione dei mezzi di locomozione' [the ever-growing spread of means of transportation], as a result of which 'non c'è più ragione di addensare fino all'estremo le abitazioni, e quindi, non essendoci più bisogno di accatastare in poco spazio, è inutile concentrare i verticalismi' [there is no longer any reason for the extreme accumulating of dwelling upon dwelling; and, therefore, since there is no longer any need for piling up in limited spaces, it becomes pointless to bundle together vertical lines].[60] If at the beginning the *grattacielo* was part of new stations, now it was obsolete. The Futurist speed embodied in the new technologies guaranteed that citizens could live further apart from each other and still communicate. The *grattacielo* had become horizontal and, as in the designs by Fiorini, was spread across a wider field. In both first- and second-generation Futurism, the *grattacielo* served the function of accommodating the individual. The individual of the liberal economies could find a home in the *grattacielo* because of

his or her ambition to touch the sky; the man of the totalitarian dictatorship did not need a vertical space; but rather a horizontal space, which could accommodate him not as a single instance but as collective instances of rituals that had to be planned in series.[61]

Notes to Chapter 5

1. Le Corbusier, *Towards a New Architecture* (Marston Gate: BN Publishing, 2008), p. 90.
2. See Antonio Sant'Elia and Filippo Tommaso Marinetti, 'Futurist Architecture', in *Programs and Manifestos of 20th Century Architecture*, ed. by Ulrich Conrads (Cambridge, MA: MIT Press, 1971), pp. 34–40; in this edition, the passages added by Marinetti and Cinti are printed in italics. On Marinetti's additions to the manifesto, see note 24.
3. The first 'Town Planning Exhibition and Conference' was held in 1910 in London, at the RIBA Institute. It allowed experts from all over the world to participate and thus exchange face-to-face innovative ideas about urban planning. Significantly, this event marked the end of the nineteenth-century concept of the garden-city introduced by the Scot Ebenezer Howard to foster a more empirical approach to city building and planning. This conference also marked the beginning of the discipline of urban studies. In 1909 the Housing and Town Planning Act, the first urban law in Britain, was passed. Other significant references could be to Richard Rummel's sprawling city and to Grand Central station, NYC.
4. Bruno Zevi, *Spazi dell'architettura moderna* (Turin: Einaudi, 1973 [1953]), pp. 312–15. All translations, unless otherwise stated, are by the author of this chapter.
5. Manfredo Tafuri and Francesco Dal Co, *Architettura contemporanea*, I (Milan: Electa, 1979), pp. 102–03; Cesare De Seta, *La cultura architettonica in Italia tra le due guerre* (Rome and Bari: Laterza, 1972), p. 21 and Iain Boyd Whyte, 'Futurist Architecture', in *International Futurism in Arts and Literature*, ed. by Günter Berghaus (Berlin: de Gruyter, 2000), p. 354. On Boccioni's *Manifesto* and for a reassessment of Futurist architecture, see also John Golding, *Boccioni's Unique Forms of Continuity in Space* (Newcastle upon Tyne: University of Newcastle, 1972) and Maurizio Calvesi, *Umberto Boccioni: disegni e incisioni* (Florence: La Nuova Italia, 1973).
6. Enzo Godoli, *Il futurismo* (Rome and Bari: Laterza 1983); Esther da Costa Meyer, *The Works of Antonio Sant'Elia: Retreat into the Future* (New Haven, CT: Yale University Press, 1995), p. 110.
7. For a comprehensive overview of Futurist architecture, see Enrico Crispolti, *Architettura futurista: Attraverso l'architettura futurista* (Modena: Galleria Fonte d'Abisso, 1984).
8. Depero started frequenting the Futurists at the end of 1913 and in 1915 as one of the 'Futurist Abstractists'. In 1916 Depero drew a number of architectural visions, called 'Plastic Futurist Pavilions' (Aerial City) and later worked out the concept of 'Promotional Architecture', which he saw as an investigation on how typography could be applied to architecture.
9. On this point, see Claudia Salaris, *Artecrazia. L'avanguardia futurista negli anni del fascismo* (Florence: La Nuova Italia, 1992), pp. 137–50. Salaris mentions how Fillìa in his *La città futurista* described his effort towards a new architecture in terms of 'crearsi una fisionomia costruttiva' (Fillìa, 'Futurismo e fascismo', *La città futurista*, 1.1, Turin, April 1929), quoted in Salaris, *Artecrazia*, p. 138. For an overview of the relationship between Futurism and Fascism from the beginning of the century through to the fall of the regime and for a series of interviews and first-hand testimonies, see *Futurismo e fascismo*, ed. by Alberto Schiavo (Rome: Giovanni Volpe editore, 1981); Terry Kirk, *The Architecture of Modern Italy: Visions of Utopia 1900–Present* (New York: Princeton Architectural Press, 2005), pp. 52–57; Michelangelo Sabatino, *Pride in Modesty: Modernist Architecture and the Vernacular Tradition in Italy* (Toronto: Toronto University Press, 2012).
10. This tension is particularly obvious in the debate on architecture in the thirties construction of the *arte di stato* and that the role of Futurist architecture (onwards from the days of Sant'Elia) could still play in this context, see Salaris, *Artecrazia*, pp. 141–49.
11. Claudia Salaris, *Dizionario del futurismo: idee provocazioni e parole d'ordine di una grande avanguardia* (Rome: Editori Riuniti, 1996), pp. 9–10.

12. See Filippo Tommaso Marinetti, 'Nascita di un'estetica futurista', in *Guerra sola igiene del mondo* (1915 but published in French in 1910) (Florence: Spes, Salimbeni, 1980); Marinetti's famous diatribes against 'Roma passatista' or 'Contro Venezia passatista' could also be recalled.
13. Sant'Elia and Marinetti, 'Futurist Architecture', p. 38.
14. For a detailed view on Futurist architecture as a whole see, De Seta, *La cultura architettonica in Italia tra le due guerre*, and Enzo Godoli, *Guide dell'architettura moderna. Il Futurismo* (Rome and Bari: Laterza, 2001).
15. Bernard Tschumi, *Architecture and Disjunction* (Cambridge, MA: MIT Press, 1996), p. 50.
16. Ibid., pp. 15–17.
17. Ibid., p. 19.
18. The Manifesto was rediscovered in 1971 by Zeno Birolli and published in 1972. Boccioni, 'Manifesto', in *Altri inediti e apparati critici*, ed. by Zeno Birolli (Milan: Feltrinelli, 1972), p. 40.
19. Gail Fenske, *The Skyscraper and the City: The Woolworth Building and the Making of Modern New York* (London: The University of Chicago Press, 2008), p. 67.
20. Manfredo Tafuri, 'Evoluzione del grattacieli di Chicago', in *La scuola di Chicago e gli architetti della prateria 1971/1910*, ed. by Camillo Gubitosi (Naples: Clean Edizioni, 2012), pp. 158–79.
21. In 1913, the supermarket magnate Woolworth built in New York a gothic-like palace with a 241-metre-tall spire in New York. The building, inaugurated by President Wilson, is defined as a 'commercial cathedral'.
22. Pier Giorgio Gerosa, *Mario Chiattone. Un itinerario architettonico fra Milano e Lugano* (Milan: Electa, 1985). Chiattone was born in Como where he qualified as a master builder. He opened his own office in Milan and later continued to work from Switzerland, where he abandoned his proto-futurist experience.
23. Sant'Elia drawings were listed as: 1. La città nuova (Station for Airplanes and Trains) — One Drawing. 2. La città nuova (details) — Six Drawings. 3. La casa nuova — One Drawing. 4. Electric Plants — Three Drawings. 5. Architectural Sketches — Five Drawings.
24. It is not easy to determine to what extent Marinetti reworked the original draft (20 May) by Sant'Elia, but for a discussion of the genesis and attribution of the manifesto, see Cesare De Seta, *Architetti italiani del Novecento* (Milan: Electa, 2006), p. 17, and Whyte, pp. 353–56. They both identify a strong synergy between Sant'Elia and Boccioni as reflected in the manifesto and in the 'Messaggio' issued during the 'Nuove Tendenze' exhibition in Milan on 20 May 1914. For an analysis of the representation and significance of the city and urban planning in Futurist manifestos, see Francesco Iengo, *Cultura e città nei manifesti del primo Futurismo (1909–1015)* (Chieti: Vecchio Faggio, 1986), pp. 160–94. Iengo's argument focuses on the utopian and vitalist drive emerging from the Futurist city.
25. See Godoli, *Futurismo*, p. 121 on van Doesburg's appreciation of Sant'Elia's new city.
26. Associated with the movement from 1912 onwards, Prampolini occupied important positions in the Futurist magazines *Noi* and *Stile futurista*. Prampolini enjoyed the most frequent contacts with wider European avant-garde movements (the Dadaists, Der Sturm, the Novembergruppe, and the Bauhaus) as both a scenographer and a painter. It can be claimed that Prampolini's *Atmosferastruttura. Basi per un'Architettura* of 1913–1914 marked the start of Futurism in architecture although not, as yet, in its totally mature form.
27. Umbro Apollonio, *Antonio Sant'Elia* (Milan: Il Balcone, 1958), p. 248.
28. Balla was one of the most outstanding figures in Futurist painting. In 1910 with Boccioni, Carrà, Russolo, and Severini, he signed the 'Manifesto dei pittori futuristi' as well as 'La pittura futurista. Manifesto tecnico'. Within the newborn movement, he developed his own particular interest in the domestic landscape, in furniture and interior design, see *DINAMISMO + LUCE. Balla e i futuristi*, ed. by Ada Masoero and Danna Battaglie Olgiati (Milan: Silvana Editoriale, 2005).
29. Sant'Elia and Marinetti, 'Futurist Architecture', p. 35.
30. *Sviluppo di una bottiglia nello spazio* [*Development of a Bottle in Space*, 1913], *Forme uniche nella continuità dello spazio* [*Unique Forms of Continuity in Space*, 1913], *Muscoli in velocità* [*Muscles in Speed*, 1911] are some of Boccioni's most illuminating sculptures as far as this theoretical position is concerned. It is worth mentioning that Boccioni's *Gigante e pigmeo* contains *in nuce* the theme that will be fully developed in his Futurist painting-manifesto *La città che sale* [*The City Rises*], see Ada Masoero, *Umberto Boccioni. La città che sale* (Cinisello Balsamo: Silvana Editoriale, 2003).

31. Sant'Elia and Marinetti, 'Futurist Architecture', p. 35.
32. See for example Muthesius and Van de Velde, 'Werkbund Theses and Antitheses' (June 1914), in *Programs and Manifestos of 20th Century Architecture*, ed. by Conrads, p. 28 and Sant'Elia and Marinetti, 'Futurist Architecture', p. 36.
33. Sant'Elia and Marinetti, 'Futurist Architecture', p. 35.
34. Ibid., p. 38.
35. For an overview of the way masses are formed and shaped, see Jeffrey T. Schnapp and Matthew Tiews, *Crowds* (Stanford: Stanford University Press, 2006).
36. See also *La metropoli futurista. Progetti im-Possibili. Mostra multimediale sull'architettura futurista*. Florence, Galleria degli Uffizi, 2 October–14 November 1999, ed. by Vincenzo Capalbo (Palestrina: Officine del Novecento, 1999).
37. Sant'Elia and Marinetti, 'Futurist Architecture', pp. 35–36.
38. On this point, see da Costa Meyer, p. 114, and Godoli, p. 124 who rightly dismisses Sauvage's influence on Sant'Elia's use of funiculars in touristic locations, such as Lake Como.
39. On the use of setbacks in France and the USA, as well as the use by Loos in Alexandria, and their influence on Sant'Elia's drawings, see da Costa Meyer, pp. 115–16.
40. In 1896 Enrico Bernardi started the production, in Italy, of cars with an internal combustion engine.
41. Da Costa Meyer, p. 114. See also 'La circolazione futura e i grattanuvole a Nuova York', *L'Illustrazione italiana*, 1913, with a reproduction of H. Wiley Corbert's traffic circulation.
42. Umberto Boccioni, *Pittura scultura futuriste (Dinamismo plastico)* (Milan: Edizioni futuriste di Poesia, 1914), p. 263.
43. Apollonio, p. 124.
44. Sant'Elia always remained in favour of iron over concrete.
45. New York Grand Central Station (Reed, Stem, Warren, and Wetmore) was opened to the public in 1913 and *L'illustrazione italiana* (issue of 1 February 1913) dedicates ample space to celebrating this event.
46. The first ideas on mobile homes are from count Vincenzo Fani (Volt) in his 'Manifesto dell'architettura futurista', written in Nice, 19 August in 1919 on Marinetti's suggestion. Volt wrote that 'Ascensori fulminei balzeranno di scatto fino all'altezza del 100° piano. Non vi saranno più scale' [Elevators will jump instantaneously till the 100th floor. There will be no longer staircases], in Godoli, p. 188.
47. Da Costa Meyer, pp. 133–36.
48. *Guido Canella. Architetti italiani del Novecento*, ed. by Enrico Bordogna, Enrico Prandi, and Elvio Manganaro (Milan: Christian Marinotti edizioni, 2010), pp. 152–53.
49. *Fortunato Depero*, Museo provinciale d'arte. Sezione contemporanea, Galleria museo Depero (Rovereto, Trento, Italy), ed. by Maurizio Fagiolo dell'Arco, Nicoletta Boschiero, and Gabriella Belli (Milan: Electa, 1988), p. 44.
50. Fortunato Depero, *Un futurista a New York* (Montepulciano: Edizioni del grifo, 1990), p. 56.
51. On Depero's works and biography, see Maurizio Scudiero and David Leiber, *Depero futurista & New York* (Rovereto: Longo Editore, 1986).
52. Emilio Gentile noted how 'According to Ardengo Soffici, one of the major Fascist artists and leader of aesthetic anti-Americanism, the '"so-called American civilization" was a "false civilization", "transitory and ephemeral", its rational architecture was the typical expression of a "reinforced concrete civilization", that is, of "a non-civilization"' (*The Struggle for Modernity: Nationalism, Futurism, and Fascism* (London and Westport, CT: Praeger, 2003), p. 164).
53. Fillìa (Luigi Colombo, 1904–36), a leading protagonist of Futurism in Turin, worked mainly as a painter and a sculptor. His interest in architecture remained constant throughout his life because of his connections with the rationalist movement; this constant interest is also illustrated by some drawings, such as a thirties rendering of Chiattone's style in his famous version of the Futurist church, *Chiesa futurista*.
54. Guido Fiorini (1891–1965), very active in Paris, was especially well known in Italy for his 'tensistrutture' (tensile structures).
55. Fiorini met Le Corbusier in Paris in 1931 on the occasion of the Colonial Exhibition (*Exposition coloniale internationale*).

56. In 1919, he had also designed a skyscraper on a triangular lot in the Friedrichstraße in Berlin.
57. Compositional themes borrowed from Sant'Elia are: the buttresses configured as an assembly of volume, of equal geometric shape but of different sizes; the monumental frame structures; the inclined planes, which contribute to stress compositional pyramid-like planes; the combination of massive concrete structures and enclosures of light, iron, and glass; the turreted bellies connected to the main building.
58. Godoli, p. 225.
59. Cesare Augusto Poggi, *Architettura futurista* (Florence: Gruppo futuristi d'iniziativa, 1933), p. 1, now in *Manifesti, proclami, interventi e documenti teorici del futurismo, 1909–1944*, ed. by Luciano Caruso (Florence: Coedizioni Spes-Salimbeni, 1980), item no. 239.
60. Ibid.
61. I should like to dedicate this article to my father and my friend Adriana, two futurists always on the move.

CHAPTER 6

The Letterhead

Maria Elena Versari, Carnegie Mellon University

The earliest documentation of a letterhead designed specifically for the Futurist movement dates to the end of 1911, roughly three years after the movement's founding manifesto[1]. While scholars have recorded with considerable precision the date of its appearance, one question has passed unexamined: why did Marinetti wait so long to provide his artistic and cultural movement with its own stationery?

If we review the different kinds of letterheads used in Futurism's first years, we might be surprised to discover how the movement's disaffiliation from its founder's previous enterprises was a slow, piecemeal process. As we know, the *Manifesto of Futurism* was diffused at the beginning of 1909 in letter format, signed by Marinetti, 'Director of POESIA,' and sent to the press and to several public personalities and intellectuals.[2] The text, in blue ink, was preceded by the logo for *Poesia. Rassegna Internazionale* [*Poetry. International Review*], on the left, and flanked by a note on the right, which read: 'La Rassegna internazionale "POESIA" ha fondato una nuova scuola letteraria, col nome di "FUTURISMO" [The international review 'POESIA' has founded a new literary school that goes by the name of 'FUTURISM'...][3] (see fig. 1). The blue letterhead was a slight variation of the one created for *Poesia*, which Marinetti had used until then. The older letterhead featured the journal's title and logo, in red, along with Marinetti's name and address, in gothic lettering and blue ink[4] (fig. 2). The journal ceased publication in 1909, but its stationery did not die with it.

Indeed, even after the launch of Futurism and until well into 1911, the Futurists continued to use the classic letterhead of *Poesia* for their correspondence. This led to some interesting mismatches. Perusing the archives, we discover, for instance, that in the spring of 1910 Umberto Boccioni used this same old stationery when he wrote to Gino Severini and Gian Pietro Lucini, formulating some major tactical strategies for the enlargement and theoretical codification of the Futurist group[5]. While the letters' content clearly attests to the birth of a new movement, their visual appearance seems instead to reduce it to a minor side project born under the aegis of Marinetti's long-deceased journal. As for the founder of Futurism, his continued use of *Poesia*'s logo reveals the contradictions between the multiple roles he had assumed until then and his ambition to set Futurism in motion as an autonomous enterprise.

In 1909, he wrote, for instance, to one of his early backers:

FIG. 1. *Manifeste du futurisme* in letter format (first page of 4), January 1909, Private Collection.

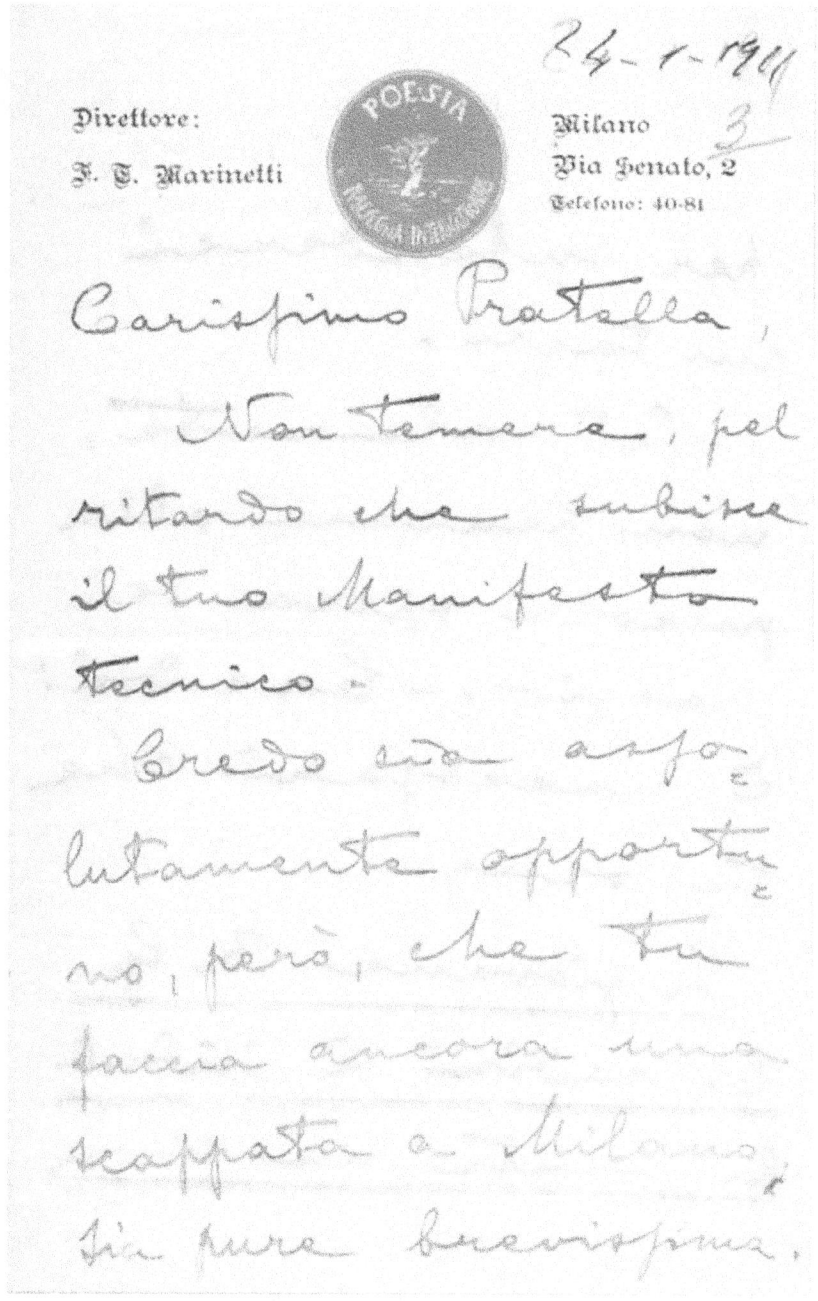

Fig. 2. Letter by Filippo Tommaso Marinetti to Francesco Balilla Pratella, 24 January 1911 on the stationery for *Poesia*, Fondo Pratella — Biblioteca Comunale 'F. Trisi' — Lugo (Ravenna).

> Vi ringrazio anzitutto, caldamente, della vostra franca adesione (benché parziale) al nostro manifesto.
>
> Non mi stupisco della gazzarra che si va facendo intorno al mio nome a questo proposito, ma me ne dolgo nondimeno profondamente, poiché preferirei che si dimenticassero il mio nome e la mia persona, per discutere, semplicemente, le idee.
>
> [I warmly thank you, first of all, for your frank (although partial) support of our Manifesto.
>
> I'm not surprised at the hullabaloo that is being raised around my name on this issue, but I'm however truly sorry for it, since I would prefer that my name and person be forgotten, in order to discuss, simply, the ideas].[6]

How this might have been possible, when, as we saw, he himself had printed and distributed his manifesto on paper decorated with the sensuous image of a nude woman — *Poesia*'s logo — surrounded by his own name and address, would soon be an issue of not minor concern.

In the same letter, he theorised the exploitation of modern advertising techniques in the domain of intellectual debates. First, he stressed the need to move beyond the small and self-referential networks that characterised the world of publishing houses and literary magazines. For him, new ideas required new, startling means of propagation. In making his point, he outlined the effects of modernity on human psychology:

> Credo che le idee feconde e rinnovatrici non possano essere più propagate solo mediante il libro. Esse vi si smarrirebbero irreparabilmente dato lo straripare delle forze industriali e commerciali, le facili nausee e la stanchezza del cervello umano, scosso dal frastuono incessante degli interessi economici, in una vita diventata, quasi per tutti, cinematografica e affannosa quanto mai.
>
> [I believe that ideas that are fertile and innovative cannot be propagated merely through the book anymore. They would be irreparably lost in it due to the overwhelming industrial and commercial forces at work, the predictable nausea and the fatigue of the human brain, shaken by the continuous hubbub of economic interests, in a life that has become, almost for everyone, cinematographic and frantic as never before.][7]

Intellectual discourse must therefore adopt the same tools that commercialism uses to force its way into the mind of a weary public or, as Marinetti himself put it, it must 'adapt the movement of ideas to the frenetic [movement] of our acts'.[8]

At the time that Marinetti wrote this letter, the *Giornale d'Italia* had just attacked him for having abandoned the writer's desk in favour of the advertising agency's workshop. In addition to the mailing of the first, letter version of the *Manifesto of Futurism*, its founder had also masterminded an innovative advertising campaign to announce the movement's birth. He had blanketed Milan's streets with posters on which was written in bold, red type 'Il Futurismo', followed in smaller characters by the name 'F.T. Marinetti'.[9] The newspaper had then facetiously wondered if Alessandro Manzoni, back in his time, should have followed the same strategy by plastering the walls of Milan with garish, red and white posters that shouted 'Romanticism — Manzoni'. For Marinetti, however, the *Giornale d'Italia*'s ironic

quip missed the point. 'Ma vi pare proprio, gentile amica, che vi possa essere qualche cosa di comune fra la nostra vita d'oggi e quella che conducevano i nostri nonni?' [But does it really seem to you, my kind friend, that there might be something in common between our life today and that which our grandparents led?], he wrote in the letter, adding in conclusion:

> Io credo si possa oggi perfettamente propagare un'idea con lo scoppio di due colori su pei muri delle grandi città. Ma, naturalmente, come ciò non fu mai fatto, ecco tutte le mummie d'italia sciogliere ed agitare al vento, per protestare, le loro bende odoranti di sale millenario!

> [I believe that today we can absolutely propagate an idea with the explosion of two colours on the walls of the great cities. But, naturally, since that was never done, here they are, all the mummies of Italy, unwrapping their age-old, foul-smelling bandages, and waving them in the wind].[10]

These are, in a nutshell, the same ideas that Marinetti later expressed in his 1913 manifesto *Distruzione della sintassi. L'immaginazione senza fili. Parole in libertà* [*Destruction of Syntax. Untrammeled Imagination. Words in Freedom*], when he wrote: 'I am initiating a typographical revolution directed against the beastly, nauseating concept of the book of verse'.[11]

If establishing a new way of diffusing new concepts was Marinetti's first concern, he was also resolute in creating a tight-knit circle of artists and writers around them. On the circular announcing the birth of Futurism, he had defined it as a 'new literary school' founded by *Poesia*, but the term 'school' was already showing its limitations. As he wrote in the letter, still countering the objections raised by the *Giornale d'Italia*, more than a 'school' proper, Futurism was a 'corrente di idee diametralmente opposte a tutti i rancidi indirizzi letterari e artistici' [current of ideas radically opposed to all rancid literary and artistic bias].[12] It was not, however, the simple result of an idiosyncratic stance. Marinetti insisted on this point:

> Vi sono delle idee — lo ripeto — che noi amiamo più che le nostre ambizioni effimere; delle idee per le quali si può anche morire allegramente, come morirono, con la sigaretta fra le labbra, gli ufficiali giapponesi, sulle loro torpediniere affondanti!...

> [There are ideas — I repeat it — that we love more than our own ephemeral ambitions; ideas for which we can even happily die, like the Japanese officers died, with a cigarette between their lips, on their sinking battleships!...].[13]

As this letter clarifies, Marinetti conceived Futurism from the very beginning as a new group enterprise. Still, he refused to shelve all references to the journal *Poesia* and to the international connections that he had established around it. *Poesia* ceased publication at the end of 1909, with a triple issue dated August-September-October. As we saw, it was only two years later, in 1911, that Futurism would be officially established as a self-standing movement with the adoption of specific stationery. In the meantime (probably at the beginning of 1910), Marinetti must have commissioned a print shop to create a new series of envelopes.[14]

In 1910, he was still using the writing paper with *Poesia*'s logo. In several collections, however, we find envelopes dating from 1910 with a large typescript

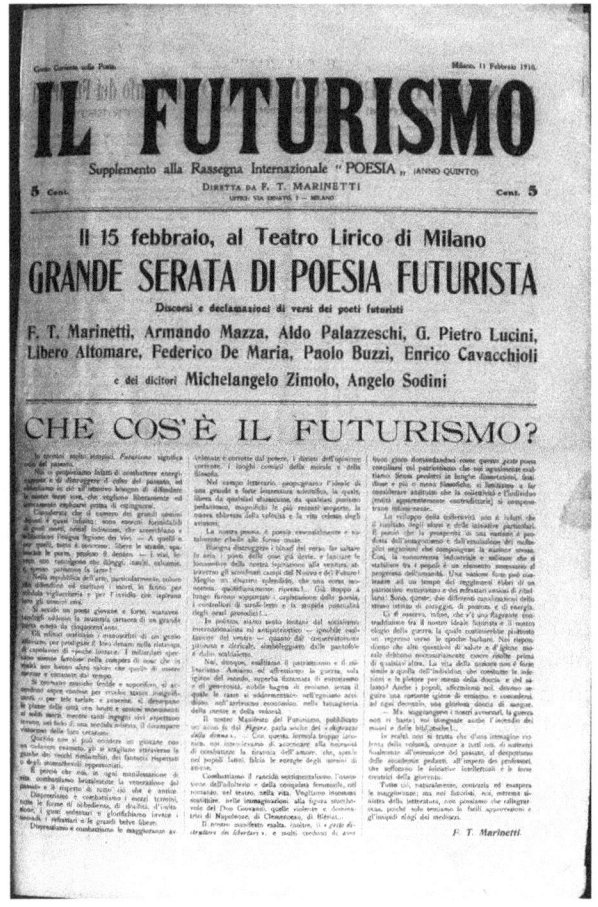

FIG. 3. First page of *Il Futurismo*, 15 February 1910, F. T. Marinetti Libroni, Beinecke Rare Books and Manuscript Library, New Haven, CT.

stating '*Poesia* motore del Futurismo' in capital letters, flanked by *Poesia*'s logo and editorial information ('Direttore F.T. Marinetti — Milano — Via Senato, 2'). These envelopes were created in Italian[15] and French.[16] While it may be possible that, at the beginning of 1910, Marinetti planned to keep publishing *Poesia*, it is more likely that his principal goal was to begin transitioning the review's international readership to the new enterprise of Futurism.[17] The 1910 publication of the two issues of *Il Futurismo*, a four-page leaflet subtitled *Supplemento alla rassegna Internazionale "Poesia" (Anno Quinto)*, further reinforces this interpretation (see fig. 3). *Il Futurismo*'s connection to *Poesia* stops however with its subtitle. This new journal was completely devoted to the new movement. It charted the first Futurist poetic and artistic events and manifestos.[18] There is only one indirect reference to *Poesia* in it — a brief note letting subscribers know that they would be reimbursed

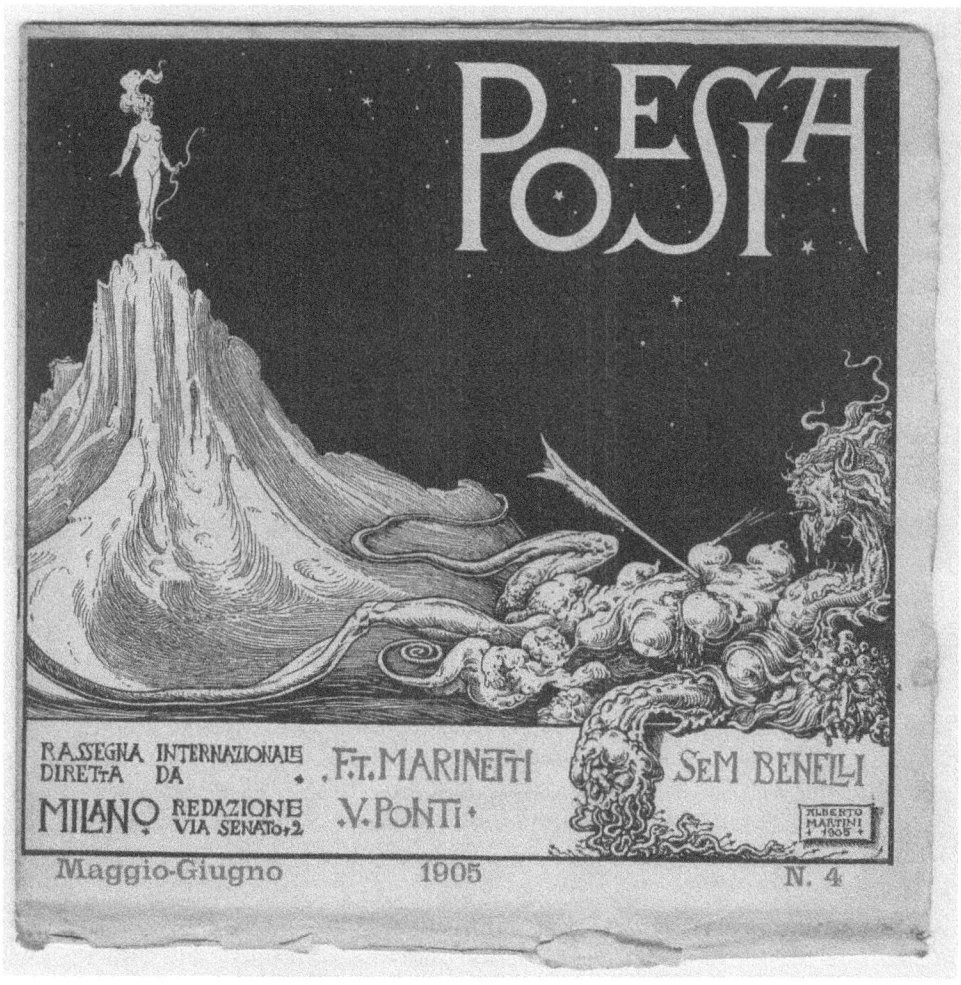

Fig. 4. Alberto Martini, cover of *Poesia*, 1, n. 4, May–June 1905, Beinecke Rare Books and Manuscript Library, New Haven, CT.

(in books) for the year 1910, and thereby implying that the older review had ceased publication.[19] In any case, Marinetti used the formulaic expression '*Poesia* motore del Futurismo' to define Futurist events beyond the last issue of the journal itself, as testified by the leaflet *Discours futuriste aux Vénitiens*, published some time after 1 August 1910.[20] At that point, all plans for the resurrection of *Poesia* were, by all accounts, definitively shelved.

From a visual standpoint, the title page of *Il Futurismo* seems to lack distinctiveness in comparison to the cover of *Poesia* (see fig. 4) or to the layout of the 1910 envelopes. And it was this shortcoming that, in all likelihood, compelled Marinetti and his typographer at the Poligrafia Italiana of Via Stella 9 in Milan to begin conducting various graphic experiments in order to give Futurism a recognisable

Movimento Futurista
diretto da F. T. MARINETTI
MILANO, Corso Venezia, 61
Telefono 40-81

FIG. 5. The First Futurist Letterhead,
Beinecke Rare Books and Manuscript Library, New Haven, CT.

visual identity.[21]

The expression 'Il Futurismo' had already appeared as a conceptual as well as visual alternative to 'Poesia', inserted as an additional title at the bottom of the journal's cover in 1909. There, the contrast between the sinuous letters of the title 'Poesia' and the short and wide, *sans-serif* typeset used for 'Il Futurismo' was striking.[22] This extremely modern solution, however, was not carried over to the masthead of the homonymous leaflet, which a year later was set using a very thick and narrow Bodoni-style typeface (fig. 3). Roughly at the same time, the 1910 envelopes celebrating '*Poesia* motore del Futurismo' employed still another visual solution. They used a very elegant Garamond-style typeface, with its slanting serifs and the slim, downward stroke of the letter R (fig. 4). Although discarded for the title of *Il Futurismo*, this latter font reappeared nonetheless on its last page, in an advertisement of the books published by the 'EDIZIONI FUTURISTE DI POESIA'.

The new 1910 leaflet, *Il Futurismo*, did not give life to a new stationery expressly created for the movement. In this period, not only Marinetti but also the first members of the Futurist group were still using the old one, created for *Poesia. Rassegna Internazionale* (fig. 2).

Giovanni Lista has suggested that the appearance of a letterhead for the Futurist movement in 1911 (fig. 5) was the result of an activist attitude, coherently tied to a collective conception of artistic work and, thus, to the birth of the modern concept of the avant-garde.[23] While this interpretation correctly emphasises the uniquely radical and programmatic stance adopted by the movement at the beginning of the century, it fails to explain the significant delay with which Futurism acquired its own letterhead. The fluctuating choice of multiple fonts, as well as the temporal hiatus between the ill-fated experiment of the *Il Futurismo* leaflet and the appearance of a new letterhead a year later might reveal something more. They might offer us insight into the inner workings that characterised in those very years the transformation of Futurism from group to movement.

In the last decades, historians, collectors and antiquarians have charted the vast print culture of Futurism, unearthing a large array of minute data from the innumerable

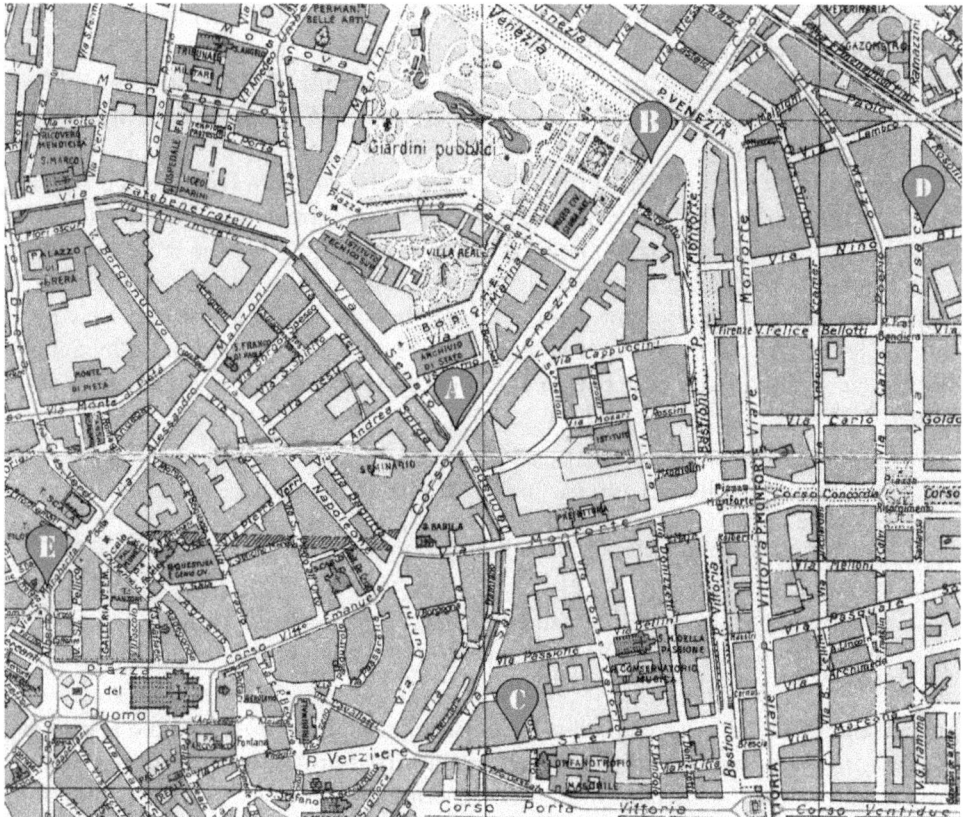

Fig. 6. Map of Milan, 1910, Artaria Publisher (detail), showing Marinetti's residences in Via Senato (A) and in Corso Venezia (B), and the location of the shops of Poligrafia Italiana (C), Tipolitografia Ripalta (B) and Tipografia Taveggia (E).

books, manifestos, periodicals and ephemera created by the movement. An interesting fact that seems to have passed unnoticed is the coalescence, between 1911 and 1912, of variations, shifts and readjustments in the printing history of Futurism. Among these, one element, in particular, warrants closer attention. Between 1912 and 1913, Marinetti started a massive republication campaign of previously issued Futurist manifestos.[24] In a footnote in her 1990 survey of Marinetti's publishing career, Claudia Salaris mentions how the practice of reissuing manifestos was part of his publicistic strategy[25] and more information about these reprinted manifestos has since been made available in several antiquarian catalogues.[26]

Still, and this is something that has eluded critics until now, the decision to reissue the manifestos of Futurism had important repercussions on the movement's identity. Scholars aware of this minor editorial fact can divide the leaflets into two separate groups. Antiquarian catalogues sometimes highlight the distinction between the first and the second runs of the manifestos by referring to the print shops used by Marinetti: Poligrafia Italiana for the first and Taveggia for the second.

Some have attributed this change of print shop to a change in Marinetti's residency, for, at roughly the same time, the founder of Futurism moves from Via Senato to the famous 'casa rossa' of Corso Venezia. The second run of the manifestos, in fact, invariably reports Marinetti's address as 'Direzione del Movimento Futurista: Corso Venezia, 61 –MILAN'.[27]

If we consult a map of Milan from those years (fig. 6), however, we can see that the trajectory to the Poligrafia Italiana, located on a street then called Via Stella (now Via Corridoni) [C on the map], would have taken roughly the same amount of time from Marinetti's old apartment [A on the map] as from his new one [B on the map]. Proximity alone does not seem to justify the selection of an entirely new print shop. A letter written by Marinetti to Luciano Folgore, already signalled by Salaris, casts some light on the real reason for the change: 'Tutto è momentaneamente arenato' [Everything is stalled], he wrote,

> anzitutto dalla preparazione della grande esposizione di Parigi che esige la maggior parte della mia attività. Inoltre, la mia tipografia, cioè quella che mi serviva, è in liquidazione. Bisogna perciò trasportare il tuo volume, quello di Cavacchioli e quello di Paolo Buzzi in un'altra tipografia.
>
> [first of all for the preparation of the great Futurist exhibition in Paris, which demands most of my efforts. Moreover, my print shop, that is, the one I've used, is being liquidated. We must therefore find another one for your book, Cavacchioli's and Paolo Buzzi's.][28]

Several events seem to have taken place between the end of 1911 and the beginning of 1912, in conjunction with the arrival of the first Futurist letterhead. Marinetti's lease for the flat on Via Senato was up on September 29th, 1911[29] and his contentious relationship with the owner, a certain signor Dall'Acqua, may have been behind the change of address. On the exact same date, the outbreak of the Italo-Libyan war spurred Marinetti to chronicle the conflict as a reporter. He left for Tripoli, arriving at the hotel Minerva on 12 October 1911.[30] He returned to Milan between the very end of December 1911 and the first days of January 1912.[31] It was probably around this time that the Poligrafia Italiana folded.[32]

This event had significant repercussions on the Futurist movement. Not only was the publication of the books planned for the Edizioni di *Poesia* halted, but the transfer of the movement's business to the print shop owned by Angelo Taveggia (fig. 6, E on the map) inaugurated a new chapter in the history of Futurism. Marinetti's 1914 masterpiece, *Zang Tumb Tuuum*, which contained many of his famous *tavole parolibere*, was printed in Taveggia's workshop. In the book, the head of Futurism famously acknowledged the contribution of Cesare Cavanna, an anarchist typographer who worked for the company.[33] Cavanna became a close friend of Marinetti and would work for him for more than a decade. The movement's manifestos and leaflets issued from 1912 to circa 1926, as well as several Futurist books published in the tens, were in all likelihood realised under his oversight.[34] After Marinetti's move to Rome in the mid-twenties, they kept in touch. At times, they would even exchange friendly verses in Milanese dialect.[35] It was probably Cavanna, in particular, who oversaw the transfer of Balla's drawing, *Boccioni's Fist*,

into the layout of the stunning Futurist letterhead that the movement used in the 1920s.

So, was the first Futurist letterhead also the product of such a collaboration? Did it originate in Taveggia's workshop?

This hypothesis seems to be in tune with the overall narrative of a conceptual turn that takes place with the reissuing of the early manifestos. In the first run of manifestos, the text and signatures are generally followed by a reference to *Poesia*, with the indication of Marinetti's first address (Via Senato, 2, Milan). In the second run, instead, the leaflets are endorsed by 'Direzione del Movimento Futurista: Corso Venezia, 61, Milano'. This new, formalised designation for the group reveals the desire to craft a more precise public image for Futurism. New stationery with a letterhead explicitly created to declare Futurism's status as a 'movement', would correspond to the way that the movement's image was recodified and strengthened through the reprinting of the manifestos.

Some facts, however, counter this hypothesis. First, the manifestos reissued by Taveggia were printed later, in 1912 or 1913. When the Poligrafia Italiana closed, Marinetti initially used the Tipolitografia Ripalta, located on Via Pisacane 36, a ten-minute walk eastward from Corso Venezia, 61 (fig. 6, D on the map). Folgore's volume, *Il canto dei motori* [*The Song of Engines*] and the anthology *I poeti futuristi* [*The Futurist Poets*] were published there for the Edizioni futuriste di *Poesia* in 1912.[36]

The last Futurist item printed at the Poligrafia Italiana, on the other hand, seems to have been the republication of an article by the writer and art critic Camille Mauclair, which had originally appeared in *La Dépêche de Toulouse* and was dated 30 October 1911.[37] The leaflet, entitled *Il Futurismo e la giovane Italia* [*Futurism and Young Italy*], was printed in French and Italian in two columns and offers some clues about the shifting identity of the Italian movement at this time. A passage by Mauclair, in particular, is highlighted in bold in the Futurist tract. It is a section in which the author interprets Italy's recent aggressive invasion of Tripolitania as a symptom of how the nation's foreign policy is ideologically in tune with the specific type of arrogance personified by the Futurists. 'Ed ecco perchè *questo movimento, nato da paradossi* letterari, merita di essere preso in consderazione' [That's why *this movement, born from literary paradoxes*, is worth being taken into consideration], Mauclair wrote, 'Piaccia o non piaccia, esso costituisce un dato significante sulla nuova mentalità italiana. Pel loro patriottismo sfrenato, i futuristi guadagneranno molti partigiani' [Like it or not, it constitutes a significant document of the new Italian mentality. For their unbridled patriotism, the Futurists will gain many supporters].[38] As was often his style, Marinetti decided to turn this article into a celebration of Futurism. A short text printed at the bottom of the article, in fact, reads: 'Mentre il poeta Marinetti assiste alla conquista della Tripolitania, fase politica del movimento futurista, i Pittori futuristi preparano la loro grande Esposizione a Parigi (Galerie Bernheim-Jeune, dal 5 febbraio al 24 febbraio 1912)' [While the poet Marinetti is present at the conquest of Tripolitania, which represents [the] political phase of the Futurist movement, the Futurist painters prepare their great exhibition in Paris (Bernheim-Jeune Gallery, from 5 February to 24 February 1912)].[39] The appearance of the expression 'Futurist movement' in the tract is therefore linked with the

FIG. 7. Letter by Renzo Provinciali to F.T. Marinetti with letterhead for *L'Incendiario. Periodico Futurista*, 9 May 1911, The Getty Research Institute, Los Angeles.

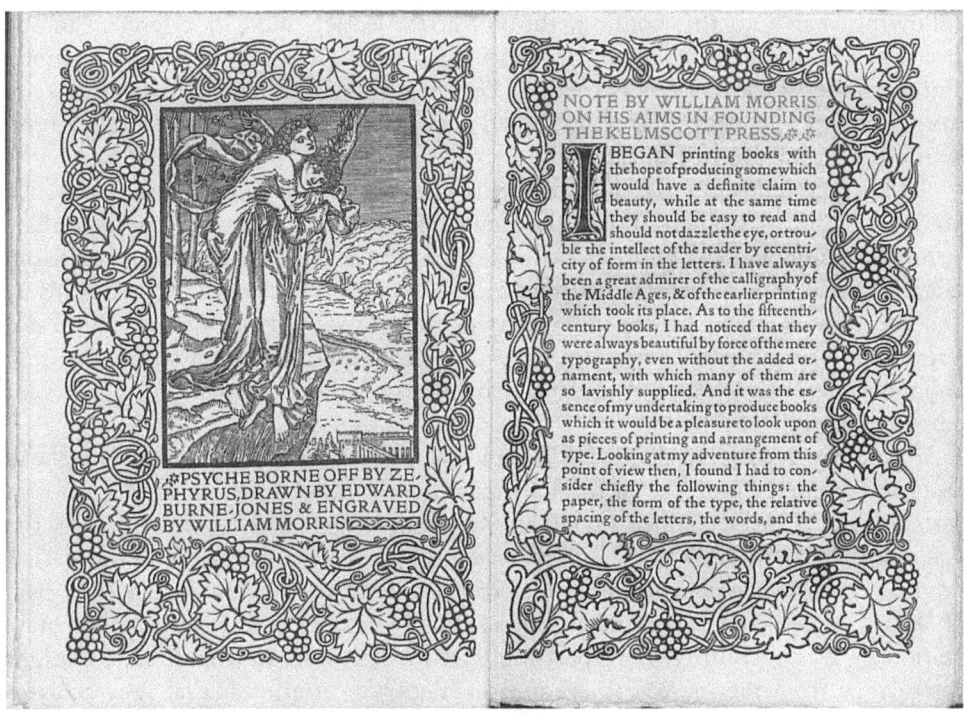

Fig. 8. Incipit of *A note by William Morris on his aims in founding the Kelmscott Press* (London: Kelmscott Press, 1898).

idea of a plurality of aims that characterises Futurism and, in particular, with the definition of a specifically 'political' phase of its activity. As Günter Berghaus has suggested,

> [T]he publication of a theoretical statement, the performance of a play, or the exhibition of a painting, however controversial and polemical it may seem, remained an act of intellectual discourse. The true transformation of art into life could only be achieved through entering the public arena in a direct and combative manner'.[40]

It is symptomatic, moreover, that the emergence of the word 'movement' coincides with an overt reappraisal of both the political and artistic activities of Futurism. 'Movement' had been used in France and Italy in the late nineteenth century as a term referring to either political or literary and artistic trends, and Marinetti himself had utilised it repeatedly.[41] However, using it to define an organisation equally active in both fields reveals a new impetus to recodify, in 1911, Futurism's undertakings under one, single operative designation. Previously, even the explicitly political manifesto of 1909, *Elettori Futuristi!* [*Futurist Voters!*], had been simply signed 'I Futuristi'.[42]

Marinetti's decision to follow the war in Libya as a correspondent deferred the artistic activities planned for the end of 1911. The Futurist exhibition of painting in Paris, in particular, originally planned for November, was postponed to the

following year.[43] In this context, the Poligrafia leaflet, with its reference to the political and the artistic 'phases' of Futurism, testifies to the desire to relaunch Futurism's artistic ambitions as part of a coherent and coordinated balance between art and politics. It was probably published between November and December 1911, while Marinetti was still in Libya.[44]

This is apparently the first Futurist leaflet that does not end with any reference to *Poesia*, or to Marinetti's old apartment, as had been the case for the others printed at the Poligrafia Italiana. At the bottom of the page we find the indication: 'Direction du Mouvement Futuriste: MILAN, Corso Venezia, 61'. It is already at the end of 1911, then, before the appearance of the second run of the manifestos printed by Taveggia, that Futurism starts presenting itself as a coherently structured organisation, evolving directly from the form of a composite 'group' into a coherent 'movement'.

It is in these same weeks that we find the first examples of Futurist letterhead used in the correspondence of the Futurists. Boccioni, for instance, uses it for two letters written in December 1911,[45] in which he refers to the preparation of the upcoming Futurist show in Paris in terms quite similar to those found in the leaflet. Marinetti must have conceived the idea of a new letterhead before he left for Libya, in anticipation of the upcoming Parisian show. During that year, the need for new stationery was becoming more pressing.[46] A further push in this direction might have come from the increasing amount of 'Futurist' letterheads that new acolytes of the movement were creating for themselves. We can only imagine Marinetti's reaction when, opening his correspondence one day in May 1911, he first discovered the newly minted stationery that Renzo Provinciali had had made for his journal, *L'Incendiario* [*The Arsonist*]. The missive by the renowned anarchist is still preserved among Marinetti's papers at the Getty Research Institute. It sports a letterhead with a stamped red image, quite similar to the icon of *Poesia*, but surrounded by the words: 'L'Incendiario Periodico Futurista'[47] (see fig. 7).

In 1911, then, the decision to define Futurism specifically as a 'movement' that acts autonomously, without the supporting structure of a journal, is made evident by the introduction of a specific letterhead and of a corresponding, codified address line in the manifestos. But if the letterhead is not linked to the masthead of a periodical, how should it look?

We are now quite familiar with the features of the first Futurist stationery (fig. 5). Its colour, red, had been employed by Marinetti as a trademark for the group's identity since its inception. The colour red was used in the posters Marinetti plastered on the walls of Milan in Futurism's first advertising campaign. It re-appeared later, in the alternative title ('Il Futurismo') on the cover of *Poesia* in 1909 and in the ink used for the 'transitional' envelopes of 1910, advertising '*Poesia* motore del Futurismo'.

The typeface used in the letterhead is, however, quite uncommon and merits a closer look. It seems to be a Jenson-style font, probably modelled on the example of William Morris' own Golden type (fig. 8). The letters' axes are slanted, the font is bold and sports an iconic diamond-shaped dot. Scholars of Futurism are familiar

with it, since it was used for the letterhead of the movement well into the mid-twenties. For a certain period, this stationery even co-existed with the more famous one incorporating Balla's drawing, *Boccioni's Fist*. The font was not, however, an *unicum* invented for the movement. It was used repeatedly by the Casa Editrice Treves to advertise its publications.[48] It also appears in *Poesia*, which was published by the Poligrafia Italiana in the last part of its run, from 1907 to 1909.

While today this typeface might seem to be a very original and almost esoteric choice, at the beginning of the twentieth century it held an entirely different meaning. In typographic circles, the choice of a character modelled after the clear and elegant types designed in Venice by Nicolas Jenson during the Renaissance amounted to a decisive rejection of the incoherent mingling of typefaces that had characterized the mid-nineteenth century. It was also a clear statement in support of the more recent trends toward the definition of streamlined visual types to be used in a uniform manner for each printed document, a goal that William Morris had championed with his own Kelmscott Press. In Italy, moreover, the need to maintain a certain level of visual coherence in commercial typographic work was associated with the search for a specifically 'national' character that would revive the glory of the great printing traditions of the past. In his 1912 volume devoted to the use of typefaces and decoration in the print shop, the Milanese typographer Arturo Malacrida, for example, wrote that ' in linea generale, ogni lavoro moderno esige dei caratteri di un solo stile e non permette l'introduzione di gruppi di altri caratteri' [in general, any modern work requires a single style of typeface and does not allow for the introduction of other typefaces].[49] And the *Giornale della libreria, della tipografia e delle arti e delle industrie affini* [*Journal of the Book Industry, Typography, and Related Arts and Crafts*], introducing Malacrida's book, framed his plea for simplicity and modernity as a sign of 'l'attuale appassionato momento di riforma grafica per la ricerca di un carattere schiettamente italiano' [the current, impassioned moment of graphic reform, in which a distinctly national typeface is being sought].[50]

The visual strength of the first Futurist letterhead results from a mix of simplicity and boldness in colour and typeface, in line with the more advanced contemporary trends in the field of graphic design. But some questions remain unanswered. Why did Marinetti select this particular typeface for the letterhead? Why not use the Garamond-style font of the 1910 *Poesia* envelopes, or the sans-serif font of the lower title 'Futurismo' that had already appeared on the cover of *Poesia* in 1909? What was specifically 'Futurist' in the choice of this typeface?

We have established that the first Futurist letterhead was composed, with all probability, in the workshop of the Poligrafia Italiana at the end of 1911. It would therefore be interesting to compare this stationery with other ephemera created by the same company for the Futurist group. Since very few scholars are aware of the fact that two different print runs of the manifestos exist, and that they were printed by two different print shops, nobody seems to have tried to retrace the original, typographic appearance of the first Futurist manifestos. However, if we distinguish the first run of these leaflets, published by Poligrafia Italiana, from the second,

FIG. 9. First page of *La musica futurista. Manifesto tecnico,* dated 11 March 1911, Fondo Pratella — Biblioteca Comunale 'F. Trisi' — Lugo (Ravenna).

published by Taveggia, we see that a certain visual pattern emerges. In the first run of the manifestos, the majority of the titles are created using the same typeface of the Futurist letterhead. It appears, albeit not in boldface, in the first *Manifesto dei pittori futuristi* [*Manifesto of the Futurist Painters*], created in the second half of February 1910 and signed by Umberto Boccioni, Carlo Carrà, Luigi Russolo, Aroldo Bonzagni e Romolo Romani.[51] In August 1910, the masthead of the *Discours futuriste aux Vénitiens* employs the exact typeface of the future letterhead. Most of the subsequent manifestos and leaflets published until 1912 follow the same visual model (fig. 9).[52]

Apparently, maintaining the same font for the heading of the leaflets was the result of an explicit decision on the part of Marinetti. This choice of visual coherence was, however, later buried and forgotten under the profusion of the

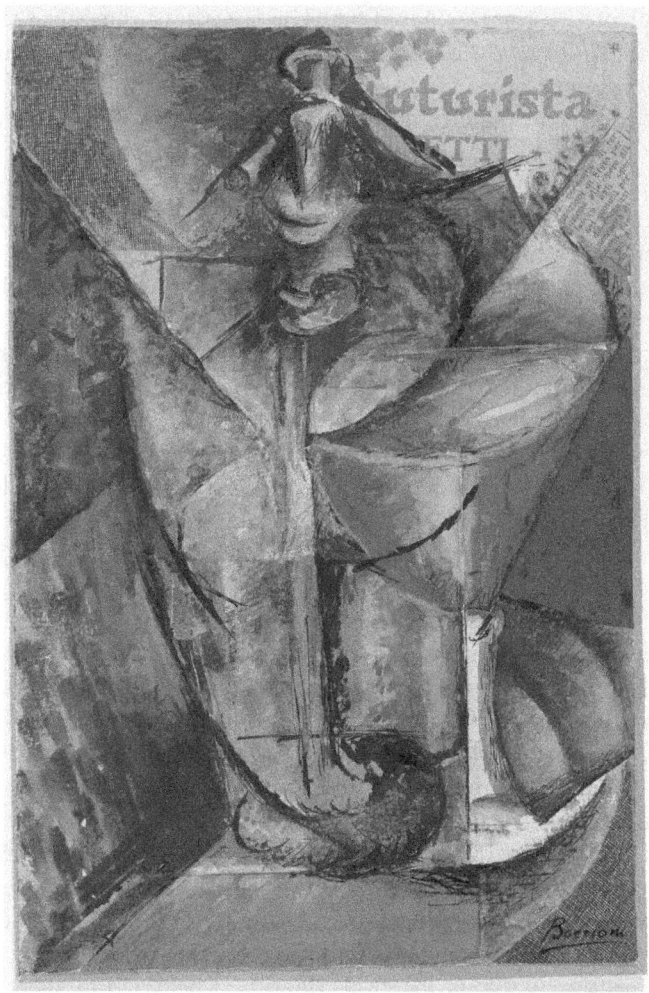

FIG. 10. Umberto Boccioni, *Still Life: Glass and Siphon*, collage, gouache, pen and ink, 1914, Yale University Art Gallery, New Haven, CT.

subsequent reprints. In the eyes of scholars working a century later, all manifestos were considered equally original. But to the Futurists, in 1911, the need to visually brand their identity through a recurrent visual clue, a typographical *fil rouge* if not already a proper logo, was a capital issue. At the moment in which they officially assumed the status of a coherent movement, their letterhead functioned as an ideal mnemonic pattern for their numerous manifestos and achievements.

The letterhead's typeface was maintained as the font for the manifestos for a few months after the switch to the Taveggia workshop.[53] It was replaced in the middle of 1912 with another old-style typeface. The headings of the leaflets for Boccioni's *Manifesto tecnico della scultura futurista* [*Technical Manifesto of Futurist Sculpture*] and Marinetti's *Manifesto tecnico della letteratura futurista* [*Technical Manifesto of Futurist*

Literature] are printed using this new font. The letterhead, however, survived in its original form for quite a while. Marinetti must have, at a certain point, requested copies of this stationery, since we find it still in use well into the twenties. A letter that he wrote to Gino Soggetti in 1921, for example, was written on a type of stationery that used the same letterhead on a smaller sheet of paper.[54] It was probably created by reprinting the original letterhead through an electrotype duplicate, shrinking it to the size of the new smaller sheet and adding the address line in another font underneath it.[55]

In conclusion, it is quite possible that the delay in the creation of a letterhead specifically devoted to the Futurist movement owed to the laborious process of making a difficult decision — that of moving away from the more traditional models of identity available to artistic and political associations at that time. In other terms, it owed to the drive to fully become a 'movement'. In a cultural environment deeply rooted in the idea that journals are the preeminent forums of debate and the centres of activity, Marinetti's decision not to resurrect *Poesia* was clearly radical. For the Futurists, disentangling themselves from the direct association with a journal meant reconfiguring their presence in the fields of art and politics as an autonomous entity. And the fact that their identity as a movement, typographically spelled out on their letterhead, carried with it the visual echo of the manifestos that they had diffused until then is an element that should not be overlooked.

It is probably for this reason that two years later Umberto Boccioni decided to insert a sheet of the Futurist stationery in one of his most striking collage still lifes (fig. 10).[56] The majority of the Cubists would have by default selected one of the many journals and reviews of the time. In those same months, his *amis-ennemis* from *Lacerba* were turning their paintings into a celebration of their periodical. Boccioni's choice was instead to insert the red letterhead of the movement as the ideal backdrop for the representation of a siphon, one of his favourite icons of modern life in the city. The dimensions of this collage are similar to those of the Futurist writing paper, so that the letterhead on the upper-right corner maintains a striking, direct referential connection with its material identity. The writing sheet is not glued onto the base of the collage, but the upper-right side of the composition is instead cut to insert the Futurist stationery, and this enhances the visual effect of flatness and uniformity. The painted surface and ink drawing expand from the image of the siphon on top of the letterhead. The black ink, however, does not cover the letters 'I' and 'E' of 'Marinetti', as if Boccioni had deliberately blotched the ink dry on those letters to make sure that the name remained readable. On the upper left- and lower right-hand corners of the work, he glued two blue paper elements, angled and convex, filled with a thin, web-like pattern. They ideally contain and enclose the composition. On closer examination, the pattern appears to be a fine, irregular warp of lines. Boccioni used shreds of the interior of a common envelope, which at the beginning of the twentieth century started to be covered with these kinds of coloured patterns, in order to make the white paper less transparent and impede people from deciphering the text contained in it. The envelopes created for the Futurist movement did not have this patterned interior and therefore Boccioni

could not use them to enhance the blue and pink tonality of the collage. He cut the pieces from a more common, commercial envelope. According to Marino Bignami, historian and expert of the Italian postal system, this patterned surface was obtained at the time by photoengraving (or direct engraving) a piece of real gauze. This explains why the web of blue lines is irregular. Boccioni used it in the shaded areas that surround the siphon and glass, perhaps in order to suggest the pattern of a blue tablecloth that covers a small café table. In the conceptual structure of the collage, these pieces of envelope refer both to the café, as the modern setting in which the Futurists held their meetings, and, along with the red Futurist stationery, to the centrality of letters and correspondence in the inner organisation and activity of the movement.

The collage, with its bright colours and subtle intersection of materials, can be read as a polemical response to Cubist collages. But it is also a statement on the remarkable distinctiveness that Futurism had achieved among the modernist trends of the time. Far from being contained on the pages of a monthly, its true identity as a movement is rooted in a ceaseless and boundless activity of intellectual production and diffusion, which finds in the red letterhead its ultimate icon.

Notes to Chapter 6

1. For Giovanni Lista, the first Futurist letterhead appeared quite probably toward the end of 1911. Maurizio Scudiero agrees with that year, on the basis of postmarked examples found in the Futurist correspondence. See Giovanni Lista, *L'art postal futuriste* (Paris: Jean-Michel Place, 1979), p. 15–18; Maurizio Scudiero, 'Le intestazioni del movimento futurista', in *Futurismi postali*, ed. by Maurizio Scudiero (Rovereto: Longo Editore, 1986), p. 29.
2. See Giovanni Lista, *Les futuristes* (Paris: Henri Veyrier, 1988), pp. 107–09 and, more recently, Domenico Cammarota, *Filippo Tommaso Marinetti. Bibliografia* (Geneva and Milan: Mart-Skira, 2002) and Paolo Tonini, *Caffeina d'Europa. Marinetti nella collezione dell'Arengario, 1898–1945* (Gussago: Edizioni dell'Arengario, 2009), pp. 12–13.
3. The Poligrafia Italiana printed two versions of the leaflet, one in Italian and one in French. A second printing of the same leaflet was issued in black ink. The letter is reproduced in Paolo Tonini, *I Manifesti del Futurismo. 1909–1945* (Gussago: Edizioni dell'Arengario, 2011), p. 7. See also *Futuravanguardismi. Libri, riviste, opere e documenti originali del Futurismo e dei movimenti d'avanguardia pro contro o ad esso vicini* (Gussago: Edizioni dell'Arengario, 2011). While this essay was being published, two articles have called attention to the manifesti's editions. See Paolo Tonini, '1909. Le prime edizioni del Manifesto del Futurismo' http://www.arengario.it/futurismo/storia-del-futurismo-1909-il-manifesto-del-futurismo (accessed 22 May 2016) and Giacomo Coronelli, 'Spigulature bibliografiche sui manifesti futuristi 1909–1910 (con nuovi elementi per una sistemazione cronologica)', in *ALAI: Rivista di cultura del libro dell'Associazione Librai Antiquari d'Italia*, 2 (2016) http://www.alai.it/pubblicazioni/alai-rivista-di-cultura-del-libro-dell-associazione-librai-antiquari-d-italia-n-2–2016 (accessed 1 August 2016).
4. Examples of the three different versions of the *Poesia* envelopes used between 1908 and 1910 are reproduced in Giacomo Coronelli and Laura Nicora, *Futurismo. Ephemera Manoscritti con collaudo di Domenico Cammarota* (Milan: Libreria Antiquaria Pontremoli, 2010), p. 118.
5. See the letters by Umberto Boccioni to Gino Severini, undated (but written between 27 April and 17 May 1910) and by Umberto Boccioni to Gian Pietro Lucini (undated but written between 28 May and 30 August 1910) in Umberto Boccioni, *Lettere futuriste*, ed. by Federica Rovati (Milan: Mart-Skira 2009), pp. 17–19, 193–97 and 199.
6. Letter of Filippo Tommaso Marinetti to an unknown woman (probably Amalia Guglielminetti), undated but 1909, F.T. Marinetti correspondence and papers, 1886–1974, 850702, box 8, folder

3, The Getty Research Institute, Los Angeles. A short passage from the letter is cited in Walter L. Adamson, 'Futurism, Mass Culture, and Women: The Reshaping of the Artistic Vocation', *Modernism/Modernity*, 4.1 (1997), 89–114 (p. 100). Adamson however locates the letter in the Marinetti collection housed in the Beinecke library at Yale University. It is possible that the Getty and the Beinecke contain two different drafts of the same letter.
7. Ibid.
8. Ibid.
9. Marinetti recalls the event in *La grande Milano tradizionale e futurista. Una sensibilità italiana nata in Egitto*, ed Luciano de Maria (Milan: Arnoldo Mondadori Editore 1969), p. 92. See also Claudia Salaris, 'Marketing Modernism: Marinetti as Publisher', *Modernism/Modernity*, 1.3 (September 1994), 109–27 (p. 112).
10. Letter of Filippo Tommaso Marinetti to an unknown woman (probably Amalia Guglielminetti), undated but 1909, F.T. Marinetti correspondence and papers, 1886–1974, 850702, box 8, folder 3, The Getty Research Institute, Los Angeles.
11. Filippo Tommaso Marinetti, 'Destruction of Syntax — Untrammeled Imagination — Words-in-Freedom,' in F. T. Marinetti, *Critical Writings*, ed. by Günter Berghaus, (New York: Farrar, Straus and Giroux, 2006), p. 128. See also David Cundy, 'Marinetti and Italian Futurist Typography', *Art Journal* 41.4 (Winter 1981), 349–52.
12. Letter of Filippo Tommaso Marinetti to an unknown woman (probably Amalia Guglielminetti), undated but 1909, F.T. Marinetti correspondence and papers, 1886–1974, 850702, box 8, folder 3, The Getty Research Institute, Los Angeles.
13. Ibid.
14. It appears that these envelopes were used in 1910 at the earliest. Lista and Scudiero both date them to this year. See also *Futurismo. Ephemera Manoscritti*, p. 118.
15. An Italian version is published in Scudiero, 'Le intestazioni', p. 30.
16. A French version in published in Lista, *L'art postal*, p. 15.
17. As reported by Salaris, Marinetti had announced the transformation of his monthly into a weekly in a letter to Le Mercier d'Erm, probably dated to the end of 1909. Cfr. Salaris, *Marinetti editore* (Bologna: Il Mulino, 1990), p. 90. Two years later, in 1912, organising the layout of Luciano Folgore's *Il canto dei motori* and of the anthology *I poeti futuristi*, Marinetti will insert an advertising page dedicated to '*Poesia* motore del Futurismo (sixth year)' at the end of these volumes. Again, however, more than the actual re-launch of the journal, this appears to be a ploy to publicise the catalogue of the homonymous Edizioni futuriste di *Poesia*. See Luciano Folgore, *Il canto dei motori* (Milan: Edizioni futuriste di *Poesia*, 1912), p. 203.
18. On the first page of the first issue of *Il Futurismo*, Marinetti advertises the 'Grande Serata di Poesia Futurista' of 15 February 1910 at the Teatro Lirico in Milan. The leaflet contains Marinetti's essay 'Che cos'è il Futurismo?' (p. 1); the 'Manifesto del Futurismo' and 'Il trionfo dei Futuristi a Trieste' (p. 2); reviews of Paolo Buzzi's *Aeroplani* and Gian Pietro Lucini's *Revolverate* (p. 3); 'I significati del Futurismo secondo Paolo Arcari del giornale clericale *L'Avvenire d'Italia* di Bologna' (11 January 1910) (pp. 3–4).
19. On page 4 of the first issue of *Il Futurismo*, in the advertising section, we read: 'The subscription to the Rassegna Internazionale *Poesia* (10 lire for Italy, 15 for abroad) is completely reimbursed by the gift of 4 works to be chosen' among the books of the Edizioni Futuriste di *Poesia*'. At that date the editions comprise ten volumes: Paolo Buzzi's *L'Esilio*, Enrico Cavacchioli's *L'incubo velato*, Emilio Zanotto's *Giovanni Pascoli*, Federico de Maria's *La leggenda della vita*, Gian Pietro Lucini's *Il verso libero*, Gian Pietro Lucini's *Il carme di angoscia e di speranza*, Enrico Cavacchioli's *Le ranocchie turchine*, Paolo Buzzi's *Aeroplani*, Gian Pietro Lucini's *Revolverate*, Aldo Palazzeschi's *L'incendiario*. The leaflet also lists four works 'of imminent publication' by Marinetti: the *Enquête internationale sur le Vers libre*; *Futuristi e passatisti* (500 pages); *Les remparts du passé* (400 pages); *La victoire du futurisme* (400 pages).
20. See the facsimile of this manifesto reproduced in Jean-Pierre de Villers, *Debout sur la cime du monde. Manifestes futuristes 1909–1924* (Paris: Éditions Dilecta, 2008), pp. 44–47, where a reference to '*Poesia* Moteur du Futurisme. 2, Via Senato — MILAN' follows Marinetti's signature.
21. The first issue of *Il Futurismo*, dated 11 February 1910, was published by the Società Anonima

Poligrafica Italiana [Poligrafia Italiana], located in Via Stella (now Via Corridoni), 9, Milan. It was the same typographic company that published the last three years of *Poesia*, the very first issue of the *Manifesto of Futurism* and other early manifestos. See Salaris, *Marinetti editore*, p. 40. The Società had been established in 1907, bringing together several printing enterprises. See *Il Giornale della libreria, della tipografia e delle arti e industrie*, 20. 43, (10 October 1907), 526. Only the first issue of *Il Futurismo*, however, was published in Milan. The second and final issue, undated, was published in Padua by the Stabilimento Grafico A. Molini. Its masthead is composed of thick and narrow fonts, which differ from the Bodoni-style ones used by Poligrafia Italiana for the first issue. The second issue advertises Boccioni's show at Ca' Pesaro, which opened on 17 July 1910, and the Futurist Artistic Soirée at the La Fenice Theatre in Venice planned for 1 August 1910. It might have been published in Padua because it was conceived as a leaflet to be distributed at the Venice soirée, which was followed shortly by another event in Padua. The fact that it does not have a publication date adds to the impression of a somewhat more *impromptu* release. Marinetti would continue to work with the Poligrafia Italiana for the entire following year of 1911.
22. The font is quite similar to the Zeppelin type produced by Rudolf Koch at the Klingspor Foundry between 1927 and 1929.
23. Lista, *L'art postal*, p. 15–18.
24. Antiquarian catalogues generally date these reprints to 1912. The typeface and layout used for them, however, seems to appear only later and is used for example in the Italian and French leaflets for Russolo's *L'arte dei rumori*, dated 11 March 1913.
25. Salaris, *Marinetti editore*, p. 159. Footnote n. 55 reads: 'Si ricordi peraltro che Marinetti usava far ristampare sempre i vecchi manifesti, che continuava a distribuire anche se era passato del tempo dalla loro prima apparizione' [It should be noted, in any case, that Marinetti used to reprint his old manifestos, which he continued to circulate even long after they had first been issued].
26. Unfortunately, a complete list of the manifestos, outlining first editions and reprints does not currently exist. In his otherwise very useful bibliography, Domenico Cammarota does not clarify the distinction between the first and the second printing of certain manifestos. See, for instance, Francesco Balilla Pratella's *La musica futurista. Manifesto tecnico* (Manifesti futuristi 10; Futurismo volantini 47), which appears in Cammarota's bibliography as published originally with the caption 'Direzione del Movimento futurista'. However, the first edition of this manifesto was issued with the caption 'Dalla redazione di *Poesia*', while the reference to the 'Movimento' must have appeared only in a subsequent reprinting, probably dated around 1912–1913. See Domenico Cammarota, *Futurismo. Bibliografia di 500 scrittori italiani* (Milan: Mart-Skira, 2006), p. 251 and 271. The two editions of the manifesto are described in an antiquarian catalogue from the Libreria Pontremoli: *Futurismo 1909–2009. Collaudo Pablo Echaurren* (Milan: Libreria Pontremoli, 2009), p. 14. See also the 'Catalogo cronologico degli scritti e delle trascrizioni musicali di F.B. Pratella editi dal 1900 dal 1995,' in Domenico Tampieri, *Francesco Balilla Pratella: edizioni, scritti, manoscritti musicali e futuristi* (Ravenna: Longo 1995), pp. 404–16.
27. Tonini, *Caffeina*, p. 13.
28. Letter by Marinetti to Luciano Folgore in Filippo Tommaso Marinetti and Luciano Folgore, *Carteggio futurista*, ed. by Francesco Muzzioli (Rome: Officina 1987), p. 41 and Salaris, *Marinetti editore*, p. 116. Salaris dates the liquidation of the company to January 1912 and suggests that this was the reason why the first edition of Marinetti's *La battaglia di Tripoli* was published by Tipografia Elzeviriana in Padua. See Salaris, *Marinetti editore*, pp. 115–16.
29. Federica Rovati (Umberto Boccioni, *Lettere futuriste*, p. 218) refers to the original lease contract held at the Getty (F.T. Marinetti Correspondence and Papers, 850702, box 1, folder 19: *Investitura per affitto di case*, Milan 21 April 1910).
30. Salaris, *Marinetti. Arte e vita futurista* (Rome: Editori Riuniti,1997), p. 115.
31. See the letter from Nino Caravaglios to Pratella dated 9 January 1912 and published by Matteo D'Ambrosio, *Nuove verità crudeli. Origini e primi sviluppi del Futurismo a Napoli* (Naples: Guida, 1990), p. 418. On 1 December 1911, Marinetti is still in Tripoli, according to a letter from Boccioni to Apollinaire, see Boccioni, *Lettere futuriste*, p. 31.
32. Apparently the Poligrafia Italiana stopped its activity on 9 December 1911, and was liquidated in

1913. Taveggia took over at least part of the Poligrafia's business. See *Editori a Milano (1900–1945): Repertorio*, ed. by Patrizia Caccia (Milan: Franco Angeli, 2013), p. 249 (where however the Poligrafia is indicated as 'Poligrafica') and p. 305.
33. See, for instance, Salaris, 'Marketing Modernism' (p. 119):

> In the 'heroic' period of the 'words-in-freedom', one of his [Marinetti's] followers (Cesare Cavanna) collaborated closely with a trusted typographer (working for Angelo Taveggia) under directions furnished by Marinetti during every stage of printing, from the rough sketch to the completed volume.

34. In terms of leaflets, the last issued by Taveggia should be *Che cosa propongono i 'Tricolori del Brennero'* (11 January 1926). See Cammarota, *Futurismo. Bibliografia*, p. 146. At least until the same date, Taveggia also published the periodical *Il Futurismo*. The 11 January 1926 issue of this periodical was devoted to the First Futurist Congress in Milan and printed by Taveggia. At that date, Marinetti had already moved to Rome. On the masthead, in fact, his address is indicated as 'Roma (33) — Piazza Adriana 30'. For the progressive abandonment of the medium of the manifesto leaflet, signalling a decline in the avant-gardist practice of Futurism, see Luca Somigli, *Legitimizing the artist. Manifesto Writing and European Modernism, 1885–1915* (Toronto: University of Toronto Press, 2006), p. 161.
35. See, for instance, the following from Marinetti: 'Per quest cöl coeur te podi dì / che g'ho scövert in ti: / l'amis dij amis, Cavanna, pussé dulz de la manna' ['For this, I can tell you from my heart / that I discovered in you: the friend of friends, Cavanna, sweeter than manna']. The poem is quoted in Salaris, *Marinetti editore*, p. 159.
36. Scholars do not seem to agree on the exact month of the publication of *Il canto dei motori*. According to Salaris (*Marinetti editore*, p. 116), the book was published before April 1912; according to the tract *Le vittorie della pittura futurista*, the date should be around July 1912. See the tract, dated 11 July 1912 and reprinted in *I poeti futuristi* (Milan: Edizioni futuriste di Poesia, 1912), p. 42.
37. A copy of the leaflet, with the indication of the print shop that printed it (Poligrafia Italiana — Milano), is in the collection of the Università degli Studi di Milano, Collezione '900 Sergio Reggi. Cammarota lists a version of this leaflet printed by Taveggia and proposes dating it to January 1912. This document, however, is in all likelihood a reprint. He also lists under the year 1912 another leaflet published by Poligrafia Italiana, undated (*Il musicista futurista Balilla Pratella trionfa a Pesaro*). See Cammarota, *Futurismo. Bibliografia*, p. 272 (Volantini futuristi 66). It is more probable that the latter leaflet was printed in May 1911, following the Futurist soirée at the Teatro Rossini in Pesaro. For more on the event, see Günter Berghaus, *Italian Futurist Theatre, 1909–1944* (Oxford: Clarendon Press, 1988), p. 150 and for the suggestion of the date, see *Futurismi in Italia e nel mondo: libri manifesti riviste ephemera documenti*, (Gussago: L'Arengario studio bibligrafico, 2006), p. 51.
38. Camille Mauclair, *Le Futurisme et la jeune Italie — Il Futurismo e la giovane Italia*, 4-page leaflet, undated but published at the end of 1911, unpaged but page 4. Mauclair's article explicitly links the Futurists' patriotism with the doctrines of Giuseppe Mazzini and Daniele Manin.
39. Ibid.
40. Günter Berghaus, 'Introduction: F.T. Marinetti (1876–1944): A Life Between Art and Politics', in Marinetti, *Critical Writings*, pp. xvii-xxix (p. xix).
41. See, for instance, his article 'Le mouvement poétique en Italie', *La Vogue*, April 1899, pp. 61–66.
42. See Cammarota, *Futurismo. Bibliografia*, p. 251 (section IX, item 3). See also Filippo Tommaso Marinetti Libroni Slides, Beinecke Rare Books & Manuscript Library, Yale University, GEN MSS 475 / 00013–02.
43. See Rovati's comments in Boccioni, *Lettere futuriste*, p. 216. In the preface written for the anthology *I poeti futuristi*, Marinetti cites a manifesto that he had launched before leaving for Tripoli. He explicitly refers to the need to suspend any artistic activity during the war: 'Futurist poets, painters, sculptors and musicians of Italy! Let's leave aside, as long as the war lasts, our verses, brushes, chisels and orchestras! The red holidays of the genius have started!' See 'Ai giovani italiani. Proclama di F.T. Marinetti,' in *I poeti futuristi* (Milan: Edizioni futuriste di Poesia, 1912), p. 8.

44. A letter written by Boccioni to Guillaume Apollinaire and dated 1 December 1911 seems to support this hypothesis. One passage, in particular, reads:

> Si notre ami Marinetti était là, il ne manquerait pas, j'en suis sûr, de vous exprimer lui aussi sa gratitude. Mais il est toujours à Tripoli, ou il prend une part très active à la guerre, en vaillant futuriste. J'ai sous la main un numéro du *"Piccolo"* de Trieste ou je trouve le récit d'une sanglante escaramouche dans laquelle notre ami s'est couvert de gloire. [...] Comme vous voyez, notre ami ne doit pas s'embêter là-bas!... Quant à nous les peintres futuristes, nous travaillons acharnément pour terminer de nous préparer à notre exposition chez Bernheim, le champ de bataille où dans deux mois nous mettrons en batterie nos canons...'.
>
> [If our friend Marinetti were here he would not fail, I am sure, to express you his gratitude as well. But he is still in Tripoli, where he takes an active part in the war, as a valiant Futurist. I have on hand an issue of *Il Piccolo* from Trieste in which I find the story of a bloody skirmish during which our friend has covered himself in glory. [...] As you see, our friend does not get bored over there! ... As for us, Futurist painters, we work hard to get ready for our exhibition at Bernheim's, the battlefield where in two months we will put our guns in battery...] (Boccioni, *Lettere futuriste*, p. 31).

45. The letters, written to Vico Baer and Gino Severini, are now housed at the MOMA (New York) and at the Archivio del '900 (Fondo Severini, MART, Rovereto). For the date, see Boccioni, *Lettere futuriste*, p. 218.

46. As already stated, *Poesia* ceased publication in 1909 and while the use of its letterhead might have been acceptable throughout 1910, by 1911 it had become quite outdated. Even before the arrival of the expression 'Direzione del Movimento futurista' on the new letterhead and at the end of the manifestos, the way that the Futurists' affiliation to *Poesia* was acknowledged changed significantly over time. Here is a chronological list of the different ways that *Poesia* and Marinetti's address were identified on the back of the first run of the manifestos published by Poligrafia Italiana: 'Redazione di *Poesia*, Via Senato, 2 — Milano' (Boccioni, Carrà, Russolo, Bonzagni, Romani, *Manifesto dei pittori futuristi*, leaflet undated but March 1910); 'Uffici di *Poesia* — Via Senato, 2' (Boccioni, Bonzagni, Carrà, Russolo, Severini, *La pittura futurista. Manifesto tecnico*, dated 11 April 1910); '*Poesia* — 2, Via Senato — MILAN' (Boccioni, Carrà, Russolo, Balla, Severini, *Manifesto of the Futurist Painters*, dated 11 April 1910); '*Poesia* Moteur du Futurisme 2, Via Senato — Milan' (Marinetti, *Discours futuriste aux Vénitiens*, undated but probably August 1910); 'Dalla redazione di *Poesia*, Via Senato, 2' (Marinetti, *Manifesto dei drammaturghi futuristi*, dated 11 October 1910; Pratella, *Manifesto dei musicisti futuristi*, dated 11 October 1910); 'Redaction de *Poesia*, — Via Senato, 2' (Marinetti, *Manifeste des auteurs dramatiques futuristes*, dated 22 April 1911).

47. Letter by Renzo F. Provinciali to F.T. Marinetti, Parma 9 May 1911, F.T. Marinetti Correspondence and Papers 850702, box I, folder 23. Getty Research Institute, Los Angeles. On Provinciali, see Alberto Ciampi, *Futuristi a anarchici, quali rapporti?* (Pistoia: Archivio Famiglia Berneri, 1989) and Renzo Provinciali, *Anarchia e futurismo — Gian Pietro Lucini, Revolverate*, ed. by Alberto Ciampi (Turin: Nautilus, 1993).

48. See the 'Bullettino [sic] di Novità Letterarie dei Fratelli Treves', inserted in every issue of the *Giornale della libreria, della tipografia e delle arti e delle industrie affini* and in particular the 'Bullettino' no. 57, February 1907, in *Giornale della libreria, della tipografia e delle arti e delle industrie affini* 20.10 (3 March 1907), 97–100.

49. According to Malacrida:

> In linea generale, ogni lavoro moderno esige dei caratteri di un solo stile e non permette l'introduzone di gruppi di altri caratteri, a meno che non si tratti di un lavoro commerciale di tipo litografico. Anche per i caratteri corsivi, l'applicazione in serie è un ottimo effetto e corrisponde alle moderne esigenze'.
>
> [In general, any modern work requires a single style of typeface and does not allow for the introduction of other typefaces, unless it is a commercial work of a lithographic kind. Even for italics, the application in series assures great results and corresponds to the modern requirements.]

See Arturo Malacrida, 'Per l'Officina,' *Giornale della libreria, della tipografia e delle arti e delle industrie affini* 25.3 (23 January 1912), p. 40. Malacrida's 1912 volume was entitled *L'applicazione dei caratteri e dei fregi* and was followed in 1913 by another volume, aptly titled: *Un nuovo rinascimento, studio comparativo dell'arte tipografica*. For the debate on the renewal of the graphic arts in Italy at the beginning of the twentieth century and its relation to Futurism, see Manuela Rattin and Matteo Ricci, *Questioni di carattere. La tipografia in Italia dal 1861 agli anni Settanta* (Rome: Stampa Alternativa, 1997); *Edizioni elettriche. La rivoluzione editoriale e tipografica del futurismo* (Rome: Edizioni De Luca, 1995) and Terenzio Grandi, *Dal futurismo tipografico alle nostalgie del bibliografo* (Campobasso: Palladino, 2007).

50. Notice also the political reference in the editorial introduction to Malacrida's text: 'Nell'attuale appassionato momento di riforma grafica per la ricerca di un carattere schiettamente italiano, siamo lieti di vedervi associati l'opera dei nostri intelligenti operai che, all'infuori dei soliti turbolenti meetings di rivedicazione proletaria, studiano e lavorano' [In the current passionate moment of graphic reform in search of a genuinely Italian character, we are pleased to see the contributions of our intelligent workers who, apart from the unusual turbulent meetings on proletarian claims, study and work]. See the unsigned introduction to 'Per l'Officina,' in *Giornale della libreria, della tipografia e delle arti e delle industrie affini* 25.3 (23 January 1912), p. 40.

51. It is well known that Marinetti had a predilection for the number 11 and employed it to assign a date to the Futurist manifestos, which are in fact often arbitrarily dated on the 11^{th} day of the month. For the dating of this manifesto, see also *Galleria d'arte moderna Aroldo Bonzagni di Cento*, ed. by Fausto Gozzi (Cento: Federico Motta editore-Comune di Cento, 2006), p. 36. Two different fonts are used in the leaflet for the following manifesto *La pittura futurista. Manifesto tecnico* [*Futurist Painting. Technical Manifesto*], dated 11 April 1910 and originally signed by Boccioni, Bonzagni, Carrà, Russolo, Severini (Bonzagni's name will be replaced by Balla's in subsequent printings). See the manifesto in the Collezione '900 Sergio Reggi, Università degli Studi di Milano.

52. I have not been able to consult the entire series of manifestos published by the Poligrafia Italiana. Some of them are still coming to light in public collections, antiquarian catalogues or online sales. However, on the basis of the print shop listed on the back of the manifestos and of the typographic font used, it is possible to correct some of the contradictory data that appear in Cammarota's bibliography. I consulted the originals in the online collection of the Università degli Studi di Milano, Collezione '900 Sergio Reggi (Reggi) or reprinted in Jean-Pierre de Villers, *Debout sur la cime du monde* (Villers). The following is therefore not an exhaustive list of manifestos printed by the Poligrafia Italiana which use the same typeface of the first Futurist letterhead: *Manifesto of the Futurist Painters*, 11 April 1910 (probably printed around December 1910, to be distributed at Marinetti's conference at the Lyceum Club in London) and *Discours futuriste aux Vénitiens*, undated (August 1910) (Villers); *Manifesto dei drammaturghi futuristi*, 11 October 1910 (Reggi); *Manifesto dei musicisti futuristi*, 11 October 1910 (private collection); *La musica futurista. Manifesto tecnico*, 11 March 1911 (*Note futuriste. L'archivio di Francesco Balilla Pratella e il cenacolo lughese*, ed. by Orlando Piraccini and Daniele Serafini (Bologna: Editrice Compositori, 2010), p. 18); *Manifeste des Auteurs dramatiques futuristes*, 22 April 1911 (Reggi and Villers); *Manifeste des musiciens futuristes*, 11 May 1911 (*Futuravanguardismi*, n. 351). The same typeface is also used for at least one manifesto published by Taveggia in the first part of 1912: the *Manifesto della donna futurista*, dated 25 March 1912 (Reggi and Villers).

53. The letterhead's font is still used, in bold, for the title of the *Manifesto della donna futurista* by Valentine de Saint-Point, dated March 1912 and issued by Taveggia in Italian and French. In these two leaflets, however, the body of the text as well as subtitles and signatures are all created by using other fonts. When Taveggia later printed the leaflet for the German translation of the same manifesto, *Manifest der Futuristischen Frau*, which had appeared in the May 1912 issue of *Der Sturm*, he used another font. It is possible that Taveggia did not possess the entire stock of types utilized by the Poligrafia Italiana or that Marinetti abandoned the idea to use a uniform typeface for all his subsequent leaflets. Still, there appears to be a distinction between the leaflets published by Taveggia in 1912 and those published after 1913. In the latter series, in particular, titles are often in capital letters and/or with a double underline. Leaflets printed in 1912 have lower-case titles that are not underlined.

54. Letter from F.T. Marinetti to Gino Soggetti, [undated but 28 April 1921], Gino Soggetti Papers, 860387, box I, folder 1, The Getty Research Institute, Los Angeles.
55. I wish to thank John Hutcheson who suggested that the letterhead on the stationery used in the 1920s was probably a reprint from an electrotype duplicate and pointed out the change in fonts in its address line. I would also like to thank Suzanne Greenawalt at the Yale Art Gallery, Marino Bignami, author of *Storia postale italiana* (http://www.postaesocieta.it/), Emanuele Mensa of the Archivio Tipografico (Turin) and Ilaria Chabert of Antiche Officine Pineider (Florence) for their help with my research.
56. For a reassessment of this collage, see Christine Poggi, *In Defiance of Painting. Cubism, Futurism and the Invention of Collage* (New Haven and London: Yale University Press 1992), pp. 181–83 and Federica Rovati, 'Opere di Umberto Boccioni tra il 1914 e il 1915', *Prospettiva* 112 (October 2003 [but November 2005]), 48–50. Rovati identifies the stationery used in this collage with a variation of the original 1911 one, with the added slogan 'Marciare non marcire'. However, this slogan is not visible in the collage and Boccioni did not use that letterhead consistently and in any case not before 1915. It is more plausible that, here, Boccioni employed the first and more iconic Futurist writing paper.

CHAPTER 7

❖

Numbers

Matteo D'Ambrosio, Università Federico II, Napoli


The artist of number is coming to replace the artist of word

VELIMIR KHLEBNIKOV, 1919[1]


All major artistic and literary movements of the twentieth century felt the inclination to define their roots and precursors. While André Breton liked to refer to the Marquis de Sade, and considered Lautréamont, among others, as one of the fathers of Surrealism, Marinetti viewed artists like Michelangelo and Leonardo to be Futurists. A form of writing with a strong sensitivity towards numbers plays a major role in such historical self-portrayals and other types of writing of the historical avant-gardes and their successors. Famous examples include the works of certain Dadaists, perhaps most notably the number poems of Kurt Schwitters published in 1921 by the Dutch magazine *De Stijl*. The later numerical art by American artist Richard Kostelanetz, and the way texts of Concrete Poetry were used for early experiments in Computer Poetry, offer just a few more recent illustrations. This chapter focuses on a number of salient cases from Russian and Italian Futurism, in particular because a microhistorical take on the interest in numbers in both movements contributes to highlight to what extent, and contrary to what is often maintained, the dialogue between Italian Futurism (and Marinetti in particular) and its Russian counterpart (especially Velimir Khlebnikov, via Roman Jakobson) has been multi-faceted and complex.

The great linguist and literary theorist Roman Jakobson liked to say, on every possible occasion, that he considered Velimir Khlebnikov to be the greatest poet of the twentieth century. Khlebnikov[2] had studied mathematics at the University of Kazan. In December 1912 he famously published, together with his fellow artists Burliuk, Mayakovsky, and Kruchenykh, *Poščečina obščestvennomu vkùsu* [*Slap in the Face of Public Taste*], the first manifesto of Russian Futurism. This manifesto appeared in a booklet that also contained a brief poem, 'Bobéobi', which can be considered among the most impressive instances of Khlebnikov's experimental transrational language he called *zaum*.[3] 'Comme bien d'autres avant lui, Khlebnikov rêve de la langue unique et parfaite permettant une communication immédiate et sans équivoque' [Like many others before him, Khlebnikov dreamt of a single language, perfectly suited for immediate and univocal communication].[4] He actually believed that the language of numbers, being the first universal language, was to be preferred

over verbal language systems, and especially that numbers in mysterious ways hid the secrets of the histories of states and men.

According to Khlebnikov the language of numbers is the language of the universe, and he turned numerical calculation into one of the various criteria for composition that were at the origin of his creative texts. 'Il voulait transférer le rapport qu'on a avec le concept de nombre au concept de mot, pour pouvoir l'élargir' [He wanted to transfer the relation we have with the concept of the number to the concept of the word, in order to expand the latter].[5] While one of his early poems praises the values of numbers,[6] another is dedicated to the number 317,[7] whose extraordinary power he believed to have discovered.[8] Having long appreciated in the first place the communicative function of numbers, in 1919 he eventually asserted that he had gone 'over to numerical writing, like an artist of number'.[9]

The young Futurists in Moscow and St. Petersburg, as well as the critics who later on would introduce Formalism in literary studies (for instance, Jakobson[10] and Yury Tynyanov[11]), were very familiar with Khlebnikov's research, ideas, and poetic production, yet they differed in their opinions of his work. According to Vasilij Kamensky, Khlebnikov was just sick with 'cyphermania',[12] while Mayakovsky believed he was the discoverer of 'nuovi continenti poetici' [new poetic continents],[13] the Columbus of a new universe of knowledge.[14]

At the end of the twenties, Jury Tynyanov wrote the introduction to the first edition in five volumes of the complete works of Khlebnikov.[15] And it is in this introduction that he calls the author 'le Lobatchevski du mot' [the Lobachevsky of the word],[16] comparing him to the scientist that had radically changed the mathematical sciences and the study of geometry in Russia.

In February 1914 the head of the Italian Futurist movement made his appearance in Moscow and St Petersburg,[17] at the invitation of Professor Genrix Edmundovich Tastevin, one of whose students was Roman Jakobson. Marinetti spoke only French and Tastevin chose the young Jakobson (who at that moment was only eighteen years old) as a translator and guide for Marinetti.[18] An Italian journalist that month sent a report to a newspaper in which he describes the encounters between Marinetti and the Russian Futurists, including Khlebnikov.[19] The reporter informed his readers that Khlebnikov's research on numeric calculations apparently had made it possible for him to establish the date of forthcoming historical events, and he had discovered in particular that in history every 1,387 years the fall of a great empire takes place. Khlebnikov therefore expected that in 1917, 1,387 years after the fall of the empire of the Vandals, something extraordinary would happen.[20]

Marinetti returned to Italy the following month,[21] publishing a leaflet with a manifesto entitled *Lo splendore geometrico e meccanico e la sensibilità numerica* [*Geometrical and Mechanical Splendour and Numerical Sensibility*], a text that circulated in French as well and that was dated 11 March 1914.[22] One can believe that Marinetti, when he was in Russia, already thought of the subject and various arguments of this manifesto, and that in Moscow and St Petersburg he had the chance to discuss his ideas with the Russian Futurists he met in the presence of Roman Jakobson. Khlebnikov was not always part of this group of poets and visual artists, however,

as apparently he preferred to be in Moscow when Marinetti was in St Petersburg and in St Petersburg when Marinetti was in Moscow.[23]

In a letter by Jakobson to Khlebnikov (a letter transcribed for the first time in 1940 but dated February 1914),[24] the future linguist proposed that Khlebnikov produce poems consisting only of numbers:

> It seems to me that verses made out of numbers are realizable. The number is a two-edged sword, extremely concrete and extremely abstract, arbitrary and fatally exact, logical and nonsensical, limited and infinite. [. . .] You know numbers, and therefore, even if you recognize that the poetry of numbers is an unacceptable paradox, but a sharp one, please try and give me at least a small model of such verse.[25]

We do not know Khlebnikov's response; in fact, we do not even know whether he ever responded to Jakobson's suggestions. The reason why he probably did not reply is that from the end of 1912 onwards, he was mainly engaged in the enterprise of creating poetry no longer made of words but of combinations of letters, morphemes, and verbal stems devoid of meaning. This is the so-called *zaum* language, one of the most complex, radical, and stimulating experiments of all the international poetic avant-gardes of the first decades of the twentieth century.[26] Jakobson must have been aware of Khlebnikov's experiment. Why then did he put this question to him, given the fact that he was very well aware of Khlebnikov's ideas, and of what he was trying to achieve? It is most likely that Jakobson had heard Marinetti talk about some of the ideas that later on would be spelled out in the manifesto *Lo splendore geometrico*, and in particular in the last section of the manifesto, in which he stressed the importance of a 'numerical sensibility'. Clearly, Jakobson considered the use of numbers, associated with combinations of sounds and letters, to be capable of increasing the expressive potential of a text, and therefore useful for transcribing the results of new poetic experiments. He later also remembered having addressed these matters, especially in relation to *zaum*, in his correspondence with Kruchenykh and Khlebnikov in the years 1912–14.[27]

Marinetti's thoughts on 'numerical sensibility' apparently played a role in all this. In order to understand what Marinetti meant precisely with the term 'numerical sensibility', it is necessary to refer to four of his works: (1) a book that has remained unpublished, but of which a considerable number of pages (about a hundred) are held in the Marinetti Archives in the Beinecke Library at Yale University;[28] (2) the already mentioned bilingual manifesto *Lo splendore geometrico*; (3) *Zang Tumb Tumb*, a book he published, notably, shortly after his trip to Russia;[29] (4) the volume *Les mots en liberté futuristes*, published in 1919.[30]

Page number 45a of the unpublished book contains a handwritten poem composed almost exclusively of numbers (see fig. 1).[31] It is important to recall that two years earlier, in the appendix to the 'Manifesto tecnico della letteratura futurista' [Technical Manifesto of Futurist Literature], Marinetti had defined the limited usefulness of mathematical signs: 'I have recourse to the arid abstraction of mathematical signs which give quantities by subsuming all explanations, devoid of padding'.[32] By contrast, in the manifesto *Lo splendore geometrico* (fig. 2), Marinetti

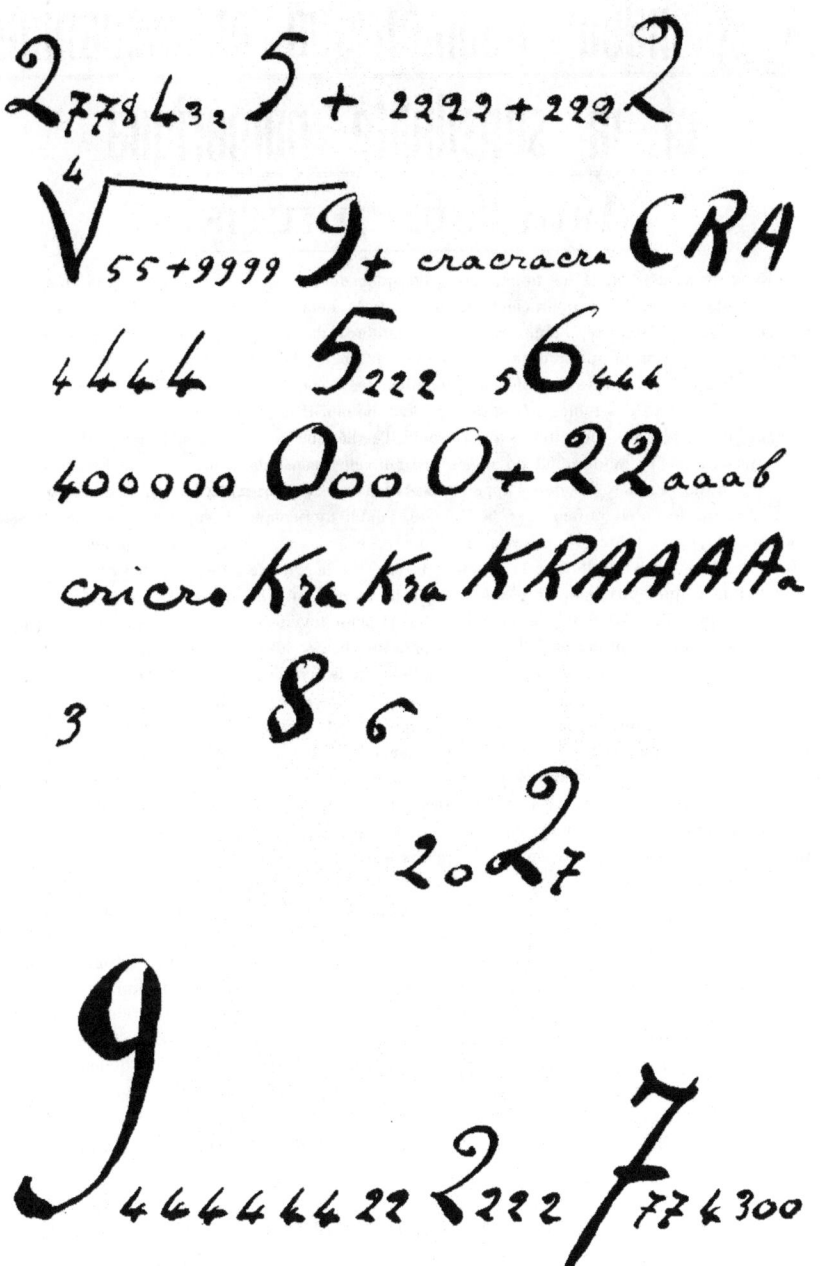

FIG. 1. Filippo Tommaso Marinetti, [number poem], s.d. [usually 1915; date proposed by the author 1914]; Filippo Tommaso Marinetti Papers, Beinecke Rare Book and Manuscript Library, New Haven, CT.

La splendeur géométrique et mécanique et la sensibilité numérique

Manifeste futuriste

Nous avons déjà bâclé les funérailles grotesques de la Beauté passéiste (romantique, symboliste et décadente) qui avait pour éléments essentiels la Femme Fatale et le Clair de lune, le souvenir, la nostalgie, l'éternité, l'immortalité, le brouillard de légende produit par les distances de temps, le charme exotique produit par les distances d'espace, le pittoresque, l'imprécis, l'agreste, la solitude sauvage, le désordre bariolé, la pénombre crépusculaire, la corrosion, la patine = crasse du temps, l'effritement des ruines, l'érudition, l'odeur de moisi, le goût de la pourriture, le pessimisme, la phtysie, le suicide, les coquetteries de l'agonie, l'esthétique de l'insuccès, l'adoration de la mort.

Nous dégageons aujourd'hui du chaos des nouvelles sensibilités une nouvelle beauté que nous substituons à la première et que j'appelle **Splendeur géométrique et mécanique.** Elle a pour éléments le Soleil rallumé par la Volonté, l'oubli hygiénique, l'espoir, le désir, le périssable, l'éphémère, la force bridée, la vitesse, la lumière, la volonté, l'ordre, la discipline, la méthode; l'instinct de l'homme multiplié par le moteur; le sens de la grande ville; l'optimisme agressif qu'on obtient par la culture physique et par le sport; la femme intelligente (plaisir, fécondité, affaires); l'imagination sans fils, l'ubiquité, le laconisme et la simultanéité qui caractérisent le tourisme, les grandes affaires et le journalisme; la passion pour le succès, le record, l'imitation enthousiaste de l'électricité et de la machine, la concision essentielle et la synthèse; la précision heureuse des engrenages et des pensées lubrifiées; la concurrence d'énergies convergentes en une seule trajectoire.

Mes sens futuristes perçurent pour la première fois cette splendeur géométrique sur le pont d'une dreadnought. La vitesse du navire, les distances des tirs fixées du haut de la passerelle dans la ventilation fraîche des probabilités guerrières, la vitalité étrange des ordres transmis par l'amiral et brusquement devenus autonomes et inhumains, à travers les caprices, les impatiences et les maladies de l'acier et du cuivre: tout cela rayonnait de splendeur géométrique et mécanique. Je perçus l'initiative lyrique de l'électricité courant à travers le blindage des tourelles quadruples, et descendant par des tubes blindés jusqu'aux soutes, pour tirer obus et gargousses jusqu'aux culasses, vers les volées émergeantes. Pointage en hauteur, en direction, hausse, flamme, recul automatique, élan personnel du projectile, choc, broyement, fracas, odeur d'œuf pourri, gaz méphitiques, rouille ammoniaque, etc. Voilà un nouveau drame plein d'imprévu futuriste et de splendeur géométrique, qui a pour nous cent mille fois plus d'intérêt que la psychologie de l'homme avec ses combinaisons limitées.

Les foules peuvent parfois nous donner quelques faibles émotions. Nous préférons les affiches lumineuses, fards et pierreries futuristes, sous lesquels, chaque soir, les villes cachent leurs rides passéistes. Nous aimons la solidarité des moteurs zélés et ordonnés. Rien n'est plus beau qu'une grande centrale électrique bourdonnante, qui contient la pression hydraulique d'une chaîne de montagnes et la force électrique de tout un horizon, synthétisées sur les tableaux de distribution, hérissés de claviers et de commutateurs reluisants. Ces tableaux formidables sont nos seuls modèles en poésie. Nous avons

FIG. 2. Filippo Tommaso Marinetti, *La splendeur géométrique et mécanique et la sensibilité numérique. Manifeste futuriste*, Milan, Direction du Mouvement Futuriste, 11 March 1914, p. 1. Leaflet.

now reflected upon formal solutions in tune with an extended notion of expression, and identified a wide range of possible applications: mathematical signs, despite their 'semplicità astratta' [abstract simplicity], could in his mind enhance a new type of mobility on the condition that they are inserted in contexts capable of increasing their conventional semantic values. Indeed, he foresaw, among other things, that texts made up of Words-in-Freedom could include theorems and equations, together with the phonetic transcriptions of onomatopoeia. This project is obviously linked with the above-mentioned questions Jakobson formulated. The principles that were to characterise this new type of 'sensibility towards numbers', to Marinetti, were first and foremost 'precision' and 'synthesis':

> My love of precision and concentrated brevity have naturally given me a taste for numbers, which live and breathe on the page like living beings in our new **numerical sensibility**. [. . .]
> The mathematical symbols $+ - =$ can bring about some wonderful syntheses and, in the abstract simplicity of their impersonal mechanisms, they contribute to the creation of geometric and mechanical splendor.[33]

Such splendour, in his opinion, was the distinguishing feature of the new beauty. 'For example, it would have required at least a whole page of description to portray this vast, complex panorama of battle that I have instead conveyed through this supreme lyrical equation.'[34]

Mentioning a battle here,[35] Marinetti referred to the subject of a page from his *Zang Tumb Tumb* as an illustration (see fig. 3):

> orizzonte = trivello acutissimo del sole + 5 ombre triangolari (1 km di lato) + 3 losanghe di luce rosea +5 frammenti di colline + 30 colonne di fumo + 23 vampe.
>
> [Horizon = gimlet most piercing some sun + 5 triangular shadows (1 kilometer to one side) + 3 diamond shapes of rosy light + 5 bits of hills + 30 columns of smoke + 23 blazes. (see fig. 4)][36]

In the manifesto Marinetti also went on to justify his use of x and the elimination of question marks:[37]

> I use the x to convey pauses for searching thoughts. Thus I eliminate the question mark which fixed its air of doubt too arbitrarily on only one aspect of consciousness. With the mathematical x, the pause for doubt is immediately extended over the entire assembly of Words-in-Freedom.[38]

The following passage is dedicated to the use of numbers and mathematical signs:

> In the same intuitive way, among the Words-in-Freedom, I introduce numbers that have no direct meaning or value but that (being directed by their sounds and by the eye toward our numerical sensibilities) express the varying mystical intensities of matter and the unfailing reactions of our sensibilities.
> I create some real theorems or lyrical equations, introducing numbers that are chosen intuitively and placed in the very center of a word, with a certain number of $+ - =$ x. I articulate the thickness, the preeminence, and the volume of the things that the word must express. The arrangement $+ - + - + +$ x, for example, serves the purpose of communicating the changes and the increase in

topée voilée *fiuuu fiiiii*, écho de l'autre rive. Les 2 onomatopées m'ont évité la peine de décrire la largeur du fleuve qui est ainsi définie par le contraste des consonnes *s* et *f*.

 b) Onomatopée indirecte, complexe et analogique. (Ex.: dans mon poème DUNES, l'onomatopée analogique *doum-doum-doum-doum* exprime le bruit rotatif du soleil africain et le poids orangé du ciel, en créant un rapport entre les sensations de poids, chaleur, couleur, odeur et bruit (Autre ex.: l'onomatopée *stridionlà stridionlà stridionlaire* qui revient dans le 1.er chant de mon poème épique LA CONQUÊTE DES ÉTOILES forme une analogie entre la stridence des épées et l'agitation des vagues au début d'une grande bataille d'eaux en tempête).

 c) Onomatopée abstraite, expression sonore et inconsciente des mouvements plus complexes et mystérieux de notre sensibilité (Ex.: Dans mon poème «DUNES», l'onomatopée abstraite *ran ran ran* ne correspond à aucun bruit de la nature ou du machinisme, mais exprime un état d'âme).

 d) Accord onomatopéique psychique.

 9. — Mon amour pour la précision et pour la brièveté essentielle m'a donné naturellement le goût des chiffres qui vivent et respirent sur le papier comme des êtres vivants à travers ma nouvelle **sensibilité numérique.** Ex.: au lieu de dire comme un écrivain traditionnel: *un son de cloches vaste et profond* (notation imprécise et inexpressive) ou bien comme un paysan intelligent: *les habitants de tel ou tel village entendent cette cloche* (notation plus précise et plus expressive) je saisis avec une précision intuitive le son de la cloche et j'en détermine l'ampleur en disant: **don dan** *cloches ampleur du son 20 Km.²* Je donne ainsi tout un horizon vibrant et une quantité d'individus lointains qui tendent l'oreille au même son de cloche. Je sors de l'imprécis, je m'empare de la réalité par un acte volontaire qui déforme la vibration même du métal. Les signes mathématiques $+ - \times =$ servent à obtenir de merveilleuses synthèses et concourent par leur simplicité abstraite d'engrenages impersonnels au but final, qui est la **Splendeur géométrique et mécanique.** Il faudrait en effet plus d'une page de description traditionnelle pour donner imparfaitement ce très vaste horizon de bataille compliquée dont voici l'équation lyrique définitive: «*horizon $=$ vrille aiguiiiiiisée du soleil $+$ 5 ombres triangulaires chaque côté 1 Km. $+$ 3 losanges de lumière rose $+$ 5 fragments de collines $+$ 30 colonnes de fumée $+$ 23 flammes.*» J'emploie l'x pour indiquer les arrêts interrogatifs de la pensée. J'élimine ainsi le point d'interrogation qui localise trop arbitrairement sur un seul point de la conscience son atmosphère dubitative. Au moyen de l'x mathématique la suspension dubitative se répand sur l'agglomération entière des mots en liberté. En suivant mon intuition, j'introduis parmi les mots en liberté des numéros qui n'ont pas de signification ni de valeur directe, mais qui (s'adressant phoniquement et optiquement à la sensibilité numérique) expriment les différentes intensités transcendentales de la matière et les réponses incontrolables que leur donne la sensibilité; je crée de véritables théorèmes et des équations lyriques en introduisant des numéros choisis intuitivement et disposés au milieu même d'un mot. Avec une certaine quantité de $+ - \times =$ je donne l'épaisseur et la forme des choses que le mot doit exprimer. La disposition $+ - + - + + \times$ sert à donner par ex. les changements et l'accélération des vitesses d'une automobile. La disposition $+ + + +$ sert à donner l'entassement de sensations égales. (Ex.: *odeur fécale de la dysenterie + puanteur mielleuse* etc., dans le «TRAIN DE SOLDATS MALADES» de mon ZANG TOUMB TOUMB).

 Ainsi par les mots en liberté nous substituons au *ciel antérieur où fleurit la beauté* de Mallarmé la *Splendeur géométrique et mécanique et la Sensibilité numérique.*

MILAN, le 11 Mars 1914. **F. T. Marinetti.**

DIRECTION DU MOUVEMENT FUTURISTE: Corso Venezia, 61 - MILAN

FIG. 3. Filippo Tommaso Marinetti, *La splendeur géométrique et mécanique et la sensibilité numérique. Manifeste futuriste*, Milan, Direction du Mouvement Futuriste, 11 March 1914, p. 4. Leaflet.

batteria vampe fiiiischi **strrrr** sulla testa 12 km. di volo **zang-tumb-tumb** 3 fracassati rimbalzello di 4 echi languido lawnnn-tennis di suoni onda sonora ovoidale accarezzare 3 colline abbandonarsi sul ventre verde della Maritza elasticità 150 km. monotonia sino al mare = 600 000 smeraldi

denti molli del sole mordicchiare 4 minareti di Selim Pascià brulichìo punta del ponte Turchi colpi d'ascia lampi azzurri **tza tzu tza tzu** presto puntare su di loro *(ARANCIONE ROSSO AZZURRO VERD'ORO INDACO VIOLETTO INCANDESCENTE PERITURO)* orizzonte = trivello acutissimo del sole ╋ 5 ombre triangolari (1 Km. di lato) ╋ 3 losanghe di luce rosea ╋ 5 frammenti di colline ╋ 30 colonne di fumo ╋ 23 vampe

FIG. 4. Filippo Tommaso Marinetti, *Zang Tumb Tumb* (Milan: Edizioni futuriste di *Poesia*, 1914), p. 139.

FIG. 5. Filippo Tommaso Marinetti, *Une assemblée tumultueuse (Sensibilité numérique)*, s.d. [1918].

speed of a motorcar. The arrangement + + + + + has the purpose of bundling similar (equal) sensations together.[39]

In the volume *Les mots en liberté futuristes* [*Futurist Words-in-Freedom*], published in 1919, Marinetti reproduced, among the texts included in the collection, his only Free-Word Table that explicitly mentions 'numerical sensibility' in its subtitle.[40] 'Une assemblée tumultueuse' [A Tumultuous Assembly, see fig. 5][41] is a typographical collage dedicated to a public celebration on the occasion of the end of the First World War. The collage includes items that Marinetti had previously used to evoke the numerical sensibility, such as a series of numbers and mathematical signs. The table represents a perpendicular image taken from above, and as in other Free-Word Tables, it must be read as a superposition of several different levels, each of which contains blocks and text segments. These consist mainly of fragments and pieces of printed pages, and are occupied by series of numerals or 'numbers in freedom', and transcribed with different typographical fonts and features.

Marinetti had already mentioned the principle of precision in a letter to the young Belgian poet Henry Maassen (1909)[42] and, as we just said, quoted that principle also in the manifesto *Lo splendore geometrico*. This principle eventually led him to the individuation of a true textual typology, the 'poem of precision', of which he would present only a couple of examples.

One of these examples is included, in Italian and in French, in the anthology *I nuovi poeti futuristi* (1925).[43] It is with the clear intention of showing it as an exemplary model to be imitated that he reproduces the same text, now with the title 'Velocità nel caos delle lave spente' [Speed in the Chaos of Extinguished Lava], together with the article 'I poemi precisi' [Poems of precision],[44] which proposes once again the last point (n. 9) of the above-mentioned manifesto. Marinetti reprinted the same 'poem of precision' in his metal book-object *Parole in libertà futuriste tattili termiche olfattive* [*Futurist Tactile Thermal Olfactory Words-in-Freedom*],[45] published in 1932, 'une œuvre d'art totale' [a total work of art], and 'l'un des chefs-d'œuvre de l'avant-garde européenne de la première moitié du XXe siècle' [one of the masterpieces of the European avant-garde of the first half of the twentieth century].[46] Each text is proposed in two versions. The first (fig. 6), to which a couple of numbers and simple arithmetic operations are added, has a considerable amount of phenomena of iconisation (typographical mobility, spacing, absence of punctuation) documenting a constructivist — and scarcely dynamic — adaptation of the principles of Words-in-Freedom. The second version (see fig. 7) is polychromatic and is characterised by a drastic quantitative reduction of the linguistic material, corresponding to the first linear segment. From this configuration are derived textual models that in the post-Second World War years would become part of Concrete Poetry.[47]

Like many other Futurists,[48] and more generally, other representatives of the historical avant-gardes,[49] Marinetti in subsequent years became particularly interested in the debate about the fourth dimension, a dimension he felt was represented by the plastic dynamism of some of the works of Boccioni and Balla and, more generally, by painting of 'stati d'animo' [state of minds].[50] Artistic experiments in this direction appeared to him useful to overcome mathematics.[51]

POEMA PRECISO

Un uomo 10000 camminare con una bionda 3000000 senza amore senza scopo che fare? montare in automobile languore ritmato 750 gli alberi intrisi d' oro azzurro e terrore roseo sono profumanti spazzole veloci 1000 8000 800000 foia bizzarra sparpagliata del vento ritto obelisco volante sotto il suo miliardo di capelli che sono i miei nervi correre volare penetrare nel cuore umido soffice di seta-carne goloso dello spazio Stringere il volante virilissimo lanciato contro la virilità del paracarro lontano vicino prossimo sotto temere

temere schianto $1+1=2$ inchiodarsi $1+1=2$ respirare $1+1=2$ ragionare $1+1=2$ esplorare intorno $1+1=2$ eternità $1+1=0$ silenzio tondo + attesa quadrata + bere la notte Lui e io Lei o

FIG. 6. Filippo Tommaso Marinetti, 'Poema preciso', in *Parole in libertà futuriste tattili termiche olfattive* (Savona-Roma: Lito-Latta & Edizioni futuriste di *Poesia*), 1932 (pages in tin are unnumbered).

FIG. 7. Filippo Tommaso Marinetti, 'Poema preciso', in *Parole in libertà futuriste tattili termiche olfattive* (Savona-Roma: Lito-Latta & Edizioni futuriste di *Poesia*, 1932) (pages are unnumbered).

Marinetti was also among the signatories[52] of the manifesto 'La matematica futurista' [Futurist Mathematics], published in 1940.[53] After defining scientific truth 'variabile' [variable], the manifesto asks for the application of a 'meccanica razionale alla valutazione dei quadri e delle sculture' [rational mechanics to the evaluation of paintings and sculptures].[54] This statement must be connected to the interest shown by the Futurists in a possible 'scientific' method of evaluation (or rather, of 'misurazione' [measurement]) of works of art.[55] In the course of the twenties, when he was active more or less continuously as a theatre critic, Marinetti had applied the experimental method.[56] What appears more obscure is his proposal to apply a 'geometria poetica' [poetic geometry], understood as a subjective 'misurazione astratta' [abstract measurement], to works of architecture. After having paid attention for quite some time to Einstein's theory of relativity (which he considered, in an article possibly written in 1934, 'costruita a forza di calcoli astrusi e intuizioni misteriose' [built on the basis of abstruse calculations and mysterious intuitions]),[57] Marinetti eventually invites his readers 'a rifiutare la razionalità del numero applicando alle vicende dell'esistenza la legge beffarda e combinatoria della probabilità' [to deny the rationality of numbers by applying to the vicissitudes of life the mocking and combinatorial law of probability].[58] Much preferable is 'una matematica ostile alla simmetria e alle equazioni tutta lanciata nel discontinuo e nel raro' [a mathematics hostile towards symmetry and equations completely launched towards the discontinuous and the rare], one that does not fail to affirm 'l'essenza divina del CASO e dell'AZZARDO' [the divine essence of HAZARD and RISK] (a term that should be regarded as an unconscious reference to game theory). The conclusions, however, are surprisingly entrusted to two 'calcoli [. . .] precisi' [precise [. . .] calculations] concerning as many Futurist 'victories': the 'battaglie' [battles] of Via Mercanti and of Passo Uarieu. In short, Marinetti's 'numerical sensibility', far from being a one-sided attempt to introduce mathematical precision in art, is situated at the crossroads of various interests and cultural references, and leads him to explore the use of mathematics in quite divergent and even contradictory directions.

Notes to Chapter 7

1. Quoted in Raymond Cooke, *Velimir Khlebnikov: A Critical Study*, Cambridge Studies in Russian Literature (Cambridge: Cambridge University Press, 2006), p. 102.
2. For more by and on Velimir Khlebnikov, see his *Collected Works*, 3 vols (Cambridge, MA: Harvard University Press, 1987–98); Vladimir Markov, *The Longer Poems of Velimir Khlebnikov* (Berkeley and Los Angeles: University of California Press, 1962); and the special issue of *Europe*, 88.978 (2010), devoted to him.
3. It is believed that the first morphological example of *zaum* can be found in the phonetic sequence *Incantation by Laughter*, by Khlebnikov, March 1910 (see Agnes Sola, *Le futurisme russe* (Paris: Presses Universitaires de France, 1989), p. 53).
4. Agnes Sola, 'Introduction', in Velimir Khlebnikov, *Des nombres et des lettres*, traduction et préface d'Agnes Sola (Lausanne: L'Age d'Homme, 1986), p. 12.
5. Eveline Schatz, 'Chlebnikov: ingegnere delle parole', *Rassegna Sovietica*, 28.4 (1977), p. 44.
6. Velimir Khlebnikov, 'Numbers', in *Collected Works*, III: *Selected Poems* (Cambridge, MA: Harvard University Press, 1997), p. 39; originally in *Dochlaja luna* [*The Moribund Moon*, 1913].
7. See Velimir Khlebnikov, 'La conception mathématique de l'histoire', in his 'Livre des préceptes'

(II), *Poétique*, 1.2 (1970), 250–51. See also the first part, published in *Poétique*, 1.1 (1970), 112–26, with an essay by Tzvetan Todorov, *Le nombre, la lettre, le mot* (pp. 102–11). *Poétique* published a choice of texts from the five volumes of Khlebnikov's complete works, *Sobranie proizvedenij* (Leningrad: Izdatel'stvo pisatelej, 1928–33).

8. Vasily Kamensky, 'Chlebnikov e i matematici', *Rassegna Sovietica*, 17.3 (1966), pp. 86–118 (p. 115); the essay is an excerpt from the volume *Put' entuziasta* (The Road of an Enthusiast) (Moscow: s.n., 1931). Viktor B. Shklovsky also stated that in Khlebnikov's theories the number 317 was decisive (*C'era una volta* (Milan: il Saggiatore, 1994), p. 137). It was also the number of members Khlebnikov wanted for his Society of the Presidents of Planet Earth, founded in 1916.
9. Cited in Cooke, p. 102.
10. Roman Jakobson, *Novejšaja russkaja poèzija. Nabrosok pervyj. Viktor Chlebnikov* [New Russian Poetry. First Sketch: Viktor Khlebnikov] (Prague: Tipografija "Politika", 1921).
11. Yury Tynyanov, ['On Khlebnikov'], in *Arkhaïsky i Novatory* [Archaists and Innovators] (Leningrad: Priboi, 1929). For a French translation, see 'Sur Khlebnikov', in Gérard Conio, *Le formalisme et le futurisme russes devant le marxisme* (Lausanne: L'Age d'Homme, 1975), pp. 118–31.
12. Kamensky, p. 115.
13. Vladimir Mayakovsky, quoted in *Poesia russa del Novecento*, trans. and ed. by A. M. Ripellino (Milan: Feltrinelli, 1960), p. 56.
14. See Kamensky, p. 108 (where Khlebnikov is defined 'the Christopher Columbus of the new linguistic culture').
15. The five volumes were published in Leningrad as from 1928.
16. Yury Tynyanov, 'Sur Khlebnikov', p. 125. Nikolai Ivanovich Lobachevsky (1792–1856) was a Russian mathematician and scientist, and among the first specialists of non-Euclidian geometry. He is quoted in Khlebnikov's poem 'Ladomir' (1920). Lobachevsky also had been the rector of the University of Kazan, where Khlebnikov studied.
17. For more information on Marinetti's visits to Russia, see Nicolas Khardiev, 'La tournée de Marinetti en Russie en 1914', in *Présence de Marinetti*, Actes du Colloque International tenu à l'UNESCO, ed. by Jean-Claude Marcadé (Lausanne: L'Age d'Homme, 1982), pp. 198–233; Vittorio Strada, 'Marinetti in Russia', in *F. T. Marinetti Arte-Vita*, Atti del Convegno, ed. by Claudia Salaris (Rome: Fahrenheit 451, 2000), pp. 59–67; Jean-Pierre Andréoli de Villers, 'Marinetti et les futuristes russes lors de son voyage à Moscou en 1914', *Ligeia*, 19.69/72 (2006), 129–46; Vladimir P. Lapšin, *Marinetti e la Russia: dalla storia delle relazioni letterarie e artistiche negli anni dieci del XX secolo* (Geneva and Milan: Skira, 2008).
18. See Matteo D'Ambrosio, *Roman Jakobson e il Futurismo italiano* (Naples: Liguori, 2009), esp. the chapter 'L'attività giovanile e l'incontro con Marinetti', pp. 5–36.
19. Armando Zanetti, 'Futurismo italiano e futurismo russo', *Giornale d'Italia*, 5 March 1914, p. 2.
20. 'In 534 the Kingdom of the Vandals was subjugated. Should we not therefore expect some state to fall in 1917' (Velimir Khlebnikov, 'Teacher and Student' (1912), now in *Collected Works of Velimir Khlebnikov*, 3 vols (Cambridge, MA: Harvard University Press, 1987), I: *Letters and Theoretical Writings*, p. 284. In the 'enigmatic, laconic *Vzor na 1917 god* [view on 1917], [. . .] he prophesied, on the basis of his study of "the laws of time", an event of global importance for the year 1917' (Benedikt Livshits, *The One and a Half-Eyed Archer*, trans. by John E. Bowitt (Newtonville, MA.: Oriental Research Partners, 1977), p. 122.
21. Marinetti arrived in Moscow on 26 January and left on 17 February.
22. Filippo Tommaso Marinetti, *La splendeur géométrique et mécanique et la sensibilité numérique. Manifeste futuriste / Lo splendore geometrico e meccanico e la sensibilità numerica. Manifesto futurista*, 18 March 1914 (Milan: Direzione del Movimento Futurista, 1914).
23. See D'Ambrosio, esp. pp. 8–9, 12–13, 33.
24. Roman Jakobson, letter to Velimir Khlebnikov (February 1914), for the first time transcribed in *Majakovskij. Materialy i issledovanija*, ed. V. O. Percov and M. I. Serebrjanskij (Moscow: Gos. Izd. Chudoz. Lit., 1940), pp. 385–86; subsequently published in the anthology N. Khardzhiev, K. Malevich, and M. Matiushin, *K istorii russkogo avangarda* (Stockholm: Hylaea Prints, 1976); Italian translation of the letter (by Remo Faccani) in *il verri*, 28, n. 31/32 (1983), p. 71; partly translated in D'Ambrosio, *Roman Jakobson e il Futurismo italiano*, p. 92.

25. Roman Jakobson, *My Futurist Years*, ed. by Bengt Jangfeldt and Steven Rudy, trans. with an introduction by Steven Rudy (New York: Marsilio Publishers, 1992), p. 313.
26. See Gerald Janecek, *Zaum. The Transrational Poetry of Russian Futurism* (San Diego, CA: San Diego University Press, 1996).
27. See Roman Jakobson, quoted in Johanna Drucker, *The Visible Word. Experimental Typography and Modern Art, 1909–1923* (Chicago and London: The University of Chicago Press, 1994), p. 171.
28. See Giovanni Lista, *Le Futurisme. Création et avant-garde* (Paris: Éditions de l'Amateur, 2001), p. 269.
29. Filippo Tommaso Marinetti, *Zang Tumb Tumb* (Milan: Edizioni futuriste di *Poesia*), 1914.
30. Filippo Tommaso Marinetti, *Les mots en liberté futuristes* (Milan: Edizioni futuriste di *Poesia*), 1919.
31. Reprinted in the exhibition catalogue *The Futurist Imagination. Word + Image in Italian Futurist Painting, Drawing, Collage and Free-Word Poetry* (New Haven, CT: Yale University Gallery, 1983), p. 28; now also in D'Ambrosio, *Roman Jakobson e il Futurismo italiano*, p. 93.
32. 'Technical Manifesto of Futurist Literature', in *Critical Writings*, ed. by Günter Berghaus, trans. by Doug Thompson (New York: Farrar, Straus and Giroux, 2006), pp. 107–19 (p. 116).
33. Filippo Tommaso Marinetti, 'Geometrical and Mechanical Splendor and Sensitivity toward Numbers', in *Critical Writings*, pp. 135–42 (p. 141).
34. Ibid.
35. See *Battaglia peso + odore* (pp. 3–4 in the original manifesto), a text in which Jeffrey Schnapp recognizes the additive zeros as a form of statistical hyperbole ('The Statistical Sublime', in *The History of Futurism: The Precursors, Protagonists, and Legacies*, ed. by Geert Buelens, Harald Hendrix, and Monica Jansen (Lanham, MD: Lexington Books, 2012), pp. 107–28 (p. 115).
36. Quoted in 'Geometrical and Mechanical Splendor', p. 141.
37. According to Christine Poggi the '"X" may also be read as Marinetti's version of the question mark' ('Marinetti's *Parole in Libertà* and the Futurist Collage Aesthetic', in the catalogue of the exhibition *The Futurist Imagination*, p. 7).
38. 'Geometrical and Mechanical Splendor', p. 141.
39. Ibid., pp. 141–42.
40. See also other compositions, such as 'Après la Marne, Joffre visita le front en auto' (*Les mots en liberté futuristes*, inset illustration after p. 99), in which Jeffrey Schnapp sees traces of 'hybrid notational systems' (Schnapp, p. 112).
41. Filippo Tommaso Marinetti, 'Une assemblée tumultueuse', in *Les mots en liberté futuristes*, inset illustration after p. 108; now in Gérard-Georges Lemaire, *Les mots en liberté futuristes* (Paris: Jacques Damase éditeur, 1986), p. 44.
42. See the transcriptions in Giovanni Lista, *Futurisme. Manifestes documents proclamations* (Lausanne: L'Age d'Homme, 1973), pp. 18–19); Lista, *Filippo Tommaso Marinetti. L'anarchiste du futurisme* (Paris: Nouvelles Editions Séguier, 1995), pp. 220–21. A reproduction of the original can be found in Barbara Meazzi, 'Les créations futuristes en Italie et en France: étude comparée de l'Imaginaire futuriste', PhD thesis (Chambéry: Université de Savoie, 1997).
43. *I nuovi poeti futuristi* (Rome: Edizioni futuriste di *Poesia*, 1925), p. 293, p. 314; later in *L'Antenna*, 1.1 (1926), p. 1; *ReD* (Praha), 2.6 (1929), p. 175.
44. *La Fiera letteraria*, III (1927), 27, p. 3; subsequently in *L'Osservatore politico letterario*, 20.6 (1974), pp. 32–33.
45. Rome: Edizioni futuriste di *Poesia*, 1932; layout and graphics by Tullio d'Albisola.
46. Giovanni Lista, *Le Futurisme*, pp. 276, 275.
47. For this hypothesis, see Matteo D'Ambrosio, 'La guerra nella letteratura futurista', in *Il Futurismo nelle avanguardie*, Atti del Convegno Internazionale (Milan, Palazzo Reale, 4–6 February 2010), ed. by Walter Pedullà (Rome: Edizioni Ponte Sisto, 2010), pp. 198–201.
48. See Enzo Benedetto, *Quarta dimensione. Dinamismo plastico*, Quaderni di Futurismo Oggi 14 (Rome: Arte Viva, 1973).
49. See Linda Dalrymple Henderson, *The Fourth Dimension and Non-Euclidean Geometry in Modern Art* (Princeton, NJ: Princeton University Press, 1983); Michaela Böhmig, 'Tempo, spazio e quarta dimensione nell'avanguardia russa', *Europa Orientalis*, 8 (1989), pp. 341–80; Marc Antliff,

'The Fourth Dimension and Futurism: A Politicized Space', *The Art Bulletin*, 82 (2000), 4, pp. 720–33; Tony Robbin, *Shadows of Reality: The Fourth Dimension in Relativity, Cubism, and Modern Thought* (New Haven, CT: Yale University Press, 2006).
50. Boccioni knew the theories of G. F. B. Riemann, on which modern cosmology was based.
51. See Filippo Tommaso Marinetti, 'Quarta dimensione di matematici e di artisti', *Gazzetta del Popolo*, Turin, 30 November 1928, p. 3; subsequently in *La Città futurista*, 1.1 (1929), 2; *Oggi e Domani*, 1.7 (1930), 1 (with the title 'Superare la matematica. Verso la quarta dimensione); Nuove ipotesi sulla forma dell'universo', *Gazzetta del Popolo*, 4 March 1937).
52. Marinetti declares that he had elaborated the idea together with the mathematician Marcello Puma and the Futurist doctor Pino Masnata, but Carlo Belloli, in his article 'Matematica futurista. Quando gli artisti volevano rivoluzionare anche la scienza' (*Futurismo-Oggi*, 20.11/12 (1988), p. 20) states that the manifesto was entirely conceived and written by Puma; he reproduces the autograph of the first version, which he dates back to December 1937.
53. Filippo Tommaso Marinetti, 'La matematica futurista. Manifesto', *Gazzetta del Popolo*, Torino, 2 February 1940, p. 3; subsequently *Autori e Scrittori*, 6.6 (1941), 1–2 (with a different title: 'La matematica futurista immaginativa qualitativa. Calcolo poetico delle battaglie', signed 'F. T. Marinetti Sansepolcrista Accademico d'Italia'); Filippo Tommaso Marinetti, *L'esercito italiano. Poesia armata* (Rome: Cenacolo, 1942), pp. 30–32 (with the title 'Calcolo poetico delle battaglie d'oggi').
54. Marinetti, 'La matematica futurista', p. 3.
55. See Matteo D'Ambrosio, ' "La critica non è mai esistita e non esiste". A proposito della misurazione futurista. Il Manifesto di Corra e Settimelli (1914). Il Manifesto inedito di Carmelich e Dolfi (1923). Il Manifesto di F. T. Marinetti, "misuratore di commedie" (1927)', *Avanguardia*, 15 (2010), 44, pp. 41–59.
56. See Filippo Tommaso Marinetti, *Misurazioni*, ed. by Maria Luisa Grilli (Florence: Vallecchi, 1990).
57. We know of a typescript of a review article of *Come io vedo il mondo* [*How I See the World*], in which some textual elements allow us to establish that Marinetti used the French translation of 1934 published by the Parisian publisher Flammarion (the Italian translation appeared only in the fifties). According to Marinetti, Einstein is a communist Jewish intellectual, pacifist and hostile towards all forms of nationalism.
58. Giordano Bruno Guerri, *Filippo Tommaso Marinetti. Invenzioni, avventure e passioni di un rivoluzionario* (Milan: Mondadori, 2009), p. 256.

CHAPTER 8

Football

Przemysław Strożek,
Institute of Art of the Polish Academy of Sciences

The presence of sport and in particular football — or soccer, as it is known in North America — in Futurist visual art has only partly been explored in past exhibitions that have drawn attention to the passion for sport displayed by the Futurists.[1] Indeed, football appears to epitomise the Futurist themes of dynamism, health, and virility.[2] Yet, football, the most popular sport in Italy and almost a national game, tapped into something much deeper in Futurist aesthetics than just its affinity for sports. Football victories were a matter of national pride, and the construction of modern stadiums fell perfectly in line with the striving towards modernisation of the country. For this reason, football became a reflection of many postulates of Filippo Tommaso Marinetti, who had prophesied the birth of a fully modern, imperial Italy since 1909, connecting its anticipated greatness with an art for the masses. Because it was a modern and mass phenomenon, football eventually surfaced in almost every sphere of Futurist activity, appearing in visual arts, literature, dance, theatre, and politics. The thirties were the crowning point for Italian football and affirmed the nation's international supremacy in the sport: Bologna FC won the Mitropa Cup in both 1932 and 1934, Italy hosted and won the 1934 World Cup, went on to win the football tournament in Berlin during the 1936 Olympics, and defended the World Cup trophy in France in 1938. Unsurprisingly, perhaps, the sport for that reason also continued to play a role in the later phases of Futurism.

Football and Futurist Painting

The history of modern football in Italy dates back to the early eighteen-nineties, when the first football clubs were created: Genoa Cricket and Football Club and Internazionale Football Club Torino. The Italian Football Federation (*Federazione Italiana Giuoco Calcio*) was established in 1898 and became a FIFA member a few years later. In 1909–10, while Marinetti issued the Futurist manifesto and carried out his *serate* and a series of semi-artistic interventions in Milan,[3] the local team, Inter, won their first Italian Championship; subsequently, Pro Vercelli won the title and defended it until 1913. In that very year, Umberto Boccioni painted *Dinamismo di un footballer* — most probably the first Futurist and avant-garde painting in which the topic of football appeared.[4]

In 1913, Boccioni was exploring the issues of human body dynamics with such paintings as *Dinamismo di un corpo umano* [Dynamism of a Human Body] and *Dinamismo di un ciclista* [Dynamism of a Cyclist]. *Dinamismo di un footballer* and two other paintings formed a kind of triptych on the topic of sport, meant to validate Boccioni's proclamation from 'La pittura futurista: manifesto tecnico' [Futurist Painting: Technical Manifesto, 1910], that 'movement and light destroy the materiality of bodies'.[5] The figure of the footballer, caught in the ceaseless simultaneity of the action of kicking a football, would undergo a total dematerialisation in the paintings' dynamical and luminous surroundings. The silhouette of the moving footballer anticipated the theory of plastic dynamism, according to which '*dynamic form* is a species of fourth dimension, both in painting and sculpture'.[6] Boccioni expressed the need to introduce a dynamic element in painting so that the subject would seem to be in constant motion. The truth of the modern, quickly changing world was to be expressed by omnipresent dynamism. The introduction of elements connected to sports in his paintings allowed Boccioni to try to depict dynamic continuity as a single form.

Dinamismo di un footballer did not convey the atmosphere of the stadium — the field, the goalposts, the spectator stands, or the competing footballers. Were it not for the title, it would have been difficult to guess that football was its subject at all. Boccioni depicted a footballer, shaping his body so as to maximise his physical force, expressing health and virility. Painted in such way that he rises above the ground, the footballer seems to be making movements similar to those of aeroplane propellers. Boccioni thus explored the mechanical aspects of movement — muscles built to resemble those of a machine. The footballer overcomes gravity and seems to have the ability to fly.

It appears that *Dinamismo di un footballer* not only referenced the theory of plastic dynamism, but was also an allegory of the new man, if not of a superhero. It is no accident that Boccioni's painting was one of Marinetti's favourites and was prominently displayed in the poet's apartment in Rome. All in all, *Dinamismo di un footballer* constituted one of the greatest achievements of Futurist painting, where all that was dynamic, mechanical, and modern merged with the vision of the Futurist superhuman.

When it comes to painterly 'dynamisation' of the human form, the motive of 'a footballer in movement' resurfaced in the years to follow in the works of successive generations of Italian Futurists. At the beginning of the twenties, impressions of football matches appeared in Iras Baldessari's *Giocatori di pallone* [Football Players, 1920], Emilio Notte's *Partita di pallone* [Football Match, 1920], Enrico Castello's *Calciatori* [Football Players, 1920], and *Il portiere* [The Goalkeeper, 1922]. These works showed footballers caught in the moment of field rivalry. Notte and Castello explored above all the dynamics of a football game — the competition, the struggle of muscular bodies. Baldessari in turn presented the footballers' silhouettes as a composition of geometric forms, placing them not so much within the Futurist aesthetic as somewhere between Cubism and Constructivism.

At the beginning of the twenties, Fortunato Depero created a series of sketches entitled *Giocatori di pallone* [Football Players, 1920–21]. They examined the phases

of movement of a footballer approaching a goalpost and resembled the analysis of the stages of movement as known from Etienne-Jules Marey's chronophotography. The latter had used photography to track physiological functions and mapped out the transformation of corporeal energies while his subjects performed different movements. The silhouette of Depero's footballer, with its shape of a dummy, resembled the characteristic toys ('giocattoli futuristi') designed by the painter for the Casa d'Arte Futurista (founded in Rovereto in 1919), and the footballer-dummy's kinetic phases of movement were evocative of his puppet theatre sketches.

Sport was a common subject in Depero's work. In the late twenties, he would design the covers for the magazine *Lo Sport Fascista*, edited by Lando Ferretti.[7] His involvement with sports was a testimony to the ardent support with which Futurists endorsed the Fascist campaigns of revitalisation of sports in Italy. Even if Marinetti was disillusioned with Benito Mussolini's support of the Vatican and the monarchy after he took power in 1922, the ways of the Futurists and Fascists would meet again in the mid-twenties. Since 1926, when the Futurists were assigned their own pavilion at the 15th Venice Biennale, Futurist art began to constitute, for the first time on such a scale, an expression of Fascist propaganda. It revealed a stronger-than-ever-before support of the politics of the government. This fact was of enormous importance for the reappearance of football as a subject in Futurist art.

The year 1926 saw a breakthrough in the history of Italian football. The Fascist government seized control of *calcio*, issued the *Carta di Viareggio* [Viareggio charter], the document that reorganised, rationalised, and nationalised the game, and provided facilities worthy of the new order and of the Italian national passion.[8] In 1926, Luigi Ridolfi, who admired Futurism and had cooperated with Ardengo Soffici and other Florentine Futurists before the war, founded the AC Fiorentina with Italo Foschi and became the club's first director, remaining in charge for fifteen years.[9] The year 1926 also saw the launch of the national stadium-building programme, spearheaded by Bologna's Littoriale arena. The aim of the programme was to provide a stadium for every *comune* of Italy.[10] The imposing stadiums symbolised the regime's national campaign to build infrastructure for mass spectacles. Fascists wanted to transform Italy into a sporting nation that would gain the admiration of the people. Also around that time, discussions began for an Italian league as round-robin tournament, which as Serie A, as it is structured today, began in 1929.

After 1926 and up until the late thirties, the subject matter of football would return in the art of the Futurists with additional force. One of the main representatives of 'Secondo Futurismo', Gerardo Dottori, created at the time a series of sketches called *Appunti allo stadio* [*Notes in the Stadium*] which depicted a number of particular football situations. These had little to do with the Futurist aesthetic, but indicated the painter's particular interest in the subject. In 1928, he created one of his best-known paintings, *Partita di calcio* [*Football Match*], in which the football players were surrounded by a landscape simultaneously rendered dynamic by circular forms, diverse perspectives, dimensions, and scales. The players were inscribed in rays of refracted light, which resembled Boccioni's solutions from *Dinamismo di un footballer*. Yet in Dottori's work, the silhouettes of the footballers' moving bodies did not dematerialise quite as radically. The competing players soared towards

the sky as if being drawn up by the sunlight, evoking the use of refracted rays in religious paintings and landscape paintings of central Italy. This ascension of footballers seemed to take place among the forests of Umbria. In the entire scene, one distinguishes players sporting blue shirts and white shorts. The national colours of *Gli Azzurri* [The Blues][11] suggest that the game depicted in *Partita di calcio* is taking place at an international level. In the 1928 Summer Olympics tournament in Amsterdam, which is described as the precursor to the first FIFA World Cup held in 1930 in Uruguay, Italy won the bronze medal. *Partita di calcio* might thus have been a painterly variation on one of the games, set in the local landscape of Umbria; it might also have been an idealisation of the first international successes of Italy's national team.

After 1928 many Futurist painters turned to motives connected to football. Among them were Pippo Rizzo, Vittorio Corona, Tato, Thayaht, Ivanhoe Gambini, Mario Guido dal Monte, Cesare Tarrini, Bruno Munari, Marisa Mori, and Giulio D'Anna. A sketch by D'Anna entitled *Calciatore* [*Football Player*, 1930] bore a striking resemblance to the silhouette of the new twentieth-century hero from Boccioni's sculpture *Forme uniche della continuità nello spazio* [*Unique Forms of Continuity in Space*, 1913], which sought to exemplify Marinetti's dream of a man/machine hybrid.[12] D'Anna's footballer resembled a soldier marching in the war, but here his intention was to catch the ball, and his duty to shoot and score a goal.

Three years later, Giulio D'Anna revisited the subject of football, once again referring to Boccioni's oeuvre. In a 1933 painting called *Football*, he created the illusion of a running footballer, caught in the simultaneous action of taking aim and kicking the ball. D'Anna displayed the stages of movement, and as a consequence the footballer becomes two persons — two heads, four arms, four legs. Such a way of expressing the dynamics of a sportsman perfectly matched the passage from the technical manifesto of Futurist painting of 1910, which read:

> On account of the persistency of an image upon the retina, moving objects constantly multiply themselves; their form changes like rapid vibrations, in their mad career. Thus a running horse has not four legs, but twenty, and their movements are triangular.[13]

D'Anna's painting, like many others, served as proof of the vitality of Boccioni's ideas among the younger generations of Futurist painters. Still in the thirties *Dinamismo di un footballer* functioned as a model for Futurist dynamic representation of a footballer's silhouette.

Sidestepping Boccioni's legacy in painting, and setting off in an entirely unique direction, was *aeropittura*, a current promptly codified into staunch nationalist aesthetics under the Fascist regime. *Aeropittura* was based on painterly sensations, intoxicating flights in the skies and the experience of the vastness of the heavens. The sky became an unlimited realm of cosmic fantasies towards spiritualism. In the world seen from a plane's perspective, football — the new religion of the Italian masses and a tool of Fascist propaganda — was also present. The painting by Dottori discussed above could be seen not only as a predecessor of Futurist sacred art, but also of *aeropittura*, defined in 1929. Around that year — the year Marinetti

was called into Mussolini's Royal Academy, the year during which the Futurists supported Fascist rule with renewed zeal — a number of new Italian artists joined Marinetti's movement. Among them was one of the most noted representatives of *aeropittura*, Mino Delle Site.

Hailing from the Italian south, Delle Site was fascinated by football — so much so that he created illustrations of the physiognomies of the players of a local Lecce club for the *Salento* almanac, directed by Gregorio Carrugio and published in Bari.[14] In 1930, when he moved permanently to Rome and joined other aeropainters, he also got involved in the popularisation of sports in general and football in particular. In that same year, he painted *Sport* — a view of a football stadium seen from the perspective of a plane. In the mid-thirties, Delle Site was hired as the interior designer for the *Casa dello studente* at the Sapienza University, and in 1937 he held a solo exhibition in the very same place, inaugurated by Marinetti, with *composizioni sportive* which also included football compositions. In the sketch of *Decorazioni per la palestra — Casa dello Studente Città Universitaria* [Decorations for the Gym — Student's Home, University Campus] he included an example of an *aeropittura* sketch showing the football field floating in the air.

Mino Delle Site's work at the Sapienza University was reminiscent of Enrico Prampolini's *aeropittura* experiments. After 1929 Prampolini was much involved in the new Futurist trend and wanted to explore 'l'equilibrio assoluto dell'infinito ed in esso dare vita alle immagini latenti di un nuovo mondo di realtà cosmiche' [the total equilibrium of the infinite, thereby giving life to images latent in a new world of cosmic reality].[15] His desire was to express the new aerial visual perspective connected with cosmic dimensions and sacred art, and the football motive was also used to that end. After 1926, in the Fascist state football was becoming the masses' new religion, and its magic was meant to reach the heavens. It is by no means accidental that Prampolini's painting *Angeli della terra* [Angels of the Earth, 1936] took the football phenomenon into a heavenly expanse. Boccioni's soccer player from the tens simply overcame gravity. Dottori's players, from the end of 1928, ascended to heaven. In the mid-thirties, Prampolini displayed the *Azzurri* as angels. White and blue silhouettes painted on geometrical figures evocative of football players suggested open wings. They carry the sportsmen upwards and towards the ball, which glides almost as high as the sun and follows a trajectory of a dotted line towards its target. This target is an outline of a goalpost, guarded by yet another angelic goalkeeper. The geometric figures, which emulate the bodies of footballers, are filled with blue, which undoubtedly suggests the national outfits of the *Azzurri*. The painting was a reminiscence of the Italian team's victory in the 1934 World Cup, which had been held in Italy. This is further confirmed by the outline of the Apennine peninsula placed in the central part of the painting. The angel footballers are hovering above the map of their home country, where the victorious tournament took place. Prampolini's surrealistic vision of a football game brought together a thirties Futurist aesthetic and the ideology of Fascist propaganda. All that is national, masculine, modern, victorious, and dynamic had been related to the aspects of new spiritualism and cosmic reality in the form of the football match.

Around that time, Prampolini created two paintings related to football, and one of them was prepared to represent Italian art at the Art Competitions of the XI Olympics in Berlin in 1936. Football elevated to the status of a new religion was the most significant indication of sports fever in Italy, and it is no accident that this Futurist vision of a football game was shown in Germany. A few months earlier, the most significant Fascist sports art show had taken place. Organised by the Comitato Olimpico Nazionale Italiano (CONI), the *Prima mostra nazionale d'arte sportiva* (February–March 1936) was meant to single out the best works for the Berlin Olympics. The exhibition was held at the Palazzo delle Esposizioni, and included ninety-eight paintings and sculptures, including some football works by Futurists. The catalogue listed, among others, Marisa Mori's *Radiotrasmissione di una partita di calcio* [Radio Broadcast of a Football Match][16] and Tato's *Incontro calcistico di campionato* [Championship Football Match].[17] The *Seconda mostra nazionale ispirata allo sport* organised by CONI in 1940 in Rome, featured a section on Futurist aeropainting, and included a work by Angelo Saveli, which depicted football fans (*tifosi*).[18] During the war years, the interest in football understandably waned, and the Futurist involvement turned instead to the glorification of war operations led by Mussolini.

Football and Futurist Performance

Futurists explored the idea of the medium of football as performance and put forward the idea of introducing *calcio* into the theatre. The most interesting experiment combining football and theatre was a dance piece called *Danza del Football* [Football Dance], which premiered in June 1928 as one of the projects of Enrico Prampolini's Futurist Pantomime Theatre. The programme of the show in Teatro delle Feste in Turin included four examples of *danze sportive*. It starred Zdenka Podhajska in a Futurist performance choreographed by Prampolini entitled *Tennis* (music by Silvio Mix), *Foot-ball* (music by F. M. Hradil), *Vortice* [Vortex] (music by Francesco Balilla Pratella), and *Danza dell'elica* [Dance of the Propeller] (music by Franco Casavola). Her performance in costumes designed by Prampolini was yet another take on the Futurist exploration of the world of sports, aeroplanes, and machines — this time in dance.

In the same year, 1928, Marinetti published the manifesto 'Mie proposte di nuovi sports' [My Proposals for New Sports], where in a characteristically over-the-top, exalted manner, he argued for the Futurist precedence in the presentation of modern aspects of sport in arts:

> Il nostro tempo è dominato dallo Sport, grande religione dei muscoli e dei coraggio, religione disinteressata poichè i tre quarti dei suoi fedeli guarda l'altro quarto che agisce.
>
> Lo Sport vince la politica l'arte la tavola l'amore. Lo Sport è la difesa offesa sfida che l'Umanità oppone alla sua more incalzante. Noi Futuristi, primi fra tutti, abbiamo portato lo Sport nella poesia e nel l'arte.
>
> [Our time is dominated by sport, a great religion of muscles and courage, a selfless religion since three-quarters of its followers watch the other quarter acting.

Sport surpasses politics art cuisine love. Sport is defence attack challenge that Humanity opposes to its relentless death. We Futurists are the first to have introduced Sport in poetry and art.][19]

Moreover, Marinetti wanted sports to become more exciting. To this end, he promoted 'simultaneous sports', which combined two different activities. Their aim was to counteract the influence of traditional sports and athletic spectacles that were becoming increasingly popular in the thirties, especially in the form of the Olympic Games which Marinetti explicitly condemned.[20] An example of a simultaneous sport, which opens the list in the manifesto, was a combination of football and the art of improvisation: '1. Gara di calcio con corsa a piedi. I giuocatori inseguono e si disputano il pallone in diversi campi successivamente conquistati, alcuni predisposti, altri improvvisati al momento' [1. Football match with running race. The players chase the ball in various fields subsequently conquered, some as planned, others improvised on the spot].[21]

The same idea to invent Futurist sporting performance appeared a couple of years later in the manifesto 'Simultaneità nello sport. Manifesto Futurista' [Simultaneity in Sport. Futurist Manifesto] (1931) and later in Marinetti's 'Nuovi sports latini' [New Latin Sports].[22] A football game, watched by a crowd filling the stands, indeed resembled a modern theatre spectacle — owing to its spectacular nature and the active way of shared participation. Mussolini's failure to establish a fixed form of mass theatre meant an opportunity for football.[23] Futurists, as it turned out, were convinced of this too. In the modern football stadium, collective emotions, joy and tragedy, constituted an integral part of every show. The role of the theatre could thus be taken over by that of a football stadium — a true Futurist Colosseum, modernised through Benito Mussolini's version of Fascism. The stadium-building fever, which took over Italy since it had been granted in 1932 the right to organise the 1934 World Cup, also meant the creation of space for mass spectacles. It is no coincidence that Filippo Tommaso Marinetti launched the project of a Sports Theatre in 1932. Aeropoet Bruno Sanzin wrote later that the 'teatro sportivo' was meant to be staged in the stadium of the Foro Mussolini to celebrate the tenth anniversary of the Black Shirts March on Rome, but for financial reasons the project never saw completion.[24] It is also worth mentioning that it was Enrico Ragusa who planned to put on a show in the spirit of 'teatro sportivo' at the Teatro Bellini in Palermo with the participation of the local football team.

Football and Futurist Literature

While football was a frequent subject in Futurist painting and Futurist forms of theatre, it appeared less often in poetical experiments, some of which are nevertheless worth mentioning. In the early forms of Futurist literature, football made its appearance in the poem 'Battaglia peso + odore' [Battle Weight + Smell, 1912], in relation to the war events on the Libyan front. For Marinetti, war movements triggered off a string of associations with modern sport: 'waltz leap rage spoils explosions shells-gymnasts crashes trapezes explosion rose joy stomachs-watering-cans heads-foot-ball scattering'.[25] A poetical reference to football testified Marinetti's

claim expressed in *Distruzione della sintassi — Immaginazione senza fili — parole in libertà* [*Destruction of Syntax — Imagination without Strings — Words-in-Freedom*, 1913] to indicate in poetry: 'The passion, art, and idealism of Sport. Idea and love of the "record"'.[26] The influence of sport on Futurist literature was also noted by a group of poets, who went by the name 'paroliberi': 'Noi paroliberi amiamo, come la tenia cordelliforme ama le budella, la nostra scuola che è *calcio*, sport, pugno, volo, zam parapàaaa [Like a tapeworm loves your guts, we poets of Words-in-Freedom love our school, which means football, sport, fist, flight, zam parapàaaa].[27]

In a further exploration of the motif of football in other branches of Futurist art, one could mention the Words-in-Freedom recited during meals of Futurist cuisine. Marinetti recalled that during one of the dinners, a radio chronicler would recite the improvised *parole in libertà* on the magnificence of a soaring football during a Bologna–Milan game.[28]

At the time of the football fever, initiated by the fact that the 1934 World Cup had been assigned to Italy at the Stockholm congress of 1932, the Italian poet Umberto Saba went as far as writing a poetical reminiscence of a football game. Even though not a member of the Futurist movement, Saba experienced the enthusiasm of the crowd, after witnessing a match between the poet's hometown Triestina and the rival Ambrosiana in his *Cinque poesie sul gioco del calcio* (1933–34). The best-known poem of the series is the last, 'Goal', written in 1934.[29] *Goal* was also the title of a poem by Futurist aeropoet Bruno Sanzin, who explored the notions of dynamics and the joy of the crowd of supporters in a form resembling that of the popular radio transmission:

> area di rigore
> convergere accanito d'uomini intorno Pallone indeciso tra le punte delle scarpe contrastanti
> 　　　(entrare o no?)
> groviglio difesa offesa dinamismi colori calci scudi petti schiene deviare allontanare cercare momento conclusivo
> 　　　trepidazione
> 　　　ansia
> 　　　cen-tel-li-na-re gli attimi che passano
> 　　　(i cuori tifosi hanno cessato di battere per non turbare lo spasmodico silenzio dell'attesa)
> 　　la tensione nervosa della moltitudine ha fasciato e ingigantito la palla fino a riempirne l'universo
> 　　ATTENTI
> 　　il nocciolo di cuoio schizza via dalla vibrante polpa muscolosa e corre a posarsi là
> 　　　solo
> 　　in attesa del calcio atletico, che
> 　　ECCO arriva l'altro
> 　　　　scaltro
> 　　　　　scocca preciso in porta
> 　　　　　　　G O A L [. . .]

[penalty area
avid converging of men around undecided Ball between the tips of conflicting shoes
(to enter or not to enter?)
tangle defence attack dynamics colours kicks shields chests backs deviate breasts backs divert remove search closing moment
trepidation
anxiety
s-i-p the moments that pass
(the hearts fans have stopped beating so as not to disturb the spasmodic silence of waiting)
the nervous tension of the multitude has wrapped and amplified the ball up to filling the universe with it
CAREFUL
the core of leather shoots away from the vibrant muscular flesh and swiftly rolls to rest there
alone
waiting for the athletic football, which
LOOK the other arrives
astute
strikes precise at the goal
G O A L ! [. . .][30]

Football fever played an important role in the modernisation of the country. The construction of new stadiums was for Marinetti part of the vision of the great Fascist Italy. The country was turning Futurist, he would claim, thanks to the politics of autarchy. In his aeropoem *Il poema non umano dei tecnicismi* (1940), he flies over the country and admires the beauty and the originality of Imperial Fascist Italy. The poem concludes with a vision of prosperity and national pride:

> Piscine d'operai bambini d'operai campi di calcio e bocce
>
> Viali Vittorio Veneto e Arnaldo Mussolini
>
> Teatri e refettori per migliaia d'operai
>
> Alto albergo di platani ed ippocastani per un popolo di biciclette
>
> In alto viaggiare viaggiare senza fine la nuova costellazione le cui stelle formano la parola AUTARCHIA
>
> [Workers' swimming pools worker's children soccer fields and bowling greens
>
> Vittorio Veneto and Arnaldo Mussolini avenues
>
> Theatres and refectories for thousands of workers
>
> High shelter of plane trees and horse chestnut trees for a population of bicycles
>
> High above traveling endlessly the new constellation whose stars form the word AUTARCHY][31]

That Marinetti would include football fields in his vision of a great Italy under the Fascist regime was by no means coincidental. To many they symbolised the new

Italian architecture for the new Italian society, and from the thirties onwards they reflected Italian victories as an expression of national pride.

Conclusion

Football, the most popular sport in Europe, became the subject of interest not only to the Futurists, but also to other avant-garde artists, such as Kazimir Malevich, László Moholy-Nagy, Lux Feininger, John Heartfield, Willy Baumeister, El Lissitzky, Alexander Rodchenko, and others.[32] It seems, however, that among the particular currents of the interwar avant-garde, Futurism was affected by football most profoundly. Here, painting, poetry, and performance art connected with football exemplified the ideas of dynamism, modernity, national victories, many of the postulates of Marinetti's as well as of Fascist public policy.

The presence of football can be observed in all the most important examples of Futurist artistic endeavours: plastic dynamism, aeropainting, early Futurist poetry, aeropoetry, theatre of surprise, the Futurist pantomime, dance, the Futurist exploration of *radiocronache*, Futurist-Fascist propaganda and the Futurist dream of a modernised Italy, the exemplification of national pride and the cult of national superheroes. In the case of painting, football allowed for vast possibilities of artistic creation: particular reports of field happenings, analyses of the expressivity of the human body, studies of struggle, rivalry, effort, and, finally, the generalisation of movement, of dynamics. Painters of almost all regions in Italy tackled the subject: Boccioni, Notte, Gambini (Lombardy), Castello (Liguria), Depero, Baldessari (Trentino), Dottori (Umbria), Thayaht, Mori (Tuscany), Tato (Emilia-Romagna), Rizzo, D'Anna, Corona (Sicily), Prampolini (Lazio), Mino Delle Site (Apulia). Not only did it confirm the fact that the interest in football was visible in Futurist activity, but it also indicated a nationalist fever, unifying different areas of the country by glorifying the victories of the national team. Such painters as Dottori or Prampolini inscribed the national football team into the space of aeropainting, the Futurist idea of sacral art, bestowing upon it the importance of a new mythology, a new religion for the new masses. Football performance was (and in fact still is) particularly revered by Italian society, and the Futurists could not remain indifferent to that. Even though during the first two decades football was not particularly significant in Futurist art, the situation changed after 1926, when Fascists institutionalised *calcio* as a national game. In the moment of the Futurist reconciliation with Mussolini's regime, football became a subject explored by artists in diverse ways, reflecting the most important artistic concepts and ideological postulates. It would represent the totality of a work of art, a new phenomenon admired by intelligentsia, bourgeoisie, proletariat, even by leaders of totalitarian systems. The preparations for the World Cup in Italy in 1934 were a major factor in the realisation of the plans of stadium construction and in the modernisation of cities. The triumph of Italy in 1934, at the 1936 Olympics in Berlin, and in 1938 in France was to be reflected in the victories of Fascism in its military expansion during the Second World War. Football thus became an allegory of the modernisation of the country, of modernity and of

spectacular victories under Italy's tricolour banner. Central to many artistic projects as well as to Marinetti's postulates, football proved to be an essential element of the Futurist aesthetic.

Notes to Chapter 8

1. See *Dinamismo sportivo* (Milan: Galleria Il Dialogo, 1981), *X Mostra arte e sport — Futurismo e sport* (Florence: Palazzo Strozzi, 1982), *Football: I domini del calcio: memoria, cultura, comunicazione* (Rome: Spazio Peroni, 1990), *Allo sport l'omaggio dell'arte* (Salerno: Biennale delle Scienze e delle Arti del Mediterraneo, 2001), *Appunti allo stadio. 90 opere sul tema del calcio nell'arte italiana del XX secolo* (Rome: Palazzo delle Esposizioni, 2002; Seoul: Arts Center, 2002), *SportArte. Mito e gesto nell'arte e nello sport 1900–1950* (Predappio: Casa Natale Mussolini, 2002), *Sport e '900: il gesto sportivo nell'immaginario artistico* (Novi Ligure: Museo dei Campionissimi, 2004), and *Arte e sport nel '900 italiano* (Rome: DART, 2004)
2. On Futurism and sport see also: A. Baitini, 'Per i futuristi lo sport era dinamismo totale', *Stadium*, Aprile-Maggio 1982, pp. 25–26; Giorgio Triani, 'Dal Futurismo al futuribile', *L'Unità*, 10 November 1986, p. 20; Sergio Giuntini, 'Marinetti e lo sport', *Il Calendario del Popolo*, April 1994, pp. 43–44; Giuseppe Brunamontini, 'Il movimento aggressivo molla del Futurismo', *Lo Sport Italiano*, Dicembre 1994, pp. 40–43; Sergio Giuntini, 'Sport e fascismo a Milano, da Marinetti a Salò', in *Sport e fascismo*, ed. by Maria Canella and Sergio Giuntini (Milan: Franco Angeli, 2009), pp. 351–68.
3. Since the very beginning of football tournaments, the game in Italy had been full of violence, echoing the stories of Marinetti's famous semi-artistic actions, in which he would often be attacked by a crowd hurling anything that was at hand. As John Foot argued:

 > Violence was a part of *calcio* from the very beginning. [. . .] Between 1911 and 1914, a number of incidents marred games. Stones were hurled at a referee in 1912 in a match between Genovese team Andrea Doria and Inter. [. . .] Pitch invasions became commonplace [. . .]. In the brutal atmosphere of post-war Italy, football violence exploded on and off the field. (John J. Foot, *Winning at All Costs: A Scandalous History of Italian Soccer* (New York: Nation books, 2007), p. 18)

4. Up to that time, French painters Albert Gleizes, Robert Delaunay, and André Lhote painted fragments of games, often entitling them 'football', but in reality what they painted were rugby games. This indicates that in Europe the names of both games were not yet fully distinguished. Rugby was historically a form of football (the main association is still called Rugby Football Union, RFU), and it was only in the late nineteenth century that it split from 'association football', which is the present form of football.
5. Umberto Boccioni, Carlo Carrà, Luigi Russolo, Giacomo Balla, and Gino Severini, 'Futurist Painting: Technical Manifesto 1910', in *Futurist Manifestos*, ed. and introduction by Umbro Apollonio (New York: The Viking Press, 1973), pp. 27–31 (p. 30).
6. Umberto Boccioni, 'Plastic Dynamism 1913', in *Futurist Manifestos*, pp. 92–95 (p. 93).
7. Daniele Marchesini, 'Fascismo a due ruote', in *Sport e fascismo*, pp. 85–98 (p. 85).
8. Simon Martin, 'Football and Fascism: Foreign Bodies on Foreign Fields', in *In Corpore: Bodies in Post-Unification Italy*, ed. by Loredana Polezzi and Charlotte Ross (Cranbury: Associated University Presses, 2007), pp. 80–107 (p. 80).
9. See Simon Martin, *Football and Fascism: The National Game under Mussolini* (New York: Berg, 2004), p. 142.
10. Ibid., pp. 88–140.
11. *Gli Azzurri* (The Blues) of course refers to a nickname for Italian national team. Since 1911 Italian soccer players wore blue kits.
12. Christine Poggi, *Inventing Futurism: The Art and Politics of Artificial Optimism* (Princeton: Princeton University Press, 2007), p. 170.

13. Umberto Boccioni, Carlo Carrà, Luigi Russolo, Giacomo Balla, and Gino Severini, 'Futurist Painting: Technical Manifesto 1910', in *Futurist Manifestos*, pp. 27–30 (p. 28).
14. *I futuristi: i manifesti, la poesia, le parole in libertà, i disegni e le fotografie di un movimento rivoluzionario, che fu l'unica avanguardia italiana della cultura europea*, ed. by Francesco Grisi (Rome: Newton Compton, 1990), p. 395.
15. Catalogue statement by Enrico Prampolini, in *Mostra futurista di aeropittura e di scenografia*, Milan, 1931, Quoted in Raymond Fearn, *Italian Opera since 1945* (Amsterdam: Harwood Academic Publishers, 1997), p. 4.
16. First shown at the *Prima mostra nazionale d'arte futurista*, Rome, 29 Oct. 1933.
17. Carlo Alberto Bucci and Flavia Matitti, 'L'iconografia del calcio nell'arte italiana nel '900', in *Dizionario del calcio italiano*, ed. by Marco Sappino (Milan: Baldini&Castoldi, 2000), p. 1916.
18. Another Futurist work treating the topic of the *tifosi* is the sketch *Il tifoso* made in the thirties by Bruno Munari.
19. Filippo Tommaso Marinetti, 'Mie proposte di nuovi sports', *Gazzetta del Popolo*, 14 June 1928.
20. Marja Härmänmaa, 'Futurism and Nature: The Death of the Great Pan?', in *Futurism and the Technological Imagination*, ed. by Günter Berghaus (Amsterdam and New York: Rodopi, 2009), pp. 337–60 (p. 352).
21. Marinetti, 'Mie proposte di nuovi sports'.
22. See: Mario Verdone, *Teatro del tempo futurista* (Rome: Bulzoni, 1988), p. 424.
23. Mussolini's dream for mass theatre only reached fruition on 29 April 1934 and the reviews of the '18 BL'. See: Jeffrey T. Schnapp, *Staging Fascism: 18 BL and the Theater of Masses for Masses* (Stanford, CA: Stanford University Press, 1996).
24. Günter Berghaus, *Italian Futurist Theatre 1909–1944* (Oxford: Clarendon Press, 1996), pp. 540–41; Claudia Salaris, *Artecrazia. L'avanguardia negli anni del Fascismo* (Florence: La Nuova Italia, 1992), p. 162.
25. Filippo Tommaso Marinetti, 'Battle Weight + Smell', in *Selected Poems and Related Proses*, selected by Luce Marinetti, essay by Paolo Valesio (New Haven, CT: Yale University Press, 2002), pp. 81–82 (p. 82).
26. Filippo Tommaso Marinetti, 'Destruction of Syntax — Imagination without Strings — Words-in-Freedom', in *Futurist Manifestos*, pp. 95–106 (p. 97).
27. Dario Tomasello, *Oltre il futurismo: percorsi delle avanguardie in Sicilia* (Rome: Bulzoni, 2000), p. 164.
28. Mario Verdone, *Drammaturgia e arte totale. L'avanguardia internazionale: autori, teorie, opere* (Soveria Mannelli: Rubettino, 2005), p. 76.
29. 'Five Poems for the Game of Soccer', trans. from the Italian by Geoffrey Brock, in *The Global Game: Writers on Soccer*, ed. by John C. Turnbull, Alon Raab, and Thom Satterlee (Lincoln, NE: University of Nebraska Press, 2008), pp. 230–34.
30. [Manuscript] Bruno Sanzin, *Goal*, F. T. Marinetti Papers, Beinecke Rare Book and Manuscript Library, Yale University.
31. The original is quoted from Filippo Tommaso Marinetti, *Il poema non umano dei tecnicismi* (Milan: Mondadori, 1940) p. 51. [I have respected the use of blank spaces in the original]. The translation is quoted from Cinzia Sartini Blum, *The Other Modernism: F. T. Marinetti's Futurist Fiction of Power* (Berkeley and Los Angeles: University of California Press, 1996), p. 142.
32. Przemysław Strożek, 'Footballers in Avant-garde Art and Socialist Realism before World War II', in *Handbuch des Sportgeschichte Osteuropas*, ed. by Anke Hilbrenner, Ekaterina Emalientseva, Christian Koller, Manfred Zeller, and Stefan Zwicker (Regensburg: IOS), <http://www.ios-regensburg.de/fileadmin/doc/Sportgeschichte/Strozek_Footballers.pdf>; Andreas Kramer, '"Everyman his Own Football"': Dada Berlin, Sport and Weimar Culture', in *Virgin Microbe. Essays on Dada*, ed. by David Hopkins and Michael White (Evanston, IL: Northwestern University Press, 2014), pp. 252–74.

CHAPTER 9

Gymnastics

Michael Syrimis, Tulane University

Gymnastics is a recurrent motif in Futurism and reflects one of the movement's fundamental traits, what we may describe as an ongoing state of restlessness, an unremitting combat between two seemingly clashing states of mind: one defined by order, rationality, equilibrium, and certainty, the other by chaos, irrationality, imbalance, and volatility. At first glance, gymnastics belongs to the former category. It exhibits order, equilibrium, and certainty. It employs methods based on rationality and repetition to develop specific physical and mental attributes, such as bodily coordination, stability, and agility, the last one being the most relevant to my discussion, as we will see. Yet if gymnastics exhibits such qualities in its performance aspect, its inner constitution entails a constant battle against the haphazard obstacles posed by the body's limitations and by nature at large. It thus involves a non-stop negotiation with the irrational, the disorderly, and the erratic.

Nonetheless, drawing an analogy between gymnastics and Futurism seems to contradict Futurism's most flamboyant claims about itself, about its task as a radical attack on tradition aiming to demolish the status quo and build a world anew. Let me repeat, however, that the combat that I am addressing — between rational and irrational, orderly and chaotic, stable and erratic — is, as in gymnastics, ongoing. As I will argue by discussing some key instances of the gymnastics motif, specifically in relation to other crucial aspects of Futurist discourse — education, war, theatre, poetry, and dance — Futurism may have sought chaos at times, but not to obliterate tradition and implement a permanent new order. Furthermore, Futurist chaos was not pure. It bore the seeds of order. Hence, it needed to be ignited afresh, to prevent any order from taking root. This is why, as concerns Futurism, order and chaos were only *seemingly* clashing. Indeed, they were complementary. The one did not aim to annihilate the other but craved the other's presence so as to maintain the combat. As performances, Futurism and gymnastics diverged: the former theatricalised its attack on order, whereas the latter theatricalised its conquest of chaos. Yet in essence both were ongoing states of combat between two inter-reliant forces. Agility is key in this process; it is where the two forces visibly converge. Either in the physical or in the mental sense, agility is nurtured by order and discipline, yet its *raison d'être* is its encounter with the haphazard, its making a spectacle out of the reconciliation between rationality and irrationality, firmness and volatility, order and chaos.

In its literal applications, the gymnastics motif reinforces the Futurist worship

of physical characteristics, such as strength, agility, swiftness, and endurance, as well as psychological ones, such as bravery, aggressiveness, political anti-neutralism, contempt for intellectual passéism, and man's liberation from the anguish of romantic love — all of which were crucial to the bolstering of the Futurist mindset. Engaging in gymnastics is essential to what defines a Futurist. As Marinetti states in a 1919 definition of Futurism, a Futurist is one 'who loves the open-air life, sport, and gymnastics, and pays close attention to the strength and agility of his own body every day'.[1] The motif is indispensable to documents that envision a radical programme of education for the young in a purportedly future world order. According to Marinetti's 'Il proletariato dei geniali' [The Proletariat of Talented People, 1919], the Italian race surpasses all others in the number of geniuses that it produces. Yet prior to Futurism, he contends, this supreme intellect was wasted on the passéist intellectualism that dominated education, an intellectualism of German origin, antipatriotic, internationalist, which separated the body from the spirit, yearned for cerebral hypertrophy, was obsessed with books, and was mere pedantry. What further defined it was 'the scorn for gymnastics, the brutalisation of boys in closed, foul-smelling classrooms, a total lack of attention to health and muscular strength.'[2] The 'Manifesto del partito futurista italiano' [Manifesto of the Futurist Political Party, 1918] instead aspires to '[t]he abolition of many useless universities and of classical education. Obligatory technical instruction in the workplace. Obligatory and legally enforced gymnastics, sport, and military education in the open air. School promoting courage and the Italian spirit.'[3] Likewise, the third Futurist political manifesto, written in 1913, had already envisioned 'Many institutes for physical education. Gymnastics in schools every day. Supremacy of gymnastics over books.'[4]

The abolition of universities and classical education and the predominance of gymnastics over books by no means imply that physical education will sweep away intellectual progress. Rather, a type of intellect is to be fostered the values of which differ from those of passéist intellectualism. The swiftness and agility of body that one attains via the comparatively simple mechanics of gymnastics are to bear psychological benefits as well, in that they will translate into swiftness and agility of mind, to achieve decisiveness, clarity of thought, sincerity of expression free of hesitation, and laconicism, tending, one might say, towards a mode of behaviour that in aesthetic terms the Futurists would call 'synthetic'. Indeed, the 1915 manifesto on 'Il teatro futurista sintetico' [Futurist Synthetic Theatre] offers this type of performance — thanks to its extreme dramatic and linguistic brevity, or its 'synthetic' structure — as a form of gymnastics, or training, of the spirit: 'Every evening the Futurist theatre will provide rigorous training [*ginnastica*] for our race in the rapid, dangerous feats that this Futurist year demands.'[5]

Given that the manifesto of the 'synthetic theatre' was written in early 1915 (that is, a few months prior to Italy's entry into the First World War on the side of the Entente of Britain, France, and Russia, a moment at which passionate Interventionism was the core of Futurist ethos), the 'rapid, dangerous feats' in which gymnastics is to train the spirit denote the drive to perform acts of boldness and bravery related

to war. The war ideal informs the very opening of the manifesto: 'While waiting for the start of our great, much-called-for war, we Futurists alternate our violent antineutralist action in the piazzas and universities with our artistic activities, thereby preparing Italian sensibilities for the great hour of supreme Danger.'[6] The mental gymnastics that the synthetic theatre is to constitute, at this electrifying moment, is a form of education superior to any lethargic reading activity. For Italy's swift, aggressive, and resilient participation in war, books are useless.

> They are tedious, they are obstacles and slow things down; they can only dampen enthusiasm, cut short our forward dash, and poison the minds of a people at war with doubts. War, which is an intensified form of Futurism, compels us to march and not to fester in libraries and reading rooms.[7]

The nurturing of laconicism via gymnastics, physical or mental, is therefore crucial to the refinement of a belligerent spirit, while the manifesto of the synthetic theatre is not the only document that links gymnastics to patriotism and the Futurist cult of war. As noted, while the passéist intellectualism that suppressed virility is described as of German origin, gymnastics is also envisioned as part of a programme that comprises military education.[8]

The very notion of gymnastics was indeed a matter of national pride for Italians in the 1910s, following Alberto Braglia's winnings of the individual all-around gold medal in the 1908 Olympic Games in London and again in the 1912 Olympics in Stockholm, as well as a third gold medal as a member of the Italian team, which in Stockholm won the team all-around competitions.[9] This is not to say that the Futurists' use of the term *ginnastica* refers specifically to Olympic gymnastics, which in 1912 included performances on horizontal bar, parallel bars, rings, and pommelled horse.[10] While it may not exclude those, the term conveys a more general meaning, referring to physical activities that involve rational and repetitive methods of improving strength, body control, and agility. It is evidently more specific than 'sport', a term next to which 'gymnastics' is often listed, hence suggesting that the two differ in meaning. It may also be as specific as acrobatics, as suggested by Marinetti's praise of the variety theatre, 'by virtue of the dynamism of its form and colour (simultaneous movement of jugglers, ballerinas, gymnasts, multicolored riding troupes, dancers *en point*, whirling around like spinning tops)'.[11] The 1916 film *Vita futurista*, the single film realised collaboratively by the Futurists as a movement, which included the episode 'Ginnastica mattutina' [Gymnastics in the morning], might have given us a good sense of what they meant by 'ginnastica', had it been extant.[12] It is likely, nonetheless, that the Futurist notion of gymnastics involves, generally speaking, a methodical practice marked by rationality, order, and discipline. It is addressed as such in *Democrazia futurista*, which proposes 'rational gymnastics' as a means of strengthening and defending the male spirit against the tyranny of love, the obsession with conquering woman, the romantic ideal of fidelity, and other such strokes of pathos that may be deemed irrational and that breed *ipersensualismo*, decimating the energies of men of action. Such tendencies must be countered with violent sports, fencing, swimming, and 'una ginnastica razionale, atta ad amplificare il torace, a dilatare i polmoni, [. . .] per la formazione

di un corpo d'uomo bello, svelto, forte e resistente, che sappia pensare, volere ed atterrare uomini, idee e cose con uguale disinvoltura' [a rational gymnastics, able to amplify the thorax, to dilate the lungs, [. . .] in order to shape a beautiful, slender, strong, and resistant body, capable of thinking, willing, and bringing down with the same ease men, ideas, and things].[13]

The idea of gymnastics as an inherently rational structure informs also the metaphorical references to the figure of the gymnast in images of imposing technological products, such as bridges or howitzers, for the engineering of which the application of rationality was imperative. The 1909 founding manifesto of Futurism proclaims its heroes' intention to celebrate numerous phenomena that represent the Futurist mindset: danger, energy, temerity, courage, rebellion, movement, insomnia, the slap, the punch, speed, and war; the destruction of museums, libraries, academies, moralism, and feminism; emblems of modern urbanity, such as large crowds, railway stations, factories, steamers, aeroplanes, and 'bridges which, like giant gymnasts, bestride the rivers, flashing in the sunlight like gleaming knives'.[14] Moreover, Marinetti's 'Battaglia peso + odore' [Battle Weight + Stench, 1912], written in *parole in libertà*, consists of a chain of Futurist 'analogies', one of which links the howitzer to the gymnast ('howitzer-gymnasts'; 'obici-ginnasti').[15] The metaphorical use of such images as gymnasts suggests that the literal implementation of physical gymnastics in schools or mental gymnastics in the synthetic theatre, which is to cultivate a Futurist sensibility based on swiftness, agility, vitality, laconicism, boldness, bravery, and so on, finds its primary inspiration in the achievements of science and in the rationality that inheres therein. Moreover, such products, in so far as they constitute 'gymnasts' or trainers, provide models for the human body to imitate, thus summoning Marinetti's celebrated 'uomo moltiplicato' [Extended Man], the ideal Futurist who embodies the imminent identification between man and motor, a 'nonhuman, mechanical species, built for constant speed, [that] will quite naturally be cruel, omniscient, and warlike',[16] and immune to the love for women, detrimental to his vitality, which he replaces with his adoration of his locomotive.

The relationship between gymnastics and rationality seems more elusive, however, when Marinetti associates the motif with particular aesthetic forms, such as theatre, poetry, and dance. If the synthetic theatre was a form of mental gymnastics to train the spirit in the 'rapid, dangerous feats' of the war years, thanks to its essential brevity that promoted directness, swiftness, and laconicism — attitudes with a clear kinship to the rational mechanics of physical gymnastics — several years thereafter, in defining the 'Teatro della Sorpresa' [Theatre of Surprises, 1921], Marinetti and Cangiullo praised this new concept of theatre for its *a-logical* gymnastics, for training the spirit 'into full play, with all its spiritual, a-logical gymnastics'.[17] The element of 'surprise' had been crucial in Marinetti's praise of the variety theatre almost a decade earlier. Variety's audience physically participated in the evening's hilarious acts, thus replacing traditional theatre's fixation on *psicologia* with an exhilarating *fisicofollia*, or body-madness. Through further interventions, Futurism was to transform variety into a truly Futurist event. Specifically, it was to maximise

the element of 'surprise' in the auditorium and make a side-splitting show out of the spectators: by sprinkling the seats with glue or itching and sneezing powder, selling the same seat to many, or offering free admission to obnoxious individuals.[18] Perhaps because the synthetic theatre, its structural brevity having been inspired by variety, had counterproductive effects — in that its orchestrated scenes, acted by professionals, restrained rather than excited the audience — Marinetti and Cangiullo looked back to variety to articulate a new concept of theatre of which 'surprise' was the fundamental principle.[19] Yet their aim for 'spiritual, a-logical gymnastics' does not constitute an irredeemable inconsistency. The term 'gymnastics' here is obviously less specific than its application to education or to the synthetic theatre with its affinity to physical gymnastics. It represents mental exercises that aim at the elasticity of the mind, at the development of ways of reasoning that counter the logic fostered by traditional discourses, theatrical or otherwise.

It is in the motif's associations with Futurist poetry, however, that the question of its rational premise becomes perplexing. On the one hand, in 'Lo splendore geometrico e meccanico e la sensibilità numerica' [Geometrical and Mechanical Splendour and Numerical Sensibility, 1914], Marinetti proposes a correlation between the *parole in libertà* and things like order, discipline, and method. The traits of the modern condition that he calls 'geometrical splendour' together promote the refinement of a Futurist sensibility free of any analytical ponderings that clutter the mind: 'A healthy forgetfulness, hope, desire, unbridled strength, speed, light, the will, order, discipline, method [. . .] an aggressive optimism stemming from a passion for sport and the toning of muscles'.[20] The precursors of Futurist poets are the gymnasts whose activities embody the codes of modernity's splendour: 'Their precursors are gymnasts and tightrope walkers, who in the swelling, relaxation, and pulsating rhythm of their muscles demonstrate the sparkling perfection of precision instruments, and the geometrical splendor that we wish to attain in poetry through our Words-in-Freedom.'[21] Hence, precision and absolute bodily coordination are sources of inspiration for poetry. He lays out the formal characteristics of the *parole in libertà* (Words-in-Freedom) — non-narrative form, unadorned nouns, verbs in the infinitive, synoptic tables, onomatopoeia, essential brevity, and more — conveying indeed a form of writing affine to the vibrant simplicity, momentum, and geometric patterns of the acrobat's motions, no less than the visual emblems of a modern industrial order.[22]

On the other hand, the rejection of narrative, syntax, grammar, and punctuation that defines the *parole in libertà* ascribes a sense of disorder to the discourse as a whole, even if isolated elements (a synoptic table, an analogy, an onomatopoeic sign) reflect the orderliness of geometry, mechanical methods, and numerical tables. In fact, Marinetti's earlier poetics in the 'Manifesto tecnico della letteratura futurista' [Technical Manifesto of Futurist Literature, 1912] undermines the later work's harmony between poetry and geometry. Whereas later he posits 'order, discipline, method' as essential traits of the 'geometrical splendour' — the condition of which the gymnast's controlled and poetry-inspiring muscular manoeuvres constitute the realisation — the 'Technical Manifesto' states that: 'Since every sort

of order is an inevitable product of cautious intelligence, we have to orchestrate images by arranging them with a maximum of disorder.'[23] Moreover, a recurrent idea in the 'Technical Manifesto' is poetry's attack on 'logic'. Marinetti proposes the abolition of the 'I' in literature and its substitution with the 'lyrical obsession with matter' (metals, stones, wood), the essence of which is to be grasped not through a logical application of traditional disciplines, such as physics and chemistry, but by strokes of intuition: 'The man who is damaged beyond redemption by the library and the museum, who is in thrall to a fearful logic and wisdom, offers absolutely nothing that is any longer of any interest.'[24] He closes this manifesto with a decisive rejection of 'logic', proclaiming its identification with death. By building a friendship with matter, of which scientists know nothing but the physicochemical reactions, the Futurists are preparing for the creation of the 'Mechanical man, one who will have parts that can be changed. We shall liberate him from the idea of death, and therefore from death itself, which is the all-embracing definition of logical intelligence.'[25]

To be sure, as in the case of the a-logical gymnastics of the 'theatre of surprises', the 'logic' that Marinetti aims to attack via poetry is the kind that is nurtured by traditional scientific disciplines or literary discourses relying on conventional rules of language. Yet we are perplexed once we pit his attack on scientism against his adulation of geometry, mechanics, and numerical structures. What exactly differentiates the 'logic' of traditional disciplines from geometry's logic? Is the former a historically specific kind, the mere historicity of which justifies its eradication, whereas the latter is abstract or one that governs the life of matter, which is more complex than what science can apprehend and tabulate, and which must therefore be apprehended via intuition? Noteworthy is the fact that poetry's mission against 'logic' is absent from the later document on 'Geometrical Splendour'. One wonders whether Marinetti, once his fascination for geometry ripened, wished to correlate Futurist poetry to geometry, yet carefully avoiding that previous motif, the problem of 'logic', which might have suggested ambivalence or contradiction. I prefer, nonetheless, to view this so-called ambivalence, contradiction, or inconsistency as an instance not of insincerity on Futurism's part but of that fundamental Futurist trait that I noted in introducing this discussion, and of which, I add, Marinetti was aware: an ongoing combat between rationality and irrationality, order and disorder. Futurist poetry theatricalises its break with tradition (grammar, syntax, 'logic') and causes chaos, yet reverts to the remnants of tradition that it carries within, to the seeds of order that Futurist 'chaos' carries within.

The *parole in libertà* are words 'freed' from the prison of syntax, grammar, punctuation, and linguistic adornments such as adjectives and adverbs. A main formal feature is 'analogy', which professedly rejects logic. Interestingly, like logic itself, analogy is widely discussed in the 'Technical Manifesto' yet barely appears in 'Geometrical and Mechanical Splendour'. Analogy is the 'deep love that connects objects that are distant in kind, seemingly different and hostile'.[26] It is the direct pairing of any noun with its double (albeit too hostile to it from a traditionalist's perspective), free of conjunctions or other linguistic reparations. It is industrial modernity's gift: 'Since the speed of air travel has greatly increased our knowledge

of the world, perception through analogy is becoming ever more natural for human beings.'[27] Yet analogy becomes truly revolutionary when the first of its two terms is eliminated: 'Better still, we should fuse the object directly with the image that it evokes, providing a glimpse of the image by means of a single, essential word.'[28] The sequence of 'second terms' will trigger the 'untrammeled imagination', to reach the unexplored capabilities of the mind, attaining levels of logic that surpass the notion as we know it:

> We shall arrive, one day, at an art that is even more essential, when we have dared to suppress all the first terms of our analogies so as to give nothing more than the uninterrupted second terms. Because of this, we shall have to renounce being understood.[29]

Marinetti aspires to attain the 'illogical sequence which is no longer explanatory, but intuitive, in the use of only the second terms of many analogies, all disconnected, one from the other, and very often of opposing meaning, one to another'.[30]

Yet neither the lack of logic nor the disjointedness between the second terms results in structural chaos. The purportedly disjoined elements usually relate to the work's overarching theme, such as war in Marinetti's 'Battaglia peso + odore' or *Zang Tumb Tuuum*, which defines the diegetic context, allowing us to draw logical connections between them. Marinetti's own language sometimes suggests the logical links among the otherwise drifting nouns. His metaphor of the 'carriages in the train of analogies' to describe the placement of nouns or unconjugated verbs into an analogical series draws an image of collaboration rather than rupture between the succeeding elements.[31] Furthermore, if the 'Technical Manifesto' proposes the noun's complete riddance of adjectives to release its inherent dynamism,[32] Marinetti later promotes the 'signal adjective, beacon adjective, or atmospheric adjective',[33] which involves the use of an adjective not as an element attached to a single noun (as in traditional practice) but as separated and placed in brackets so that its meaning permeates a whole segment of the work:

> If, for example, in an agglomeration of Words-in-Freedom that describes a sea voyage, I place the following signal adjectives in parentheses: (calm blue methodical regular-in-its-habits), not only is the sea *calm blue methodical regular-in-its-habits*, but the ship, its engines, its passengers, what I am doing, and my very spirit are *calm blue methodical and regular-in-their-habits*.[34]

Though innovative, the 'signal adjective' aids the construction of a diegesis marked by atmospheric coherence, the effect not differing entirely from that of a traditional literary passage. Occasionally Marinetti also discloses the Futurist's degree of reliance on traditional forms: 'Sometimes it [= genius] demands slow analyses and explanations. No one can suddenly revitalise his own sensibilities.'[35] Elsewhere, he states: 'In the Words-in-Freedom, imbued with my unrestrained lyricism, you will still find, here and there, traces of normal syntax and even some grammatically logical sentences. This imbalance between precision and freedom is inevitable and natural.'[36]

His acknowledging that traditional forms are sometimes inevitable indicates not a utopian vision of a future poetics that will gradually transcend its present and

become wholly purged of all traces of passéism — its 'logic', its order — but an awareness that Futurism is and will remain a struggle between the pursuit of the new and the relentlessness of the old. In fact, more than awareness, it indicates an intention. The old neither can nor should perish, but must serve as the undying adversary against which Futurism will uphold its fight, its *raison d'être*. Diachronically speaking, the new will become old and must be attacked. The founding manifesto reads: 'When we reach forty, other, younger, and more courageous men will very likely toss us into the trash can, like useless manuscripts. And that's what we want!'[37] Futurism is not a mission to be accomplished by Marinetti and company, attaining contentment. Rather, it is *movement* in the physiological sense of the term. That it entails, in essence, a non-stop struggle becomes plain in Marinetti's remarks on war. Futurist Interventionism did not aspire to a defeat of the Austrians followed by a triumph of peace. It was so for the passéists and pacifists. They, he claims, by defeating Germany and Austria, hoped to kill war itself, as if war constituted but a remnant of barbarism. Instead, 'War cannot die, for it is one of the laws of life. Life = aggression. Universal Peace = the decrepitude and death throes of races.'[38] Futurism sought an infinite process of destruction, reconstruction, and rejuvenation, not victory or anything that led to rest, peace, acquiescence, or closure. Futurism was war, and war was Futurism: 'War, which is Futurism intensified, will never kill off war, as the traditionalists would like, but it will kill traditionalism.'[39]

Futurism troubles our understanding of the relationship between gymnastics and rationality in that it posits gymnastics as inspiration for a poetics marked by precision, order, discipline, and method, while elsewhere it associates this very poetics with disorder and illogic. This contradiction is not irredeemable if we distinguish, as suggested above, the part from the whole, that is, if we recognise the rational basis of each poetic element in isolation, while the interrelations of the various elements, displaying diverse styles and moving in multiple directions, form a totality marked by disorder. As for the corresponding visual code that we may draw from gymnastics, one may imagine a space in which gymnasts engage simultaneously in diverse practices, forming a spectacle defined by opposition and incongruity, yet with the display of strength, vitality, and agility as its chief and unifying characteristic. What I find more suggestive, however, in Futurism's interest in gymnastics is its ontological affinity to it. Gymnastics is not a Futurist invention, nor are geometry, or war. They, like many others, are traditional phenomena, which Futurism adapts to its own programme, not so much to create a world anew as to glorify life's aporias: the clash between rational and irrational, order and chaos, old and new, or life and death. More specifically, like gymnastics, Futurism is a state of being defined by an inherent battle between clashing forces. If gymnastics summons rationality to exhibit its subjugation of the unpredictable, Futurism stages shock to exhibit a disdain of the familiar. Yet in each system, each force requires the perseverance of the other for the process to carry on. The process must carry on because any form of closure would defy the essence of either system.

I conclude with some observations on dance, an art that combines bodily movement with performance, thus allowing Futurism to envision the staging of

its faith in the body's ability to unite, like gymnastics, its physical and rational capabilities in fighting the unpredictable; to thus theatricalise a quality highly praised by Futurism: agility. In the 'Manifesto della danza futurista' [Futurist Dance, 1917], Marinetti reviews the innovative work of Diaghilev, Nijinsky, Isadora Duncan, Valentine de Saint-Point, and Dalcroze. The problem with Dalcroze's 'ginnastica ritmica', he claims, is that it limits its effects to muscular hygiene and the description of rural labour. He declares his preference for Loie Fuller and the Afro-American cakewalk dance, which display 'use of electric light and mechanical devices'.[40] Evidently, Dalcroze's 'rhythmic gymnastics', his emphasis on the body's internalising of musical rhythm, is something static for Marinetti, unlike gymnastics in general or the mechanical aspect of his preferred kinds of dance. Those, far from mere repetitiveness of rhythmic exercises, signify the body's identification with machines, which emblematise the dynamism of modernity:

> We have to go beyond what muscles are capable of and, in the dance, strive toward the ideal of the *body extended* into machine, something we have envisaged for a long time. With our actions, we should imitate the movements of machines.[41]

What attracts Marinetti in Fuller and the cakewalk is that these forms, though different from one another, combine rigidity with spontaneity, mechanicalness with fluidity, a strict control over muscle and physical movement with the semblance of shock and the unforeseen. As Patrizia Veroli notes, applying immense muscular strength to an austere control over her body, Fuller dexterously handled her massive silk garments, up to 450 metres in width, to achieve a semblance of high volatility, evoking 'the flight of a giant butterfly, the blooming of a lily, the uncoiling of a serpent', and the 'slow flickering of a fire turning into violent flames'.[42] The cakewalk, originating in the plantation era and then included in travelling minstrel and variety shows, displayed the ability to maintain a perfectly erect body as well as perform a prancing strut.[43]

Following these supreme displays of agility, for Futurist dance Marinetti proposes, at this time of war, the body's imitation of the shrapnel, to stage the exact moment in which the projectile's trajectory violently interrupts the body's tranquillity:

> 2. Movement. With open arms, trace at a moderate speed the whistling trajectory of the shell as it passes over a soldier's head and then explodes too high above him or somewhere behind him. [. . .] 7. Movement. The swaying, by which the dancer will continue to express this war song, will be interrupted by the second movement (whistling trajectory of shrapnel).[44]

Like Fuller's union of rigidity and fluidity, or the cakewalk's prancing struts, the tranquil body's harmless crossing with the violent projectile becomes a triumph of agility, of its spectacle of reconciliation between order and chaos, certainty and volatility. That we are speaking of performance and not of a real instance of war or physical education is crucial. Futurism wishes to theatricalise, not merely articulate, its own essence. It fabricates the unpredictable in order to rehearse, for the world's eyes, its encounter with it, to stage a tale about itself as an infinite trajectory of clashing forces.

Notes to Chapter 9

1. Filippo Tommaso Marinetti, 'What is Futurism? Elementary Lessons', in *Critical Writings*, ed. by Günter Berghaus, trans. by Doug Thompson (New York: Farrar, Straus and Giroux, 2006), pp. 367–69 (p. 367).
2. 'The Proletariat of Talented People', in *Critical Writings*, pp. 304–08 (p. 305).
3. 'Manifesto of the Futurist Political Party', in *Critical Writings*, pp. 271–75 (p. 271).
4. 'Third Futurist Political Manifesto', in *Critical Writings*, pp. 75–77 (p. 76).
5. 'A Futurist Theater of Essential Brevity', in *Critical Writings*, pp. 200–07 (p. 205).
6. Ibid., p. 200.
7. Ibid.
8. See also 'In this Futurist Year' (original title: '1915 In quest'anno futurista'), in *Critical Writings*, pp. 231–37 (p. 236), and 'The Meaning of War for Futurism: Interview with *L'avvenire*', in *Critical Writings*, pp. 238–44 (p. 241).
9. Bill Mallon and Ture Widlund, *The 1912 Olympic Games: Results for All Competitors in All Events, with Commentary*, Results of the Early Modern Olympics, VI (Jefferson, NC: McFarland, 2002), pp. 223–27.
10. Ibid., p. 223.
11. 'The Variety Theater', in *Critical Writings*, pp. 185–92 (p. 187).
12. 'Some Parts of the Film *Futurist Life*', in *Critical Writings*, pp. 266–68 (p. 267).
13. Filippo Tommaso Marinetti, 'Democrazia futurista', in *Teoria e invenzione futurista*, ed. by Luciano De Maria (Milan: Mondadori, 2005), pp. 343–467 (p. 456); the author's translation.
14. 'The Foundation and Manifesto of Futurism', in *Critical Writings*, p. 14.
15. 'Battle / Weight + Stench', quoted in 'Answers to Objections', in *Critical Writings*, p. 118.
16. 'Extended Man and Kingdom of the Machine', in *Critical Writings*, pp. 85–88 (p. 86).
17. 'The Theater of Surprises', in *Critical Writings*, pp. 383–85 (p. 384).
18. 'The Variety Theater', in *Critical Writings*, pp. 185–92.
19. On the relation between variety and the brevity of the 'synthesis' see Michael Kirby and Victoria Nes Kirby, *Futurist Performance* (New York: PAJ Publications, 1986), pp. 41–42. On the counterproductive effects of the synthetic theatre see R. S. Gordon, 'The Italian Futurist Theatre: A Reappraisal', *Modern Language Review*, 85 (1990), 349–61 (pp. 352–53).
20. 'Geometrical and Mechanical Splendor and Sensitivity toward Numbers', in *Critical Writings*, pp. 135–42 (p. 135).
21. Ibid., p. 137.
22. Ibid., pp. 136–42.
23. 'Technical Manifesto of Futurist Literature', in *Critical Writings*, pp. 107–19 (p. 110).
24. Ibid.
25. Ibid., pp. 113–14. For similar references to 'logic' in the 'Technical Manifesto', see ibid., p. 112. See also the second section of 'Answers to Objections', Marinetti's supplement to the 'Technical Manifesto', where he further explains the difference between 'intuition' and 'intelligence' (ibid., pp. 114–15).
26. 'Technical Manifesto of Futurist Literature', p. 108.
27. Ibid.
28. Ibid., p. 108.
29. Ibid., p. 112.
30. Ibid., p. 115.
31. 'Destruction of Syntax — Untrammeled Imagination — Words-in-Freedom', in *Critical Writings*, pp. 120–31 (p. 127).
32. 'Technical Manifesto of Futurist Literature', p. 107.
33. 'Destruction of Syntax — Untrammeled Imagination — Words-in-Freedom', p. 126
34. Ibid., p. 126. See similar discussion in 'Geometrical and Mechanical Splendour and Sensitivity toward Numbers', pp. 135–42.
35. 'Technical Manifesto of Futurist Literature', p. 113.

36. 'Destruction of Syntax — Untrammeled Imagination — Words-in-Freedom', p. 124.
37. 'The Foundation and Manifesto of Futurism', p. 17.
38. 'In This Futurist Year', p. 235.
39. Ibid., p. 236. See also 'Democrazia futurista', in *Teoria e invenzione futurista*, p. 360.
40. 'Futurist Dance', in *Critical Writings*, pp. 208–17 (p. 210).
41. Ibid.
42. Patrizia Veroli, 'Loie Fuller's Serpentine Dance and Futurism: Electricity, Technological Imagination and the Myth of the Machine', in *Futurism and the Technological Imagination*, ed. by Günter Berghaus (New York: Rodopi, 2009), pp. 125–47 (pp. 129–30).
43. See *Futurism: An Anthology*, ed. by Lawrence Rainey, Christine Poggi, and Laura Wittman (New Haven, CT and London: Yale University Press, 2009), p. 553 (note 6) and Lynne Fauley Emery, *Black Dance in the United States from 1619 to 1970* (Palo Alto, CA: National Press Books, 1972), pp. 91–92, 206–14.
44. 'Futurist Dance', pp. 211–13.

CHAPTER 10

The Café

Sites of Futurist Propaganda

Ernesto Livorni, University of Wisconsin

At the dawn of the twentieth century, cafés already had a long and respectable history as places in which ideas and movements took form and cultural changes took place. The café tradition that spread during the Age of Enlightenment and grew stronger throughout the nineteenth century received its last great impulses in the first half of the twentieth century, when the cafés of the main European capitals and cities (Paris, London, Berlin, Rome, but also Milan, Florence, Zurich) hosted the creative and innovative minds of the modernist avant-gardes.[1] Futurism was among the most prominent avant-garde movements, and some of the cafés that its members regularly frequented became famous also because of their patronage. More importantly, perhaps, the Futurists referred to cafés in a significant and even programmatic way in some of their major literary or visual works of art.

By the time Futurism officially appeared on the European literary and artistic scene in 1909, the literary function of the café had been changing for two centuries. Perhaps even more importantly, the café had also generated new forms of entertainment, in particular the music-hall and the café-concert or café-chantant.[2] As the names themselves reveal, these two forms developed especially in the British and French context respectively, but they may be reunited to some extent in the Italian definition of *teatro di varietà*. In fact, a variety of artistic expressions is necessary to the music-hall and it is ultimately this variety that attracted Futurism: after all, during their last trip to the United Kingdom in June 1914, Marinetti and Luigi Russolo presented the manifesto 'L'arte dei rumori' [The Art of Noises] at the Coliseum in London, which was the largest music-hall in the world.[3] The variety theatre, in turn, was a show with various acts and performers whose abilities could not be admired in the traditional theatre, but in a new setting that was called 'music-hall' before that name was extended to the performance itself. It is not by chance that in 1913 Marinetti published the manifesto 'Il Teatro di Varietà' [The Variety Theatre].[4]

The café was the place where the Futurists met (continuing a trend that other avant-gardes adopted), but it also figured as a subject in their artistic production; these two functions of the café cannot be separated, as life and art go hand in hand

and constantly intertwine. In the first part of this essay, I will consider Futurist works of art celebrating the café and examine the programmatic dimension of the café within the aesthetic project of the movement. In the second part of the essay, I will concentrate on two literary cafés that lived through a 'Futurist' phase, the Caffè Zucca in Galleria in the Galleria Vittorio Emanuele II in Milan and the Giubbe Rosse café in Florence; both of these cafés will allow me to focus on the presence of Futurism in both of these cities, and to consider some other literary cafés, including some that only to a certain extent are linked to Futurism.

The Café in the Futurist Project: Manifestos, Literature, Visual Arts

In the early manifestos written before the First World War, the café is often mentioned, sometimes just in passing, as an example of modern life that is attractive to the Futurists.[5] The manifestos on theatre cannot avoid references to the café-concert, considered an integral part of the Futurist theatre as late as 1921, and often appearing as a first step towards the Futurist understanding of theatre and performance in general.

In the visual arts, the situation is quite different. Several painters depict the café, either referring to specific places or evoking the general atmosphere of that particular environment. In this respect, the Futurist painters still walk in the footsteps of the Impressionists — for instance, Edgar Degas's *Femmes à la terrasse d'un café le soir* [*Women outside a Café, Evening*, 1877], *Dans un café, dit aussi L'absinthe* [*Absinthe Drinker in a Café*, 1873], *Café-Concert* (1876–77), *Le Café-Concert aux 'Ambassadeurs'* (1876–77), and *Le chanteur avec le gant* [*Singer with a Glove*, 1878].[6]

Several Futurist painters were fascinated by the café and displayed their fascination on several occasions. Carlo Carrà's *Sintesi di un caffè concerto* [*Synthesis of a Café Concert*, 1910–12] and *Caffè concerto* (1912) are two good examples of the Futurists' interest in the café as a place that appeared to offer a synthesis of city life. However, the finest renditions of café life in Futurist art in the first years of the avant-garde are to be found in the works of Gino Severini and Umberto Boccioni. Severini focused especially on a couple of themes such as dancing that evoked the café environment in an emotional way rather than through a direct depiction of the object. The subject of dancing also gave him the opportunity to focus on movement, one of the main concerns of Futurism as well as one of the critical reasons for Severini's interest in Cubism. In paintings such as *Ballerina blu* [*The Blue Dancer*, 1912] and *Ballerina bianca* [*The White Dancer*, 1912], Severini elaborates his interest in the relationship of the subject (the dancer) with the environment (the café), so much so that the folding of the dancer's dress merges with the surrounding space through the penetration of light. The same structure may be said to apply to *La danza del pan pan al Monico* [*Dancing the Pan-Pan at the Monico*; 1911, painted again in 1959 after the destruction of the painting during the Second World War] and *Geroglifico dinamico del Bal Tabarin* [*Dynamic Hieroglyph of the Bal Tabarin*, 1912].[7] In both paintings, the movement of the dance is caught in two famous cabarets of Montmartre, in Paris. The second painting in particular, featuring a woman

dancing in the cabaret Bal Tabarin, famous since the turn-of-the-century Belle Époque, contains not only allusions to possible dances ('Polka' and 'Valse' are French for polka and waltz), but also references to contemporary political nationalism. In fact, such elements as an Arab figure riding a camel and Italian flags (top centre and top right corner, respectively) allude to the Italo-Turkish war between the Ottoman Empire and Italy from September 1911 to October 1912. To the interest in these multi-ethnic expressions of dance one might add Severini's *Ballerine spagnole al Monico* [Spanish Dancers at the Monico; date unknown], which may be contrasted with a previous painting by Severini, *Ballerine al Monico* [Dancers at the Monico, 1910]. When in August 1913 Severini married Jeanne Fort, daughter of the French poet Paul Fort, the reception took place at the Café Voltaire, which would lend its name to the Cabaret Voltaire, one of the main venues for Dada performances.

Boccioni's interest in the café converges with Severini's in paintings such as *La risata* [The Laughter, 1911], in which the female figure's body movement caused by the intensity of her laughter reverberates in the surrounding environment, which loosely recalls that of a café. Another example is *Donna al caffè (compenetrazione di luci e piani)* [Woman in a Café: Compenetrations of Lights and Planes, 1912], where the subtitle of the painting clearly refers to specific tenets of the 1910 'La pittura futurista. Manifesto tecnico' [Futurist Painting: Technical Manifesto] co-signed by Boccioni, Carrà, Russolo, Balla, and Severini. Furthermore, there is at least one painting by Boccioni in which the café is portrayed as the place of choice for Futurist events such as the so-called 'serate' or the violent riots like the one that took place in Florence at the Giubbe Rosse café in 1911: *Rissa in galleria* [Riot in the Galleria, 1910] frames the violent outburst of the titular brawl before the gigantic window of a café, as the illuminated sign on that window unmistakably states.[8] The café in question may very well be the Biffi Caffè, at the time frequented by some of the wealthiest businessmen in the city (it is not by chance that on 7 November 1919, it was the target of the young anarchist Bruno Filippi, who died killed by his own bomb). It was also the first café in the city to install electric lighting, an innovation that the Futurists certainly appreciated. However, it is more likely the Gran Bar Zucca (first known as Campari, after its founder Gaspare Campari), which was founded at the time of the inauguration of the Galleria Vittorio Emanuele II in 1867 and, before becoming a gathering place for the Futurists (especially painters such as Boccioni himself and Carrà), had been often been frequented by the Scapigliati writers and by musicians such as Giuseppe Verdi and Arturo Toscanini.[9]

The Futurist writers and poets were also interested in the café, although cafés are cited more often in their autobiographical writings than in their literary work. An exception is Ardengo Soffici's poem 'Caffè', a text containing several lines in English, French, and Spanish as well as quotes from several songs such as the Neapolitan 'Funiculì funiculà', and that for this reason could be called a phantasmagoria of languages. In its formal composition, and in particular in the evocation of the enchanting atmosphere of the café, the poem recalls the intents of a painter such as Severini.[10] Soffici, who was also a painter, returned to this theme in his painting *Caffè Apollo* (1915).[11] It must be said that Soffici, along with Giovanni

Papini, was a regular of the Caffè Paszkowski in Piazza Vittorio Emanuele II (now Piazza della Repubblica) in Florence even before the foundation of Futurism. In that same *piazza*, but this time at the Caffè Giubbe Rosse, the Milanese Futurists got in contact with Soffici, Giuseppe Prezzolini, and Medardo Rosso in 1911.

Marinetti himself made reference to the café-concert on a couple of occasions in the manifestos of 'Il Teatro di Varietà' [The Variety Theatre, 1913] and 'Il Teatro della Sorpresa' [The Theatre of Surprise, 1921].[12] In the manifesto on the variety theatre, when listing the nineteen reasons why Futurism exalts this form of theatre, Marinetti includes a reference to café-concert in the thirteenth point:

> In contrast, the Variety Theatre gives meaning to, and a taste for, casual love affairs that are ironical, without commitment. Open-air café-concert performances on the terraces of casinos offer a very entertaining battle between a consumptive moonlight, tormented by endless desperation, and the electric light that flashes frenziedly over imitation jewels, painted flesh, highly colored petticoats, velvets, and the false, cherry-colored lips. Of course, in the end, it is the lively electric light that triumphs, while the feeble, faltering moonlight is defeated.[13]

The café-concert, then, is the ultimate battlefield where moonlight and electric light face each other, with the inevitable victory of the latter. In 'Il Teatro della Sorpresa', written with Cangiullo, instead, Marinetti considers 'the theatre of surprise' as an overcoming of both synthetic theatre and of the body-madness of a Futurist café-concert. In other words, after the First World War, Futurism wants to go beyond the formula of the café-concert, by now obsolete and too close to the entertainment of the *fin de siècle*.

Finally, in the same period Cangiullo published a booklet, *Caffè-concerto: Alfabeto a sorpresa* [Café-concert: Surprise Alphabet, 1919], in which the two parts of the title explicitly recall the battle for the renewal of the forms of theatre.[14] In this book, the compositions are also illustrations inspired by café-concerts and performances in variety theatres in which the letters of the alphabet themselves become characters in a performance. The book is composed of drawings in which the figures are whimsically arranged through the combination of letters and numbers. In this respect, the compositions in the book are not only great illustrations of what Marinetti in the 1912 'Manifesto tecnico della letteratura futurista' [Technical Manifesto of Futurist Literature] had defined as 'parole in libertà' [Words-in-Freedom], but they also make good examples of so-called 'tavole parolibere' [Free-Word Tables].

Futurists and Futurism in and around the Café

Futurist artists frequented cafés in Paris even before the founding of Futurism, as Carlo Carrà points out in the second chapter of his autobiography, titled 'Paris'.[15] Cafés also played a role in the daily activities of the Futurist artists, especially in Milan, Florence, Rome, and Naples. Given the popularity of café-concerts especially in Rome and Naples, it is not a surprise that artists such as the Neapolitan Francesco Cangiullo would gather there and celebrate them as an iconic institution

of Futurism. Cangiullo recalls his involvement with Futurism during the first years of the movement in *Le serate futuriste* [*Futurist Soirées*], a book that appeared in two very different editions. As could be expected, many of the episodes mentioned in both versions of the book take place in Naples, Cangiullo's home base and a frequent destination of Marinetti and other Futurists. It was in Rome, however, that one of the first fights with the public took place, as Cangiullo relates in the chapter 'La Serata al Costanzi'.[16] Cangiullo recalls the crowd that followed the Futurists to the Caffè Aragno, where Marinetti was returned the shoe he had lost in the fight while kicking Prince Altieri (at least according to Palazzeschi, whose version of the fight is quoted by Cangiullo).[17] At the 'Caffè dei Quattro canti di campagna',[18] 'Marinetti ordina un gelato in rivoluzione. Cangiullo una bibita: il poeta aveva quella notte occhi di mammole' [Marinetti orders an ice-cream in revolution. Cangiullo a drink: the poet that night had eyes like shrinking violets].[19] However, the evening ended with a fight in the course of which many glasses and bottles were broken, though apparently no one paid the owner of the café for the damage. The same thing happened in Trieste, at the Caffè Milano. To be sure, there was great camaraderie in that café, where Palazzeschi read some of his poems and Mazza recited the founding manifesto of Futurism. As more artists from Trieste showed up in support of Futurism, the group moved to another café, Eden, attended by Austrian officers, as well as by Hungarian patriots with whom the Futurists socialised. In recounting this episode, Cangiullo emphasises the patriotism of both the Italians (mentioning for instance 'i patrioti fratelli Tamaro, redattori dell'*Indipendente*' [the patriotic Tamaro brothers, editors of the *Indipendente*]), and of the Hungarians (described as 'allegri martiri del patriotismo' [joyful martyrs of patriotism]).[20] This chapter ends with a recollection of Cangiullo's encounter with Giovanni Verga in an unspecified café in Catania.[21]

Of course, it is in Naples that visits to the cafés become routine: '2 volte al giorno, come cura, ultraclamoroso lancio automobilistico di carta rossa e volantini multicolori, al rombo dei megafoni. La sera poi, tutti in smoking, si andava distribuendone altri nei principali Caffè e restaurants' [twice a day, as cure, ultra sensational automobile throwing of red paper and multi-coloured fliers, at the rumble of the megaphones. Then, in the evening, all in tuxedo, we went distributing more in the main cafés and restaurants]. This gives Cangiullo the opportunity to recall one evening in which 'si formò un grande corteo napoletanissimo che ci accompagnò fin nel Gambrinus' [a great and very Neapolitan procession started that accompanied us all the way to the Gambrinus], which the author does not hesitate to call '[i]l più bel caffè d'Italia' [the most beautiful café of Italy].[22] Cangiullo could not omit retelling 'la cazzottata artistica Marinetti-Soffici' [the artistic Marinetti-Soffici punch-up] at the Caffè delle Giubbe Rosse, which he reports in Marinetti's words, as he was not present when it happened.[23] The Giubbe Rosse is also the café where the Futurists gather after the 'battle' at the Teatro Verdi in order to jot down an account of the evening: 'Grande Serata Futurista. Firenze. Teatro Verdi. 12 dicembre 1913. Resoconto sintetico' [Great Futurist Evening. Florence, Teatro Verdi. 12 December 1913. Synthetic Account].[24] From that moment and until the

end of the First World War, the Caffè delle Giubbe Rosse became the meeting point of the Futurists in Florence, so much so that the café itself became an attraction and people went there just to watch them, as Luciano Folgore recalled.[25]

In Milan, one of the first cafés that the Futurists considered their own headquarters was the Caffè del Centro, the meeting place for Boccioni, Carrà, and Marinetti, who attended other cafés as well — for instance, the one in Piazza Vittoria where, according to Carrà's memoirs, he met with Boccioni and Russolo the morning after having spent the entire evening at Marinetti's house writing 'un manifesto ai giovani artisti' [a Manifesto to young Italian artists].[26] Other important meeting points were the Caffè Savini, where Marinetti would go before and after the Futurist evenings that animated Italian and European cities in the years before the First World War,[27] and the Caffè Zucca in Galleria, situated at the entrance of the Galleria Vittorio Emanuele II, by the porticos leading to the Cathedral and its square.

Caffè Zucca was founded in 1867 by Gaspare Campari, who by then had already opened a café bearing his own last name — the name he also used for the liqueur that had become popular among prominent artists, including musicians, composers, and singers who performed at the nearby Teatro alla Scala, from Giuseppe Verdi to Arturo Toscanini. Needless to say, Marinetti himself, the 'caffeine of Europe' as he was called, often went there as well. The Savini had been founded several years after the Caffè Zucca: in 1881 Virgilio Savini acquired the popular café-concert Stocker Beerhouse in the Galleria Vittorio Emanuele II, and in 1884 he transformed it into a blend of café and restaurant. In the final decades of the nineteenth century, the café was a popular meeting place for the Scapigliati writers as well as for Verismo writers such as Verga and Capuana, and in the twentieth century it was the presence of Marinetti and his fellow Futurists that gave way to another important episode in the history of the Savini Caffè.

However, the most influential literary and cultural café of the twentieth century in Italy is probably the aforementioned Caffè Letterario Giubbe Rosse in Florence, and the considerable (although short-lived) acclaim Futurism enjoyed in Florence contributed to this fame. Along with the Caffè Michelangiolo in the same city, the Giubbe Rosse marked the first phase of the cultural history of the Kingdom of Italy until the First World War. However, its influence continued even after the Great War into the Fascist era and beyond.[28] In fact, one can speak of three main phases for the Giubbe Rosse café: the first before the First World War, a second in the interwar period, and the third after the Second World War.[29] Located in Piazza della Repubblica 13–14/r, the Caffè Letterario Giubbe Rosse continues up to this day to host readings by the most renowned Italian writers in an atmosphere that is at once friendly and sophisticated.[30] The Giubbe Rosse literary café opened in 1897, only two years after the inauguration of the square with its triumphal arch that substituted the Mercato Vecchio [Old Market], demolished in 1881. It became immediately popular and it was even listed in the Baedeker tour guide.[31] At that time, the café was actually a brewery, founded by the Reininghaus brothers, German brewers. Where a wine bar once stood, the café proudly showcased waiters

dressed in flaming red smoking jackets with loose-fitting white aprons, wrapped around them like a cassock, according to the Viennese fashion of the time.[32] Thus, it turned out to be easier for the patrons to refer to it as the café with those waiters in flaming red smoking jackets ('giubbe rosse') rather than to attempt to pronounce the name of its German owners. Between this moment and 1913, satirical depictions of Piazza Vittorio Emanuele II little by little gave way to admiring descriptions of the rooms of this café, where foreigners in particular gathered to read newspapers and magazines, and in the third room members of a chess club met to play. At the Giubbe Rosse it was possible to find political refugees and passing tourists alike, reading the foreign newspapers made available by the café's owners.

It is no surprise that in 1913, having spontaneously become the meeting place of a variety of groups with often quite different interests, the third room became the 'office' of a group of writers gathered around the newly founded journal *Lacerba*, just at the time when its main editors Giovanni Papini and Ardengo Soffici became interested in Filippo Tommaso Marinetti's Futurism.[33] Florence, a place that for centuries had been associated to the Renaissance and that Gabriele D'Annunzio had recently chosen as his main residence (in fact, in 1898 the poet had moved into La Capponcina, a villa on the hills of Settignano), now became an energised centre of the avant-garde. In 1913 an exhibition of Futurist paintings was held in the café, and admirers and curious visitors alike lined up to attend the event. Together with the 'grande serata futurista' held on 12 December 1913 at the Verdi Theatre in Florence and concluded, as Viviani reports, at the Giubbe Rosse café,[34] the exhibition boosted both the popularity of the Futurist movement and that of the Giubbe Rosse café, and its legend began to take shape.[35] In those days, the café was regularly frequented not only by Marinetti, but also by Carrà and Boccioni, 'il più elegante il più raffinato tra i futuristi del gruppo Milanese' [the most elegant the most refined among the Futurists of the Milanese group].[36] However, the devotion and admiration of the younger generation went overwhelmingly to Papini, as is exemplarily illustrated by Marino Moretti's account of his first encounter with the author of *Un uomo finito* [*A Finished Man*], Giovanni Papini, while in the company of Aldo Palazzeschi.[37] In the years 1913–15 the cultural activity of the café was so distinct and prominent that the literary critic and linguist Bruno Migliorini coined the adjective 'giubberossisti' to refer to its regulars. Yet, the official name of the café remained Reininghaus until 1933, when a sign renaming the café 'Giubbe Rosse' was posted over the entrance door.

Of course, in the years before the First World War the Giubbe Rosse café had to compete with other cafés that billed themselves as literary gatherings. One of these rivals was the Paszkowski café, founded in 1896 as Caffè Centrale and renamed in 1904, which to this day sits in front of the Giubbe Rosse café.[38] Literary journals such as *La Voce* [*The Voice*], founded by Giuseppe Prezzolini in 1908, and the aforementioned *Lacerba*, which made the history of militant Italian literature of those years, took shape on the tables of the Giubbe Rosse.[39] However, the contributors of other important journals, such as *Solaria* founded in 1926 by Alberto Carocci, *Letteratura*, founded in 1937 by Alessandro Bonsanti after the suppression of

Solaria, *Il Frontespizio*, founded in 1929 by Enrico Lucatello and Piero Bargellini, and *Campo di Marte*, directed in 1938 and 1939 by Alfonso Gatto and Vasco Pratolini, regularly met at the Paszkowski café before also moving to the Giubbe Rosse café.[40] In the interwar years other cafés, in particular the Gambrinus and the San Marco, challenged in vain the primacy of the Giubbe Rosse, whose main competition came from the Trattoria of the Antico Fattore, a restaurant that became famous for the poetry award of the same name established in 1931.[41] By 1935, the so-called Hermeticist poets (*poeti ermetici*) definitively moved from the San Marco café to the Giubbe Rosse, thus marking the end of the latter's Futurist period.

The national fame of the Giubbe Rosse café was well established before the First World War thanks to the literary activity promoted by the Florentine avant-garde artists who gathered there. The popularity and attraction of the literary activities in this café were so high that writers and artists from different parts of the country came to attend the meetings and mingle with the regular patrons. One of these 'pilgrims' was Giani Stuparich, one of the Triestine writers who left the Garibaldi café in his native city to join his friends at the Giubbe Rosse. According to his own testimony, many literary travellers came from all over Italy, 'da Roma, dalle città del Nord, dal Mar Ligure e dalla provincia marchigiana' [from Rome, from the northern Italian cities, from the Ligurian Sea, and from the Marche region provinces]:[42] they include Giovanni Boine, Piero Jahier and Scipio Slataper. When journals such as *La Voce* and *Lacerba* began their pro-intervention campaigns, the Giubbe Rosse café also became a centre of the demonstrations they organised in favour of war, from the one held on 20 October 1914, to the formation of the political league called 'Revolutionary Interventionist Florentine Fasces'.[43] As the First World War menacingly approached, among the artists who gathered at the Giubbe Rosse café one could not miss the figure of another young man who had just arrived in Florence: Dino Campana. The author of *Canti orfici* [*Orphic Songs*] managed to sell a good number of copies of his book at the café with the help of his friends Papini and Soffici.[44]

With the war, the situation changed dramatically, for 'Le "Giubbe Rosse" intanto languivano nel più desolato abbandono' [in the meantime, the Giubbe Rosse café declined in the most desolate abandonment].[45] Many artists and writers were by then fighting in the trenches and some of them, most notably Boccioni, died during the war or simply did not come back to Florence when it was over. The only noticeable presence was that of Italo Tavolato still trying to convert customers to his theory of sexual revolution.[46] After all, the revolutionary period of the Futurist avant-garde movement in Florence faded away; some of the journals such as *Lacerba* which lived in the café had closed down; the artists who had gathered in Florence because of the Futurist meetings moved to other cities, especially Rome and Milan.

However, after the First World War and especially in the first years of the Fascist regime, when *le rappel à l'ordre* also meant less space for the influence of foreign fashion, Mussolini tried to close down tabarins and cabarets, measures that ended up affecting the cafés as well. These measures represented the decline of a social and intellectual lifestyle that in vain Marinetti tried to keep alive well into the

twenties. In 1924, disappointed by the little consideration that Mussolini reserved to Futurism in general and at the Venice Biennale in particular, Marinetti attended the inauguration of the exhibition and interrupted the ceremony. Arrested and immediately released, he went to the Caffè Florian to announce a new action that would take place that very evening at the Teatro La Fenice, where Giuseppe Verdi's *Aida* was to be performed.[47] But the era of those collective 'serate futuriste' in the cafés was over.

Notes to Chapter 10

1. As a confirmation of the slowly decreasing importance of the cafés after the Second World War, the title that Enrico Falqui chose for the introductory essay of the fundamental work *Caffè letterari* is telling: 'Compianto del caffè letterario' [Lamentation for the Literary Café] in Enrico Falqui, *Caffè letterari*, 2 vols (Rome: Canesi, 1962), I, 3–14.
2. See at least Legrand-Chabrier, 'Le music-hall', H.-G. Ibels, 'Le café-concert et la chanson', 'Les cabarets littéraires et artistiques', in *Les spectacles à travers les âges: théâtre — cirque — music-hall — cafés-concerts — cabarets artistiques*, with a preface by Denys Amiel (Paris: Aux Éditions du Cygne, 1931), pp. 247–88, 289–326, 327–64; François Caradec and Alain Weill, *Le café-concert* (Paris: Hachette — Massin, 1980); Concetta Condemi, *Les cafés-concerts, histoire d'un divertissement (1849–1914)* (Paris: Éditions Quai Voltaire Histoire, 1992); Jacques Feschotte, *Histoire du music-hall* (Paris: PUF, 1965); Dario Salvatori, *Il Café-chantant a Roma: Canzoni, soubrettes e comici di una grande stagione dello spettacolo* (Rome: Newton & Compton, 1996); Rodolfo De Angelis, *Caffè-concerto. Memorie di un canzonettista* (Milan: Edizioni SACSE, 1940); now *Café-chantant: personaggi ed interpreti*, ed. by Stefano De Matteis (Florence: La Casa Usher, 1984); Rodolfo De Angelis, *Storia del café-chantant* (Milan: Il Balcone, 1946); Mario Dell'Arco, *Café-chantant di Roma* (Milan: Martello, 1970); Paolo Guzzi, *Café-chantant a Roma: il caffè-concerto tra canzoni e varietà da Lina Cavalieri alla Bella Otero, da Fregoli a Petrolini* (Rome: Rendina, 1995).
3. For an account of the presence of Futurism in England, see at least Roberto Baronti Marchiò, 'The Vortex in the Machine: Futurism in England', in *International Futurism in Arts and Literature*, ed. by Günter Berghaus (Berlin and New York: Walter de Gruyter, 2000), pp. 100–21. Other important music-halls were the Wintergarten in Berlin and especially Les Folies Bergère, the Olympia, and the Empire theatre in Paris.
4. Interestingly enough, an example offered in item 12 of Marinetti's 'The Variety Theater' manifesto focuses on the dance performed 'a year ago, at Les Folies-Bergère' (in *Futurism: An Anthology*, ed. by Lawrence Rainey, Christine Poggi, Laura Wittman (New Haven, CT and London: Yale University Press, 2009), p. 161). The café-concert is considered as an essential element also in another manifesto that Marinetti and Cangiullo wrote in 1921: 'The Theater of Surprise' (*Futurism: An Anthology*, p. 271).
5. See at least Umberto Boccioni, 'I fondamenti plastici della scultura e della pittura futuriste', *Lacerba*, 1.6 (1913), 51–52; then in *Pittura e scultura futuriste (Dinamismo plastico)* (Milan: Edizioni di Poesia, 1914) (English translation: 'The Plastic Foundations of Futurist Sculpture and Painting', in *Futurism: An Anthology*, pp. 139–42); Ardengo Soffici, 'Il soggetto nella pittura futurista', *Lacerba*, 2 (1914), 1 (English translation: 'The Subject in Futurist Painting', in *Futurism: An Anthology*, pp. 169–70).
6. In the case of the absinthe drinker, the first titles of the painting insisted on the location (*A Sketch of a French Café*; *Figures at a Café*) before acquiring the current title *L'Absynthe* in 1893. The café in question is the Café de la Nouvelle Athènes in Paris.
7. Regarding these two paintings, see at least Gino Severini, *La vita di un pittore* (Milan: Feltrinelli, 1983); English translation: *The Life of a Painter: The Autobiography of Gino Severini*, trans. by Jennifer Franchina (Princeton, NJ: Princeton University Press, 1995), pp. 53–54 (the latter page recalls that 'When I escorted my Futurist friends from Milan there sometime later, they were, quite frankly, amazed'), 62–64, 83, 89, 95, 104, 106, 139, 216, 221.

8. For references to the riots occasionally taking places in the cafés in the Galleria in Milan, see at least Francesco Cangiullo, *Le serate futuriste. Romanzo storico vissuto* (Milan: Casa Editrice Ceschina, 1961), pp. 89–94, 145–48.
9. Today what used to be the Gran Bar Zucca is the Caffè Miani.
10. Ardengo Soffici, 'Caffè', in *BÏFSZF + 18 = Simultaneità — Chimismi Lirici* (Florence: Edizioni La Voce, 1915); English translation of the poem 'Café' in *Futurism: An Anthology*, pp. 427–28. To appreciate the different incisive effect of the tenets of Futurism in this poem, one may read by contrast a poem by Francesco Cangiullo, 'Caffè Morgano' (1940), in *Poesia innamorata 1911–1940* (Naples: Morano, 1943), pp. 215–16, written at a time in which the poet had left Futurism and Futurism itself was substantially over.
11. In later years Soffici made a lithograph titled *Caffè* (1962).
12. Filippo Tommaso Marinetti, 'Il Teatro di Varietà', in *Lacerba*, 1 (1913), 19; now in Filippo Tommaso Marinetti, *Teoria e invenzione futurista*, ed. by Luciano De Maria (Milan: Mondadori, 1983 [1968]), pp. 80–91; English translation in *The Daily Mail*, 21 November 1913; now as 'The Variety Theater', in *Futurism: An Anthology*, pp. 159–64. Filippo Tommaso Marinetti, Francesco Cangiullo, 'Il Teatro della Sorpresa', in *Il Futurismo*, 11 Ottobre 1922; now in Marinetti, *Teoria e invenzione futurista*, pp. 166–69; English translation: 'The Theater of Surprise', in *Futurism: An Anthology*, pp. 270–72. See also Francesco Cangiullo, 'La Tournée del Teatro della Sorpresa', in *Le serate futuriste. Romanzo storico vissuto, con giudizi di Marinetti, Ojetti, Borgese, Simoni, Lipparini, Goll* (Pozzuoli: Editrice Tirrena, 1930), pp. 271–302; Francesco Cangiullo, 'Il Teatro della Sorpresa e le Sorprese del Teatro', in *Le serate futuriste* (1960), pp. 273–84 (see note 8). The common title is deceiving: the two books are organised differently in the division of chapters and the content of each chapter also differs in the two editions, even when the same episode is recounted. The references, therefore, will be to either edition, according to the episode that is discussed. Cangiullo left Futurism in 1924, but he remained good friends with Marinetti and the other Futurists, as the letters he wrote to the founder of Futurism confirm: see Filippo Tommaso Marinetti and Francesco Cangiullo, *Lettere 1910–1943*, ed. by Ernestina Pellegrini, Quaderni della Fondazione Primo Conti (Florence: Vallecchi, 1989). For an account of Cangiullo's contribution to this aspect of Futurism, see at least Giovanni Lista, 'Le manifeste *Le Music-Hall*', 'Les premiers spectacles futuristes et l'apport de Cangiullo', 'Des synthèses au *Théâtre de la Surprise*', in *La scène futuriste* (Paris: Éditions du CNRS Centre National de la Recherche Scientifique, 1989), pp. 115–28, 128–36, 167–76.
13. Filippo Tommaso Marinetti, 'The Variety Theater', in *Critical Writings*, ed. by Günter Berghaus, trans. by Doug Thompson (New York: Farrar, Straus and Giroux, 2006), pp. 185–92 (pp. 188–89).
14. Francesco Cangiullo, *Caffèconcerto: Alfabeto a sorpresa* (Milan: Edizioni futuriste di *Poesia*, 1918); ed. by Luciano Caruso (Florence: SPES-Salimbeni, 1979) (see also the publication of the manuscript that Cangiullo had prepared already in 1915: Francesco Cangiullo, *Caffè concerto* [Manuscript], ed. by Luciano Caruso (Bologna: TAU/MA, 1978). See also Francesco Cangiullo, 'Il mobilio futurista', *Roma futurista*, 22 February 1920. To better appreciate Cangiullo's fascination with the café, see also his book *La Maddalena del Caffè Fortunio: Pittoriche e pittoresche avventure galanti. Con prefazione dell'autore* (Naples: Casa Editrice Bideri, 1916), besides the already mentioned editions of *Le serate futuriste*. In fact, in this book, Cangiullo inserts a chapter dedicated to his own book: 'Grigio-verde e Alfabeto a sorpresa', in *Le serate futuriste* (1930), pp. 251–61.
15. Carlo Carrà, 'Paris', in *The Life of a Painter*, pp. 25–65, especially the sections dedicated to the years 1908 and 1910, ibid., pp. 52–56.
16. Cangiullo, *Le serate futuriste* (1930), pp. 41–49.
17. For another account of that evening, see also Walter Vaccari, 'La Grande Serata al Costanzi', in *Vita e tumulti di F. T. Marinetti, Con tavole fuori testo* (Milan: Omnia Editrice, 1959), pp. 279–92. Another episode also took place at Caffè Aragno concerning the tailor Petrosemo and Balla's anti-neutral tricolour suit (see Cangiullo, 'Interventismo a Roma e a Milano', in *Le serate futuriste* (1930), pp. 187–226). This episode is also recalled in the 1960 edition, in the chapter 'Morte e Resurrezione di Petrosemo', pp. 199–210. The Caffè Aragno is also the stage, so to speak, on which Futurists celebrated the declaration of war against the Austrian Empire, as Giorgio

Amendola recalls in *Una scelta di vita* (Milan: Rizzoli, 1976, pp. 25–26), as that was the café where his mother used to take him to see D'Annunzio and Marinetti. On Caffè Aragno, see at least Orio Vergani, 'Il mito della terza saletta', *Corriere della Sera*, 23 June 1938; Anton Giulio Bragaglia, 'L'archeologo futurista', *Momento*, 15 May 1951; both articles are now in *Dal Greco al Florian. Scrittori italiani al caffè*, ed. by Riccardo Di Vincenzo (Milan: Archinto, 2003), pp. 138–41, 142–47.

18. Cangiullo, *Le serate futuriste* (1930), p. 66.
19. The episode is also recalled in the 1960 edition, in a chapter titled 'L'eroe dei quattro canti', pp. 253–62.
20. Cangiullo, *Le serate futuriste* (1930), pp. 80–81.
21. The same episodes in Catania and Trieste are recalled in the 1961 edition, in the chapters titled 'Carta Rossa, Giovanni Verga e Luigi Capuano [sic]', 'Irredentismo Futurista' (1961), pp. 67–73, 263–71. Regarding the *serata futurista* in Trieste, see also Filippo Tommaso Marinetti, 'Rapporto sulla Vittoria del Futurismo a Trieste', in Aldo Palazzeschi, *L'incendiario* (Milan: Edizioni futuriste di *Poesia*), p. 9. Although he does not say which were frequented by the Futurists, Pier Antonio Quarantotti Gambini ('I caffè triestini', *Corriere della Sera*, 18 July 1962; now in *Dal Greco al Florian*, pp. 169–75), writing about the cafés in Trieste, mentions all those with patriotic names. When Marinetti went to Fiume in 1919, he and fellow Futurist Barbesti frequented the Caffè Redenzione, but he also went often to the Caffè Budai: see Filippo Tommaso Marinetti, *Taccuini 1915–1921*, ed. by Alberto Bertoni (Bologna: Il Mulino, 1987), pp. 433, 437.
22. Cangiullo, 'Rentrée a Napoli; schiaffeggiate su tutta la linea; battaglia d'intonarumori a Milano', *Le serate futuriste* (1930), pp. 111–23 (pp. 113, 119). The same words are used in 'Rentrée a Napoli: l'intervento di Scarfoglio', *Le serate futuriste* (1961), pp. 75–87 (p. 83). The Neapolitan Caffè Gambrinus is also recalled in the episode in which Ferdinando Russo invited Marinetti for lunch there ('Vela Latina e il Caffettuccio', *Le serate futuriste* (1930), pp. 239–50): this chapter also relates the joke Marinetti and Cangiullo played at Boccioni's expense in the café recalled in the title of the chapter itself. Other Neapolitan cafés such as 'il *Caffè Stinca*, alla Torretta' and 'Sotto la Galleria Umberto I, il *Salone Margherita*, [. . .] il più cèlèbre ed elegante *Café-chantant* d'Italia', are recalled in Cangiullo's novella 'La ferita della rosa' inserted in the chapter with that title (*Le serate futuriste* (1961), pp. 171–98; quotation on p. 188). Regarding Caffè Gambrinus in Naples, see at least Alberto Consiglio, 'Il Caffè Gambrinus a Napoli', in Falqui, *Caffè letterari*, pp. 777–94.
23. Cangiullo, *Le serate futuriste* (1930), p. 156. This famous episode is told with much greater emphasis in the 1961 edition, where it takes up two chapters: 'La vigilia alle Giubbe Rosse', *Le serate futuriste* (1961), pp. 95–99 and 'La battaglia di Firenze', ibid., pp. 101–08. See also Carlo Carrà, *La mia vita* (1943; Milan: Giangiacomo Feltrinelli Editore, 1981) p. 84.
24. This article was published in *Lacerba*, I.24 (1913).
25. Luciano Folgore, 'Negli hangars del Futurismo', in Claudia Salaris, *Luciano Folgore e le Avanguardie* (Florence: La Nuova Italia Editrice, 1997), p. 149.
26. Carrà, *La mia vita*, p. 72. See also Carlo Carrà, 'Il caffè come studio', in *Dal Greco al Florian*, pp. 67–75.
27. Among the accounts of such events, besides the chapter 'Una notte di maggio', in Cangiullo, *Le serate futuriste* (1961), pp. 235–43, see at least Carlo Linati, *Memorie a zig-zag* (Turin: Buratti, 1929), pp. 15–17 and Carlo Linati, *Milano d'allora* (Milan: Domus, 1946), pp. 81–104.
28. In his introductory pages to the section on Florence of Falqui's *Caffè letterari*, Roberto Papi wrote: 'E per due volte Firenze, in questi cento anni, si è assunta il compito di rappresentare la Toscana anche nella storia dei caffè: col famoso Caffè Michelangiolo, dal 1850 al 1865; con le Giubbe Rosse dal 1910 al 1920. E anche dopo' [And twice Florence, in these one hundred years, has assumed the role of representing Tuscany even in the history of the cafés: with the famous Michelangiolo Café, from 1850 to 1865; with the Giubbe Rosse from 1910 to 1920. And even later] ('Quasi un'introduzione alla Toscana', in Falqui, *Caffè letterari*, II, 428). About the Caffè Michelangiolo, see Piero Bargellini, 'Il Caffè Michelangiolo a Firenze' and Telemaco Signorini, 'Al caffè coi Macchiaioli', both in Falqui, *Caffè letterari*, II, 435–42 and 443–46.
29. Eugenio Miccini suggests that the period of the 'third Giubbe Rosse' coincided with the arrival

of the Hermeticist poets in the early thirties ('Il Caffè Paszkowski e il Caffè delle Giubbe Rosse a Firenze', in Falqui, *Caffè letterari*, II, 531, 538). Others, such as Arnaldo Pini, take the period between the two World Wars as a whole and move the third period to the years 1947–1960 (*Incontri alle Giubbe Rosse: Landolfi, Loffredo, Luzi, Malaparte, Montale, Parronchi, Thomas, Traverso* (Florence: Polistampa, 2000), p. 13). For the sake of simplicity, I am following this second partition.

30. For most Florentines, Piazza della Repubblica, to be sure, is not their favourite square, as in the last twenty years of the nineteenth century the area underwent a dramatic transformation: in 1881 the historical site of the Old Market (Mercato Vecchio) was demolished and renamed Piazza Vittorio Emanuele II after the first king of Italy. Paintings by the Tuscan Macchiaioli and old photographs by Brogi and the Alinari brothers bear witness to what the site looked like before the demolition of the Old Market. After the establishment of the Republic in 1946, the square was aptly renamed Piazza della Repubblica, '[la] più antiestetica e borghese piazza che possa esservi al mondo' [the most antiaesthetic and bourgeois square in the world] (Alberto Viviani, *Giubbe Rosse. Il caffè fiorentino dei futuristi negli anni incendiari 1913–1915*, ed. by Paolo Perrone Burali d'Arezzo (Florence: Vallecchi Editore, 1983)). The publisher Barbera announced the first edition of Viviani's book (1933) with a flier that showed a sketch by Dino Tofani depicting Marinetti and Papini sitting at a café table (reproduced in Viviani, *Giubbe Rosse*, p. 227). It is evidence of the role played by Futurism in building the popularity of the Giubbe Rosse café before World War I.

31. The information is in Alberto Viviani, 'Il Caffè delle Giubbe Rosse a Firenze', in Falqui, *Caffè letterari*, II, 456.

32. Here is how Viviani describes the café:

> Due grandi vetrate, una chiusa ed una che serviva da ingresso, sormontate da un fregio in legno massiccio con un angiolo ghiotto di birra, sotto una grande scritta: 'Reininghaus'; molte lampade ad arco, di quelle che oggi si rincontrano soltanto a Parigi e che spandono una strana luce riposante, sfolgoravano all'ingresso. I camerieri attillati in uno *smoking* rosso fiamma e con un ampio grembiule bianco che li fasciava tutti come una sottana, davano all'ambiente una nota di originale gaiezza difficilmente dimenticabile.
>
> [Two big glass doors, one closed and one that served as entrance, surmounted by a frieze in solid wood with an angel thirsty for beer, under a big inscription: 'Reininghaus'; many arc lamps, of those that today one finds only in Paris and that spill a strange relaxing light, dazzled at the entrance. The waiters dressed in a flame-red dinner-jacket and with a wide white apron that wrapped them all like a skirt, gave an unforgettable note of original gaiety to the environment.] (*Giubbe rosse*, p. 35)

In the caption of the photograph depicting the entrance of the café the invention of the name is attributed to the Futurists themselves (p. 13). In his essay in Falqui, *Caffè letterari*, II, 452, Viviani notes: 'La scritta "Giubbe Rosse" fu dipinta sul bordo della grande tenda esterna soltanto nel 1933 dopo la pubblicazione del mio libro con lo stesso titolo.' [The inscription "Giubbe Rosse" was painted on the large awning outside only in 1933, after the publication of my book with the same title.]'

33. The Futurists first 'invaded' the Giubbe Rosse café on 30 June 1911, when Marinetti, Boccioni, and Carrà took Soffici by surprise and slapped him in retribution for the negative review 'Arte libera e pittura futurista', published in *La Voce*, 22 June 1911 (see Viviani, *Giubbe Rosse*, p. 30; Francesco Cangiullo, *Le serate futuriste* (1961), pp. 15–22). Viviani (in Falqui, *Caffè letterari*, II, 461) offers a partial list of the intellectuals who were patrons of the café, which is useful to get an idea of the different crowds that frequentated the place:

> Ma altri ancora frequentarono la terza saletta delle Giubbe Rosse, se non tutti come collaboratori di *Lacerba*, come amici di Papini e di Soffici o di Marinetti, e alcuni debbono essere ricordati: Giannotto Bastianelli, musicista; Louis Le Cardonnel, abate e poeta; Bino Binazzi, scrittore e poeta; Mario Novaro poeta e fondatore della rivista *La riviera ligure*; Theodor Däubler poeta; Giuseppe Vannicola violinista e poeta; Federico Tozzi poeta e scrittore; Ugo Tommei anarchico, scrittore, volontario, caduto in guerra; Danilo Lebrecht

[Lorenzo Montano], poeta; Giovanni Bellini commerciante in sottaceti, poeta, caduto in guerra; Ottone Rosai pittore; Th. Neal alias Angelo Cecconi, critico d'arte; André Gide poeta; Guillaume Apollinaire poeta; Arturo Reghini matematico filosofo teosofo; Nicola Moscardelli, poeta; Ferdinando Agnoletti, lattaio dilettante, scrittore e musico; Gigiotti Zanini pittore.

[But others still came to the third room of the Giubbe Rosse if not all as contributors to *Lacerba*, as friends of Papini and Soffici or Marinetti, and some must be noted: Giannotto Bastianelli, musician; Louis Le Cardonnel, abbot and poet; Bino Binazzi, writer and poet; Mario Novaro, poet and founder of the journal *La riviera ligure*; Theodor Däubler, poet; Giuseppe Vannicola, violinist and poet; Federico Tozzi, poet and writer; Ugo Tommei, anarchist, writer, volunteer, fallen in the war; Danilo Lebrecht [Lorenzo Montano], poet; Giovanni Bellini, merchant of pickles, poet, fallen in the war; Ottone Rosai, painter; Th. Neal alias Angelo Cecconi, art critic; André Gide, poet; Guillaume Apollinaire, poet; Arturo Reghini, mathematician, philosopher, theosophist; Nicola Moscardelli, poet; Ferdinando Agnoletti, amateur milkman, writer and musician; Gigiotti Zanini, painter.]

34. Viviani, *Giubbe Rosse*, p. 70. On this occasion Papini read his speech 'Contro Firenze passatista' (in *Lacerba*, 1.24 (1913)), then titled 'Discorso di Firenze' and included in Giovanni Papini, *L'esperienza futurista* (1920), now in *Opere*, ed. by Luigi Baldacci (Milan: Mondadori, 1977) pp. 387–502. See Walter Adamson, *Avant-Garde Florence: From Modernism to Fascism* (Cambridge, MA and London: Harvard University Press, 1993), pp. 153–55.
35. In Falqui, *Caffè letterari* (II, 463), Viviani gives the list of paintings on exhibition:

 La mostra comprendeva undici opere di Boccioni, quattordici di Carrà, due di Russolo, quattro di Balla, dieci di Severini, diciotto di Soffici. Un quadro di Soffici: *Compenetrazione di piani plastici*, occupava tutta la parete di una sala di fondo, in modo che dalla strada lo si poteva agevolmente vedere: i capannelli di curiosi che si fermavano a rimirarlo davano giornalmente un gran daffare ai tranvieri e agli altri conducenti di veicoli.

 [The exhibition comprised eleven works by Boccioni, fourteen by Carrà, two by Russolo, four by Balla, ten by Severini, eighteen by Soffici. A painting by Soffici: *Interpenetration of Plastic Planes*, took up the whole wall of a room at the end, so that from the street one could easily see it: the groups of curious people stopping by to admire it gave every day a lot of work to the tram-drivers and the other drivers of vehicles.]

 See also Viviani, *Giubbe Rosse*, pp. 59–63.
36. Viviani, *Giubbe Rosse*, p. 110. Marinetti had contacts with the Giubbe Rosse well before the evening at the Teatro Verdi, as at least the correspondence with Palazzeschi attests (Filippo Tommaso Marinetti and Aldo Palazzeschi, *Carteggio. Con un'appendice di lettere a Palazzeschi*, ed. by Paolo Prestigiacomo (Milan: Mondadori, 1978), pp. 75, 87). In the same volume there are also letters from Papini and Soffici to Palazzeschi (pp. 127, 137, 153–54) that confirm how the Giubbe Rosse was in the years of *Lacerba* the editorial headquarters of the journal.
37. First published in Marino Moretti, *Il libro dei miei amici* (Milan: Mondadori, 1960), then included in Marino Moretti, *Tutti i ricordi* (Milan: Mondadori, 1962), pp. 1075–76.
38. See 'Il Caffè Paszkowski a Firenze', in Falqui, *Caffè letterari*, II, 478–88.
39. Extensive selections from these journals are available in *La cultura italiana del Novecento attraverso le riviste: 'La Voce' (1908–1914)*, ed. by Angelo Romano, 4 vols (Turin: Einaudi, 1960), II–III, and *La cultura italiana del Novecento attraverso le riviste. 'Lacerba', 'La Voce' (1914–1916)*, ed. by Gianni Scalia (Turin: Einaudi, 1961), IV. In summarizing the changes that took place around what was then Piazza Vittorio Emanuele, Adamson concluded: 'Although the Florentine avant-garde would, on the whole, deplore this change, it was perhaps indicative of the contradictoriness of their position that the back room of the Giubbe Rosse would later serve as *Lacerba*'s only true editorial office' (*Avant-Garde Florence*, p. 40). The project of *Lacerba* had in fact started at the Castelmur café, in Via Calzaioli. In the summer of 1908, however, the café closed and a movie theatre opened in its place. Soffici, who had a preference for this café, at that point resigned to meeting at the Giubbe Rosse, which Papini, on the contrary, had favoured since at least 1904 (Giovanni Papini, 'Passato remoto', in *Tutte le opere*, 13 vols (Milan: Mondadori, 1962), IX, 865–67). On

the importance of cafés, see also Giovanni Papini and Ardengo Soffici, *Carteggio*, ed. by Mario Richter, 4 vols (Rome and Fiesole: Edizioni di Storia e Letteratura/Fondazione Primo Conti, 1991), I, 77, 146–47, 150, 153–54, 161, 205, 257, 262, 291; II, 28, 155, 170, 194, 213, 218, 262, 265, 268, 299, 311, 313, 316–17, 327, 331, 332, 344, 364, 367, 375, 416.

40. On these journals see Pier Paolo Carnaroli, *'Solaria' (1926–1934). Indice ragionato* (Florence: Firenze Libri, 1989); *'Solaria', 'Letteratura', 'Campo di Marte'*, ed. by Alberto Folin (Treviso: Canova, 1973); Ruggero Jacobbi, *'Campo di Marte' trent'anni dopo. 1938–1968* (Florence: Vallecchi, 1969); Maria Serafina Mazza, *Not for Art's Sake: The Story of 'Il Frontespizio'* (New York: Columbia University — King's Crown Press, 1948); Enzo Siciliano, *Antologia di 'Solaria'*, with an introduction by Alberto Carocci (Milan: Lerici, 1958). To be sure, some critics tend to downplay the role of the Giubbe Rosse café for some of these journals. See for instance Lorenzo Bedeschi, *Il tempo de 'Il Frontespizio'. Carteggio Bargellini — Bo, 1930–1943* (Milan: Camunia Editore, 1989), pp. 54–55.

41. Viviani recalls the cafés he frequented with his parents up to 1909, when he went to visit Marinetti in Milan:

> Con loro due ero stato qualche volta di domenica nel borghesissimo Caffè *Gambrinus* o al Bottegone, dove i clienti (tutta gente morigerata e benpensante) sorbivano in silenzio il ponce o il caffè, leggendo i giornali sorretti da una lunga stecca di legno.
>
> [Sometimes on Sundays, I would go with the two of them to the very bourgeois Gambrinus Café or to the Bottegone, where the customers (all moderate people of good morals) silently sipped ponce or coffee, reading the papers held by a long wooden stick.] (*Giubbe Rosse*, p. 21)

This description of the Gambrinus café and its clientele helps to explain why this café and other similar ones could not compete with the Giubbe Rosse. Regarding the Trattoria dell'Antico Fattore, see *Firenze: dalle Giubbe Rosse all'Antico Fattore, con pagine dall'inedito 'Giornale di bordo' di Arturo Loria*, ed. by Marcello Vannucci (Florence: Le Monnier, 1973) and Marcello Vannucci, *Le tre stagioni dell'Antico Fattore* (Florence: Premio Chianti Ruffino Antico Fattore, 1983).

42. Stuparich, quoted in Pini, *Incontri alle Giubbe Rosse*, p. 10.

43. Adamson, *Avant-Garde Florence*, p. 196.

44. Viviani, *Giubbe Rosse*, p. 122. Viviani also recounts that he invited Marinetti to the Gambrinus café to buy a copy of Campana's book, but the poet of the *Canti Orfici* ripped a few pages out of the book with the explanation that the Futurist leader would not understand them. See also Giovanni Papini, 'Il poeta pazzo', in *Tutte le opere*, IX, 865–70.

45. Viviani, *Giubbe Rosse*, p. 155.

46. *Lacerba*'s managing editor Guido Pogni and Italo Tavolato were tried for offence against morality after the latter published his article 'Elogio della prostituzione' [In Praise of Prostitution] in the journal — one of the best-known episodes from the Futurist years of the journal. For an account of the event with details on the café, see the first part of Sebastiano Vassalli, *L'alcova elettrica* (Turin: Einaudi, 1986), pp. 5–125. Tavolato had also published an 'Elogio del caffè' [In Praise of the Café] in *Lacerba*, 15 March 1914.

47. Filippo Tommaso Marinetti, 'Il Re disse: che ha Marinetti?', *Originalità*, 10 August 1924. On the Caffè Florian as a literary café, see Gino Damerini, 'Il Caffè Florian a Venezia', in Falqui, *Caffè letterari*, pp. 61–93, and Danilo Reato, *Il Caffè Florian* (Venice: Filippi Editore, 1984).

CHAPTER 11

The Cocktail

Marinetti and Alcohol from Absolutism to a Peach Orchard

Marja Härmänmaa, University of Helsinki

'Aperitivo'

The differences between Marinetti and the Russian Futurists went far beyond their respective artistic theories, and many of these dissimilarities became apparent during Marinetti's legendary visit to Russia in 1914. Whereas Marinetti was wealthy and prosperous, the Russian artists were mainly poor, and many of them lacked even any form of academic background. The Italian who claimed to revolutionise the arts, culture, and even life itself, turned up in Moscow carefully dressed in a fine suit; the bohemian Russians demonstrated their revolutionary inclinations also through their clothing and appearance. All in all, at least in the eyes of the Russians, they were the radicals, whereas Marinetti was solely and irredeemably middle class.[1]

In addition to their different outfits, their moral principles were also quite distinct, if not opposite: among other things, the liberal-minded Russians advocated free love and life in community. Marinetti, too, in his youth condemned matrimony, but subsequently changed his views and even married in church;[2] and last but not least, he did not drink — or in any case he enjoyed alcohol in moderation.[3]

This is not to say that Marinetti's abstemiousness was a consequence of his upper middle-class background. Still, I do claim that his attitude towards alcohol offers an indication of the reactionary nature of the Futurist 'revolution', which Marinetti hid behind the apparently radical rhetoric and artistic language of the avant-garde he used. Finally I shall demonstrate that the way Marinetti changed his attitude towards drinking corresponds to the entire transformation that Futurism went through during the thirties and beyond.

The English Husband and the Rough American

The strong fear of degeneration, which was widely diffused from the second half of the nineteenth century onward, was considered to be the consequence of different factors.[4] The idea that alcohol had a degenerative effect had already been presented by Bénédict Augustin Morel (1809–73). According to the founder of the theory

of medical degeneration, alcohol was one of the principal poisons to cause human deterioration. Subsequently Morel's theory was developed by French scholars who concluded that alcohol was among the most important social reasons for an individual's physical and psychical degeneration.[5] These convictions, for their part, prepared the ground for a widespread attitude of suspicion towards drinking, as well as for the various temperance movements that gained popularity all over the Western world during the second half of the nineteenth and the beginning of the twentieth century.[6]

Apparently Marinetti did not belong to any temperance movement; nor is it correct to say that he was obsessed with alcohol. Nevertheless, drinking is constantly present in his works, and usually in a negative way. On several occasions alcohol indeed serves as a tool of situational irony to indicate both the national and individual degeneration that is the core of Marinetti's creed; and to this Futurism, with its bellicosity and its vision of the mechanical man and his environment of steel, was supposed to offer a remedy.[7]

Alcohol is already represented in threatening terms in *Come si seducono le donne* [How to Seduce Women, 1917], in the sense that in this book it is suggested that men who are pathetic losers tend to turn to alcohol as a substitute for women and sex. As the title clearly indicates, the collection of autobiographical short stories is about seducing women. More precisely, it is about the different 'Futurist' qualities a man needs to possess in order to conquer ladies, and — of course — it is also about Marinetti's personal experience in the field. In the chapter entitled 'La donna e il coraggio' [Woman and Courage], Marinetti narrates how he has been able to seduce different women by showing himself to be particularly courageous. In one of the cases a beautiful English lady admires Marinetti's verses, and wishes to have an affair with him. After the dinner, the husband brings out his usual bottle of cognac. During Marinetti's declamation, he drinks four glasses and dozes off in his armchair. Whilst the husband is sleeping and spilling the last drops left in the glass on himself, Marinetti and the wife are 'caressing' each other in the very same room. The lesson of the story is clear: whereas the virile and courageous Marinetti manages to seduce the lady, the husband instead turns into a pitiful cuckold because of his drinking.[8]

On this occasion, alcohol connotes indifference towards a woman. Drinking is a sign of impotence, and therefore an opposite of the strenuous virility that Marinetti energetically promoted from *Mafarka il futurista* (1909) onwards. On the one hand, the cult of virility bore similarities to the canons of the highly popular erotic literature of the period, thus having commercial purposes;[9] and on the other, it also served to communicate Marinetti's nationalistic convictions.[10]

In *Come si seducono le donne*, being virile is represented as an imperative to safeguard the future of the nation and of the race.[11] This is the ultimate reason why a male must be capable of seducing women. Curiously enough, the masculine imperative and the exaltation of virility were accepted by the female Futurists, too. One needs only recall Valentine de Saint-Point's 'Manifesto della Donna futurista' [Manifesto of the Futurist Woman, 1912] in which the author, following Marinetti's

argument, stresses the necessity of virility not only for the seduction of women, but also for the sake of the entire Nation. Therefore she states: 'Per ridare una certa virilità alle nostre razze intorpidite nella femminilità bisogna trascinarle alla virilità, fino alla brutalità' [To restore some manhood to our race, which has been made numb by femininity, we must drag it into virility, and even to brutality].[12] And indeed, in Marinetti's war rhetoric the transformation of virility into brutality becomes overwhelmingly apparent.[13]

At this early stage of Futurism, Marinetti's utopia of the new healthy society was built on a vision of women full of 'animality'[14] and beast-like men.[15] For many artists, the return to a sort of primitive stage was one of the ways to respond to cultural pessimism.[16] Nevertheless, Marinetti did distinguish the charm of genuine exoticism from mere barbarism, intended as the utmost degradation of Occidentalism. In the context of the latter, alcohol once again offers a stimulating point of view.

In 'La locomotiva blu' [The Blue Locomotive, 1922], alcohol in fact turns into a sign of rough barbarism and extreme madness.[17] The short story is one of 'programmi di Vita con variant a scelta' [programmes of life with a choice of variations], a 'sana ginnastica extralogica' [healthy, extra-logical gymnastics] aimed at training the spirit of the readers to achieve simultaneity and velocity — as Marinetti characterised them.[18] These short stories formed part of a popular genre in the period, destined to amuse a mass audience.[19] As such, they are hilarious parodies of the middle class, their habits and environment, to the point of being grotesque.[20]

In 'La locomotiva blu', the protagonist Franco becomes bored with his middle-class love life, and goes to Florida in the company of the narrator. Florida is described as a place of absolute barbarism, 'una zona boschiva popolata d'ingegneri pazzi e di forsennati accumulatori d'oro' [a wooded place populated by crazy engineers, and mad gold collectors]. It is a place ruled by money, where people speak a 'barbaro miscuglio' [barbarous mixture] of languages.[21] In this cradle of savagery, the narrator and Franco meet Ramblok, an American mechanic. Drinking is part of his ruthlessness, which is apparent in the signs that alcohol has left on his face. Therefore Ramblok is 'tarchiato, panciuto, faccia bitorzoluta rossavìolagialla d'alcool brutalità' [stocky, paunchy, lumpy, with a red-violet-yellow face of alcoholic brutality].[22] He is a mad daredevil who drives the Blue Locomotive in a race. This ends up in an apocalyptical accident and the death of all the animals and humans on the two trains that collide on a bridge. And it is not by accident that the pact to run the race between the barbaric American and the equally barbaric Americanised Italian, who drives the other train, is 'innaffiato di buon rhum' [watered with excellent rum].[23]

The Drunken Dessert

On the one hand, the will to aestheticise everyday life, which Marinetti inherited from the artists of the *fin de siècle*, and on the other, the need imposed by the nascent mass society to reform the role of the intellectual and the arts by bringing them into close contact with contemporary reality, were synthesised in the concept of

'art-life'.[24] This notion led Marinetti to perform all kinds of extra-artistic activity, which also included cuisine. In addition to dishes, *La cucina futurista* [*The Futurist Cookbook*, 1932] contains several recipes for cocktails, in which different kinds of alcohol are creatively mixed. The drinks were part of Marinetti's wider campaign against *esterofilia* (i.e. the adoration for all that is foreign), and are an explicit parody of the cocktails that, together with other English habits, had been gaining popularity since the end of the nineteenth century.[25] Moreover, the purpose of the mostly undrinkable cocktails is the same as that of the whole Futurist cuisine, that is to say 'strengthen, dynamize and spiritualize' the eating habits of the Italians, and to substitute 'quantity, banality, repetition and expense' with 'experiment, intelligence and imagination'.[26] Therefore, whereas the entire gastronomic revolution was indeed targeted to bring optimism to the tables that had been disheartened by the economic crisis, the Futurist cocktails, like the dishes themselves, end up becoming culinary jokes.[27] In Futurist cuisine, apart from being an ingredient of the dishes, alcohol has a quite marginal role. Nonetheless, one remarkable exception can be found in 'Official Dinner', in which a drunken man is a concrete example of alcohol abuse.

'Official Dinner', described by Marinetti in *The Futurist Cookbook*, is a proposal for a diplomatic banquet.[28] As such, it is an evident parody of international politics, towards which Marinetti always had been highly and openly sceptical.[29] The parody culminates in the so-called dessert in which all kinds of international diplomacy are represented as pure nonsense. After the three courses entitled indicatively as 'The Cannibals Come to an Agreement in Geneva', 'The League of Nations', and 'The Solid Treaty', the Organiser of the dinner deliberately keeps the guests waiting for dessert. Finally, as the atmosphere gets ever more nervous, instead of the ice cream cake 'that just collapsed in the kitchen', or the exotic fruits that were supposed to arrive from the Equator, but that have encountered disasters on the road, including train derailments, into the dining room enters a drunkard picked up on the street. He will be given the best Italian wines on the condition that he speaks for two hours 'on possible solutions to the problems of disarmament, the revision of treaties and the financial crisis'.[30]

Africa and Alcohol

Like most of Marinetti's activities, his opposition to alcohol was also related to his nationalistic ideology: alcohol abuse was a threat to the nation, and for this reason it had to be condemned. In Marinetti's various theatrical plays, drinking emerges as one of the obstacles to the development of Africa. In the drama *Il tamburo di fuoco* [*Fire Drum*, 1922] the protagonist Kabango incarnates Marinetti's mission to rescue the nation from degradation.[31] He is a civilised and educated African prince and legislator who puts all his effort into developing Africa. In addition to 'isolamento', 'clima torrido', and 'terra generosa' [isolation, torrid climate, generous land], Kabango describes the reasons for the backwardness of his continent as excessive sexual activity and rum.[32]

In *Luci veloci* [*Fast Lights*, 1929] the theme of drinking and national degradation is developed at its best.[33] This is one of Marinetti's last plays in which the characters still have psychological personalities, and the events follow each other in a logical order.[34] The play is autobiographical, inasmuch as the protagonist Musoduro is a 'poeta celebre' [famous poet], a politician and a wounded veteran of the First World War who wishes to 'terminare il mio studio sulla verità storica e sulla deformazione dei fatti attraverso la fantasia collettiva' [terminate his study of historical truth and the deformation of facts through collective fantasy].[35] In addition to serving as an expression of Marinetti's political disillusion, *Luci veloci* is a parody of the British, and speaks in favour of Italian colonialism in Africa.[36] The play is rich in symbolism, for not only do the characters have a symbolic meaning, but also drinking is depicted as a sign of both Africa's and the British rulers' decay. In fact, not only do all the main characters abuse alcohol, the noise of a brawl coming out of a bar also offers an appropriate soundscape to the play, the main topic of which is indeed an international 'brawl'.

The play is located in Bassabulà, a fictional village on the Egyptian coast, where a colonial war is about to start between the native Arabs and the British rulers.[37] The English governor, although he is 'un uomo di dovere' [a man of duty], drinks a lot. This day he has had no fewer than ten cocktails prepared by Sir Roll. The latter is an English captain, who in many ways presents a parody of the British. Like the governor, Sir Roll is a complex character whom Musoduro finds sympathetic, whilst Perlina, the daughter of the latter, thinks he is 'un temperamento militare, rude e violento' [a military temperament, rude and violent].[38] Sir Roll is reliable, although he too 'beve molto' [drinks a lot]. For him, a good cocktail seems to be a solution to any problem. For instance, when Mahmud has been beaten in a brawl, Sir Roll's natural and immediate reaction is to prepare him a good cocktail.[39]

Mahmud Bay, instead, incarnates the decay of Africa. He is a young Arab politician who, in different ways, including in his Western clothing, tries to imitate Europeans. (He stands thus as an opposite to Kabango, who is a genuine African hero.) Mahmud is the most suspicious character in the play. Having betrayed the Arabs, and being an ally of the British, he has neither values nor principles.[40] He drinks too much, and also uses some kind of drugs ('misteriosi effluvi di farmacia').[41] According to Musoduro, alcohol is precisely the factor that makes Mahmud unreliable, as he varies 'dal mestiere del gioco al rimunerativo nazionalismo africano' [from gaming to lucrative trade of African nationalism].[42] Finally, echoing the theme of virility of *Come si seducono le donne*, alcohol and drinking are among the main reasons why Perlina, Musoduro's daughter and a symbol of juvenile idealism, does not want to get engaged either with Mahmud, or with John Roll.[43]

In *Luci veloci*, maybe more explicitly than on any other occasion, Marinetti describes alcohol as a symbol of the decadence of both a nation and an individual. Alcohol is the only consolation in colonial Africa, as Mahmud says: 'Beviamo tutti qui, fra le macchine e i petroli di questa Africa masticata e divorata dagli Europei. Ciò serve ad uccidere la nostalgia' [We all drink here, between the machines and petrol of this Africa chewed and devoured by the Europeans. It serves to kill

nostalgia].[44] In the prohibitionist atmosphere of the thirties, Marinetti's repulsion for alcohol abuse did not diminish. In a draft of a letter to Hitler, he even expressed his desire to accept the artistic policy of National Socialism that condemned the German avant-garde, as this 'pur essendo indiscutibilmente ricca di genio attività prestigio mondiale, era anche [. . .] quasi tutta avvelenata da degenerazioni sessuali, alcool, cocaina' [although unquestionably rich in geniuses activities world-class prestige, it was also [. . .] almost entirely poisoned by sexual degenerations, alcohol, cocaine].[45]

Marinetti's opposition to alcohol and its different counterparts throughout Europe are to be situated within the context of the rapidly developing mass society. In addition to temperance movements and the prohibition laws that some countries adopted, during the first half of the twentieth century authorities in various countries put into effect numerous other programmes that aimed to create 'healthy societies'. New social politics, attention to hygiene, encouragement of all kinds of physical exercise, and the application of eugenics in different forms, all had a common goal to rescue the West from 'degeneration' by increasing the number of the 'good' citizens and 'improving' their mental and physical qualities.[46]

The very same kind of human reform had been an integral part of Marinetti's ideological programme since the very inception of Futurism. The first result of Marinetti's 'rivoluzione per un disumanesimo anticristiano' [revolution for anti-Christian dehumanisation] — as Emilio Gentile recently baptised it[47] — was a utopia of a brave new 'superman', a science-fictional figure born out of a liaison between man and machine. The paramount result of it was Gazurmah in *Mafarka il futurista*.[48] Later on, and especially during the thirties, this individualistic cyborg was replaced by a more realistic programme of 'bonifica umana' [human improvement],[49] with the aim of improving the quality of Italians for the sake of the Fatherland, and to create what Arnaldo Ginna called 'un superuomo volitivo' [a volitional superman].[50]

In accordance with his own alcohol-free lifestyle, Marinetti envisioned a new healthy society of healthy men who in many ways represented the antithesis to the pale, syphilitic, and alcoholic type cherished by *decadentismo*.[51] In the thirties, Marinetti became seriously interested in medicine and the physical condition of the Italians. Together with Arnaldo Ginna he founded the Futurist Naturist movement that, among other things, aimed at improving the fitness of Italians by means of a suitable diet, appropriate housing, physical exercise, good health care, and proper lifestyle.[52] Curiously, in the manifesto of 'Il Naturismo futurista' [Futurist Naturism, 1934] alcohol is not completely forbidden; instead, along with 'un'alimentazione leggera, prevalentemente vegetale' [light, mainly vegetal alimentation] and 'frutta mangiata cruda' [fresh fruit], Marinetti and Ginna recommend local, genuine wine.[53] Consequently, the Italian wines, together with other agricultural products, were well represented in the Futurist Naturist exhibitions.[54] This leads to the question how and to what extent wine can be said to occupy a special position in the Futurist programme.

Care for Some Wine?

Faithful to his anti-alcoholic admonition, Marinetti did not drink. However, during his Russian visit Marinetti is said to have emptied four bottles of champagne to demonstrate to the Russians that the Italians were just as capable of drinking if the honour of the Nation required it.[55] The volume *Firenze biondazzurra* [*Celestial Blond Florence*], written by Marinetti in Venice during the summer of 1944 with the Tuscan writer and poet Alberto Viviani (1894–1970),[56] contains an episode in which some of the Futurists propose to go for a drink but Marinetti declares his preference for a hygienic cure of water and milk ('considero igienica la cura dell'acqua e del latte'), whereas the best wine for him was 'quello dell'orgoglio italiano e delle armi guerresche' [the one of Italian pride and bellicose weapons].[57] This statement sums up well his attitude towards alcohol. The most important qualities for the brave new Futurist man were mental and physical hygiene, and therefore, instead of alcohol or drugs, the superlative excitement was a patriotic war. However, during the Second World War, when Marinetti revised many of his previous ideas, he also paradoxically changed his opinion concerning drinking, and especially drinking of wine.[58]

The politics in favour of Italy's autarchy started in 1925 with the so-called 'battle for grain' (*battaglia del grano*). The demand for self-sufficiency grew ever stronger after the League of Nations imposed sanctions against Italy in 1935. If the agricultural autarchy had first stood for the production of grain and meat, especially during the second half of the thirties till the beginning of the Second World War, ever greater attention was paid to viticulture, ranging from wine production to table grapes and to all other products that could be derived from the grapevine (like copper from the leaves). The importance given to viticulture is not a surprise, as Italy, *l'antica Enotria*, had produced wine for thousands of years, and had the most extensive vineyards both in absolute (the percentage of land within the country devoted to viticulture) and in relative terms (compared to other countries). Taking into account the working hours, wine growing was equally important for the country's economy.[59]

Regardless of the benefits of viticulture, there were people in Italy who, in the prohibitionist spirit of the thirties, emphasised the disadvantages of wine consumption, and demanded the abolition of the vineyards and the cultivation of grain instead. The speech by a certain professor Dalmasso in favour of wine growing was precisely directed against 'dei melanconici medici o igienisti che, magari in buona fede, vorrebbero attribuire al nostro onesto vino i malanni più gravi e le colpe più impensate' [the melancholic doctors or hygienists who, perhaps in good faith, would like to attribute to honest Italian wine the most serious ills and the most unexpected faults].[60] In a similar vein, the Futurists spoke out in favour of Italian wine. However, the reasons for this were first and foremost nationalistic, and related to the politics of autarchy. Before the Second World War, the Futurists did not encourage drinking; that was to happen only after the war had actually begun.

The close affinity between Futurist art and modern advertising has been

recognised by different scholars.[61] As early as 1974, Guido Guglielmi wrote that 'il Futurismo fornì al capitalismo avanzante l'ideologia del macchinismo e della fredda violenza, e i prototipi di quella tecnica del sensazionale che sarà della pubblicità e dell'industria culturale' [Futurism gave emerging capitalism the ideology of the machine and of cold violence, and the prototypes of the technique of the sensational that would become typical for the advertisement and cultural industry].[62] However, Futurism not only preceded modern advertisement: to a great extent the Futurist art was *per se* a form of advertisement, like the manifesto. For the Futurists art was 'un'arma' [a weapon] and 'uno slogan'.[63] It was aimed at propagating a message — whether it was a vision of the new world, a new aesthetic principle, idolatry of technology, war, or nationalistic conviction.[64]

Especially in the thirties, for the sake of autarchy and as a statement against so-called *esterofilia*, Marinetti's patriotism led him to energetically promote Italian products of all kinds. The Futurist campaign in favour of Italian wines had started with Futurist cuisine. It was notoriously strengthened with the Naturist movement, and finally, during the Second World War wine made its way into the literary works on which we shall concentrate next.[65]

In *Firenze biondazzurra* there is a clearly different attitude towards wine-drinking (especially towards Tuscan Chianti), and towards life in general.[66] The book is a sort of history of Futurism, having as a focus the collaboration between Marinetti and the Florentine Futurists. The last chapter, entitled 'L'estuario dei poeti beati' [The Estuary of the Blessed Poets], consists of an imagined dialogue between Dante Alighieri and Jesus Christ, with Dante thanking Jesus for having sublimated the 'torturanti motivi letterari degli anni vissuti sulla terra' [the torturous literary motifs of the years lived on earth].[67] The dialogue, the chapter, and the whole oeuvre culminate in Dante's exhortation to Jesus to impede 'quell'atroce volo nero famelico di uccelli calunniatori' [the atrocious, black, and ravenous flight of the scandalmonger birds], and for this purpose, to make use of Futurist wording, the 'Ardore entusiastico creativo di elogi letterari senza fine ad ogni costo' [Enthusiastic creative ardour of literary praise without end at any cost].[68] The dialogue can thus be understood as a metaphorical but still pathetic excuse and attempt to justify Futurism, its legacy with Fascism, and its bellicose message, which made it in part guilty for Italy's ongoing misfortune. Likewise, although well grounded, the emphasis on Futurism's artistic activity must also be interpreted as an effort to polish the movement's image and, on the eve of the final collapse of Fascism, as a tactical preparation for the new, post-Mussolini Italy. These are the premises for reading *Firenze biondazzurra*.

Even if most of the volume deals with the Futurists' artistic activity, it also discusses other aspects of the movement's history. One chapter entitled 'La cura antialcoolica di Vannicola a Uscio' [Vannicola's Anti-Alcoholic Cure in Uscio] is dedicated to Marinetti's and other Futurists' visit to a sanatorium in Uscio where one of their colleagues, Giuseppe Vannicola, is recovering from alcoholism. Contrary to what might be expected, the episode is not a moral condemnation of Vannicola's deplorable state, but instead a parody of the Naturist lifestyle, which

Marinetti had in part sustained with Futurist Naturism, but which he now openly ridiculed.

The episode is a sort of official farewell to the previously held healthy lifestyle, and a glorification of the pleasures of life instead. First of all, the Futurists arrive at 'l'alpino romitaggio' [the alpine hermitage], 'ben satolli di rosbif e polli arrosto resi giocondi da schietto vino rosso inebriati da ottime sigarette tonificati da un caffè squisito' [well satiated with roast beef and roast chicken, merry because of the genuine red wine, crazed by excellent cigarettes, and reinvigorated by delicious coffee].[69] The sanatorium, instead, is a 'verde prigione del "quisisana" per signore grasse astemie' [green prison of the 'quisisana'[70] for fat and teetotal ladies].[71] The distressing mood of the place is explained by Vannicola who declares: 'Qui si muore di aria pura perché la salute del corpo impedisce di vivere fumando una sigaretta e bevendo del vino' [Here one dies from the fresh air because the health of the body denies life in the form of smoking a cigarette and drinking wine'].[72] To 'pillole quotidiane di cura antialcoolica' [daily pills of the anti-alcohol cure], to 'sterile seno' [sterile breast] of a fat bath attendant or to a scrawny teacher of 'ginnastica svedese' [Swedish gymnastics], Vannicola prefers 'vita' [life], in other words the modern world with its pleasures. Together with his Futurist friends he leaves the clinic, and happily breathes the gasoline fumes from a car on the street.[73]

In the chapter entitled 'La festa dell'alta poesia del vino' [The Feast of the High Poetry of Wine], the Futurists from Milan and Florence who love Chianti gather together in the *trattoria* Gobbo to celebrate wine — although 'some' of them (presumably a reference to Marinetti) still drink only water. To emphasise the pleasure of drinking, wine is compared to a woman: 'L'odore mordente del "Chianti" che afferra deciso la gola di tutti come i dentini lievemente feroci di una generosa femmina' [The mordent odour of Chianti decisively seizes the throat of everyone like the slightly fierce teeth of a generous female].[74] Maybe in order to defend his changed ideas, Marinetti explains the Futurist way of drinking that differs from that of those who drink to forget, or to experience a brief moment of pleasure, or to discover reality according to the ancient proverb *in vino veritas*. Instead, for the Futurists, wine is a creative and dynamic force, and it is to be enjoyed as such: 'Noi futuristi invece beviamo e festeggiamo il "Chianti" come un elemento simile a noi per forza creativa e potenza dinamica' [We Futurists drink and celebrate Chianti as an element that is similar to us on account of its creative force and dynamic power].[75] The occasion, in which Italian, French, and English poets participate, turns into a festivity of poetry and creativity — thanks to wine.[76]

In addition to being a source of artistic creativity, wine is also venerated as a source of reinvigoration. In the chapter 'La cena futurista e le guance della sposa cinese' [The Futurist Dinner and the Chinese Wife's Cheeks] the Futurist painter Ago is keen on painting a portrait of his Chinese wife along the river Arno. However, the pale face of the wife does not fit with the strong colours of the Tuscan countryside. The only way to get some red blush on her cheeks is to make her drink Chianti wine.[77]

The Ultimate Jag

Firenze biondazzurra was not the only occasion in which the Futurists exalted wine drinking. During the Second World War, in the middle of the disasters of warfare, wine became a symbol of joy, playfulness, and love in Futurist rhetoric, and even an image epitomising the Fatherland as a whole. In the last years of the movement, it was the outstanding vehicle of Futurism's tenacious optimism, which now had to come to terms with the disastrous outcome of the war.[78]

Italian arts and literature have always dedicated a special place to wine. During the nineteenth century wine also had a notorious place in opera, such as in Verdi's aria 'Libiam' in *La traviata*, Donizetti's *L'elisir d'amore*, or Mascagni's *Cavalleria rusticana*.[79] However, the most important period for wine was the Middle Ages. It was the period in which wine consumption in Italy was exceptionally high. In the absence of tea, coffee, and other modern drinks, wine was among the few medieval beverages, and more hygienic than water, which was often taken from muddy and polluted wells. In addition to being among the few forms of entertainment that society tolerated, wine also had a particular significance in medieval Christian theology. Whilst bread was the symbol of activity, wine signified the contemplative life: it stood for the possibility of knowing the essence of things, *gnosis*, the greatest virtue God had given to man.[80] Therefore, not by accident Dante (who is strongly present in *Firenze biondazzurra*) dedicates a tercet of the *Commedia* to Chianti wine, called in the Middle Ages 'vermiglio'.[81] He compares man's soul, given to a foetus by God, to wine, the gift of the Sun that gives life to the grapevine.[82]

In 1943 Marinetti published the *Canzoniere futurista amoroso e guerriero* [*Futurist Songbook on Love and War*], a collection of poems and songs written by some of the last Futurists. The poems mainly deal with war experiences, yet two of them are dedicated to wine. In these poems war is present only vaguely, whilst the main topic is the exaltation of happiness and the pleasure of life. In Bruno Sanzin's poem 'Chianti Barbera Lambrusco' the joyful wines of Italy epitomise the country's energy and are expected to encourage its inhabitants. As a sign of the cheerful atmosphere, instead of the noise of the ongoing warfare, the country is full of merry popping of bottles of the sparkling wine of Asti:

> Chianti Barbera Lambrusco vin dei Castelli sintesi
> vigorosa e gioconda della Penisola in alto i cuori per
> amare e per marciare armati così senza rimpianti
> virtù dei forti e degli spavaldi mentre qua li [sic] giù su
> sparano risate augurali di spumante le bottiglie d'Asti
> secco e semisecco.
>
> [Chianti Barbera Lambrusco wines of Castelli, the vigorous
> and joyful synthesis of the Peninsula, uplift your hearts to
> love and to march armed without regret
> virtue of the strong and bold while here there up down
> shooting greeting laughter the sparkling wine bottles of Asti
> dry and semi-dry].[83]

Acquaviva's 'Chicchi d'uva' [Grapes] is about a grape harvest that is transformed into a most sensuous rite. Wine, the final result, embodies love; the bunch of grapes is a bunch of kisses, whilst the fruit of the grape is both a precious and beautiful pearl and a bullet (an image that recalls the war and insists on the invigorating force of grapevine):

> Vendemmia taglia e piglia son grappoli di baci
> Empi la corba e pigia dietro il tino il bacio ti scocca
> Son gocce di mare
> Son occhi di sole
> Cuore su cuore
> Perle ma scatteranno proiettili alla nemica stretta
> Ti abbraccio porgi la bocca
> Ed ecco il vino eho! festa al succo d'amore.
>
> [Harvest cut and seize they are bunches of kisses
> Fill the basket and press behind the vat the kiss smacks you
> They are drops of sea
> They are eyes of the sun
> Heart over heart
> Pearls but they will snap bullets toward the enemy in dense array
> I hug you reach out your mouth
> And here is the wine hey! party to the love juice.][84]

Likewise in Marinetti's poem 'Poetare e tracannare nella osteria dei soldati repubblicani alla salute dell'Italia immortale' [Poetry and Guzzling in the Tavern of Republican Soldiers to the Health of Immortal Italy, 1944], wine has a substantial role as a bearer of happiness.[85] As in Marinetti's other works of the period of the Second World War, in this poem too the atrocities of the war are clearly present.[86] They are represented by references to the husband of the owner of the *osteria*, a volunteer in the war,[87] to the buildings destroyed by bombs,[88] and to the Futurist poet Maria Goretti who is described as a Red Cross nurse tenaciously marching on the 'strada | di fango | di neve | di sole | piedi sanguinosi | piedi congelati' [road | of mud | of snow | of sun | bloody feet | frozen feet].[89] The horrors of war are even symbolically described in the gloomy night scenery dominated by shadows that have replaced the bright lights of the peacetime nights. Now, instead, the war is also reflected in the aggressiveness of nature, in which the pines are fighting against the poplars:

> Bei tempi andare con le barche con le luminare per la festa della Madonna ed ora Guerra anche le ombre vanno a frotte nella notte la luna s'appiatta e i pini a terra fanno Guerra coi pioppi ma tu non aver paura non piangere creatura l'erbe s'allungan leggere come un nulla e ti fanno la culla.
>
> [Those were lovely times going by boat with the illuminations for the feast of Our Lady and now War also the shadows go in droves in the night the moon is flattened and pines on the ground make war with poplars but do not be afraid do not cry creature herbs lengthen as light as nothing and rock you in the cradle.][90]

Nevertheless, the atmosphere is joyful, both in the poem and in the situation that is

represented, and this is precisely due to food, songs, and wine. The poem evokes the highly antifuturist setting of a peach orchard in Savona, where the Futurists have gathered to eat *caciucco*, a traditional fish soup prepared by the mistress of the house. The return to organic nature is crucial, for it can be associated with a major change in Marinetti's ideology: the rejection of a certain necrophilia that came with the idolatry of artificial nature.[91] This change is particularly manifest in a new attitude towards war, but also in a different take on drinking.

While Italy is fighting the last phase of the war, Marinetti is no longer willing to exalt combat: he calls the Futurist artists 'musicians' and 'singers', and encourages everyone to forget fighting and to drink 'Basta bevici ecco il vino eho! festa per il succo d'amore e voi aviatori accordate i motori noi siam suonatori siamo cantori' [Enough drink here is the wine, hey! party for the love juice and you aviators tune the engines we are musicians we are singers].[92] The poem contains many intertextual references to the *Canzoniere*, which makes it plausible to think that it was written after that work. In addition to quoting indirectly the poem of Sanzin,[93] Marinetti echoes Acquaviva in calling wine 'succo d'amore' [love juice],[94] but he also goes beyond that. As in the case of the colonised Africa in *Luci veloci*, also for Marinetti at the end of the war wine offers consolation. As the air is full of 'cannonate fucilate pallottole mitraglia lanciafiamme siluri bombe d'ogni calibro' [cannon shot gun shot bullets machine gun flamethrowers torpedoes bombs of every calibre], Marinetti's only comment to the disaster is: 'Let's drink on it'![95]

Notes to Chapter 11

1. On Marinetti's visit to Russia, and on the relationship between Russian Futurism and Marinetti, see Vladimir Pavlovič Lapšin, *Marinetti e la Russia. Dalla storia delle relazioni letterarie e artistiche negli anni dieci del XX secolo* (Milan: Skira, 2008), pp. 97–189; Cesare De Michelis, *L'avanguardia trasversale. Il futurismo tra Italia e Russia* (Venice: Marsilio, 2009); Claudia Salaris, *Marinetti. Arte e vita futurista* (Rome: Editori Riuniti, 1997), p. 156; Enzo N. Terzano, *Futurismo. Cinema, teatro, arte e propaganda* (Lanciano: Carabba, 2011), pp. 162–64; Benedikt Livšic, *L'arciere da un occhio e mezzo* (Florence: Hopeful Monster, 1989), pp. 227–69.
2. See for instance, Filippo Tommaso Marinetti, *Come si seducono le donne* (1917) (Florence: Vallecchi, 2003), p. 110; Filippo Tommaso Marinetti, 'Contro il matrimonio' and 'Orgoglio italiano rivoluzionario e libero amore', in *Democrazia futurista* (1919), now in Filippo Tommaso Marinetti, *Teoria e invenzione futurista*, ed. by Luciano De Maria (Milan: Mondadori, 1996), pp. 368–74.
3. Filippo Tommaso Marinetti and Alberto Viviani, *Firenze biondazzurra sposerebbe futurista morigerato*, ed. by Paolo Perrone Burali d'Arezzo (Palermo: Sellerio, 1992), p. 244.
4. See for instance, Charles Bernheimer, *Decadent Subjects: The Idea of Decadence in Art, Literature, Philosophy, and Culture of the Fin de Siècle in Europe*, ed. by T. Jefferson Kline and Naomi Schor (Baltimore, MD: Johns Hopkins University Press, 2002); *Degeneration: The Dark Side of Progress*, ed. by J. Edward Chamberlin and Sander L. Gilman (New York: Columbia University Press, 1985); Daniel Pick, *Faces of Degeneration: A European Disorder, c.1848–c.1918* (Cambridge: Cambridge University Press, 1989).
5. Rafael Huertas, 'Madness and Degeneration, II', in *Alcoholism and Degeneration*, ed. by C. M. Winston, *History of Psychiatry*, 4 (1993), 2–5.
6. For the temperance movement, see for instance Mark L. Schrad, *The Political Power of Bad Ideas: Networks, Institutions, and the Global Prohibition Wave* (New York and Oxford: Oxford University Press, 2010).
7. Marja Härmänmaa, *Un patriota che sfidò la decadenza. F. T. Marinetti e l'idea dell'uomo nuovo fascista, 1929–1944* (Helsinki: Academia Scientiarum Fennica, 2000).

8. Marinetti, *Come si seducono le donne* (Florence: Vallecchi, 2003), pp. 61–65.
9. According to Cinzia Sartini Blum, *Come si seducono le donne* was the first and the most successful of the Futurist texts in the genre of social-erotic literature that became very popular after the war. Cinzia Sartini Blum, *The Other Modernism. F. T. Marinetti's Futurist Fiction of Power* (Berkeley, Los Angeles, and London: University of California Press, 1996), p. 89.
10. According to Barbara Spackman, for Marinetti, virility is related to nationalism. See Barbara Spackman, *Fascist Virilities: Rhetoric, ideology, and Social Fantasy in Italy* (Minneapolis and London: University of Minnesota Press, 1996), pp. 1–16. It is worth remembering that George Mosse links nationalism and the idea of manliness to the bourgeois identity. George L. Mosse, *Nationalism and Sexuality: Respectability and Abnormal Sexuality in Modern Europe* (New York: Howard Fertig, 1985).
11. See also Spackman, *Fascist Virilities*, p. 7, *passim*.
12. 'Saint-Point, Valentine de', in *Futurismo & Futurismi*, ed. by Pontus Hulten (Milan: Bompiani, 1986), p. 569. About de Saint-Point and virility, see also Spackman, *Fascist Virilities*, pp. 37–40. For women and Futurism, see Valentina Mosco, *Donna e futurismo, fra virilismo e riscatto* (Florence: Centro editoriale toscano, 2009); Claudia Salaris, *Futurismo. L'avanguardia delle avanguardie* (Florence: Giunti, 2009) pp. 124–29; *Le futuriste. Donne e letteratura d'avanguardia in Italia (1909–1944)* (Milan: Edizioni delle donne, 1982); Cecilia Bello Minciacchi, *Scrittirce della prima avanguardia. Concezioni, caratteri e testimonianze del femminile nel futurismo* (Florence: Le Lettere, 2012); Silvia Contarini, *La femme futuriste. Mythes, modèles et représentations de la femme dans la théorie et la littérature futuristes* (Paris: Presses Universitaires de Paris 10, 2006).
13. For Marinetti's war rhetoric during the First World War, see especially Mario Isnenghi, *Il mito della grande guerra* (Bologna: Il Mulino, 1997); after that war, see Härmänmaa, *Un patriota che sfidò la decadenza*, pp. 202–35.
14. In *Come si seducono donne*, Marinetti writes: 'It is positive that real women are full of animality, and love danger and those who are familiar with it' (p. 61).
15. Here I am refering to the manifesto 'Uccidiamo il Chiaro di Luna' [Let's kill the moonlight, 1909], in Marinetti, *Teoria e invenzione futurista*, pp. 14–26.
16. See for instance Colin Rhodes, *Primitivism and Modern Art* (London: Thames and Hudson, 1994); Robert Goldwater, *Primitivism in Modern Art* (Cambridge, MA: Belknap Press, 1986). For the primitivism in Marinetti, see also Cinzia Sartini Blum, 'Incorporating the Exotic: From Futurist Excess to Postmodern Impasse', in *Africa in Italian Colonial Culture from Post-Unification to the Present*, ed. by Patrizia Palumbo (Berkeley, Los Angeles, and London: University of California Press, 2003), pp. 138–62.
17. The short story was first published in a collection entitled *Gli amori futuristi* (1922), and later in *Novelle colle labbra tinte* [*Novellas with Tainted Lips*] (Milan: Mondadori, 1930), pp. 375–93. The volume is a synthesis of Marinetti's two previous collections, *Gli amori futuristi* (1922) and *Scatole d'amore in conserva* [*Cans of Preserved Love*, 1927].
18. F. T. Marinetti, 'La simultaneità in letteratura', in *Novelle colle labbra tinte*, p. xviii.
19. Sartini Blum, *The Other Modernism*, p. 135.
20. Also, in these short stories Marinetti shows the usual hero-soldier who is given the mythical mission to guide others. Giusi Baldissone, *Filippo Tommaso Marinetti* (Milan: Mursia, 1986), pp. 143–44.
21. Marinetti, *Novelle con le labbra tinte*, p. 379.
22. Ibid., p. 380.
23. Ibid., p. 382.
24. See for instance, Claudia Salaris, *Dizionario del futurismo. Idee, provocazioni e parole d'ordine di una grande avanguardia* (Rome: Editori Riuniti, 1996), pp. 14–15.
25. See Härmänmaa, *Un patriota che sfidò la decadenza*, p. 256.
26. Filippo Tommaso Marinetti, *The Futurist Cookbook*, ed. by Lesley Chamberlain (San Francisco, CA: Bedford Arts, 1989), p. 21.
27. Lesley Chamberlain has called *The Futurist Cookbook* 'one of the best artistic jokes of the century' (Lesley Chamberlain, 'Introduction', in Marinetti, *The Futurist Cookbook*, p. 7). On Futurist cuisine, see also Enrico Cesaretti, 'Recipes for the Future: Traces of Past Utopias in The Futurist

Cookbook', Special Issue: *Future Imperfect — Italian Futurism between Tradition and Modernity*, ed. by Marja Härmänmaa and Pierpaolo Antonello, *The European Legacy*, 14, 7 (2009), pp. 841–56; Claudia Salaris, *Cibo Futurista. Dalla cucina nell'arte all'arte in cucina* (Rome: Stampa alternativa, 2000).

28. Marinetti, *The Futurist Cookbook*, pp. 110–11.
29. On Marinetti's nationalism and political futurism, see for instance Günter Berghaus, *Futurism and Politics: Between Anarchist Rebellion and Fascist Reaction, 1909–1944* (Providence and Oxford: Berghahn Books, 1996), pp. 59–73; Emilio Gentile, 'Il futurismo e la politica. Dal nazionalismo modernista al fascismo (1909–1920)', in *Futurismo, cultura e politica*, ed. by Renzo De Felice (Turin: Fondazione Giovanni Agnelli, 1988), pp. 105–59; Emilio Gentile, *The Struggle for Modernity: Nationalism, Futurism, and Fascism* (London: Praeger, 2003); Emilio Gentile, *'La nostra sfida alle stelle'. Futuristi in politica* (Rome and Bari: Laterza, 2009).
30. Marinetti, *The Futurist Cookbook*, p. 111.
31. The play is indeed rich in ideas, among them Marinetti's persistent interest towards the relationship between man and woman. According to Giusi Baldissone, however, the play is autobiographical. Kabango is a hero who has been fighting for the liberation of his people, but has been betrayed. He escapes with Sinrun, a fetish of the law. At the end of the play, the betrayed Kabango dies violently, but Simrun is safe. Baldissone considers this a parable of Marinetti's political defeat: the king dies, but his ideas survive (Baldissone, *Marinetti*, p. 202).
32. Filippo Tommaso Marinetti, 'Il tamburo di fuoco', in *Teatro*, ed. by Giovanni Calendoli, 3 vols (Rome: Vito Bianco editore, 1960), III, 46–47.
33. Filippo Tommaso Marinetti, 'Luci veloci', in *Teatro*, III, pp. 275–330.
34. Giovanni Calendoli, 'Introduzione', in Marinetti, *Teatro*, I, p. lxvi.
35. Marinetti, 'Luci veloci', p. 280.
36. Ibid., p. 312.
37. About the play, see also Sartini Blum, 'Incorporating the Exotic', pp. 138–62.
38. Marinetti, 'Luci veloci', p. 282.
39. Ibid., p. 294.
40. Ibid., p. 306.
41. Ibid., p. 282.
42. Ibid.
43. Ibid., p. 297.
44. Ibid.
45. The 'Lettera aperta dei futuristi italiani a Hitler' [Open letter of the Italian Futurists to Hitler] is conserved in Getty Center, Papers of F. T. Marinetti and Benedetta Cappa Marinetti, 1902–1965. Now in Härmänmaa, *Un patriota che sfidò la decadenza*, p. 267.
46. See for instance, Maria Sophia Quine, *Population Politics in Twentieth-Century Europe* (London and New York: Routledge, 1996). On eugenics in Italy, see Claudio Pogliano, 'Scienza e stirpe: eugenica in Italia (1912–1939)', *Passato e presente*, 5 (1984), 61–79.
47. See Emilio Gentile, 'Marinetti e la rivoluzione futurista per un disumanesimo anticristiano', in *Il Futurismo nelle avanguardie*, ed. by Walter Pedullà (Rome: Ponte Sisto, 2010), pp. 507–24.
48. Härmänmaa, *Un patriota che sfidò la decadenza*, pp. 114–43.
49. The term was often used by Arnaldo Ginna to explain the target of Futurist Naturism. See for instance Arnaldo Ginna, 'Coltivare la pianta umana', *Stile futurista*, 2.8–9 (1935), 36.
50. Arnaldo Ginna, 'Naturismo futurista', *Stile futurista*, 2 (1935), 6–7; Härmänmaa, *Un patriota che sfidò la decadenza*, p. 40 and passim.
51. Ibid., pp. 34–43.
52. Ibid., passim; Marja Härmänmaa, 'Futurism and Nature: The Death of the Great Pan?', in *Futurism and the Technological Imagination*, ed. by Günter Berghaus (Amsterdam: Rodopi, 2009), pp. 347–52.
53. Filippo Tommaso Marinetti and Arnaldo Ginna, 'Il naturismo futurista. Manifesto futurista 1934', *Stile futurista*, 1.4 (1934), pp. 11–12.
54. Cesare Meano, 'Colori e immagini del naturismo futurista', *Stile futurista*, 2 (1935), 13–14; 'La mostra del naturismo in Piemonte', *Stile futurista*, 2 (1935), 11–12 (p. 1) [s.a.]; Fillìa, 'Il naturismo

futurista e la mostra del futurismo in Piemonte', *Stile futurista*, 2 (1935), 13–14.
55. Salaris, *Marinetti. Arte e vita futurista*, p. 155.
56. After Marinetti's death, the publisher rejected the book, and it was published only in 1992, edited by Paolo Perrone Burali d'Arezzo. Perrone Burali d'Arezzo, 'Introduzione', in Marinetti and Viviani, *Firenze biondazzurra*, p. 15.
57. Marinetti and Viviani, *Firenze biondazzurra*, p. 244.
58. For instance, during the thirties Marinetti changed his ideas about the countryside, love, and Christian religion. See Härmänmaa, *Un patriota che sfidò la decadenza*, passim.
59. See in particular, the talk of Prof. Giovanni Dalmasso, *Viticoltura ed autarchia*, collana di quaderni agrari 23 (Torino: Società cultura propaganda agraria, 1940). About the history of wine-growing in Italy, see also Giuseppe Sicheri, *Storia della vite e del vino* (Vercelli: Enoteca regionale della Serra, 2001), pp. 55–84.
60. Dalmasso, *Viticoltura e autarchia*, p. 6.
61. See especially Terzano, *Futurismo*, pp. 146–64.
62. Guido Guglielmi, *Ironia e negazione* (Turin: Einaudi, 1974), p. 17.
63. Maurizio Calvesi in Terzano, *Futurismo*, p. 148.
64. During the thirties Futurist advertisement was developed. Fortunato Depero, one of the most important artists of advertisement wrote in 1931: 'Extolling with the genius our products and our businesses, that is to say the prime factors of our life, we only create true and pure modern art' (Fortunato Depero, 'Il futurismo e l'arte pubblicitaria', in *Numero Unico Futurista Campari 1931* (Florence: Studio per edizioni scelte, 1991), pp. 19–21. In 1939 Marinetti edited a special issue for the journal *Campo grafico* dedicated to Futurist advertisement. The issue contains the manifesto 'Pubblicità futurista' [Futurist advertisement], signed by Cesare Andreoni, and Marinetti's manifesto 'Rivoluzione futurista delle parole in libertà e tavole sinottiche di poesia pubblicitaria' [The Futurist revolution of words-in-freedom and the synoptic tables of advertising poetry]. See *Campo grafico*, 7 (1939), 3–5.
65. In addition to the Naturist movement, already in *The Futurist Cookbook* Marinetti had published a part of an article in which the author hoped the avant-garde artists would be involved in the promotion of Italian wines. See Marinetti, *The Futurist Cookbook*, p. 80. About Marinetti's promotion of Italian products, see Härmänmaa, *Un patriota che sfidò la decadenza*, pp. 255–59.
66. Although it seems that Viviani was an abstainer, too. Marinetti and Viviani, *Firenze biondazzurra*, p. 260.
67. Ibid., p. 294.
68. Ibid., p. 295.
69. Ibid., p. 105.
70. The term 'quisisana' is one of the Italianised terms, invented by Marinetti during the thirties, for 'linguistic' autarchy's sake, and literally it means 'here you get well'. About Marinetti's linguistic reform, see Härmänmaa, *Un patriota che sfidò la decadenza*, pp. 255–56.
71. Marinetti and Viviani, *Firenze biondazzurra*, p. 106.
72. Ibid.
73. Ibid., p. 107.
74. Ibid., p. 254.
75. Ibid., pp. 254–55.
76. Ibid., pp. 256–57.
77. Ibid., pp. 258–62.
78. For Marinetti's activity as a propagandist before and during the Second World War, see Matteo D'Ambrosio, 'La guerra nella letteratura futurista', in *Il Futurismo nelle avanguardie*, pp. 189–204.
79. Sicheri, *Storia della vite e del vino*, pp. 80–83. About the wine in the Italian literature, see also Pietro Gibellini, *Il calamaio di Dioniso. Il vino nella letteratura italiana moderna* (Milan: Garzanti, 2001).
80. Antonio Ivan Pini, 'Il vino nella civiltà italiana', in *Il vino nell'economia e nella società italiana medioevale e moderna. Convegno di Studi, Greve in Chianti, 21–24 maggio 1987* (Florence: Accademia economico-agraria dei Georgofili, 1988), pp. 7–12.
81. Sicheri, *Storia della vite e del vino*, p. 67.

82. 'E perché meno ammiri la parola | guarda il calor del sol che si fa vino, | giunto a l'omor che de la vite cola' (*Purgatorio*, XXV, 76–78). The new soul, breathed by God into the foetus, absorbs in itself the two preceding souls so that they cannot be distinguished, just as in wine it is impossible to distinguish the warmth of the Sun from the energy of the land absorbed by the vine; see Pini, 'Il vino nella civiltà italiana', p. 1.
83. Bruno Sanzin, 'Chianti Barbera Lambrusco', in *Canzoniere futurista amoroso guerriero*, by Marinetti, Farfa, Giovanni Acquaviva, and Aldo Giuntini (Savona: Edizione Istituto Grafico Brizio, 1943).
84. Acquaviva, 'Chicchi d'uva', in *Canzoniere futurista amoroso guerriero*.
85. The 22-page long typescript poem is located in the same folder together with a group of typescript and carbon poems by 'Gli aeropoeti Marinetti, Acquaviva, Farfa, e le aeropoetesse Anna Viva, Maria Goretti, Dina Cucini, Desiderio Rosa'. s.d., but one of the poems is dated 1 March 1944. On the basis of the references, Marinetti's poem must have been written after *Canzoniere futurista*. It is conserved in Filippo Tommaso Marinetti Papers. General Collection, Beinecke Rare Book and Manuscript Library, Box 33, folder 1526. Practically the same poem is published with the title 'Alla salute dell'Italia Immortale — Cantare sparare e non morire, di F. T. Marinetti e Giovanni Acquaviva', in *Manifesti futuristi savonesi*, ed. by Giovanni Farris (Savona: Sabatelli editore, 1981), pp. 48–53. The original version of the latter is conserved in the archives of the Acquaviva family, as the editor mentions on page 92. Also according to Farris, the poem was written after *Canzoniere*. See the note on p. 98. Presumably neither version was published while Marinetti was alive.
86. About Marinetti's writings before and during the Second World War, see D'Ambrosio, 'La guerra nella letteratura futurista'; Härmänmaa, *Un patriota che sfidò la decadenza*, pp. 202–35.
87. Marinetti, 'Poetare e tracannare', p. 1. On the typescript, see *supra*, note 85.
88. Ibid., p. 4.
89. Ibid., p. 2.
90. Ibid., p. 4.
91. For Erich Fromm and Marinetti's necrophilia, see Härmänmaa, *Un patriota che sfidò la decadenza*, p. 233; Terzano, *Futurismo*, pp. 25–50.
92. Marinetti, 'Poetare e tracannare', p. 4.
93. Ibid., p. 1.
94. Ibid., p. 4.
95. Ibid., p. 2.

CHAPTER 12

Seduction

Or, *Gli amori futuristi*: a Failed Attempt to Seduce Readers

Barbara Meazzi, Université de Nice Sophia Antipolis

According to Italian-language dictionaries, the term *seduzione* [seduction] invariably refers to the idea of amorous conquest (De Mauro-Paravia), of the capacity to attract (Treccani), and of the sexual possession of a woman or of a girl (Sabatini-Colletti) who is, in fact, the object of enticement. The man, it should be noted, is not so much the object, but rather the victim of seduction. If a woman dares to seduce a man and if this man succumbs, the implication is that the woman is a sort of sensual monster, as is illustrated by literary characters such as Giovanni Verga's Lupa, Frank Wedekind's Lulu, and Barbey d'Aurevilly's Vellini. The etymology of 'seduction' refers to betrayal, as 'to seduce' means to lead away from the right path, to separate, to distance from good and pull toward evil; seduction is hence an action that incites someone to commit a moral infraction.

In a previous study I have identified the techniques of seduction proposed by Futurism, which, it must be noted in passing, does not offer particular solutions or methodologies, apart from the general suggestion of a certain offhandedness and self-confident initiative.[1] Marinetti is the seducer *par excellence*, he is the Futurist *par excellence*, *ergo* the Futurist is a seducer *par excellence*. It is therefore unnecessary to provide specific information. This is particularly true for *Come si seducono le donne* [*How to Seduce Women*]: for those needing advice in this area it will suffice to draw inspiration from the exemplary life of the founder of Futurism. Even though Enif Robert, in a famous open letter addressed to Marinetti, protests and affirms that 'il verbo "sedurre" ha perduto da tempo ogni significato' [the verb 'to seduce' lost any meaning a long time ago][2] because 'real' (that is, Futurist) women 'hanno lasciato indietro nella vita l'ingombrante bagaglio di sentimentalità decadente' [have left behind in their lives the cumbersome burden of decadent sentimentality], it is evident that man — the Futurist man — is doomed to ride the wave of 'possesso vittorioso' [triumphant possession] — or at least to try to do so, following the example of the Master.

From the twenties on, however, Marinetti extended the meaning of what seduction could entail by not just targeting women but elaborating techniques of

seduction also in the field of literary communication. In fact, Marinetti transferred the idea of seduction to the realm of writing through his attempts to seduce new readers outside the intellectual sphere of the avant-garde by publishing short stories and romance novels with a Futurist setting. An example of this attempt to articulate seduction also as a literary concept is represented by the collection of short stories *Gli amori futuristi* [*Futurist Loves*], issued in 1922 by the publishing house Ghelfi.[3] The book, and the title in particular, was intended as a sort of lure for the reader: yet, in spite of Marinetti's intentions, and probably unwittingly, *Futurist Loves* offered male and female readers of the time not just a sentimental, escapist leisure reading, but tricked them into reading a text with rather transgressive structures closely tied to what could be expected from the literary avant-garde. This operation of literary seduction failed, since, as will be shown in this short essay, the structure of the text proved too daring for the broader audience Marinetti had in mind.

The volume, in truth, was presented as a veritable metatextual programme, not only because of its subtitle, 'programmi di vita con varianti a scelta' [life-programmes with choice of variants], but also because of the variants that appeared even in the paratext, since the publisher (or Marinetti?) decided to issue it with three different covers (see figs. 1–3). Assuming that these were not three volumes with different contents, the reason for this editorial decision was certainly to allow the reader to choose his or her preferred cover, in addition to the programme of variants offered by the book.

There is, however, a problem: one of the three covers, rather than proposing the above-mentioned subtitle, defines *Gli amori futuristi* as a 'romanzo' [novel]. Antiquarian booksellers call this cover an 'error', but it seems curious that Marinetti and his publisher would let such a glaring misprint escape them, unless it was to mislead — or, to be more precise: to seduce — readers, inducing them to purchase a volume passed off as sentimental literature, a genre as overwhelmingly popular then as it is now.

The book is not a novel at all, and it is not even a programmatic text except in the preface, where Marinetti explains his intentions regarding the endings of the readers' choosing. It contains fifteen short stories in which a homodiegetic narrator (who sometimes presents himself as Marinetti) generously dispenses to the readers advice and suggestions useful for amorous conquests. It should be noted that Marinetti, because of his relationship with Benedetta, needed to modify his own role as a literary figure: he no longer presents himself as a young and irresistible Casanova, but only as an expert in the field of romance.

At the time, the subject of seduction (or of non-seduction) did not cause a stir. Marinetti deals with the sentimental and sexual education of his male readers more than he deals with that of his female readers. Furthermore, the narrator essentially engages in a dialogue with male characters who act as intermediaries between the author and the reader, thereby suggesting that men are the intended audience of the volume. Moreover, the interlocutor of the majority of the stories is a man who is given a first and a last name. This implies a sort of personalisation of the stories, which in this way become more plausible.

FIGS. 1–3. The three different covers of *Gli amori futuristi* (Cremona: Ghelfi, 1922). Collection Libreria Pontremoli.

At this point, however, a problem arises regarding the target audience of the work, since the choice of title, *Gli amori futuristi*, proves to be erroneous. Moreover, the catalogue of the Italian bibliographic service contains around fourteen titles, published between 1920 and 1922, containing the nouns 'love' or 'loves', the vast majority of which are presumably to be ascribed to the genre of the romance. Now, finding himself in competition with so many books whose subject matter is at least apparently similar to his own, how could Marinetti hope to get the book noticed, even if Futurist love can boast a different intensity, passion, or extravagance? The discrepancy between content and audience, in addition to the choice of title, remains problematic and contradictory.

As for the contents, it has already been remarked that Marinetti does not propose anything truly new in *Gli amori futuristi*. Futurist love does not take an interest in seduction, as was already evident in *Come si seducono le donne*. Even the presentation of a rape scene in which the victim is on the whole consenting[4] does not contain anything new, except that now the protagonist is identified with and as the reader:

> Meccanicamente in una pausa, la bocca di Berthe parlerà stonata come un libro caduto dalla tasca d'un russante. Bocca estranea al vortice delle forze voluttuose, come distaccata dai seni baciati e dal ventre rimpinzato di piacere.
> — *Tu es une brute. Je ne veux pas. Tu ne me plais pas. Tu m'es antipathique! Je n'aime que lui, je n'aime que Gaston! Je te hais.*
> Questa voce esasperante romperà le dighe del tuo piacere e lei, sentendosi tutta inondare dalla cosmica liquida fecondità scoppierà in singhiozzi lacerantissimi, strazianti. Il suo spirito sentirà con orrore il suo corpo bere golosamente una probabile non voluta vita nuova.
> — *Non! Non! Non! Par pitié! Ah! Que je suis malheureuse!*
> Tu ti distacchi, ti rialzi, accendi la luce ti guardi allo specchio, non riconosci il tuo viso di pazzo contento e stralunato, poi torni alla tua vittima, le ravvii le vesti aperte sgualcite e commosso la supplichi di perdonarti. Tu insisti.
> — *Ne pleure pas, Berthe, cherie* [sic], *pardonne-moi. Ce n'est pas ma faute! J'ai perdu la tête! C'est ta beauté qui m'a rendu fou, fou, fou! Je ne suis pas une brute. Pardonne-moi. Je te supplie a* [sic] *genoux de me pardonner.*
> La domatrice muta si rialza e incomincia a pettinarsi la vasta capigliatura selvaggia che si lascia fare ormai docile contenta come una belva pasciuta.

> [Mechanically during a pause Berthe's mouth will speak out of tune like a book fallen out of the pocket of someone snoring. A mouth to which the whirlwind of voluptuous forces is unknown, as if detached from kissed breasts and the womb filled with pleasure.
> — *Tu es une brute. Je ne veux pas. Tu ne me plais pas. Tu m'es antipathique! Je n'aime que lui, je n'aime que Gaston! Je te hais.*
> This exasperating voice will breach the dams of your pleasure, while she, feeling herself flooded by cosmic liquid fertility, will burst into heartrending, excruciating sobbing. Full of horror your spirit will feel her body eagerly drinking in a likely unwanted new life.
> — *Non! Non! Non! Par pitié! Ah! Que je suis malheureuse!*
> You move away, get up, turn on the light, look at yourself in the mirror, you don't recognize your face of a happy and thunderstruck madman, then you go

back to your victim, you tidy up her open crumpled clothes and, moved, you plead to be forgiven. You insist.

— *Ne pleure pas, Berthe, cherie* [sic]*, pardonne-moi. Ce n'est pas ma faute! J'ai perdu la tête! C'est ta beauté qui m'a rendu fou, fou, fou! Je ne suis pas une brute. Pardonne-moi. Je te supplie a* [sic] *genoux de me pardonner . . .*

Silently, the female tamer gets up and starts combing her vast wild hair, which lets itself be taken care of now tame happy like a well-fed beast.][5]

And while Corra, for example, vaguely describes erotic scenes full of sighs and female ecstasies in his novels published around the same years,[6] Marinetti prefers to show the impetuousness of the male character who possesses a proud lion-taming woman, making himself in turn a tamer of women.

On the surface, Berthe, in Marinetti's short story, does not at all enjoy the first assault and appreciates even less the 'cosmica liquida fecondità' [cosmic liquid fertility] — an extraordinary euphemism — that has filled her womb, though without irreparable consequences: the danger of a 'probabile non voluta vita nuova' [likely unwanted new life] would seem to have been averted, given that a possible pregnancy would impede the carrying out of the two multiple-choice finales. In the first variation, in fact, the protagonist gets rid of the lion, too bothersome and too jealous of its owner; in the second variation, Berthe, the lion, and the man share the same bed without too many difficulties after each has found his or her own space. In particular, the lion will find his after devouring one of the man's calves: in closing, the narrator will ask the reader not to circulate that variation because stories with lions are too passéist.

Eight of the fifteen short stories contain more than one ending, while two stories, instead of multiple endings, offer the reader only some advice. In the case of the story 'Una notte bene impiegata' [A Night Well Spent], the narrator advises the insomniac reader to spend an evening at the home of Paola Bordoni, a beautiful, extravagant woman with unusual sexual preferences, in order to distract himself and overcome night-time boredom.

> Avrete modo, così, di passare delle serate intellettuali divertenti con recite di teatro sintetico futurista, parole in libertà, esperienze di tattilismo, esercitazioni extralogiche. Avrete anche molto spiritismo e delle notti a sorpresa.
>
> [You will thus have the chance to spend pleasant intellectual evenings with representations of Futurist synthetic theatre, Words-in-Freedom, experiences of tactilism, extra-logical exercises. You will also have a lot of spiritualism and nights with surprises.][7]

Paola Bordoni leads a complicated life, and the protagonist frequently finds himself in unpleasant and embarrassing situations, in particular because of the woman's son, who always appears at the least opportune moment, just when it seems like his mother intends to give in to the sensual flatteries of her ardent and always humiliated admirer.

It matters little if the man, whom the narrator addresses with a generic 'voi' [you], will succeed in his sexual conquest of the lady; what counts is above all 'concludere [. . .] una notte così bene impiegata, che fa da contrappeso, sulla bilancia delle forze, a ben tre miliardi di notti borghesi, male impiegate' [to achieve [. . .]

a night so well employed that, on the scales of forces, it provides a counter-weight to at least three billion poorly employed bourgeois nights].[8] After the allusions to Futurist synthesis, the sole variation appears in the finale:

> VARIANTE
> Volete impiegare bene la vostra notte? Fate una lunga passeggiata e prendete con voi a letto un libro di Romain Rolland.
> Nulla di più efficace contro l'insonnia.
>
> [VARIATION
> Would you like to make good use of your nights? Take a long stroll and take to bed with you a book by Romain Rolland.
> Nothing works better against insomnia.][9]

For Marinetti, Romain Rolland is a sort of exemplary whipping boy: a writer and intellectual constantly unpopular with the Futurists, his name appears every time that Marinetti wishes to facetiously indicate the antithesis of the Futurist artist.

The theme of amorous seduction — or rather of possession — is preponderant but not univocal. In 'La carne congelata' [Frozen Meat], it is a question of necrophilia. In another story, 'Rissa di bandiere' [Riot of Flags], Astori, the narrator's interlocutor, possesses a woman struck by a strange illness that condemns her to being unable to have sexual relations, and in doing so knowingly provokes her death. Other stories, such as 'La guancia' [The Cheek] and 'Il negro' [The Negro], are about sadist women attracted by cannibalism. Two short stories, furthermore, are openly erotic: 'La domatrice di leoni' [The Female Lion Tamer] and 'Fa troppo caldo' [It Is Too Hot].

If the themes of the stories, even in their gory obscenity, are quite predictable and presented in a somewhat banal fashion, what changes radically is the relationship that the author/narrator establishes with the reader — a relationship that goes beyond personalised involvement. In 'Fa troppo caldo', for example, the narrator does not present a list of final variants to the reader, but instead offers him a sort of catalogue of stories that he can compose in his own way. This move anticipates the structure of the collective volume *Il segretario galante* [*The Gallant Secretary*][10] in which, indeed, the authors offer their readers epistolary materials ready to be used in any circumstance of one's love life:

> Quale programma di vita vuoi? Vuoi un amore frenetico e felice? Ne ho di 23 qualità. Vuoi una scalata ambiziosa di montagne d'onori e di ricchezze? [. . .] Vuoi educare delle masse, civilizzare dei selvaggi, creare una aristocrazia intellettuale? [. . .] Ho a tua disposizione 300 scenari diversi, puoi scegliere fra i 465 tramonti di cui dispongo in questo momento.
>
> [Which life programme would you like? Would you like a frantic and happy love? I have 23 kinds of it. Would you like an ambitious climb of mountains of recognition and riches? [. . .] Would you like to educate the masses, civilize savages, create an intellectual aristocracy? [. . .] I can give you 300 different scenarios, you can choose among the 465 sunsets I have available right now.][11]

Therefore, not only does the reader find himself needing to choose the conclusion, but now it is even up to him to assemble the story, selecting the material on the basis of a hypothetical catalogue provided to him by the narrator. Only outlined here,

the idea of the reader composing his own writing starting from a handbook will be taken up and developed in *Il segretario galante*. Although it is perhaps only a *boutade*, the image of the reader constructing his own text from a well-stocked selection of samples is undoubtedly modern and audacious. Perhaps even too much so.

From a narratological point of view, the introduction of the variations in the endings is also quite transgressive, although it proves difficult for Marinetti to renounce fully his role as Futurist demiurge — after all, the game of variants does not appear in every short story. In all of the stories, however, the author-narrator has the role of a great adviser: it is he who orients the destinies of the characters and therefore of the readers, which is perfectly coherent with the anthropological revolution Marinetti imagines he is launching at the beginning of the twenties with *Al di là del comunismo* [*Beyond Communism*], hoping to turn Futurism into a social and political alternative to Fascism.

Although the scope of Marinetti's intentions was not quite this visible and recognizable, it is difficult not to see in them the libertarian attitude already practised in Fiume by figures like Guido Keller or Giovanni Comisso:

> — Viva la nudità! Abbasso i vestiti!
> Ti rivolgerai poi agli uomini deboli e terrai loro questo discorso persuasivo:
> — Se tutti i popoli vivessero nudi sarebbero finalmente abolite le lotte, i pugni, le coltellate. Nessuno osa affrontare, nudo, un coltello alzato. I vestiti sono gli ultimi scudi dell'Umanità. Aboliteli e abolirete ogni aggressione! [. . .] Nudi ci accoppieremo, naturalmente come si mangia, si beve e si dorme, senza febbre e senza complicazioni snervanti. Salute e moralità! Gridate con me: Abbasso i vestiti!
> Viva la nudità! Gridate anche voi o avari! Colla abolizione dei vestiti stringerete la più appagante economia!
>
> [— Hurrah for nakedness! Down with clothes!
> You will speak to weak men and you will pronounce this persuasive speech:
> — If all peoples lived naked fights, fisticuffs and knife-fights would finally be abolished. No one dares face a knife when naked. Clothes are the last shield of human beings. Abolish them, and you will abolish all aggression! [. . .] Naked, we will mate, as naturally as we eat, drink, and sleep, with no excitement or unnerving complications. Health and morality! Shout with me: Down with clothes! Hurrah for nakedness! You misers, shout with me! With the abolition of clothing you will obtain most gratifying savings!][12]

The introduction of the ending with variants represents an absolute innovation and entails, on the part of the author, the transfer of his rights to the reader, as well as the delaying of the end of stories, which, in fact, do not conclude. This is the case in the last tale, entitled 'Le notti di spazzavento' [The Nights of Windsweeping], which narrates the story of a free, independent, Futurist woman who lives alone in an isolated house. The woman must continually defend herself against assaults from thieves and police officers who try to gradually rob her of her possessions.

In the single final variant, the narrator invites the woman to place mines all over her garden in such a way that only a robust Futurist capable of avoiding the

exploding flowers will be able to reach her door. The two will then make love in the garden, amid a new type of mechanical flora, aware of the fact that the explosion that they will achieve might not be only of a sensual nature:

> Amanti graziosi, vi lascio. Poiché tutto, ora, dipende esclusivamente da voi e dal vostro ardore, che spero non vorrete vigliaccamente frenare.
> (Senza fine)
>
> [Pretty lovers, I take my leave. Because now everything is up to you and to your passion, which I hope you will not in cowardly fashion restrain.
> (Without ending)][13]

Forced to give up his prerogative, the author lets the characters determine their own future and allows the reader to appropriate the work: as already is the case in Futurist theatre,[14] the audience thus has the role of character thrust upon itself. The author's narratological audacity was great, and yet the audience, his specific audience, did not seem to appreciate the novelty.

In spite of everything, *Gli amori futuristi* went completely unnoticed: the attempt to seduce the readers failed, and popular success did not arrive. These carnal, carnivorous, and cannibalistic adventures — like that of Guzzo, the soldier who devours the head and feet of the women he loves so that they cannot think or flee[15] — left the public and critics of the time indifferent: the scarce number of reviews, gathered with great care by the Futurist head office and conserved in the Marinetti archives in the Beinecke Library, suggest that the volume received no attention from the public.

To equal the success of authors such as Guido da Verona, Giuseppe Zucca, or, later, Achille Campanile, Marinetti would most likely have had to exclude any theoretical pretensions, avant-garde techniques, and Futurist claims from his writing, and simply to adopt the style and structures used by authors of popular fiction. Until the beginning of the twenties, his novels had been a mix of Symbolism, Futurism, and patterns from popular fiction, but in the course of the twenties, Marinetti started to follow more closely the models of the successful popular literature of that period, precisely in an attempt to seduce a mass audience and to overcome the indifference that Futurist prose fiction had encountered until then. Yet, as a true intellectual of the avant-garde, Marinetti could not resign himself to write in an exclusively sensationalist-popular-erotic-sentimental manner, and he padded his novels with Futurist references and motifs. He was also the originator and co-author of the first and only novel of the twentieth century written by ten authors, *Lo Zar non è morto* [*The Tsar is not Dead*],[16] an extraordinary piece of fiction that combines adventure and romance but proved to be too daring and modern in structure. Indeed, its popular success was very limited and such an undertaking would not be repeated. In 1930, the stories contained in *Gli amori futuristi* would be reprised in *Novelle colle labbra tinte* [*Novellas with Tainted Lips*],[17] once again without arousing much interest (and this is an understatement). Marinetti's project of literary seduction of the audience at large through crossovers between sentimental fiction and Futurist techniques would thus remain only a pipe dream.

Translated by Kathleen Gaudet

Notes to Chapter 13

1. *L'arte futurista di piacere. Sintesi di tecniche di seduzione*, ed. by Barbara Meazzi (Cuneo: Nerosubianco, 2011).
2. Enif Robert, 'Come si seducono le donne. Lettera aperta a F.T. Marinetti', in Filippo Tommaso Marinetti, *Come si seducono le donne* (Florence: Vallecchi, 1917), pp. 113–15 (p. 114).
3. Filippo Tommaso Marinetti, *Gli amori futuristi* (Cremona: Ghelfi, 1922).
4. The subject of endured and (apparently) appreciated rape is not new within Futurism. Settimelli, for example, had already published a short story about a woman who, after being raped, falls in love with her rapist because, in the end, the suffered act did not at all displease her; see Emilio Settimelli, *Donna allo spiedo. Beffe bizzarrie avventure tutta la vena d'un fiorentino d'oltrarno* (Milan: 'Modernissima' Casa Editrice Italiana, 1921).
5. Marinetti, *Gli amori futuristi*, pp. 130–31.
6. See for example Bruno Corra, *Femmina bionda* (Milan: Sonzogno, 1921).
7. Marinetti, *Gli amori futuristi*, p. 87.
8. Ibid., p. 101.
9. Ibid., p. 102.
10. *Il novissimo segretario galante. 400 lettere d'amore per ogni evenienza* (Rome: Sapientia — Edizioni dei Dieci, 1928).
11. Marinetti, *Gli amori futuristi*, p. 153.
12. Ibid., pp. 159–61. Cf. Barbara Meazzi, ' "Pane, amore e rivoluzione": l'irrationnel au pouvoir entre 1919 et 1921', in *Irrationnel et création aux XIX et XX siècles*, ed. by Pascal Vacher (Dijon: Éditions de l'Université de Bourgogne, 2008), pp. 131–45.
13. Ibid., p. 238.
14. In the manifesto 'Il Teatro di Varietà' [The Variety Theatre, 1913], Marinetti imagines he will 'transform the variety theater into the theater of amazement, of record-setting, and of body-madness' and plans to introduce 'the element of surprise and the need for action among the audience in the stalls. Here are some random suggestions: spread a strong glue on some of the seats [. . .]; sell the same seat to ten different people)' ('The Variety Theater', in Filippo Tommaso Marinetti, *Critical Writings*, ed. by Günter Berghaus, trans. by Doug Thompson (New York: Farrar, Straus and Giroux, 2006), p. 190).
15. Marinetti, *Gli amori futuristi*, p. 114.
16. I Dieci, *Lo Zar non è morto* (Rome: Sapientia — Edizioni dei Dieci, 1929).
17. Filippo Tommaso Marinetti, *Novelle colle labbra tinte* (Milan: Mondadori, 1930).

CHAPTER 13

❖

Doubles

Simona Cigliana, Università di Roma La Sapienza

Throughout its history, Futurism displayed a striking and unparalleled openness to the theme of the double. From Luigi Russolo's *Autoritratto (con doppio eterico)* [*Self-Portrait (with Etheric Double)*], 1910, fig. 1) to Anton Giulio Bragaglia's photodynamism, from Boccioni's formulations[1] to Marinetti's theoretical statements,[2] from the novel to the theatre, the production of Futurism is marked by an inclination towards doubling and multiplication. In fact, illustrations of this inclination are so frequent that it can even be defined as a mode of thought that permeates much of the creative work of Marinetti and his associates, both at the imaginative and at the stylistic level, and that finds expression on the plane of content as well as, and above all, on that of form.

An element of dynamism and originality, the theme of the Double and its various applications nonetheless lose, in Futurism, much of their former uncanny power. In narrative and in theatre, doubling turns into a surreal and provocative game of 'intermingling of different times and environments', of 'the discoveries (however unrealistic, bizarre, and antithetical they might be) that our genius is creating in the subconscious, in the powers of the mind that are poorly defined, in pure abstractions, [. . .] in [. . .] physical whimsy [*fisicofollia*]'.[3]

This is perfectly coherent with its emergence in relation to other thematic axes on which Futurist poetics are founded, beginning with that of speed.[4] Exalted by Marinetti as an expression of a dynamism inherent in the life of the cosmos as early as in the founding manifesto,[5] speed is fundamental for an understanding of the peculiar Futurist vision of the world. It is recognized and glorified in all of its aspects, both when it manifests in a spectacular manner, on the macroscopic level, in the astonishing motion of the stars,[6] and when it acts invisibly on the subatomic level, moving the 'mass of swarming molecules' of matter or 'its swirling electrons'.[7] Over the years, it would continue to be unfailingly glorified as a force that operates in the physical world, animating matter with 'different determining impulses' of compression and expansion, of cohesion and disintegration,[8] and impressing upon its becoming a formidable impulse of evolutionary propulsion that occurs as much in nature as in human history, through dynamic instances that entail a violent and widespread fervour of competition and of struggle for survival.

If dynamism is, for Marinetti, a kind of vital force and entelechy that moves beings and things toward the future, velocity represents, in his eyes, the thrust

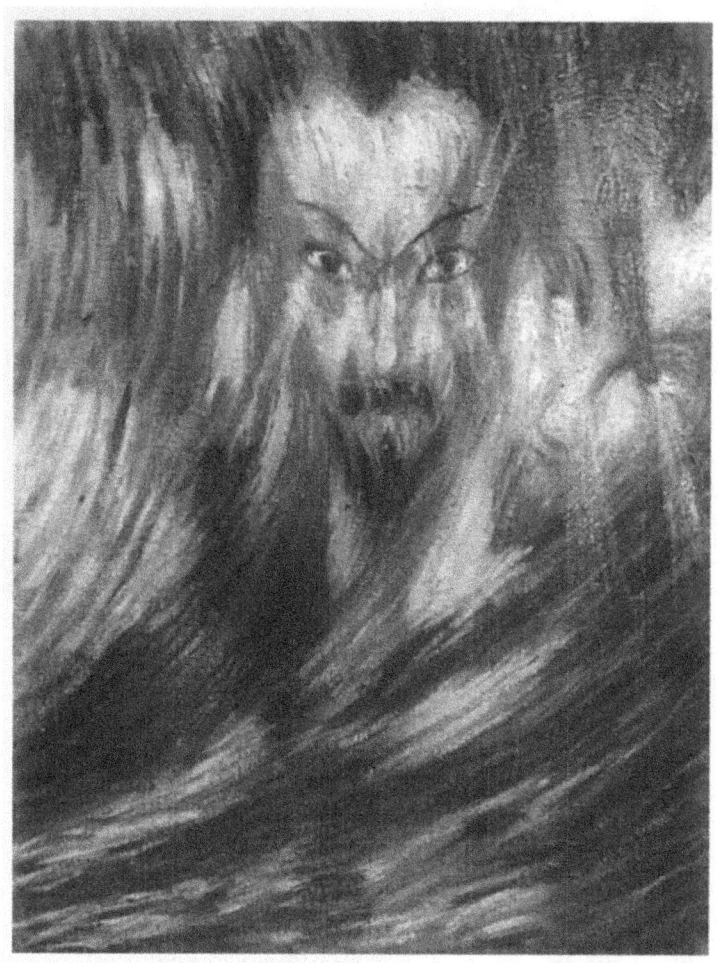

Fig. 1. Luigi Russolo, *Autoritratto (con doppio eterico)* (Self-Portrait [with Etherical Double]), 1910.

that speeds up the process through which the future becomes reality. Pursuing it means moving in sync with the universe, on the same wavelength. For this reason — and because he annihilates time and space in an eternal present[9] — Marinetti, also drawing upon Einsteinian reminiscences, would speak of the 'ethical religion [*religione-morale*] of speed' and affirm that velocity, the 'spiral ascension of the I toward the Nothingness-God', can be called 'divine'.[10]

Speed would therefore be presented to the followers of Futurism — and to the wider audience of sympathizers and non-sympathizers — as a virtue to be unfailingly performed: on the intellectual level, as a practice of intuition and of alogical and simultaneous hermeneutics; on the level of the imagination, in the synchronic contemplation of imagination and phenomena; on the level of artistic expression, as an exercise of synthesis; and on the level of aesthetic and formal choices.

Even the invention of *paroliberismo* or Words-in-Freedom, with its checklist of general principles and practical rules, was presented as a necessity of a cosmic and moral nature, responding to the double imperative of conforming artistic creation to the dictates of universal law and of adapting its expression to the style of 'intensified life' generated by modernity.[11] In fact, the discoveries of technological progress rendered relative and elastic the perception of space and time — dimensions that Marinetti, in light of the primacy attributed to intuition, considered as quite fluid. The telegraph and the telephone, the automobile and the aeroplane, the cinema and the daily press 'have a far-reaching effect on [man's] psyche':[12] on the one hand they accelerate his life, requiring of him a sort of omnipresence, a 'simultaneity'[13] of interactions; on the other they arouse the desire for a connection of intelligences, for an ubiquitous and global participation, not only physical but also mental and cognitive.

I have shown elsewhere[14] that already in 1913 Marinetti seemed to anticipate with disconcerting precision, and to see as a necessity, the advent of a connective network of intelligences, which could be realized thanks to the wonders of 'sublime electricity' and to the services of a new generation of technology: of 'triumphant machines, which keep the earth enclosed up in its net [*rete*] of speed'.[15] It is certain that, beginning with his first manifestos, he insistently underlines some phenomena that appear as symptoms of an anthropological mutation advancing in the direction of a dispersion of the I on multiple and simultaneous levels of experience.

It is precisely on this demand for a multiplication of perception — dictated, as was seen, by the double obligation of being modern and conforming to the life of the universe — that Marinetti founded the necessity to 'liberate words':[16] Words-in-Freedom would allow for 'multiplied sensitiveness',[17] ready to tune in to various cognitive and mental levels, to record and express the richness, sometimes chaotic and destabilizing, of multiple flows of information — 'vissute o ricordate, si badi' [lived or remembered, mind you], as Luciano De Maria shrewdly noted[18] — in a 'compenetrazione e simultaneità di tempo-spazio, lontano-vicino, esterno-interno, vissuto-sognato' [interpenetration and simultaneity of time-space, far-near, external-internal, lived-dreamt].[19]

The intensification of perception, the multidimensional proliferation of thought, the lyrical-imaginative, multidirectional expansion, and the aspiration for simulta-

neity all translate, in the practice of Words-in-Freedom, into a series of techniques such as multilinear lyricism, free expressive orthography, synoptic tables of lyrical values, psychic onomatopoeic arrangement, analogical-mnemonic-synesthetic synthesis, or synthesis-in-motion nouns.[20] Going beyond graphic experimentation, these techniques visibly transpose forms of multidimensional organization of thought onto the bi-dimensional page. Thus, *paroliberismo* in fact hypostatizes the tendency to cultivate 'multiple and simultaneous consciousnesses',[21] explicitly recommended to the poets and the artists of the movement precisely in the manifesto 'Distruzione della sintassi — Immaginazione senza fili — Parole in libertà' [Destruction of Syntax — Untrammelled Imagination — Words-in-Freedom, 1913].

Clearly, taken together, this entire group of techniques also conspires in the 'destruction of the I', which Marinetti advocated in the crucial point 11 of the 'Manifesto tecnico della letteratura futurista' [Technical Manifesto of Futurist Literature, 1912]. The 'reduction of the I' already begins here, not only by means of a different and divergent focalization of interest (from the observation of the self to the 'life of matter'[22]), but also and above all through a dislocation of the conscience that renounces consisting in a centre in order to 'disperse' in the 'universal flux [*vibrazione*]'.[23] The practice of 'dispersing' the self, for which Marinetti is indebted to the painters in the movement, also responds to the need to render the psychological effects of a life modernly lived in equilibrium 'upon the tightrope of speed, stretched between two opposite magnetic poles',[24] and to harmonize the creative act with the secret rhythm of the cosmos, 'the manifold, mysterious life of matter'.[25]

With the invention of *parole in libertà*, and already by 1912, the practice of simultaneity, in spite of its persistent materialist inclination, thus moves from the physical and material to the rarefied and metaphysical plane, intentionally conspiring in the direction of a weakening — even a demolition — of the boundaries of individual identity. Pushed by the universal motion of dynamic expansion, the Futurist I fragments, doubles, and multiplies, with considerable consequences on the level of literary experimentation. The so-called 'Free-Word Tables' (*tavole parolibere*), in fact, not only turn into visual simultaneity the 'natural' linearity of written language, conferring a surplus of concreteness and materiality on abstract concepts and sensations, but, above all, operate in the direction of the fragmentation of the authorial presence, which, stripped of adjectives, fashions its 'denied I' into a witness to its own 'scattering' and to the activity of multiple and parallel states of consciousness.[26] Nor is it any wonder that this absence also favours the emergence of removed realities, of other forms of consciousness, encouraging the evocation and/or the surfacing of pseudo-extrasensory personalities and of spectral phantoms. In the 'Technical Manifesto of Futurist Literature', Marinetti provides a significant metaphor of this centrifugal tendency of the I — experiential and psychological, more than literary — when he puts forward the image of an authorial I that, through art, 'pours forth from our bodies into the infinity of space and time'.[27]

In the creative texts that Marinetti produced in this period, along with the gradual theoretical fine-tuning of Words-in-Freedom, we also find several experiments

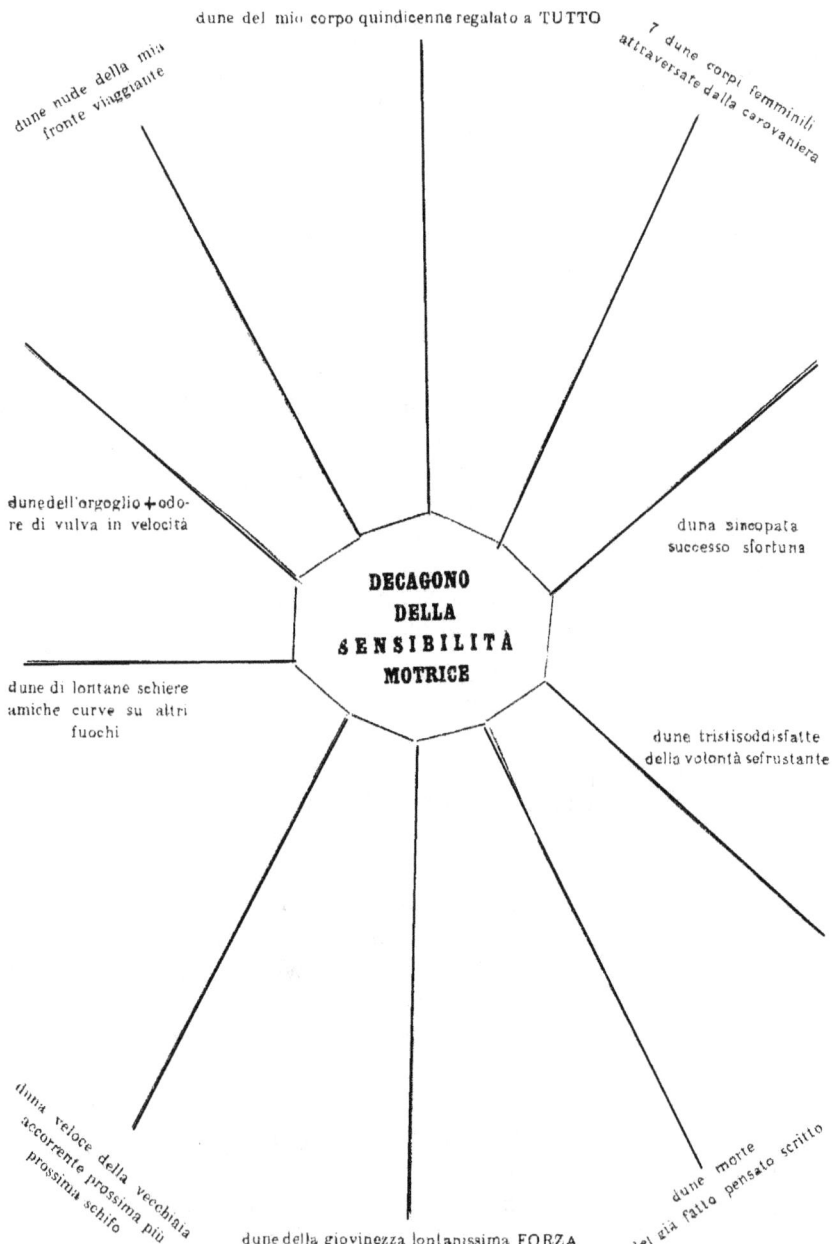

Fig. 2. Marinetti, *Decalogo della sensibilità motrice* (Decalogue of Motor Sensitivity), in *Dune*, 1914.

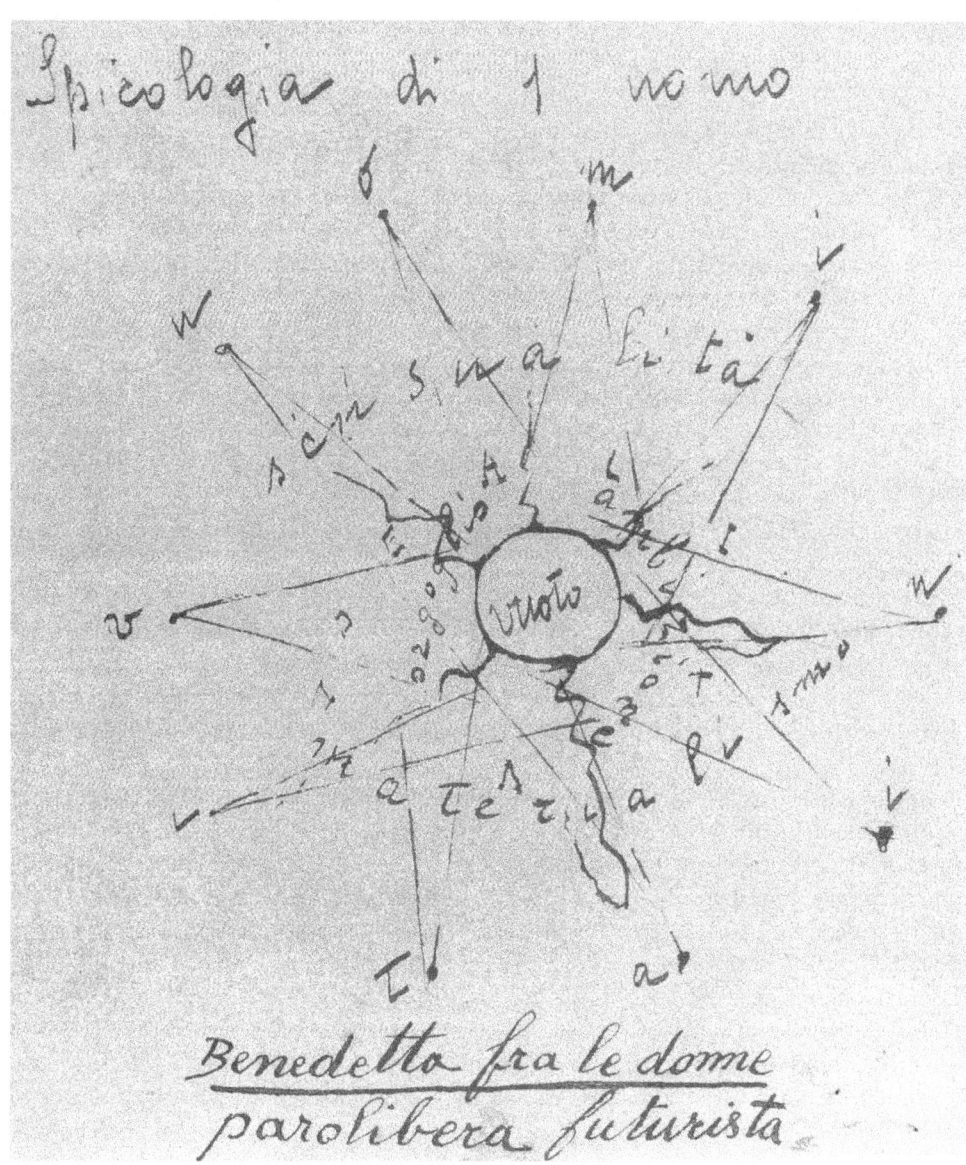

Fig. 3. Benedetta, *Spicologia di 1 uomo* (Spychology of 1 Man), 1919.

with rendering graphically this pouring forth of the I outside of itself. Among many, the one most significant to us seems the synoptic table 'Decalogo della sensibilità motrice' [Decalogue of Motor Sensibility, fig. 2], in the first pages of *Dune* [*Dunes*, 1914],[28] which reproduces a radiation of memories-sensations-experiences related to various moments of the biographical experience but completely dislocated from the space-time continuum. Other experiments are related to Marinetti's: for example, some tables by Carlo Carrà, such as *13 introspezioni* [*13 Introspections*, 1914] and *Rapporto di un nottambulo milanese* [*Report of a Milanese Night-Owl*, 1914], in which the warp of experience and thought, perceptions and subliminal memories expands radially on the white page as the result of a psychological dispersion. Benedetta's table 'Spicologia di 1 uomo' [Spicology of 1 Man, 1919, fig. 3] seems inspired by similar principles. Here, the radial projection of a Futurist I now 'vuoto' [empty] of subjectivity expands outside of itself like a star, between 'ideali' [ideals], 'sensualità', 'materialismo', 'orgoglio' [pride], and 'ambizione' towards 'uomini' [men] and 'vita' [life].[29] However, as in Marinetti's 'Decalogo', in Benedetta's table the prismatic radiation branches out from a centre that is still delimited and circumscribed (albeit now completely 'vuoto').

On the other hand, in the majority of the cases — from Marinetti to Paolo Buzzi, from Soffici to Govoni, from Severini to Carrà (who, not by chance, entitled his work 'mediumistic digressions') — Words-in-Freedom works lack a centre and show 'many different currents of [. . .] sense impressions'[30] that intersect or that diverge or that occur side by side on the basis of a 'many-sided emotional perspective'.[31]

In these works, the visual interlacing of the synesthetic analogies, of the abstract onomatopoeias, of the onomatopoeic agreements, aims to make significantly appreciable the objective reality of different states of mind, to produce graphically their equivalents as diversified and parallel streams of consciousness. The 'Carta sincrona dei suoni rumori colori immagini odori speranze voleri energie nostalgie' [Synchronous Chart of the Sounds Noises Colors Images Smells Hopes Wills Energies Nostalgias] of an aviator flying over Adrianople[32] seems to represent already a significant achievement in this direction. The tendency towards doubling, towards attention focalized on superimposed levels or streams of consciousness, will soon become an established procedure, culminating with the production of tables in which the bi- or tri- or pluri-partitioning of the page is visible testament to a corresponding psychic partitioning of the 'I' (like, for example, Marinetti's 'Manicure Faire les ongles à l'Italie' [Manicure Doing Italy's Nails]).[33]

But even among the Futurists, the theme of doubling and of the comparison of different facets of the self can become a thematic or, indeed, compositional suggestion. Consider for example, Marinetti's 'explosive novel' *8 anime in una bomba* [*8 Souls in One Bomb*, 1919],[34] whose protagonists are different components of the author's psychology. Unanimously anti-Austrian in sentiment, the eight souls nonetheless reveal themselves to be the bearers of completely contradictory demands: from the 'Lussuria' [Lust] of the fifth soul to the 'Purezza' [Purity] of the eighth, from the sentimental nostalgia of the sixth to the revolutionary genius of the

seventh. Far from wanting to compose the many changeable facets of his being into a singularity, Marinetti gives voice to a kaleidoscope of moods and to a whirligig of states of mind that proceed concurrently and even quarrel among themselves, in a crescendo of contrasts whose final result can only be the deflagration of the explosive mixture: an epilogue that is anything but tragic since, as Mino Delle Site noted, it implies a cheerful and narcissistic self-celebratory moral ('Io sono una bomba!' [I am a bomb!]).[35]

Here, as in general in all of the narrative and dramaturgical production of Futurism, the theme of the Double is used differently than in its numerous other nineteenth and twentieth-century examples. In all of the works that most obviously feature this theme — Edgar Allan Poe's 'William Wilson', Fyodor Dostoyevsky's *The Double*, Robert Louis Stevenson's *The Strange Case of Dr. Jekyll and Mr. Hyde*, Guy de Maupassant's 'Le Horla', and Oscar Wilde's *The Picture of Dorian Gray* — the appearance of the 'double' almost always responds, as Austrian psychoanalyst Otto Rank showed well,[36] to the need to represent a conflict within the protagonist, thus giving voice and shape to the opposing demands that threaten its psychological integrity. The confrontation/clash between two externalized aspects of the protagonist's personality — or between different planes of his psychic life — allows the contrast to unfold explicitly, with all the disturbing implications that the emergence of repressed tensions and desires entails, and with the tragic result that the irreconcilable conflict naturally brings with it. But for the Futurists, who aspire to nourish 'multiple and simultaneous consciousnesses in the same individual'[37] and for whom 'there is no longer any beauty except the struggle',[38] the doubling and the confrontation/opposition of two or more components of personality and levels of consciousness are instead almost always the starting point for surreal narrations and for amusing comedies devoid of dramatic implications.

This is the case even though the theme of the Double constitutes for many Futurists — and first of all for Marinetti himself — a recurring element of the authorial imagination and, in theatrical production, a frequent device to give dynamism to the action. Consider for instance Marinetti's synthetic theatre play *Donna + amici = fronte* [*Woman + Friends = Frontline*], 1917),[39] which engages the actor in a virtuoso performance to perform the doubling of the character in his two roles of rejected lover and of misogynistic and braggart *viveur*. This dramatic mechanism is taken up by the brothers Corra and Ginna in *Alternazione di carattere* [*Oscillation of Character*, 1915],[40] whose protagonists, wife and husband, are both one and double, and engage from time to time in ridiculous and cruel role play: first a husband in love, then a short-tempered and violent spouse; first a tender and passionate bride, then a querulous and aggressive wife. Among the most notable examples, centred on the fluctuations of a female personality whose limits are so transient that they change with every change of clothes, is the comedy *Nostra Dea* [*Our Dea*, 1925], in which Massimo Bontempelli, still in his avant-garde phase, elaborates in an original fashion the theme of the Double and other Futurist motifs. But the same writer had already used the theme of the double in his first novels *La vita intensa* [*Intense Life*] and *La vita operosa* [*Industrious Life*]. In both novels there is a splitting of the author into a narrator and a character. In *La vita operosa* the latter divided into an 'I' eager

to enter into the production circuit and a 'daimone', figure of a psychic instance faithful to the literary vocation and reluctant to the idea of getting a job. In the last pages the character merges again with the narrator, to consecrate the author as 'pure' intellectual, opposed to the logic of the capitalist bourgeois world.[41]

Other examples from Marinetti's theatrical production include the 'dramatic synthesis' *Elettricità sessuale* [*Sexual Electricity*, 1920],[42] which is completely built on the theme of the Double: a grotesque and unnatural double that by means of subtle, suggestive emanations takes the form of a menacing and specular presence; and the 'trisintesi' [trisynthesis] *Bianca e Rosso*,[43] staged by Bragaglia at the Teatro degli Indipendenti in 1923, an instance of redoubled doubling that, through the conflict of Sweet and Strong with their respective souls, articulates a reflection on desire and refusal in love. Here, as in *Elettricità sessuale*, the possible tragedy of the epilogue is thwarted by the lack of psychological investigation into the characters. The theme of the Double is also used artificially and even derided, in the case of *Bianca e Rosso*, by the ending with multiple-choice variants. Other syntheses by Marinetti worth mentioning are *L'arresto* [*The Detention*, 1916][44] and *Un chiaro di luna* [*Moonshine*, 1915],[45] where the doubling is, however, the product of a kind of astral materialization: in the first case of a psychic quality (the decaying traditionalism of the critic), and in the second of a combination of distressing feelings that emerge from the unconscious of the protagonists, who appear serene. Marinetti himself affirms in an explanatory 'Nota':

> l'Uomo panciuto non è un simbolo ma una sintesi alogica di molte sensazioni [psichiche]: paura della realtà futura, freddo e solitudine della notte, visione della vita 20 anni dopo, ecc
>
> [The potbellied Man is not a symbol, but an alogical synthesis of many [psychic] sensations: the fear of future reality, the cold and solitude of the night, the vision of life twenty years later, etc.][46]

The esoteric reference is even more explicit in the syntheses *Il corpo che sale* [*The Rising Body*, 1916], by Umberto Boccioni,[47] *Pesce d'aprile* [*April's Fool*, 1915], by Paolo Buzzi (where the spiritual 'double' of the dead consort returns in order to attempt to save her husband's soul);[48] or even in *Cura di luce* [*The Light Cure*, 1917], where Marinetti staged, among others, two characters named *Volontà* [*Will*] and *Corpo erotico* [*Erotic Body*],[49] and in which the second must be 'enlightened' and healed so that 'Volontà', freed from overly pressing material influences, can better deploy its action. The very Futurist content of the message should not obscure the fact that the protagonists of the play appear to have been directly derived from a book of theosophy, possibly, for example, *The Astral Plane* by Charles Leadbeater,[50] an author widely translated in Italy beginning in 1905 and well known to all those interested in psychic research at the time. Pirandello explicitly cited him in *Il fu Mattia Pascal* [*The Late Mattia Pascal*, 1904] and in the short story 'Personaggi' [*Characters*, 1906],[51] and he was studied in those years by Corra, Ginna,[52] and many other Futurists in whose works there are clear references to images and concepts popularized by the theosophical literature of the period.

Leandro Scoto, the protagonist of 'Personaggi', paraphrases Leadbeater in

explaining how everyone can generate a double from his or her own psyche:

> allorché lo spirito umano esprime positivamente un pensiero o un desiderio ben netto [. . .] il pensiero assume essenza plastica, si tuffa per così dire in essa, vi si modella istantaneamente sotto forma di essere vivente che [. . .] appena formato, non è più per nulla sotto il controllo del suo creatore, ma gode d'una vita propria, la cui durata è relativa all'intensità del pensiero e del desiderio che l'hanno generato.
>
> [when the human spirit positively expresses a very clear thought or desire [. . .] thought assumes a plastic essence, it plunges into it, so to speak, it instantaneously shapes itself in the form of a living being that [. . .], just formed, is no longer under the control of its creator, but enjoys a life of its own, whose duration is relative to the intensity of the thought and the desire that generated it].[53]

In the first edition of *Il fu Mattia Pascal*, published in *Nuova Antologia*, one can also read:

> Per fortuna, i pensieri della maggior parte degli uomini son così vaghi e indeterminati, che gli esseri che ne risultan han labilissima vita e momentanea: bolle di sapone. Ma un pensiero che spesso si riproduca e un desiderio vivo e costante formano un essere che può vivere parecchi giorni. E poiché naturalmente i nostri pensieri e i nostri desideri spessissimo son per noi stessi, avviene che attorno a noi dimorino tanti di questi esseri, che tendono a provocar di continuo la ripetizione dell'idea, del desiderio ch'essi rappresentano, per attinger forza e accrescimento di vita. Chi dunque insista e batta costantemente su un desiderio, viene a crearsi come un camerata invisibile, legato a lui dal proprio pensiero.
>
> [Luckily, the thoughts of most men are so vague and indeterminate that the beings that result from them have a very fleeting and momentary life: soap bubbles. But an often-repeated thought and an ardent and constant desire form a being that can live for several days. And because naturally our thoughts and our desires are very often for ourselves, it happens that around us dwell many of these beings, which tend to continually provoke the repetition of the idea, of the desire that they represent, in order to draw strength and longer life. Thus, those who insist and harp constantly on a desire come to create for themselves an invisible comrade, bound to them by their own thought.][54]

The sources of Pirandello, an authoritative and highly respected author for the Futurists,[55] included Alfred Binet's important treatise *Les altérations de la personnalité* [*The Alterations of Personality*, 1892],[56] extensively discussed by the Sicilian writer at the beginning of the essay *Arte e scienza* [*Art and Science*],[57] which appeared in 1908 in a volume of theoretical writings. At the time of its publication, Binet's treatise, which continued the research of the Parisian school of neuropsychopathology, intervened in the heated turn-of-the-century debate on the reality of the latent powers of the mind and on the nature and origin of the so-called 'metapsychic' phenomena, as described in the popular definition provided by Charles Richet, a doctor and physiologist known to and cited by Pirandello.[58] Apparitions of ghosts, materialisations, glossolalia, telepathy, hallucinations, and premonitions had long been the subject of intense investigation in clinical studies of hysteria, spontaneous and provoked sleepwalking, magnetic and spiritualistic trances, and all those altered

states of consciousness in which — by virtue of a centuries-old and never-refuted tradition that considers a genius to be in the grip of a supernatural enthusiasm — artistic creation was also included.[59]

In these studies at the border between science, philosophy, and parapsychology, much attention was reserved for the ideoplastic powers that some particularly gifted individuals, in a trance or altered state of consciousness, seemed to manifest: the capacity of doubling, of projecting and materialising in the surrounding space the larval ghosts of their imagination. For example, the studies of Albert De Rochas[60] and of Paul Janet,[61] well known at the time, went in that direction, as did those of linguists such as Ferdinand de Saussure.[62] The reality, origin, and extent of psychic faculties had long been the object of a positivist investigation: through this research, experimental psychology, while moving within very uncertain epistemological boundaries, had slowly shed the first unsettling light on the mysteries of personality and on the profound implications of the unconscious.

In his exaltation of unconscious activity as the creator of figures that live in reality, on their own, Pirandello, in *Arte e scienza*, had in fact hinted at that process of the emancipation of the characters that he had already developed narratively in the aforementioned short story 'Personaggi'. But just as in that case he had made use of Leadbeater's book, here, in theoretical terms via the citation of Binet, he relates the phenomenon of artistic creation — that is the creation of 'personalities' — to an altered state of consciousness, similar to the one that would produce spiritual manifestations,[63] understood by some as the effects of the 'externalisation' of personalities that had doubled and emancipated themselves from the conscious personality of the medium.

It is important to emphasise that recourse to the theosophical imagination offered Pirandello — and the Futurists, whether believers in parapsychological phenomena or not — a unique opportunity for a fantastic breakthrough from within the naturalistic *episteme* itself, and that the hypotheses postulated by metaphysics appeared not only as the hypothetical 'opposite' of an overly deterministic world vision, but also as future-oriented scenarios the protagonist of which becomes a human being made immense, who acts outside the laws of logic, space, and time on a plane of absolute simultaneity of action. This fantastic hypothesis has been discussed on various occasions by Giovanni Papini in the years 1906–07 in the magazine *Leonardo*.

That Pirandello reflected on these themes sceptically and as an 'ironist' seems well established. As for Marinetti's beliefs, they may be clarified by a passage from his *Taccuini* in which he affirms, in consonance with the above-cited passage from *Il fu Mattia Pascal*:

> Scopro per intuizione che tutte le ondate di sensibilità vissute da noi non possono spegnersi e morire subito. Certamente si staccano da noi totalmente o in parte e rimangono, più o meno legate a noi, intorno a noi. Formano l'alone della nostra vita, come una speciale massa gazosa segue un astro. [. . .] Gli uomini che hanno una vita intensa sono avviluppati da una infinità di sensibilità proprie. Gli uomini che vivono poco sono insidiati dalle sensibilità erranti degli uomini d'azione. Queste sensibilità irritate dall'impossibilità di

penetrare il loro generatore si staccano da lui e vagano cercando di penetrare nei varchi aperti da altri esseri vivi. Obbediscono così alla legge che li governa: agganciarsi su un nucleo di intensità e fasciarlo fino alla soffocazione. Così avviene che molti esseri vivi sono in pericolo per le sensibilità erranti che li assediano. I filosofi come Bergson non hanno mai intuito questa esistenza fuori di noi intorno a noi delle sensibilità-sensualità quasi materiali erranti, perché non vivono intensamente passionalmente la vita.

[I intuitively discover that all of the waves of feeling experienced by us cannot extinguish and die right away. Certainly they totally or in part break away from us and remain more or less bound to us, around us. They form the halo of our lives, as a special gaseous mass follows a star [. . .]. Men who have an intense life are enveloped by an infinity of their own perceptions. Men who live little are harassed by the errant sensitivities of men of action. These sensitivities, irritated by the impossibility of penetrating their generator, detach themselves from him and wander, trying to penetrate the gaps opened by other living beings. In this way, they obey the law that governs them: hook into a nucleus of intensity and bind it until it suffocates. Many living beings are thus endangered by the errant sensitivities that besiege them. Philosophers like Bergson have never intuited the existence outside of ourselves around us of sensitivity-sensuality that is almost errant material, because they do not live life intensely and passionately.][64]

In another slightly later diary note, Marinetti calls these wandering psychic contents 'effluvi animici' [animistic effluvia], describing them, with the language of an occultist, as 'immagini-forze [. . .] che vengono dalle altre coscenze [sic]' [image-forces [. . .] that come from other consciences], and 'tentano di invadere la nostra' [attempt to invade ours].[65]

In light of these observations, it is reasonable to wonder what beliefs or readings underlie the invention of Gazurmah, the son of Mafarka: a golem created without the involvement of a woman and generated by his father's willpower, which is transfused into him and lives in him, as in a younger and more powerful double. It is natural to ask whether the ability to externalise the force of will, to make it 'sprizzare dai [. . .] centri nervosi' [spurt from [. . .] the nerve centres] and push it out of itself 'come una forza soprannaturale' [like a supernatural force], like a strong-willed double endowed with acting force, is only the product of narrative hyperbole of a fantastic nature and not also of an unspoken belief of the Author.[66]

In a passage from his unfinished and unpublished novel *L'ottimismo artificiale* [*Artificial Optimism*], whose protagonists are, among others, Giacomo Balla, Eva Kuhn Amendola, and himself, Marinetti imagines that the psychic predisposition of the characters manifests before him in the form of doubles that are superimposed on reality, like the materialisations of 'sensibilità errante' [errant sensitivity].[67] In fact, the two friends with whom he keeps company

sono in piedi [ma] l'anima loro è distesa. [. . .] Lucia e Laura sono coricate pudicamente, ma ognuna porta in sé e sopra di sé una altra Lucia e una altra Laura trasparente molle elastica un po' viscida (di gomma resina o di gelatina viva). [. . .] Io sono seduto ma sono coperto da un altro Marinetti coricato stanco distratto gambe strette come una ragazza pudica vicino a un vecchio lascivo.

[are standing, [but] their souls are lying [. . .] Lucia and Laura are lying down modestly, but each bears in herself and over herself another Lucia and another Laura, transparent, soft, elastic, a bit slimy (made of rubber of or live gelatine). [. . .] I am seated, but I am covered by another Marinetti who is lying down tired distracted legs tight like a prudish girl near a lecherous old man.][68]

It is a case of doubling and materialisation of perception, Marinetti would say — of the projection of a repressed desire, we might say now — akin to the one suffered by the characters of Pino Masnata's 'teatro visionico' [visionic theatre] called *Anime sceneggiate* [*Dramatized Souls*],[69] who double themselves and multiply in order to bring to the stage 'incarnati, parlanti e dialoganti, i pensieri, i calcoli, i desideri, le immagini' [in body, speech and dialogue, the thoughts, the calculations, the desires, the images][70] that compose the mosaic of their secret life.

'Di una cosa ho certezza: nessun essere è chiuso dai limiti del corpo. Il mistero del subcosciente invade la vita e la sommerge. Afferriamo soltanto alcune creste delle sue onde in tempesta' [Of one thing I am sure: no being is closed by the limits of the body. The mystery of the subconscious invades life and submerges it. We seize only some crests of its waves in a storm], the female protagonist of Benedetta's novel *Astra e il sottomarino* [*Astra and the Submarine*, 1935] says in her first conversation with the captain Emilio Vidali, which is as fortuitous as it is passionate: 'La scienza le dà ragione' [Science proves you right], he answers:

> 'Da qualche anno i biologi misurano i raggi che emanerebbero dall'organismo umano e non sarebbero che elettricità. [. . .] La nostra sensibilità è ancora molto rozza. [. . .] Le vite dei combattenti uccisi, non consumate lentamente ma esplose gravitano senza dubbio con un rigurgito di forze intorno a noi, comunicandoci il loro spasimo di cosa incompiuta insoddisfatta.'
>
> [For several years, biologists have been measuring the rays that supposedly emanate from the human organism and are nothing but electricity. [. . .] Our awareness is still very crude. [. . .] The lives of killed combatants, which are not slowly consumed but have exploded, undoubtedly gravitate around us with a surge of forces, communicating to us the agony of an unfinished, unsatisfied thing.][71]

Astra responds: 'Sono convinta che ogni minuto, sia esso illusione sonno desiderio è vero [. . .] Dichiariamo che i sogni sono illusione perché lo stato di veglia è più lungo: subiamo così la legge di quantità' [I am convinced that every minute, be it illusion, sleep, desire, is true. [. . .] We proclaim that dreams are illusion because the state of wakefulness is longer: in this way, we are victims of the law of quantity.][72]

The limitations to which the majority of mortals are subjected, however, do not affect Astra and her lover. Physically separated, the two will continue to live their relationship intensely on a different, dreamlike level: in fact, it is precisely through dreams that their love, lived at a distance, grows, matures, and reaches a sad ending. For Astra, dreams are different moments of real life, in which one experiences in an unusual manner encounters and feelings, in a kind of doubling that sees 'il sub-cosciente' [the subconscious][73] prevail over waking consciousness. In sleep we are allowed to experience 'che i contorni sicuri della realtà sono a volte più insignificanti e vuoti dei sogni' [that the certain contours of reality are

sometimes more meaningless and empty than dreams]⁷⁴ — but from Astra's point of view it is also possible to interfere with reality, concretely influencing events. Benedetta's 'romanzo di vita trasognata' [novel of dreamy life] proceeds amid premonitions, visions, and telepathy that flow between one double and another: between the awakened spirit of the sleeping Astra and the alert awareness of the sleeping Emilio.

Forces from the deep that awaken and attempt to come out into the open, states of lucid sleep and somnambulist ecstasies lead to experiences of escape from the body in many texts by the Florentine Futurists, whose works are heavily peppered with 'other' states and astral travel. We find many traces of this in the writings of Primo Conti, who was persuaded that 'esistono nella vita certe momentanee demenze involontarie [. . .], demenze come simboli di una totalità di scoperte di cui rimane in loro la sostanza essenziale' [certain momentary, involuntary moments of madness exist in life [. . .] moments of madness that are symbols of a totality of discoveries of which they preserve the essential substance].⁷⁵ 'Credevo di essere prossimo a un'evaporazione' [I thought I was near evaporation], he writes, 'come se questo senso che s'era impadronito del mio spirito fosse quasi il prolungamento di un ambiente pallido e fatale e che in esso si dovesse riassorbire, volatilizzandomi così, senza dolore . . .' [as if this sense that had taken control of my spirit was almost the extension of a pallid and fatal environment in which it should be reabsorbed, thus making me vanish, without pain . . .].⁷⁶ 'Seguendo questa spirale di fumo che sale dalla mia sigaretta il mio corpo ha una vertigine strana, quasi volesse aderire a quelle movenze incorporee' [Following this spiral of smoke that rises from my cigarette, my body feels a strange vertigo, as if it wanted to join those incorporeal movements].⁷⁷

Even Palazzeschi's character Perelà is made of that same volatile and thin substance. The author allows for the possibility that his 'man of smoke' is the 'double' of a man who is 'lentissimamente carbonizzato' [very slowly carbonised], as in an alchemical process, in a 'utero nero' [black uterus] similar to an athanor, and 'trasformato nel lungo volgere degli anni, fino a rimanere di compattissimo fumo' [transformed as the long years go by, until he is made of very compact smoke], in the 'più accurata purificazione che il fuoco abbia mai compiuto sopra la carne' [most accurate purification that fire has ever carried out on flesh].⁷⁸

Arnaldo Ginna also alludes to experiences of doubling of the Self. We find him repeatedly in conversation with 'Arnaldaz',⁷⁹ a 'spiritello nascosto tra le pieghe della [sua] anima' [small spirit hidden in the folds of [his] soul].⁸⁰ Ginna writes:

> Io riconosco in Arnaldaz un potere misteriosamente occulto che sfugge all'analisi psicologica e alla matematica delle scienze esatte. [. . .] Questo Arnaldaz, che io vado conoscendo più intimamente ogni giorno, somiglia molto allo 'Spirito tutelare' e all'Angelo custode che fanno parte delle credenze religiose di ogni tempo, e della Teosofia, e delle scienze occulte.
>
> [I recognise in Arnaldaz a mysterious occult power that defies psychological analysis and the mathematics of exact science [. . .] This Arnaldaz, whom I recognise more intimately each day, seems very much like the 'protector Spirit' and like the 'guardian Angel' that are part of the religious beliefs of all times, as well as of Theosophy, and of the occult sciences.]⁸¹

> Ho creduto che oggi fosse una bella giornata perché era tutta piena di sole e di tepore. [. . .] Ma invece la mia anima dava segni di irrequietezza; era come un cavallo impaurito da strani rumori, la mia Anima, con le radici protese ed infossate nell'aldilà del corpo viveva un'altra vita, tutta sua. Infatti tutto cambiò anche nell'esteriore perché la marea montante delle forze ipersensibili si faceva sentire dai sensi. Erano stilettate, erano colpi tremendi su di me, sul mio corpo mortale.
>
> [I thought that today was a beautiful day because it was full of sunshine and warmth. [. . .] But instead my soul showed signs of restlessness. It was like a horse frightened by strange noises, my Soul; with its roots stretched and sunken in the afterlife of the body, it was living another life, one all its own. In fact, everything changed externally because my senses were affected by the rising tide of hypersensitive forces. They were knife wounds, they were tremendous blows to me, to my mortal body.][82]

The experience on which is founded Spiridigliozzi's novel *S. Francesco in aeroplano* [*St. Francis on an Airplane*, 1934], a long post-mortem cavalcade across human events observed from an immaterial perspective, is also completely outside of the body:

> Giacevo, fermo, immobile, con il viso cereo [. . .] Allora mi affrettai ad esaminare il mio secondo me stesso, ma non mi trovai. Mi sentivo solamente, ma non esistevo in materia. [. . .] Poter assistere nella mia forma ultraterrena, al film di quella vita che non avevo saputo vivere, m'incuriosì e mi trattenne ancora lontano dal mio nuovo ed incognito mondo.
>
> [I lay, still, motionless, my face ashen [. . .] Then I hurried to examine my second self, but I didn't find myself. I only felt myself, but I did not exist materially. [. . .] Being able to view, in my otherworldly form, the film of that life that I had not known how to live made me curious and held me back from my new and unknown world.][83]

Bruno Corra, for his part, states:

> Non ho conosciuto mai una manifestazione di vita che sfugga alla logica. Unica via d'uscita aprirsi una strada verso altre vite, verso il soprannaturale. Ed io cerco uno spiraglio verso l'ultranaturale.
>
> [I have never known a manifestation of life that escapes logic. The only way out is to open a road for oneself to other lives, towards the supernatural. And I look for a glimmer towards the ultranatural.][84]
>
> Esistono raffinamenti spirituali che si svolgono in arabeschi inafferrabili entro sfere di un nulla completamente estraneo a tutto ciò che è materiale . . . e io intuisco in queste sfuggevoli meraviglie una vibrazione di germogli irreali che maturano una potenza di liberazione totale.
>
> [There exist spiritual refinements that take place in elusive arabesques within spheres of a nothingness that is completely foreign to everything that is material . . . and I intuit in these elusive wonders a vibration of unreal sprouts that ripen a power of total liberation.][85]
>
> ho fissato un attimo una stella, ed è bastato questo perché mi sentissi di colpo completamente estraneo a ogni cosa terrestre. Il cielo mi ha afferrato come un vortice. Ho sentito il mio corpo sgretolarsi, in cadute successive di ingranaggi di

> forze e di astri. [. . .] Il mio corpo, divenuto una nuvola d'atomi gonfia d'anima, vagava per l'universo [. . .] queste forze onnipotenti, deviate, reagivano su di me, disgregandomi e ricomponendomi, transumanandomi, rivelandomi lembi di vite nuove, scorci di spazî ignoti, abissi, vuoto.[86]

> [I stared for a moment at a star, and this was enough to make me feel, all of a sudden, completely alien to all terrestrial things. The sky grabbed me like a whirlwind. I felt my body crumble in successive cascades of gears of forces and stars. [. . .] My body, which had become a cloud of atoms swollen with soul, wandered through the universe [. . .] the omnipotent forces, corrupted, acted upon me, breaking me apart and putting me back together, transhumanising me, revealing to me strips of new lives, glimpses of unknown spaces, abysses, nothingness.]

Spiritual refinements and intermittencies of consciousness are not foreign to Maria Ginanni either:

> Mi sono sollevata esilmente nell'aria fino al limite massimo dell'atmosfera. L'ultimo strato di essa sfiorava tangenzialmente il mio capo. Avrei potuto sporgermi nel vuoto [. . .] ho preferito far capolino nell'Universo con la più ironica fragilità; sporgere il mio piccolo indice immergendolo e agitandolo nell'etere, con una smorfia sul naso di tutti i Segreti. E intanto ho dato al mondo il più minuscolo gambo possibile.

> [I feebly raised myself in the air up to the limit of the atmosphere. Its last layer tangentially touched my head. I could have protruded into the void [. . .]. I decided to peep into the Universe with the most ironic fragility; stick out my little index finger, dipping it and shaking it in the ether, with a grimace on the nose of all of the Secrets. And in the meantime I gave the world the most minuscule stem possible.][87]

Often, as Bruno Corra experiences, creative inspiration borders on trance and risks nullifying the I to make way for a foreign entity:

> Sarò completamente sincero, cioè non penserò: chiuderò la porta al mio spirito e dirò alla mia penna: Adopera come vuoi il tuo inchiostro e la mia mano. Chi non ha provato [. . .] l'illusione del sentire la penna destarsi a una vita più forte della propria e correre per il foglio bizzarramente, trascinando il pugno? [. . .] Oggi farò così: darò la mia penna in mano all'atmosfera stramba del mio studio: sarà una cosa quasi spiritica.

> [I will be completely sincere, that is, I will not think: I will close the door to my spirit and I will say to my pen: Use your ink and my hand as you wish. Who has not experienced [. . .] the illusion of feeling the pen awaken to a stronger life than one's own and bizarrely rush across the page, dragging one's fist? [. . .] Today I will do this: I will put my pen in the hand of the odd atmosphere in my study: it will be an almost spiritualist thing.][88]

Marinetti knew this phenomenon well and, in already in 1912, in 'Risposte alle obiezioni' [Answers to Objections, 1912] he observed that:

> After several hours of dogged, exhausting labor, the creative spirit is suddenly free of the burden of all obstacles and, in one way or another, becomes prey to a strange spontaneity of conception and execution. The hand that writes seems detached from the body and continues for a long time freed from the

> brain, which also, somehow detached from the body, having taken flight looks down from on high, with an awesome clarity of vision, upon the unexpected expression coming from the pen.[89]

We thus return to Binet's and Pirandello's hypotheses on artistic creation as a process of doubling similar to extrasensory trance.

Yet, one of the most notable texts centred on the theme of the Double is undoubtedly the 'Futurist novel' *Una donna con tre anime* [*A Woman with Three Souls*, 1918] by Rosa Rosà (the Viennese Edith von Haynau).[90] Although it was related to Janet's research mentioned above and was published four years after the appearance of Otto Rank's essay *The Double*, the novel seems to be based, if it is not a coincidence, on a study by Enrico Morselli in which are described, with an abundance of specific cases, the ways in which are manifested so-called 'personalità spiritiche' [spiritualist personalities], which the psychiatrist interprets as secondary personalities that have become independent of the unconscious of the medium. They are distinguished from hysteric and hypnotic personalities in that they are 'costanti e coerenti' [constant and coherent] and 'manifestano una volontà propria, e spesso qualità intellettuali e morali diverse da quelle normali dei medi' [manifest a will of their own, and often intellectual and moral qualities that are different from the normal, average ones]. According to the psychiatrist, the subconscious of the medium in these cases 'plays with itself and with those present at a comedy that has all of the characteristics of verisimilitude'.[91]

In Rosa Rosà's story, the colourless Giorgina Rossi, following an electromagnetic and chemical accident, suffers a psychic impairment that makes her experience in a short space of time

> tre personalità diverse tra loro e diversissime dalla sua abituale natura [. . .] Nella prima sono evidenti i sintomi di amoralità [. . .]. La seconda sembra invece formata di caratteristiche che ce la fanno apparire come una personalità più maschile che femminile [. . .]. La terza [ci trasporta] in un futuro remotissimo nel quale, attraverso vertiginose evoluzioni, si sarà giunti ad un superamento della sensibilità materiale e alla nascita di nuovi sensi irradiati immaterialmente nell'Infinito.
> Ci appare di fatto una vita femminile tesa in uno sforzo mistico verso un simbolo di irrealtà.
>
> [three separate personalities, each different from the other and very different from her usual disposition. [. . .] The first manifests symptoms of amorality [. . .]. The second seems instead to be made up of characteristics causing her to appear more as a masculine than as a feminine personality [. . .]. The third personality takes us to a remote future in which, after dizzying leaps of evolution, humans will transcend material sensibilities and will witness the birth of new, immaterial senses that radiate across the Infinite.
> In fact, we have a vision of a female life reaching out in a mystic leap towards a symbol of unreality.][92]

The momentary overlap of the new I with the old and familiar personality arouses in the protagonist the sensation of being overwhelmed by specular but foreign entities that induce her to direct her thoughts towards never-imagined horizons: like a

Chinese box, the novel in fact contains many other episodes of unreality, as well as elements of potential social critique that portend a possible future emancipation of women. In relation to the scope of the investigation carried out thus far, we should also stress the final lines, in which the author expresses the conviction that 'il raddoppiamento, la moltiplicazione e l'alternazione della personalità saranno considerati come fenomeni usuali' [the doubling, the multiplication, and the alternation of personality will be considered normal] in the future. These anticipations, 'capitate nella nostra epoca, costituiscono un fenomeno continuativo progressivo, che andrà svolgendosi' [which just materialised in our era, will turn out to be a constant and growing phenomenon that will continue to unfold in the future] and that 'produrrà su certe zone del nostro globo come una nevicata continua di quelle astrazioni di tempo in ognuna delle quali sarà contenuto l'abbozzo di un "tipo" futuro' [will produce in several parts of the world a constant snow fall of these time abstractions, each containing an intimation of a future human 'type']:[93] a 'type' that is, in fact, multiplied, as Marinetti would have liked, made immense in its imagination, will, powers, and capacity for world domination.

Translated by Kathleen Gaudet and Luca Somigli

Notes to Chapter 13

1. See Umberto Boccioni, 'Prefazione al Catalogo della 1ª Esposizione di scultura futurista a Parigi', in *I manifesti del Futurismo*, ed. by Filippo Tommaso Marinetti (Florence: Edizioni di Lacerba, 1914), pp. 84–87 (p. 85):

 Between the *real* form and the *ideal* form, between the new form (impressionism) and the traditional (Greek) conception, there is a variable form, evolving, different from any concept of form that has existed up to now: *form in motion* (relative movement) and *motion of form* (absolute movement). Only this double conception of form can give the moment of plastic life in its manifestation, [. . .] without stopping it in its motion, in other words, without killing it.

2. See Filippo Tommaso Marinetti: 'Every noun must have its double' ('Technical Manifesto of Futurist Literature', in Filippo Tommaso Marinetti, *Critical Writings*, ed. by Günter Berghaus, trans. by Doug Thompson (New York: Farrar, Straus and Giroux, 2006), pp. 107–19 (p. 108)); and 'my purpose is to double the expressive power of words' ('Destruction of Syntax — Untrammeled Imagination — Words-in-Freedom', in *Critical Writings*, pp. 120–31 (p. 128)).
3. Filippo Tommaso Marinetti, Emilio Settimelli, and Bruno Corra, 'A Futurist Theater of Essential Brevity', in *Critical Writings*, pp. 200–07 (pp. 204–05).
4. See *Futurismo: I grandi temi*, ed. by Enrico Crispolti and others (Milan: Mazzotta, 1997), pp. 14–17.
5. The manifesto praises its beauty celebrating together the racing of the 'roaring motorcar' and the spinning of the earth, 'hurtling at breakneck speed along the racetrack of its orbit' (Filippo Tommaso Marinetti, 'The Foundation and Manifesto of Futurism', in *Critical Writings*, pp. 11–17 (p. 13)).
6. Filippo Tommaso Marinetti, 'The New Ethical Religion of Speed', in *Critical Writings*, pp. 253–59 (p. 255).
7. Marinetti, 'Technical Manifesto of Futurist Literature', p. 111.
8. Ibid.
9. Marinetti, 'The Foundation', p. 14: 'Time and Space died yesterday. We are already living in the realms of the Absolute, for we have already created infinite, omnipresent speed.'

10. Marinetti, 'The New Ethical Religion', p. 258 (translation modified).
11. Marinetti, 'Destruction of Syntax', p. 123.
12. Ibid., p. 120.
13. Ibid., p. 128. Marinetti borrows the word 'simultaneity' from the 'Prefazione al Catalogo delle Esposizioni di Parigi, Londra, Berlino, Bruxelles, Monaco, Amburgo, Vienna ecc.' (February 1912) signed by the painters of the movement, who use it in relation to the 'stati d'animo' [states of being] (in Marinetti, *I manifesti del futurismo*, pp. 60–68 (p. 63)).
14. Simona Cigliana, 'Marinetti prefiguratore', *Trasparenze*, 31–32 (2007), 49–67 (pp. 59–61).
15. Filippo Tommaso Marinetti, 'We Renounce Our Symbolist Masters, the Last Lovers of the Moon', in *Critical Writings*, pp. 43–46 (p. 44).
16. Marinetti, 'Technical Manifesto of Futurist Literature', p. 107.
17. Umberto Boccioni, Carlo Carrà, Luigi Russolo, Giacomo Balla, and Gino Severini, 'Futurist Painting: Technical Manifesto', in *Futurist Manifestos*, ed. by Umbro Apollonio (London: Thames and Hudson, 1973), pp. 27–30 (p. 28): 'Who can still believe in the opacity of bodies, since our sharpened and multiplied sensitiveness has already penetrated the obscure manifestations of the medium?'
18. Luciano De Maria, 'Introduzione. Marinetti poeta e ideologo', in Filippo Tommaso Marinetti, *Teoria e invenzione futurista*, ed. by Luciano De Maria, 2nd edn (Milan: Mondadori, 1983), pp. xxvii–c (p. lxxiii).
19. Filippo Tommaso Marinetti, 'Futurismo' in *Marinetti futurista. Inediti, pagine disperse, documenti e antologia della critica* (Naples: Guida, 1977), p. 51.
20. See Marinetti, 'Destruction of Syntax'.
21. Ibid., p. 121.
22. Marinetti, 'Technical Manifesto of Futurist Literature', p. 108.
23. Filippo Tommaso Marinetti, 'Geometrical and Mechanical Splendor and Sensitivity towards Numbers', in *Critical Writings*, pp. 135–42 (p. 136).
24. Marinetti, 'Destruction of Syntax', p. 121.
25. Marinetti, 'Technical Manifesto of Futurist Literature', p. 112.
26. On this theme, see Dario Tomasello and Francesca Polacci, *Bisogno furioso di liberare le parole. Tra verbale e visivo. Percorsi analitici della tavole parolibere futuriste* (Florence: Le Lettere, 2009), p. 71.
27. Marinetti, 'Technical Manifesto of Futurist Literature', p. 113.
28. Filippo Tommaso Marinetti, 'Dune. Parole in libertà', *Lacerba*, 4 (15 February 1914) (repr. in *Teoria e invenzione futurista*, pp. 781–90 (p. 785)).
29. On the esoteric implications of this table by Benedetta, see Günter Berghaus, 'Marinetti's Volte-Face of 1920: Occultism, Tactilism and *Gli indomabili*', in *Beyond Futurism: Filippo Tommaso Marinetti, Writer*, ed. by Gino Tellini and Paolo Valesio (Florence: Società Editrice Fiorentina, 2011), pp. 47–76.
30. Marinetti, 'Geometric and Mechanical Splendour', p. 138.
31. Ibid.
32. Filippo Tommaso Marinetti, 'Carta sincrona dei suoni rumori colori immagini odori speranze voleri energie nostalgie tracciata dall'aviatore Y.M.', in *Zang tumb tuuum. Adrianopoli ottobre 1912. Parole in libertà* (Milan: Edizioni futuriste di *Poesia*, 1914 (repr. in *Teoria e invenzione futurista*, pp. 641–779 (pp. 672–73)).
33. In *Futurismo & Futurismi*, ed. by Pontus Hulten (Milan: Bompiani, 1986), p. 189.
34. Filippo Tommaso Marinetti, *8 anime in una bomba* (Milan: Edizioni Futuriste di Poesia, 1919); repr. in *Teoria e invenzione futurista*, pp. 793–918.
35. Mino Delle Site, 'F. T. Marinetti, poeta e uomo d'azione', *L'Impero*, 19 January 1932, p. 3.
36. Otto Rank, *The Double: A Psychoanalytic Study*, 1914, trans. Harry Tucker, Jr. (Chapel Hill: University of North Carolina Press, 1971). The first edition appeared in issue 3 (1914) of *Imago, Zeitschrift für Anwendung der Psychoanalyse auf die Geisteswissenschaften*, edited by Sigmund Freud.
37. Marinetti, 'Destruction of Syntax', p. 121.
38. Marinetti, 'The Foundation', p. 14.
39. Filippo Tommaso Marinetti, *Teatro*, ed. by Giovanni Calendoli, 3 vols (Rome: Vito Bianco Editore, 1960), II, 407–11.

40. Arnaldo Corradini and Bruno Corra, 'Alternazione di carattere', in *Teatro futurista sintetico*, ed. by Guido Davico-Bonino (Genoa: Il Melangolo: 1993), pp. 155–56.
41. Massimo Bontempelli, *Nostra Dea* (Milan: Mondadori, 1925); collected in *Teatro di M. Bontempelli. 1916–1935* (Rome: Edizioni di Novissima, 1936), pp. 93–169. 'La vita intensa, romanzo dei romanzi' [Intense Life, Novel of Novels], *Ardita*, March–December 1919 (repr. Florence Vallechi, 1920) e 'La vita operosa, nuovi racconti di avventura' [Industrious Life. New Tales of Adventures], *I.I.I.* (Industrie Italiane Illustrate), September–November 1920 (repr. Florence: Vallecchi, 1921).
42. Filippo Tommaso Marinetti, 'Elettricità sessuale. Sintesi drammatica', in Marinetti, *Teatro*, II, 417–53.
43. Filippo Tommaso Marinetti, 'Bianca e Rosso', in Marinetti, *Teatro*, III, 83–94.
44. Filippo Tommaso Marinetti, 'L'arresto', in Marinetti, *Teatro*, II, 367–73.
45. Filippo Tommaso Marinetti, 'Un chiaro di luna', in Marinetti, *Teatro*, II, 398–401.
46. Ibid., p. 401.
47. Umberto Boccioni, 'Il corpo che sale', in *Teatro futurista sintetico*, pp. 45–47.
48. Paolo Buzzi, 'Pesce d'aprile', in *Teatro futurista sintetico*, pp. 77–82.
49. Filippo Tommaso Marinetti, 'Cura di luce', in Marinetti, *Teatro*, II, 321–24.
50. Charles W. Leadbeater, *The Astral Plane: Its Scenery, Inhabitants and Phenomena* (London: Theosophical Publishing Society, 1897); Italian translation: *Il piano astrale. Suo aspetto, suoi abitanti e fenomeni* (Roma: Società Ed. Teosofica, 1905).
51. Luigi Pirandello, 'Personaggi', *Il Ventesimo*, 30 (June 1906), final edn in Luigi Pirandello, *Novelle per un anno*, ed. by Mario Costanzo, 3 vols (Milan: Mondadori, 1985), II, 1474–79.
52. Arnaldo Ginna recalled:

 We stocked up on spiritualist and occultist books, my brother and I, from the publishers Durville and Chacornac. We read the occultist Eliphas Lévi, Papus, theosophists like Blavatsky and Steiner, Besant, secretary of the Theosophical Society, Leadbeater, Edouard Schuré. We followed the lectures of the Theosophical Society in Bologna and in Florence'. (quoted in Mario Verdone, *Cinema e letteratura del futurismo* (Rome: Edizioni di Bianco e Nero, 1968), pp. 21–22)

53. Pirandello, 'Personaggi', p. 1477.
54. The present passage from the first edition of *Il fu Mattia Pascal*, which appeared from April to June 1904 in the journal *Nuova Antologia*, was removed from the edition in volume in 1908. For the text cited, see Sergio Campailla, *Mal di luna e d'altro* (Rome: Bonacci, 1986), p. 144.
55. Cfr. Filippo Tommaso Marinetti, 'Italianità e originalità di Pirandello', Roma, 4 January 1937, p. 3; repr. in Matteo D'Ambrosio, *Le 'commemorazioni in avanti' di F. T. Marinetti* (Naples: Liguori, 1999), p. 99.
56. Alfred Binet, *Les altérations de la personnalité* (Paris: Alcan, 1892).
57. Luigi Pirandello, *Arte e scienza* (Rome: W. Modes Libraio-Editore, 1908, repr. in *Opere di Luigi Pirandello*, ed. Manlio Lo Vecchio-Musti, 6 vols (Milan: Mondadori, 1956–60), VI, *Saggi, poesie, scritti varii* (1960, 3rd edn 1973), p. 170).
58. Charles Richet (Paris, 1850–1935; Nobel Prize 1913) carried out important studies on the nervous system and on the physiology of altered states of consciousness.
59. See Cesare Lombroso's studies *Genio e follia* (Milan: Brigola, 1872) and *L'uomo di genio in rapporto alla psichiatria, alla storia, alla estetica* (Turin: Bocca, 1888).
60. Albert de Rochas, *L'extériorisation de la sensibilité. Étude expérimentale et historique* (Paris: Chamuel, 1895) and *L'extériorisation de la motricité. Recueil d'expériences et d'observations* (Paris: Chacornac, 1896).
61. Paul Janet, 'Les actes inconscients et le dédoublement de la personnalité pendant le somnambulisme provoqué', *Revue philosophique*, 22 (1886), 577–92. On the vast problem of the influence exerted by the interest in the paranormal and in scientific studies on the altered states of consciousness on culture in the 19th and 20th century, and particularly on avant-garde poetics, see Simona Cigliana, *Futurismo esoterico. Contributi per una storia dell'irrazionalismo italiano tra Otto e Novecento* (Naples: Liguori, 2002).
62. See Giulio Lepschy, 'Saussure e gli spiriti', in *Studi saussuriani per Robert Godel*, ed. by René

Amacker, Tullio De Mauro, and Luis J. Prieto (Bologna: Il Mulino, 1974), pp. 181–200. The study is about a noted case of glossolalia.
63. According to Binet (*Les altérations de la personnalité*, pp. 298–309), the manifestations of doubling of personality included also the apparitions provoked by the mediums, not 'spirits' but 'characters' of the unconscious, doubles of the medium himself 'represented' on the outside world.
64. Filippo Tommaso Marinetti, *Taccuini 1915–1921*, ed. by Alberto Bertoni (Bologna: Il Mulino, 1987), p. 479 and p. 481 (note of 5 May 1919).
65. Marinetti, *Taccuini 1915–1921*, p. 479 (note of 4 May 1920).
66. Filippo Tommaso Marinetti, *Mafarka il futurista*, ed. by Luigi Ballerini (Milan: Mondadori, 2003), p. 165. Some researches on externalization, doubling and split personality were very popular at the time: see above nn. 56, 60, 61.
67. Marinetti, *Taccuini 1915–1921*, p. 481.
68. Marinetti, *L'ottimismo artificiale*, manuscript currently at the Beinecke Library (Yale University), Marinetti Papers, Box 45, Folder 1773.
69. Pino Masnata, *Anime sceneggiate* (Rome: Edizioni futuriste di Poesia, 1930).
70. Filippo Tommaso Marinetti, *Collaudi futuristi* (Naples: Guida, 1977), p. 70.
71. Benedetta, *Astra e il sottomarino. Vita trasognata* (Naples: Casella, 1935), repr. in *I tre romanzi di Benedetta* (Cappa Marinetti). *Le forze umane, Viaggio di Gararà, Astra e il sottomarino*, ed. by Simona Cigliana (Rome: Edizioni dell'Altana, 1998), pp. 174–75.
72. Ibid., p. 175.
73. Ibid.
74. Ibid., p. 207.
75. Primo Conti, 'Coscienze', in *Imbottigliature* (Florence: Edizioni di *L'Italia futurista*, 1917; repr. in *Zig Zag. Il romanzo futurista*, ed. by Alessandro Masi (Milan: Il Saggiatore, 1995), pp. 173–232 (p. 188)).
76. Primo Conti, 'Pagine sentimentali', in *Imbottigliature*, p. 197.
77. Ibid., p. 202.
78. Aldo Palazzeschi, *Il codice di Perelà* (Florence: Vallecchi, 1920), pp. 20–21.
79. Arnaldo Ginna, 'Arnaldaz', in *Le locomotive con le calze* (Milan: Facchi, 1919), repr. in *Zig zag. Il romanzo futurista*, pp. 274–87.
80. Arnaldo Ginna, *Prose inedite e disperse*, ed. by Giorgio Patrizi (Rome: Biblioteca d'Orfeo, 2009), p. 43.
81. Ibid., p. 41.
82. Ibid., p. 99.
83. Fernando Spiridigliozzi, *S. Francesco in aeroplano* (Rome: Casa ed. Roma 900, 1934), repr. in *Zig zag. Il romanzo futurista*, pp. 379–496 (p. 390 and p. 399).
84. Bruno Corra, 'Attimo', in *Madrigali e grotteschi* (Milan: Facchi, 1919), p. 27.
85. Bruno Corra, 'Per l'onnipotenza', in *Madrigali e grotteschi*, p. 93.
86. Bruno Corra, 'Avventure', in *Madrigali e grotteschi*, p. 102.
87. Maria Ginanni, in *L'Italia futurista*, I, 7, 1 October 1916, then in *Montagne trasparenti* (Florence: Edizioni di *L'Italia futurista*, 1917), p. 83.
88. Bruno Corra, 'Chantacler', *Il Centauro*, 8 December 1912.
89. Filippo Tommaso Marinetti, 'Answers to Objections', in *Critical Writings*, pp. 114–19 (p. 115).
90. Rosa Rosà, *Una donna con tre anime* (Milan: Studio Editoriale Lombardo, 1918).
91. Enrico Morselli, 'Sull'origine subcosciente delle così dette "personalità spiritiche"', *Luce ed ombra* (January–February 1917), pp. 11–24.
92. Rosa Rosà, *A Woman with Three Souls*, trans. by Lucia Re and Dominic Siracusa, *California Italian Studies*, 2.1 (2011), <https://escholarship.org/uc/item/7k625747≥ [accessed 5 November 2014].
93. Ibid.

CHAPTER 14

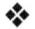

Puppets

Shirley Vinall, University of Reading

A child's puppet theatre — the eponymous protagonist of Marinetti's Futurist sketch *Il teatrino d'amore* [*The Little Theatre of Love*] — seems a far cry from the modernistic icons of speed and war generally associated with this iconoclastic and violent movement. Nevertheless, puppets played a significant part in Futurist thought and theatrical experimentation.

Puppets of many different types, sizes and means of operation have long been used in dramatic performances all over the world, but they share certain essential qualities, helpfully defined by Steve Tillis:

> [T]he puppet is a theatrical figure, perceived by the audience to be an object, that is given design, movement, and, frequently, speech, so that it fulfils the audience's desire to imagine it as having life; by creating a double-vision of perception and imagination, the puppet pleasurably challenges the audience's understanding of the relationship between objects and life.[1]

In the Italy where the Futurists grew up, public performances of puppet theatre would have been a common sight, evoked by Corrado Govoni in an early poem about the travelling fairs, with their puppets, acrobats, and clowns, which would hold such fascination for early twentieth-century avant-garde writers and artists.[2] The puppets were usually glove puppets or string-operated marionettes with moveable jointed limbs. (The term *burattino* strictly denotes a glove puppet, but can also include the *marionetta*.) The puppets used in the Sicilian dialect *opera dei pupi* were distinct, being elaborately crafted, quite large marionettes which re-enacted Carolingian epic tales.

Puppets, and the Italian terms for them, evoke a wide range of different associations, from the world of childhood (*pupo* is also a familiar word for a child) to that of the *Commedia dell'arte*, whose stock characters often survived in puppet theatre (the term *burattino* possibly derives from the trickster character of that name). *Fantoccio* can denote a model of the human figure in any material — not just a toy or puppet but also something with more frightening characteristics, like a scarecrow: Ardengo Soffici exploited its negative connotations when using *Statue e fantocci* [*Statues and Puppets*] as a collective title for his articles on people whom he admired or mocked.[3] The synonym *manichino* may also refer to a featureless artist's model or tailor's dummy.

Contrasts, contradictions, and ambiguities thus abound. While the Sicilian

marionettes portray the epic deeds of noble paladins, the large-headed *burattini*, with their caricatured features, can depict humbler characters and the baser aspects of humanity in grotesque or comic vein, possibly giving voice to views which their audience could not express in real life. Marked ambiguities have been identified in Italy's most famous puppet story, Carlo Collodi's fable of bourgeois socialisation in United Italy, *Pinocchio*.[4] The puppets' revolt against their puppeteer in Chapter X, together with Pinocchio's own disobedience, can suggest not just nostalgia for childhood freedom but also the rebellion against authority which modernist writing would associate with the puppet. However, the puppet, limited to rigid movements under the puppeteer's control, can also, as in the phrase 'governo fantoccio' (puppet government), suggest conformism and submission. Pinocchio finally becomes a well-behaved little boy, and it has been argued that Collodi is suggesting that 'perhaps it is indeed the adults in bourgeois society who are the real puppets, manipulated by a host of powers they think they have control over but in fact do not'.[5]

The paradoxical notion that puppets can be both less powerful and more powerful than human beings is reflected in the theatrical theory and practice of late nineteenth-century high culture, which drew on popular dramatic forms. The analogy between marionettes and human beings as powerless tools of fate was a key idea of the innovative dramatist Maurice Maeterlinck, a leading figure in the French and Belgian Symbolist culture which helped shape the intellectual outlook of various Futurists: his famous description of some of his works as plays for puppets — not, perhaps, to be taken literally although there were puppet productions — should be seen in the sense that his characters are 'tugged by the invisible strings of their unconscious and of the unknowable forces that conspire against them'.[6] Sharing Symbolist anxiety that the materiality and personality of living actors could disrupt the purity of a writer's vision, Maeterlinck believed that performance might after all be possible if humans were replaced on stage by 'a shadow, a reflection, a projection of symbolic forms or a being that would have the appearance of life without being alive'.[7] Marionettes, through the combination of their similarities with, and differences from, humans could have a powerful defamiliarising and disturbing effect; this could also be achieved if actors adopted the stylised characteristics and minimalist movements of marionettes — a practice adopted in the staging of many of his plays.[8]

The repetitive, ritualistic, enigmatic actions of the puppet-like figures in the dream-like, miniature fairy-tale worlds of Palazzeschi's first collection of poems, *I cavalli bianchi* [*White Horses*, 1905], recall Maeterlinck, suggesting a similar search for meaning or sense of meaninglessness.[9] There, however, the term *fantocci* designates not glove puppets or marionettes but 'quattordici teste di marmo | corrose e annerite dal tempo' [fourteen marble heads, worn and blackened by time] on the roof of a windowless castle which is thought to contain riches, although no-one has penetrated it to see them.[10] The name is given them by 'la gente', the anonymous people outside, who watch or process powerlessly in other poems in the collection. They think, too, that from the castle's roof, the beautiful world beyond can be perceived ('si dice: dal tetto si vede il bel mondo!'). Anthony Tamburri interestingly

suggests that Palazzeschi's 'choice of "fantocci", and not monsters or gargoyles' indicates his view of 'instruments (or *toys*) of amusement and merriment as the only ones capable of seeing the "bel mondo"' beyond the world of convention. He thus allies the 'fantocci' with the alienated poet, seeing here the 'first trace' of the poetics of the *saltimbanco* that will underlie his Futurist demolition of traditional poetry.[11] It is certainly true that Palazzeschi's poetics of *divertimento* develops from the multiple associations found in late nineteenth-century French culture between the artist and the Pierrot/clown/acrobat figures from popular entertainment.[12] However, the poem's final lines are also capable of less optimistic interpretations. The idea that the 'bel mondo' can be seen depends on 'si dice' [it is said]: it is the people's belief, not sound knowledge, and they may be as deluded in this as in their belief in the treasure within the castle. In contrast, the poem's last line, 'Soltanto i fantocci lo stanno a guardare' [Only the 'fantocci' are watching it], is not in the voice of 'la gente', and could be read ironically: the only objects that can 'see' 'il bel mondo' are the 'fantocci', who are lifeless and, therefore, blind. For 'la gente', the 'fantocci' may also appear as threatening presences, whose power or enchantment they hope to mitigate by the childhood association with toys or puppets.

In Palazzeschi's second collection, *Lanterna* (1907), where humour gains ground and Symbolist motifs are parodied, the often grotesque characters, now vocal individuals, have been compared to puppets in their unidimensionality: 'Ognuno dei personaggi convocati avanza per pronunziare una battuta, come un burattino, prima di scomparire nelle quinte' [Each of the characters summoned comes forward to say a line, like a puppet, before disappearing behind the curtains].[13] An actual puppet-like doll in female form also appears, a brightly-coloured 'fantoccio coperto di logori stracci' [puppet covered in worn rags].[14] The evidence of Frate Puccio's sin, it has to be consumed in the flames: the themes of transgression, punishment, and the redness of fire were to be further developed by the Futurist Palazzeschi in the defiant protagonist of 'L'Incendiario' [The Arsonist].

Marinetti's first play featuring puppets was his extravagant and unwieldy 'tragedia satirica' [satirical tragedy], *Le Roi Bombance* [*King Revelry*], published in 1905 and first performed, after the launch of Futurism, at the Théâtre de l'Oeuvre in Paris on 3 April 1909. Partly a political fable, it mocks the materialism of contemporary Italian parliamentary socialists and revolutionary syndicalists alike through its fantastic 'gastronomic' plot concerning the death of the king's cook, the attempts of the under-cooks to seize power, their failure to satisfy the hunger of the masses (led by Estomacreux, or 'Emptystomach'), the devouring of the king by the revolutionaries, the subsequent disgorging of his body, his return to life, and the final sweeping-away of everything in a flood of putrefaction. In its focus on digestive matters, treated with ribald Rabelaisian humour, it owes much to another fantastic play about revolt, Alfred Jarry's iconoclastic, supremely theatrical *Ubu Roi*, which had been performed by the same theatre in 1896, and which McGuinness describes as 'at one and the same time, Symbolist theatre's destructive culmination and its monstrous progeny'.[15] Believing, like Maeterlinck, in the capacities of puppets to express a dramatist's vision and to free theatre from conventional realism, Jarry

envisaged the 1896 production as *grand guignol*, with human actors appearing to be puppets, wearing masks and making jerky movements; but, rather than hinting at supernatural forces, this 'appropriation of the grotesque and scatological qualities of folk puppetry'[16] caricatured the basest aspects of humanity.

The costumes of *Le Roi Bombance* are in similar style (the king has an enormous nose and a huge stomach), and the procession of scullions is directed to march with the mathematical precision of Holden puppets (the Holdens were well-known expert marionettists), but Marinetti adds, as a caveat, that their movements should have the primitive quality of puppets in travelling fairs.[17] Furthermore, as the stage directions to Act IV specify, the preposterous plot requires the use of actual puppets, like giant toads,[18] to represent the characters who have consumed the king, his chaplain, and his adviser: these are then 'regurgitated', as human actors emerge from the puppets. Earlier, a different kind of puppet had appeared, when the 'Idiot', a poet claiming near-divine powers who tries to persuade the king and his subjects of the attractions of the 'Ideal', is forced by their unresponsiveness to degrade his elevated vision of his encounter with his Ideal Woman into a ventriloquist's dialogue with an improvised glove puppet ('une poupée grossière', p. 88), a scene which then takes on the boisterous character of a Punch and Judy show. As Luca Somigli has persuasively argued, the play thus represents a challenge not only to a faith in politics but also to the elitist, Symbolist belief in the power of art.[19]

Puppets have negative connotations too in another contemporary play by Marinetti, but here the complex associations make their meaning unclear, as Günter Berghaus has argued.[20] This was *Poupées électriques* [*Electric Puppets*], produced in an Italian version with the deceptively unchallenging title of *La donna è mobile* [*Woman is Fickle*] to an uncomprehending and restive audience in Turin on 15 January 1909. The 'poupées' or 'fantoches' which are central to the second act are neither glove puppets nor rag dolls but life-size models of an elderly man and woman, powered by electricity to make movements like cleaning spectacles, and to make sounds like snoring. The presence of these puppets, modelled on a magistrate and the mother of the wife of their inventor, John Wilson, adds the thrill of forbidden pleasures to the couple's love-making. For Wilson, they embody everything outside their love: 'toute la réalité affreuse: devoir, argent, vertu, vieillesse, monotonie, ennui de cœur, fatigue de la chair, bêtise du sang, lois sociales' [the whole frightful reality: duty, money, virtue, old age, monotony, the heart's discontent, the weariness of the flesh, the folly of the blood, society's laws],[21] and thus they certainly function as 'caricatures of the pillars of society',[22] to be defied or challenged, or as objectivisations of versions of the couple after their love has been destroyed by physical and spiritual decline.[23] In addition, however, as automata, they are associated with works of fantasy and early science fiction, especially E. T. A. Hoffman's *Der Sandmann* [*The Sandman*] and *L'Ève future* [*The Future Eve*] by Villiers de l'Isle-Adam. Although Marinetti's automata, unlike Hoffman's mechanical woman Olimpia or Villiers' electrically animated Hadaly, are far from being alternative erotic objects, disturbing parallels are suggested between the power of electricity over the 'fantoches' and the exciting effects of a violent thunderstorm on the nerves of Wilson's wife Mary, which he

exploits to create the illusion of her adultery, leading her to accuse him of treating his 'petite dynamo'[24] as one of his puppets. The inventor's ultimate rejection of his creations also has intriguing implications. Berghaus interprets this episode in *Poupées électriques* itself as Wilson's surrender to his wife's 'newly-acquired bourgeois attitudes'.[25] In contrast, when the play's second act, detached from the fairly conventional surrounding plot, is adapted in 1913 as the explicitly Futurist *Elettricità* for performances by Gualtiero Tumiati's acting company, the hurling of the puppets (now called Professor Matrimonio and Signora Famiglia) into the sea is acclaimed by their inventor (now called Riccardo Marinetti) as a Futurist act. Love, so frequently denounced by Marinetti as detrimental to the Futurist hero, is here, surprisingly, declared by his character to be Futurist: it tricks and destroys the slow, the old, the fearful and the sedentary.[26] Paradoxically too, the automata themselves apparently symbolise *passatismo*, although modern scientific advances seem to be celebrated, through the skill of their American inventor and his associations with electricity (which link him with Villiers's fictionalised Edison), and through the dedication of *Poupées électriques* to the aviation pioneer Wilbur Wright. Furthermore, by this time Marinetti was already developing the key Futurist myth of the 'uomo moltiplicato' [multiplied man], the inhuman blend of man and machine which he hoped would escape the corrosion of his vital energy by the forces of goodness, tenderness, and, most emphatically, love.[27]

The use of puppets can be interpreted in opposing ways, too, in Marinetti's *Il teatrino dell'amore*, one of the witty, daringly compressed Futurist *sintesi* written to challenge conventional theatre by Marinetti and his associates in conjunction with their 'Manifesto del teatro futurista sintetico' [Manifesto of Futurist Synthetic Theatre, 1915] and performed during two tours in 1915–16. In this play, involving an adulterous encounter between two characters called, simply and satirically, 'La moglie' [The Wife] and 'Il primo venuto' [The First-comer], the toy puppet theatre left outside the woman's room by the man is found by her daughter who, from a hiding-place, watches the puppets (being moved by an invisible puppeteer) as they mimic the transgressive actions of the adults. On the one hand, the puppets are again associated with inauthenticity and hypocrisy in human behaviour, symbolising the 'futilità, fugacità e teatralità della seduzione' [futility, fleetingness, and theatricality of seduction], as Marinetti's note explains.[28] On the other hand, however, this use of the puppets is a highly innovative device, linked with the desire expressed in the manifesto to introduce fantastic and illogical elements into theatre, and to stage simultaneity. As Giusi Baldissone has suggested, the *teatrino* acts as the single point of contact between the juxtaposed planes of reality (where the mother shows the theatre to the child at the end) and the surreal (the child says she has been dreaming).[29]

Even more importantly, Marinetti's note defines the little theatre as one of the principal characters in an innovative depiction of the 'vita non umana' of objects: like the pieces of furniture, it is said to live in the child's nerves. The furniture seems to speak about what it is imagined to sense, and thus can be seen to possess some, at least, of the qualities ascribed by Tillis to the theatrical puppet. In another 'dramma d'oggetti' from the same series of *sintesi*, the more famous *Vengono* [*They*

are coming], lighting effects make chairs seem to move, suggesting the mysterious 'vita fantastica' of furniture in an empty room.[30] Objects had already been given a life of their own by Maeterlinck, to suggest the power of unseen forces — in *La Princesse Maleine*, the furniture creaks and the wind howls.[31] With phrases like 'vita non umana', however, Marinetti seeks to distance his device from symbolist personifications of states of mind.[32] His use of puppets here parallels his desire, expressed in the 'Manifesto tecnico della letteratura futurista' [Technical Manifesto of Futurist Literature, 1912] and the subsequent manifesto 'Distruzione della sintassi' [Destruction of Syntax, 1913], to replace psychology with 'l'ossessione lirica della materia' [the lyrical obsession with matter]: in a vision of universal dynamism drawn from both Symbolist notions of *correspondances* and scientific discoveries about Brownian motion, atoms, and molecules, he aimed to embrace the world of matter through intuition, chains of analogies, and *parole in libertà*.[33]

In subsequent years many European avant-garde groups explored the possible uses and significance of puppets or other models of human figures. In Italy, the characters of the *grotteschi*'s 'teatro dei fantocci',[34] whose 'schematic simplification'[35] recalls Futurist *sintesi*, were represented as victims of external forces and twentieth-century urban alienation. Meanwhile, the Metaphysical painter Giorgio De Chirico was creating his many disturbing images of the deeply symbolic but enigmatic *manichino*.

The Futurists' distinctive approach, as Günter Berghaus has shown in his exhaustive studies of their many theatrical productions, worked in two complementary directions, the transformation of the human actor into a puppet-like mechanical figure, and the use of inanimate objects as artificial 'actors'.[36] Already in 1916, Marinetti had called for Futurist *parole in libertà* to be recited by someone with anonymous appearance, dehumanised expression, and rigid, mechanical movements (though, in a paradox reminiscent of *Poupées électriques*, he associated the *passéist* reciter, who moved only the upper half of his body, with a fairground glove puppet[37]). The carnivalesque performance of Cangiullo's *Piedigrotta* at the Sprovieri Gallery in Rome in 1914 had inaugurated this, he claimed retrospectively. The declamation of meaningless or onomatopoeic sounds which, with noise music, characterised several of the innovative multimedia performances at the gallery, was used in the same year by the painter Giacomo Balla in *Macchina tipografica* [Printing Press], a kind of ballet in which twelve actors, dressed as 'anonymous automata', imitated the machine's sounds and rhythmical movements.[38] As Futurist theatre experimented with the machine aesthetic in the twenties, various productions would feature dancers in costumes designed to make them resemble machines: reviews frequently compared their movements to those of marionettes. Notable examples were Ivo Pannaggi and Vinicio Paladini's *Ballo meccanico futurista* [Futurist Mechanical Dance, 1922], where the dancer in Pannaggi's rigid robot-style costume represented 'a man mutated into the machinery he operates', *Danza dell'elica* [Dance of the Propeller, 1923], *Anihccam del 3000* [Machine of 3000, 1924], and also Ruggero Vasari's complex *L'angoscia delle macchine* [The Anguish of Machines], performed in 1927, which, rather than celebrating machines, depicted their dangerous dehumanising power.[39]

The use in innovative Futurist performances of actual puppets in human, animal, or abstract form was linked with the desire to embrace different arts and integrate actors and settings in total theatre. Important precursors included Balla's *Complessi plastici* [Plastic Complexes, 1914–15], assemblies of moving objects made from different materials,[40] and Fortunato Depero's non-representational 'sintesi teatrale astratta', *Colori* [Colours], published in the second volume of Futurist *sintesi* in 1916 but not performed at the time. This envisaged a stage consisting of a blue cube, in which four three-dimensional 'individualità astratte' [abstract entities] — a grey ovoid, a red polyhedron, a white pointed shape and a black multi-globular shape — are moved by invisible strings to the accompaniment of meaningless repetitive sounds, of different pitch and quality for each shape, presumably to be provided by human voices.[41] As Balla and Depero explained in their 'Ricostruzione futurista dell'universo' [Futurist Reconstruction of the Universe, 1915], moving 'plastic complexes' were intended to capture the dynamism of the universe. Further theoretical support came from Enrico Prampolini's 'Scenografia e coreografia futurista' [Futurist Scenography and Choreography, 1915], which, influenced by Wagnerian ideas of the total art work, Edward Gordon Craig's integrated stage designs and his dream of the 'Übermarionette', envisaged replacing human actors and the traditional representational painted stage with an autonomous three-dimensional scenic environment, where moving elements, sound, and light would combine to evoke an emotional reaction in the audience.[42]

Several subsequent productions involved collaboration with musicians. Balla's set designs for an ambitious but unfortunately unsuccessful performance of Stravinsky's *Feu d'artifice* [Fireworks] by the Ballets Russes at Rome's Teatro Costanzi in 1917 included brightly coloured, solid geometrical forms which could be illuminated rhythmically to evoke the spirit of the music.[43] Depero's *Balli plastici* [Plastic Dances], performed to some acclaim by professional puppeteers at the Teatro dei Piccoli in Rome in 1918, consisted of five short mimes set to music by different composers, including Casella and, possibly, Bartók. They used wooden marionettes of various sorts — grey and black solid abstract shapes which seem to emerge from shadows in *Ombre* [Shadows], and figures of humans and animals in the others. *I pagliacci* [The Clowns] featured a row of dancing white clowns, two larger red and yellow ones, a hen laying eggs, and a ballerina constructed from geometric shapes, moving against a 'fantastic stage set consisting of a kind of luminous floral village'.[44] In *L'uomo dai baffi* [The Man with a Moustache], a grotesque moustachioed man walked clumsily along a golden road, seemingly giving birth to smaller versions of himself. In *I selvaggi* [The Savages], two groups of 'selvaggi' fought over a gigantic female, whose belly opened to reveal a miniature puppet theatre, from which a small figure emerged, to be eaten by a serpent. All reappeared in *L'orso azzurro* [The Blue Bear], accompanied by a monkey and a bear. Puppets, according to Depero's collaborator Gilbert Clavel, were the best form of representation because they could completely fulfil the author's vision;[45] and the performances were acclaimed by Settimelli as supremely Futurist because they are 'quadri che diventano danze, colori e volumi che aspirano alla musica' [paintings which become dances, colours, and volumes which aspire to music].[46]

In 1919, Prampolini similarly used a puppet play, Pierre Albert-Birot's *Matoum et Tévibar*, to experiment with his ideas of theatrical design.[47] Although Depero's dream of a *Teatro magico* — a totally autonomous world integrating performers and settings — was not realised in theatrical productions, it was expressed in the various drawings, paintings, tapestries and other textile works which depicted puppet-like circus figures, alongside fantastic flowers and animals in a brilliantly coloured surreal world.[48]

Unlike the transformation of human actors into puppet-like machines, then, Futurist puppet productions were not necessarily associated with modernistic content although they were used to explore innovative techniques. Of particular interest, finally, are those works where puppets appear alongside living actors. For example, in Luciano Folgore's *Ombre + Fantocci + Uomini* [*Shadows + Puppets + Humans*], published in 1920,[49] as well as in Prampolini's *Le marchand de cœurs* [*The Merchant of Hearts*] and Folgore's *L'ora del fantoccio* [*The Hour of the Puppet*], both produced as Futurist Pantomimes by Prampolini in 1927–28, puppets function as doubles of human characters, externalising their inner feelings.[50] In Folgore's *sintesi*, the puppets and shadows appear and move while the sleeping humans express, in altered voices, the desires hidden beneath their conventional daytime behaviour; in his later *pantomima*, the movements of marionettes apparently portrayed the erotic feelings of the two human dancers; and the three life-sized marionettes in Prampolini's *pantomima* represented the true characters of the three different women courted by the merchant: in a paradoxical exchange, the artificial object represents authentic human feelings, while the human characters are shown as subject to the control of societal norms.

Popular and ancient in origin, puppets nevertheless attracted the attention of sophisticated avant-garde writers and theatre practitioners keen to break nineteenth-century realist conventions and create art forms for the modern world. In their dual role of suggesting humanity while being clearly non-human, they possess a powerful ambiguity. They are potentially both comforting and disturbing; while being simplifications, they can suggest human complexity. Their rigidity and dependence can offer a critique of human conformism, while their carnivalesque associations suggest freedom, rebellion, and transgression. Symbols of human powerlessness in their complete subjection to the puppeteer, they can also represent an artist's desire for control over his creation, and a vision of total art. Finally, in their similarities to the robot, they can be used to explore the interchangeability between humans and machines, and the conflicting hopes and fears aroused by the industrial world.

Notes to Chapter 14

1. Steve Tillis, *Towards the Aesthetics of the Puppet: Puppetry as a Theatrical Art* (New York, Westford, CT and London: Greenwood Press, 1992), p. 65.
2. 'La fiera', from *Fuochi d'artifizio*, 1905; in Corrado Govoni, *Poesie 1903–1958*, ed. by Gino Tellini (Milan: Mondadori, 2000), pp. 73–75: 'i fantocci con i campanelli', 'I saltimbanchi coi pagliacci /incipriati ed imbellettati'.
3. Ardengo Soffici, *Statue e fantocci* (1919), now in his *Opere*, 7 vols in 8 (Florence: Vallecchi, 1959–68), I, pp. 421–613.

4. Carlo Collodi, *Le avventure di Pinocchio. Storia di un burattino* (Florence: Bemporad, 1883). (Although he is described as a 'burattino meraviglioso' (p. 11), Pinocchio is actually an autonomously moving wooden marionette.)
5. Harold B. Segel, *Pinocchio's Progeny: Puppets, Marionettes, Automatons, and Robots in Modernist and Avant-Garde Drama* (Baltimore and London: The Johns Hopkins University Press, 1995), p. 43. See also Nicolas J. Perella, 'An Essay on *Pinocchio*', introduction to Carlo Collodi, *The Adventures of Pinocchio*, trans. Nicolas J. Perella (Berkeley: University of California Press, 1986).
6. Patrick McGuinness, *Maurice Maeterlinck and the Making of Modern Theatre* (Oxford: Oxford University Press, 2000), p. 118.
7. Maurice Maeterlinck, 'Menus Propos: le Théâtre', quoted from McGuinness, pp. 107–08.
8. See McGuinness, pp. 113–18.
9. See François Livi, 'Palazzeschi e Maeterlinck', *La Rassegna lucchese*, 50 (1970), 150–65; François Livi, *Tra crepuscolarismo e futurismo: Govoni e Palazzeschi* (Milan: Istituto Propaganda Libraria, 1980), *passim*; Luciano De Maria, 'La poesia di Aldo Palazzeschi', in *La nascita dell'avanguardia* (Venice: Marsilio, 1986), p. 106; Aldo Palazzeschi, *I cavalli bianchi* (1905), ed. by Adele Dei (Parma: Edizioni Zara, 1992), *passim*.
10. 'Il castello dei fantocci', *I cavalli bianchi*, p. 45, ll. 2–3.
11. Anthony Julian Tamburri, *Of saltimbanchi and incendiari: Aldo Palazzeschi and Avant-gardism in Italy* (Rutherford, NJ: Fairleigh Dickinson University Press; London: Associated University Presses, 1990), p. 78. See also his *A Reconsideration of Aldo Palazzeschi's Poetry (1905–1974): Revisiting the Saltimbanco* (Lewiston, NY and Lampeter: Edwin Mellen Press, 1998), pp. 23–26.
12. See, for instance, Shirley W. Vinall, 'Princes and Pierrots: Palazzeschi's Early Writing and Laforgue', *Italian Studies*, 58 (2003), 104–32.
13. Livi, *Tra crepuscolarismo e futurismo*, p. 229.
14. 'La storia di Frate Puccio', from Aldo Palazzeschi, *Lanterna*, ed. by Adele Dei (Parma: Edizioni Zara, 1987), pp. 85–92, l. 33.
15. McGuinness, p. 124.
16. Scott Cutler Shershow, *Puppets and 'Popular' Culture* (Ithaca, NY and London: Cornell University Press, 1995), p. 191.
17. Filippo Tommaso Marinetti, *Le Roi Bombance* (Paris: Mercure de France, 1905), pp. 125–26.
18. Ibid., p. 19.
19. Luca Somigli, 'The Poet and the Vampire: *Re Baldoria* and the Crisis of Symbolist Values', *Italica* 91.4 (2014), 571–89 (pp. 581–82).
20. Günter Berghaus, *The Genesis of Futurism: Marinetti's Early Career and Writings 1899–1909* (Leeds: Society for Italian Studies, 1995), pp. 78–82.
21. Filippo Tommaso Marinetti, *Poupées électriques* (Paris: Sansot, 1909), pp. 134–35.
22. Berghaus, *The Genesis of Futurism*, p. 79.
23. See Didier Plassard, *L'acteur en effigie: figures de l'homme artificiel dans le théâtre de l'avant-garde historique* (Lausanne: L'Age d'homme, 1992), p. 314.
24. Marinetti, *Poupées électriques*, p. 131.
25. Berghaus, *The Genesis of Futurism*, p. 81.
26. See 'Elettricità sessuale' (a later title) in Filippo Tommaso Marinetti, *Teatro*, ed. by Giovanni Calendoli, 3 vols (Rome: Vito Bianco, 1960), II, pp. 417–60 (p. 447).
27. Filippo Tommaso Marinetti, 'L'homme multiplié et le règne de la machine', in *Le Futurisme* (Paris: Sansot, 1911), pp. 70–81.
28. Marinetti, *Teatro*, II, pp. 339–45 (p. 345).
29. Giusi Baldissone, *Filippo Tommaso Marinetti* (Milan: Mursia, 1986), pp. 198–99.
30. Marinetti, *Teatro*, II, pp. 281–85 (see Marinetti's 'Nota', p. 285).
31. See McGuinness, p. 86.
32. See Michael Kirby, *Futurist Performance* (New York: E. P. Dutton, 1971), p. 55.
33. See Filippo Tommaso Marinetti, 'Technical Manifesto of Futurist Literature', and 'Destruction of Syntax — Untrammeled Imagination — Words-in-Freedom', in Filippo Tommaso Marinetti, *Critical Writings*, ed. by Günter Berghaus, trans. by Doug Thompson (New York: Farrar, Straus and Giroux, 2006), pp. 107–19 and 120–31.

34. Silvio D'Amico, *Il teatro dei fantocci* (Florence: Vallecchi, 1920).
35. Anna Laura Lepschy, 'Realism, Identity, and Reality on Stage: Italian Drama from Unification to the Present Day', *The Italianist*, 21–22 (2001–02), 319–47 (p. 328).
36. Günter Berghaus, *Italian Futurist Theatre 1909–1944* (Oxford: Clarendon Press, 1998), p. 297, and *passim*.
37. See Filippo Tommaso Marinetti, 'Dynamic, Multichanneled Recitation', in *Critical Writings*, pp. 193–99.
38. Berghaus, *Italian Futurist Theatre*, pp. 249–51, which includes photographs of the text and designs for the performance; Kirby, pp. 61–63; Giovanni Lista, *Lo spettacolo futurista* (Florence: Cantini, [1989]), p. 49.
39. Katia Pizzi, 'Of Men and Machines: Pannaggi, Paladini and the "Manifesto of Mechanical Art"', *The Italianist*, 28 (2008), 217–26 (p. 221). The other costume designers were, respectively, Prampolini, Depero, and the Russian artist Vera Idelson. See Berghaus, *Italian Futurist Theatre*, pp. 366–69, 417–30, 447–49, 471–73; Kirby, pp. 92–93; Mario Verdone, *Teatro del tempo futurista* (Rome: Lerici, 1969), pp. 209–21, 340–42, 424–25; Patrizia Veroli, 'The Futurist Aesthetic and Dance', and Gianfranco Lucchino, 'Futurist Stage Design', both in *International Futurism in Arts and Literature*, ed. by Günter Berghaus (Berlin, New York: Walter De Gruyter, 2000), pp. 422–48, pp. 449–72; Ruggero Vasari, *L'angoscia delle machine e altre sintesi futuriste*, ed. by Maria Elena Versari (Palermo: Duepunti, 2009).
40. See Berghaus, *Italian Futurist Theatre*, p. 247.
41. The text is now in *Teatro sintetico futurista*, ed. by Guido Davico Bonino (Genoa: Il Melangolo, 1993), pp. 177–80. See Davico Bonino, p. 31, Berghaus, *Italian Futurist Theatre*, p. 300, Kirby, p. 59, and Gabriele Marino's 2009 reconstruction at <http://www.youtube.com/watch?v=ict51WbO3AI>.
42. See especially Berghaus, *Italian Futurist Theatre*, pp. 264–78; Kirby, pp. 71–79; Verdone, pp. 19–20.
43. See Berghaus, *Italian Futurist Theatre*, pp. 253–58.
44. See Museo di Arte Moderna e Contemporanea di Trento e Rovereto, *DeperoFuturista: Rome – Paris – New York 1915–1932 and More*, exhibition curated by Gabriella Belli (Milan: Skira, 1999), pp. 77–81 (p. 78). This includes the brightly coloured poster designed by Depero for the performances, his oil painting *I miei balli plastici* (1918), and photographs of the 1982 reconstructions of the puppets. See also Berghaus, *Italian Futurist Theatre*, pp. 309–15; Verdone, pp. 271–72, Veroli, p. 438.
45. See *DeperoFuturista*, p. 66.
46. Quoted in Verdone, p. 272.
47. See Kirby, p. 108; Berghaus, *Italian Futurist Theatre*, pp. 280–84, Lucchino, p. 458.
48. See Berghaus, *Italian Futurist Theatre*, pp. 315–18; *DeperoFuturista*, pp. 82–113.
49. *Roma futurista*, 18 Jan. 1920, p. 2.
50. See Segel, pp. 266–69; Berghaus, *Italian Futurist Theatre*, pp. 454–58; Kirby, pp. 80, 110; Verdone, pp. 280–82; Lucchino, pp. 466–68; Giovanni Antonucci, *Cronache del teatro futurista* (Rome: Edizioni Abete, 1975), p. 248.

CHAPTER 15

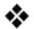

The Bed

Silvia Contarini,
Université Paris Ouest Nanterre La Défense

Cara amica, mi domandate un consiglio per guarire la vostra incurabile noia?
Se non foste stata la mia amante vi proporrei di amarmi in uno dei
mille fantasiosi letti di lirismo-pericoloso
che io so predisporre sotto i nervi delle donne.
[My dear friend, you ask for advice on how to heal your incurable boredom?
If you weren't my lover, I would suggest that you love me in one of the
thousand inventive beds of lyricism-danger that I can prepare for the nerves
of women.]

FILIPPO TOMMASO MARINETTI[1]

Introduction: The Choice of the Bed

A survey of Marinetti's thousand imaginative Futurist beds could confirm or deny their vaunted qualities as remedy for boredom, permeated as they are with inventiveness, lyricism, and danger. As is immediately evident in the epigraph, Marinetti does not allude to existing beds, but to beds that have been prepared by the Futurist imagination. Rather than an exhaustive examination, this essay proposes a close analysis of the functions and qualities assumed by the object/space/place 'bed' in the imagery and in the ideology conveyed by Futurist texts. Our objective will be to verify which fundamental precepts of the avant-garde movement are found in the meanings and the representations of the bed, real or metaphorical. Of course, Futurism, and Marinetti in particular, has accustomed us to aporias and contradictions, to discrepancies between intents, injunctions, practices, achievements, and behaviours. In previous studies,[2] I have shown how one of the major Futurist aporias can be found in questions of gender, more precisely in the gap between declarations glorifying radical transformations, and the de facto incapacity, or unwillingness, to imagine a true transformation of gender relations. At the same time, I emphasised the different position of some Futurist women, who adhered to the movement because they were convinced that Futurism (and not feminism, which was too mindful of civil rights and of keeping women tied to maternal functions) could be the driving force of change also for women.

The basic hypothesis of this chapter is that taking into consideration a 'microplace' such as the bed, packed with social values and strongly evocative for the collective

imagination, can provide exemplary illustrations of the previous observations. Through a series of Futurist texts, we will pass from bed to bed (or, rather, from one scene where the bed is ignored to another), with the intention of first exploring spaces of Futurist intimacy and the information they reveal about private life, and subsequently making our way back to artistic and public life, to ideas and theories. The bed will function as a detail that will be observed through a magnifying glass and then resituated in a broader context.

Such a microhistorical perspective seems completely appropriate to examine an avant-garde movement that has already been the subject of countless studies and yet is also so complex and dense and, as has been said, contradictory that a focus on the particular, on the singular, on minutiae, on the margin, on the symptom, could prove particularly revealing. Naturally, this is not the essay of a historian, but of a scholar of Futurism who does not attempt to narrate events. Nevertheless, the microhistorical perspective, as it is used in cultural studies, is a source of methodological inspiration: over and above the artistic dimension, it is important to understand the extent to which Futurism affected or tried to affect society, ideas, customs, relations, that is, culture and mentalities.[3] In this sense, some basic concepts of microhistory are particularly useful. First of all, the reduction of the scale of observation: if on the one hand this reduction makes possible an overall vision of a totality to which to give meaning and over which to have mastery, on the other, it allows one better to see things that are otherwise invisible and to use them as proof or counterproof of general theories. A further clarification: in microhistory, the object of study is not significant in itself; it is significant in relation to a whole. The choice of the micro-object entails the voyage back, the return to the large-scale picture.

In a seminal essay on microhistory by Carlo Ginzburg, 'Microhistory: Two or Three Things That I Know About It',[4] the author traces the evolution of the definition and of the different connotations that it has acquired. Among other things, he remarks that he was struck by George R. Stewart's passion for microscopic details: microhistory, in short, does not only entail giving space to a singular event, to a local history; it does not merely involve narrating (again) some minor event, but also the observation of peripheral elements. In the present essay the object, the bed, which is literally and figuratively both space and place, will serve as an observatory from which to view gender relations and, as a consequence, the conception of woman and man within the new world of the reconstructed Futurist universe.

From the Bourgeois Bed to the War Pallet

If it is true that male–female relations are played out in bed, and that for the Futurists such relations are principally, not to say exclusively, sentimental and erotic — which is why we are interested in the sexed meaning of the bed and its notable implications — it is nevertheless important to keep in mind that the main function of the bed is not the one implicit in expressions like 'to go to bed with someone'. Rather, the main meaning of the bed refers to sleeping or resting. However, the

Futurists reject both these functions when they are considered in the conventional sense they have in bourgeois life, which therefore makes them antithetical to the Futurist values propagated by the new man.

Let us briefly consider the rare cases of Futurist representation of the bed as a place of rest or (even worse) sleep. Marinetti's 'Fondazione e manifesto del Futurismo' [Foundation and Manifesto of Futurism], the movement's founding programmatic text, begins with these words: 'My friends and I had stayed up all night'.[5] The young Futurists have neither the will nor the time to sleep, since at night they reinvent the world rather than waste their time resting, languishing, and loving. The second Marinettian manifesto also contains an explicit refusal of sleep and of the bed: 'Uccidiamo il Chiaro di Luna' [Let's Kill Off the Moonlight] opens with an exhortation to the inhabitants of Paralysis that ends with the words: 'you [. . .] can go back once more, for tonight anyway, to your filthy beds of tradition which we no longer wish to sleep in!'[6] Among the things that separate the Futurists who have a mission to carry out from the impotent inhabitants of the old world is the bed: filthy and traditional, the bed of the enemies of Futurism is rejected by the young avant-gardists. In opposition to the heroic Futurist warrior who does not sleep, by will or by necessity (sleep is impossible when one goes to bed on wood or straw infested with bugs)[7], the bourgeois man, the 'faint-hearted, stay-at-home citizen of any provincial town', passive and opportunistic, observes from the comfort of his (bourgeois) bed the great scientific discoveries and immense transformations of the world without actively engaging in it: 'when finally he is lying down in his bourgeois bed, he can enjoy himself listening to the costly, far-off voice of a Caruso or a Burzio'.[8]

These allusions to the bed fully conform to the basic precepts of the movement and could have given rise to a typically Futurist slogan as 'vegliare e non dormire' [keep awake and do not sleep]. Yet, after the first foundational texts that fixed the image of the young Futurists scornful of sleep and of comfort, it is difficult to find explicit references to the bed, which seems to indicate that the meanings attached to the image of the bed may have been too obvious: why keep hammering against the idea of rest when no one could imagine a Futurist sleeping in a soft bed? At most, he might lie on the 'tactile' beds and divans mentioned in the manifesto 'Il tattilismo' [Tactilism], which, however, does not specify the characteristics of such items.[9]

References to the bed as the canonical site of sexual relationships are, on the contrary, quite frequent and more complex. First of all, it needs to be stressed that this function of the bed is also associated with principles rejected by Futurism, such as sensuality, romanticism, feeling, and as a consequence the bed is itself rejected and condemned. In one of the first manifestos, 'Contro Venezia passatista' [Against Traditional Venice], in which the signatories Marinetti, Boccioni, Carrà, and Russolo inveigh against the *passatismo* of Italian culture, as well as against romanticism, sentimentalism, lust, and erotic adventures — the black list of early Futurism reiterated like a refrain — Venice is accused of being repository of all of the above in the eyes of the world. With a well-chosen metaphor, the city that was once loved and is now repudiated by the Futurists is defined as a 'bed worn out

by endless droves of lovers'.[10] The pansexuality that characterises the Marinettian universe is also observable here.

The negative vision of the bed as object-space-place of sexual relations can be synthesised in two phrases from the founder of the movement: 'tutto ciò non esige il letto' [all this does not require a bed], one reads in the 'Manuale del perfetto seduttore' ['Manual of the Perfect Seducer'];[11] 'il letto non basta' [the bed is not enough], says the '5ª anima' [5th soul] in *8 anime in una bomba* [*8 Souls in a Bomb*].[12] In other words, on the one hand eroticism does not require assigned places, but can be expressed anywhere — indeed, it is best expressed in uncustomary contexts and environments. On the other hand, conventional places cannot contain the Futurist ambition for totality and for novelty that is expressed in every moment of life, and therefore also in sexuality.

The condemnation of the bed, which is past-loving, bourgeois, and conformist, expands to the living room and to the divan, both surrogates of the bed. In the chapter 'La donna e la strategia' [Woman and Strategy] of *Come si seducono le donne* [*How to Seduce Women*], which, as Nazzaro perceptively pointed out,[13] should be understood as a parody of the scenes of seduction in vogue in the culture of the time, Marinetti describes a seductive strategy that has been successful a dozen of times. A bold man begins by praising the elegance of the woman 'come un critico passatista insisterebbe su un Canto di Dante' [like a past-loving critic would insist on one of Dante's cantos], then the action shifts to the divan, the central element since, as is repeated, 'se il divano è propizio, la donna è vostra' [if the divan is propitious, the woman is yours]. The propitious divan is not plain, it is not in a room that is too white, it is not in the *empire* style, and so forth. On the contrary, what is helpful is the Oriental style, with 'divani arabi bassissimi con disordine di cuscini variopinti' [very low Arab divans and a mess of multi-coloured cushions] that creates an exotic atmosphere that is the opposite of the so-called 'white telephone' cinema (*telefoni bianchi*), the conventional and romantic bourgeois cinema of the period.[14] It is also noteworthy that Marinetti depicts the scene of seduction like a battle, and sees the living room as a topographical space one must become familiar with before the assault. Furthermore, the scene ends with the woman who rejects the lover and is besieged in the bedroom, which, after a long struggle, the daring man enters by force.

The close association within Futurism of eroticism, heroism, war, and warmongering has already been pointed out,[15] and images of the bed confirm how close these associations are. With a curious but significant overturning of representations, during wartime the sexual act is consummated in spaces where the soldier, retreating from battle, reaffirms his virility. This space is not a bedroom or a bed. The sexual act, defined as an 'operation', is carried out in brothels that are defined as operating rooms, where love is mechanised ('Le porte si chiudono ogni tanto su dei chiarori di camere chirurgiche per rapide operazioni. Meccanizzazione dell'amore' [The doors close every so often on some glimmers of surgical rooms for rapid operations. Mechanisation of love]).[16] In other cases, the attempts to seduce peasant women are battles conducted in the bed/barn where soldiers should regain their strength while

outside machine guns fire at will.[17] At the same time, the war is depicted as a vast, sexualised operation that takes place in a battlefield transformed into a bed. In the long scene that emanates from Marinetti's '5th soul', called 'Lussuria' [Lust], erotic and warlike metaphors intersect; at the end of the scene, the battle on the Carso and sexual desire overlap, and upon hearing the bomb blasts the soul exclaims: 'Quanto fragorosi i vostri amori! Quanto chiasso nel vasto letto' [How thunderous your loves! What an uproar in this vast bed].[18]

In the same scene, the author introduces a truck-vulva that anticipates Marinetti's most significant alternative to the bourgeois bed: the steel alcove. This steel alcove is the central object in the novel of the same title, *L'alcòva d'acciaio* [*The Steel Alcove*], a novel akin to a war diary of the last months of the war. The 'alcove' of the title is a multi-functional truck that serves as bed-uterus-weapon-lover. It is a sort of expansion of the bed into a fusional space, at the same time warlike and protective. One of the many metaphors is a particularly warlike-sexual scene, where the Futurist hero welcomes his lover, Italy, in the steel bed that evokes 'carni che sognano di metallizzarsi' [flesh that dreams of metallizing]:[19] 'Tu sei l'alcova d'acciaio veloce, creata per ricevere il corpo nudo della mia Italia nuda, che ora, con grazia, per i graziosissimi piedi, trascino dentro, dentro di te!' [You are the fast steel alcove, created to receive the naked body of my naked Italy, that now, with grace, by its very graceful feet, I drag inside, inside you!].[20]

In addition to the machinist's connection with the metallic alcove, Lambiase rightly sees in the Marinettian steel alcove also the derision of the 'central figure of literature of the end of the century, an over-decorated art nouveau symbol':

> Non vi è alcun dubbio che l'alcova marinettiana voglia essere, programmaticamente, la confutazione irridente e irriverente di ciò che dovrebbe denotare e connotare l'alcova. Invece che cortine ombreggiate, parati o velluti, si hanno lisce pareti metalliche.
>
> [There is no doubt that the Marinettian alcove wants to be, programmatically, the mocking and irreverent confutation of what the alcove should denote and connote. Instead of shaded curtains, drapes, or velvets, here we have smooth metallic walls.][21]

Other Futurist Beds/Non-Beds

The juxtaposition of bed and war is found again, now facetiously, in the *polibibita* [mixed drink] called *Guerrainletto* [Warinbed]. The Futurist cocktail accompanies Marinetti's recipe 'pranzo notturno d'amore' [nightly love dinner], the main ingredients of which are pork meat and large oysters,[22] and it is specified that the lovers will raise their glasses when they enter the bed — a vast bed, even lighted by the moon, and situated in the back of a room in Capri, in August. There is nothing more conventional than this bed and the whole setting it fits into; instead, what does stand out is the *polibibita Guerrainletto*, which mixes spicy, energising, and clashing ingredients (pineapple, eggs, cocoa, caviar, almonds, red pepper, nutmeg, cloves, all drowned in Strega liquor) and thus matches the Futurist spirit and heralds convolutions and perturbations (including those of the intestines). It should be

observed that the recipe dates to a later period than the texts that have been quoted so far, as it was written in the thirties, in the period of the so-called 'academic' Futurism, under then soundly established Fascist rule. What can be observed in this scene is a striking change of focus, as the Futurist operation now leaves the core elements of the scene unaffected and concentrates on the transposition of details: the romantic bed and the whole romantic setting are re-established, and only the beverage is revolutionised according to Futurist standards. This change of focus may be read as a sign of the disempowerment of the movement. Having given up on its global and radical utopia of reconstructing the world, it concentrates on revolutionising commodities such as food and drinks.

But let us go back in time to the period when the Futurists were animated by the furor of the new and fantasised lying on alternative and improvised erotic beds. It seems predictable that one of these beds should be the car, an object that, as soon as it becomes a place for sex, is transformed into a 'letto impazzito' [crazed bed], as Marinetti calls it in *Come si seducono le donne*: 'Semisdraiata, sotto una coperta, e premuta da un corpo maschile, essa [*la donna*] si sente scivolare irresistibilmente come in un letto impazzito giù giù in fondo al gorgo dell'orizzonte' [Half lying down, under a blanket, pressed against the man's body, she [the woman] is irresistibly drawn down down towards the whirlpool of the horizon as if in a crazed bed].[23] Replacing the immobility of the bed with the speed of the car, this image is also founded on the simile offered by the shape of the cars of the early years of the twentieth century, in which driver and passenger were positioned with legs stretched out (and in fact half lying down) and used blankets to protect themselves from the wind.

For the Futurists, speed and mechanics certainly produce strong and new emotions. In addition to the car, the train too is an attractive alternative to the boredom of the conventional bed. For the Futurist hero Marinetti, the train provides the setting for new types of conquest: in a train, obviously moving fast because it is an express, the jolts in the compartment accompany the bodies that come together following the 'ritmo furibondo' [furious rhythm] of the locomotive. On another occasion, in the obscurity of the half-empty compartment, the enterprising Futurist, acquainted with neither sleep nor rest, launches into an attack on a woman that takes place while her husband, perfect emblem of the cowardly bourgeois, blissfully sleeps.[24]

After the car and the train, one could expect similar examples figuring the aeroplane. However — perhaps because it is less practical than the train or the car, or perhaps because it evokes an aerial, incorporeal dimension — the aeroplane does not easily replace the bed. Going beyond the earthly bounds, and the bounds of narrative realism, Paolo Buzzi imagines an ethereal coupling in his experimental science-fiction novel *L'ellisse e la spirale* [*The Ellipse and the Spiral*]. The novel describes a war of the sexes that at first concludes with the creation of a republic of women and the defeat of the men, then with the massacre of the women. The virgin queen Deliria is an expert aviatrix: alone in her aeroplane, she experiences the thrill of altitude and power. After various adventures, the prince Naxar, at the helm of his aircraft, launches an assault. The 'metafisica fornicazione' [metaphysical fornication]

takes place in the heavens, in an ethereal dimension, and is expressed in *tavole parolibere* [Free-Word Tables] that replace linear writing: the graphic composition of the words evokes the biplane, the climb, propellers, wings, tremors.[25] This is an extreme case of what we could call a 'non-bed' because of its incorporeal nature. As in the case of the other Futurist beds, however, the bed-aeroplane epitomises Futurist qualities such as mechanics, speed, thrill, novelty, defiance of conventions and of danger, quickness of contact, struggle, and conquest.

Another exemplary case allows us to note once again the profound rejection of the bourgeois, *passatista* bed, a place of comfort that cannot provide the strong sensations that Futurists are searching for. Even bare stone is preferable to the bed and the divan that the two lovers could afford in a luxurious hotel in Palermo during a scorching summer: 'Fui felice di sdraiarmi con lei sulla pietra nuda, lontano dai divani e dai letti torridi' [I was happy to lie with her on bare stone, far from sweltering beds and divans].[26]

The 'filthy beds' into which Marinetti prides himself on bringing his snobby Parisian lover not once, but more than fifty times, can be considered from the same perspective:

> Una signora parigina del Faubourg Saint-Honoré, che pur non essendo maniaca avrebbe preferito suicidarsi piuttosto che coricarsi in un letto inelegante, fu da me naturalmente sdraiata in più di cinquanta letti assolutamente fetidi di più di cinquanta alberghi ultrafetidi del Quartiere Latino.
>
> [A Parisian lady of Faubourg Saint-Honoré, who, while not obsessed, would have preferred suicide to a tasteless bed, allowed me to make her lie in over fifty utterly filthy beds in over fifty super-filthy hotels in the Latin Quarter.][27]

Notice how the principle of seriality and of multiplication here overlaps with the taste for behaving like a scoundrel and *épater le bourgeois*, which excites the Futurist.

Let us move on to a last example, a scene that is both in a geographical and in an ideological sense remote from the amorous Parisian adventures: the scene of Javanese incest mentioned in the Words-in-Freedom composition 'Caucciù e Guttaperca' included in *Zang tumb tumb*: in a hut in Java, on a night when everything exudes sex and eroticism, a wife, in order to keep back her warrior husband, offers him their daughter in her 'vasto letto cooperativo' [vast cooperative bed].[28]

Women's Beds

In these last two examples, the 'filthy' bed and the 'cooperative' bed, the implicit humiliation or subjection of the woman raises the question of how Futurist women represented beds in their work. Two important Futurist women writers, Enif Robert and Rosa Rosà, have proposed their own — and apparently quite dissimilar — visions of womanly literary beds.

The hospital bed plays a central role, both real and symbolic, in *Un ventre di donna. Romanzo chirurgico* [*A Woman's Womb. Surgical Novel*].[29] It should be remembered that the novel claims to report the true story of an illness experienced by Enif

Robert, the name of the author and of the protagonist who tells the story in the first person, and is signed not only by Robert, but also by Marinetti, whose contribution seems to be limited to some texts inserted in Robert's story. The sick woman spends months and months in a hospital bed that she hates.[30] For her, the bed represents martyrdom[31] and torture[32] because, in addition to the suffering it causes, it also forces her to stay immobile. Marinetti writes for her a *Manuale terapeutico del desiderio-immaginazione* [*Therapeutic Manual of Desire-Imagination*] in which he exhorts his sick friend no less than three times to defeat her immobility by using her imagination to move from the bed.[33] In a letter sent from the front, Marinetti also compares the bed to a trench, as both represent a battleground ('Voi inchiodata in un letto, io in una trincea fangosa' [You are caught in a bed, I in a muddy trench]). The problem is that both their enemies as well as the necessary remedies are different: Robert fights against her infected genital organs, against a lethal uterine femininity, and she will defeat the disease by liberating herself from it, radically and courageously, becoming in this way a Futurist woman. In reality, in the novel Enif Robert does not achieve a complete transformation. While her story closes with her convalescence, an imaginary princess, also affected by a sick womb, appears in the last chapter. She undergoes surgery against the wishes of her husband, who is killed by an *ardito*; eventually, and finally free, 'balza nuda dal letto' [she jumps out of bed, naked].[34] In effect, in the novel we witness the metamorphosis of a conventional woman into a liberated woman, a metamorphosis that entails — in the abandonment of sickbed, gynaecological sufferings, and immobility — a redefinition of the prerogatives of gender. In contrast with the Futurist beds analysed up to now, Robert's bed does not accommodate two bodies that rapidly consummate the sexual act, but a sexed woman's body that undergoes a long and tormented process of change.

The second example is taken from 'Non c'è che te' [There's Only You], a short story by Rosa Rosà.[35] The story seems conventional: Edwige, a bourgeois lady, longingly awaits her adored lover, who has been avoiding her lately. After vainly waiting for him for hours, she sees an old male friend; upset and desperate, she tells him about her pangs of love. The friend takes advantage of her distraught state by bringing her to his place and making her drink. The woman continues to talk to him about her unhappy love, then insists that he bring her back home. When the friend tries to kiss her, she puts up a fight, but the door is locked. The friend tries over and over again; in the end, the woman, exhausted, convinces herself that her lover also betrays her and 'in fondo — che importa?' [In the end — what did it matter?]. The story continues thus: 'Quando Edwige recuperò i sensi, udì il rumore della pioggia. Si svegliò trovandosi sdraiata per terra, sullo scendiletto davanti al letto' [When Edwige came to her senses, she heard the sound of the rain. She awoke and found herself lying on the floor, on the bedside rug by the bed].[36] Incapable of reacting, disgusted with herself, dejected, she remains at length on that bedside rug, the site of her humiliation, of female weakness before male predation. Yet, the protagonist does not praise fidelity and marriage at all and indeed, the story closes with an acute reflection on the reasons for which she is separating in the name of freedom. Rather, she stresses aspects such as consciousness, desire, pleasure: a

woman should not be the object of male serial conquests, but an autonomous subject capable of making decisions. To the fickle woman who does not know how to resist masculine pressures (the prey of the Futurists in the manual *Come si seducono le donne*) and finds herself unconscious and disgusted on a bedside rug, Rosà opposes an independent and involved woman who would maybe say yes to the bed, but certainly not to the bedside rug.

In sum, the hospital bed and the bedside rug are not Futurist versions of the traditional bed. Rather, they too are the beds of a culture that forces women into traditional roles. Like the male Futurists, Enif Robert and Rosa Rosà associate the bed with sexuality rather than with sleep or with dreams, but, aware of the issues that it involves, they do not propose a thousand erotic, fantastical beds, but the rejection of the beds of female subjection.

Conclusions

In a Futurist manifesto dedicated to the architecture of the thirties, the bed returns as an object or place within the domestic space, in a role that is revised and no longer associated with male–female relations: the Futurist house will no longer have bedrooms or even dining rooms, only variable spaces with automatic furniture and walls.[37]

Our survey of texts from the first years of Futurism has shown aeroplanes, trains, cars, barns, battlefields turned into beds; whether they are situated in luxurious or fetid places, the real or symbolic beds of the Futurists have invariably expressed Futurist principles like speed, mechanicalness, multiplicity, *antipassatismo*, anti-bourgeois spirit, praise of the new, technology and mechanics, virility, and warlike heroism. The Futurist beds (or non-beds) that have been mentioned also resemble each other for another reason: because of the sexual relations that take place in them they do not distinguish themselves from the norm — that is, from ordinary relations between man and woman (provided one does not consider adultery and prostitution, the oldest profession, as being unordinary). The new man remains a warrior, a hunter, an oppressor. Whether it is straw, cars, alcoves, or other variations, the masculine Futurist imagination goes rampant as far as space/time features are concerned, but it does not stray from the conventional when it comes to relationships — sexual, first and foremost — with women: predation and cataloguing. What emerges out of the Futurist version of the bed, for all the anti-bourgeois and antipasséist pretensions, is a vision of the Futurist man, of women, and of gender relations that does not tarnish deep-rooted preconceptions.

Not even the Futurist women fully succeed at proposing new representations: Robert gets up from the bed of female immobility, but says nothing about the new woman's future bed. As for Rosà, she imagines that women can arise from the bedside rug and that freedom is on the horizon, but stops there. We conclude that the avant-garde movement seems to have proposed a Futurist man who in bed does not differ from non-Futurist men, if not for an exasperation of his virile characteristics: in his thousand fantastical, dangerous, lyrical beds, he wants to

seduce all women. Yet does that include the Futurist woman? Her seduction proves to be difficult, because the Futurist woman does not see herself as prey. Here, then, appears the dissymmetry of the utopia of the new Futurist world: pushing the logic to its limits, in the Futurist bed there are new men and old women. The new women are looking for alternative models.

Translated by Kathleen Gaudet

Notes to Chapter 15

1. Filippo Tommaso Marinetti, *Scatole d'amore in conserva* [*Canned Love*] (Rome: Edizioni d'arte, 1927), p. 32. The citation is taken from the chapter 'Consigli a una signora scettica' [Advice to a Sceptical Lady], illustrated by a drawing by Ivo Pannaggi showing a black man holding an enormous cylinder in his hands.
2. Silvia Contarini, *La femme futuriste. Mythes, modèles et représentations de la femme dans la théorie et la littérature futuristes (1909–1919)* (Nanterre: Presses Universitaires de Paris 10, 2006).
3. For the connections between microhistory and cultural studies, see the entry 'Microhistory' edited by Ida Fazio in the *Dizionario di cultural studies* (<http://www.culturalstudies.it/dizionario/lemmi/microstoria.html>). The website culturalstudies.it is a project by Michele Cometa, University of Palermo.
4. Carlo Ginzburg, 'Microhistory: Two or Three Things That I Know about It', *Critical Inquiry*, 20.1 (1993), 10–35.
5. Filippo Tommaso Marinetti, 'The Foundation and Manifesto of Futurism' (1909), in *Critical Writings*, ed. by Günter Berghaus, trans. by Doug Thompson (New York: Farrar, Strauss and Giroux, 2006), pp. 11–17 (p. 11).
6. Filippo Tommaso Marinetti, 'Second Futurist Proclamation: Let's Kill Off the Moonlight' (1909), in *Critical Writings*, pp. 22–31 (p. 22).
7. 'it's very cold not enough blankets impossible to sleep on wood on straw bedbugs', Filippo Tommaso Marinetti, *Zang Tumb Tumb* (Milan: Edizioni futuriste di *Poesia*, 1914), now in *Teoria e invenzione futurista*, ed. by Luciano De Maria (Milan: Mondadori, 2005), pp. 641–779 (p. 678).
8. Filippo Tommaso Marinetti, 'Destruction of Syntax — Untrammeled Imagination — Words-in-Freedom' [1913], in *Critical Writings*, pp. 120–31 (p. 121).
9. Filippo Tommaso Marinetti, 'Tactilism: A Futurist Manifesto' [1921], in *Critical Writings*, pp. 370–76 (p. 374).
10. Filippo Tommaso Marinetti, Umberto Boccioni, Carlo Carrà, Luigi Russolo, 'Against Traditional Venice' [1910], in *Critical Writings*, pp. 158–64 (p. 163).
11. Filippo Tommaso Marinetti, *Come si seducono le donne* (Florence: Edizioni da Centomila copie, 1917). Citations are from the reprint of the second edition of 1918 (Florence: Vallecchi, 2003).
12. Filippo Tommaso Marinetti, *8 anime in una bomba. Romanzo esplosivo* (Milan: Edizioni futuriste di *Poesia*, 1919), now in *Teoria e invenzione futurista*, ed. by Luciano De Maria, pp. 795–912 (p. 846).
13. Nazzaro notes that these scenes of seduction aim to ridicule a whole atmosphere, that of the bourgeois drawing room, a topos in the literature and the theatre of the *fin-de-siècle*. Cf. Giambattista Nazzaro, 'Futurismo ed erotismo', chapter 8 of *Introduzione al futurismo* (Naples: Guida, 1984), p. 146.
14. Marinetti, *Come si seducono le donne*, pp. 31, 32, 33.
15. See at least Mario Isnenghi, *Il mito della Grande Guerra* (1970) (Bologna: Il Mulino, 1989), pp. 179–81.
16. Filippo Tommaso Marinetti, *L'alcova d'acciaio. Romanzo vissuto* (Milan: Vitagliano, 1921). All quotes are from the 1985 edition (Milan: Serra e Riva), with Alfredo Giuliani's excellent preface (this quote is from p. 9).
17. Marinetti, *8 anime in una bomba*, pp. 815–19.
18. Ibid., p. 850.

19. Marinetti, *L'alcova d'acciaio*, p. 59.
20. Ibid., p. 198.
21. Sergio Lambiase, 'Dall'alcova liberty a *L'alcova d'acciaio*', in *Marinetti futurista* (Naples: Guida, 1977), p. 165 and p. 163.
22. Filippo Tommaso Marinetti and Fillìa, *La cucina futurista* (1932) (Milan: Viennepierre, 2007), p. 152. See also the website *Sapere bere, cocktail non codificati*, which gives a lighter version for Valentine's Day (<http://www.saperebere.com/cocktail-non-codificati.html>).
23. Marinetti, *Come si seducono le donne*, p. 51.
24. Actually, there are three seduction scenes that take place in the train recounted in *Come si seducono le donne* (see pp. 52–54).
25. Paolo Buzzi, *L'ellisse e la spirale. Film + parole in libertà* (Milan: Edizioni futuriste di *Poesia*, 1915). The quotations are from the reprint Florence: SPES, 1990, pp. 244–49.
26. Marinetti, *Come si seducono le donne*, p. 82
27. Ibid., p. 23.
28. Marinetti, *Zang Tumb Tumb*, p. 754.
29. Filippo Tommaso Marinetti and Enif Robert, *Un ventre di donna: romanzo chirurgico* (Milan: Facchi, 1919). On this novel, see Barbara Zecchi's essay 'Il corpo femminile tra scrittura e volo. Enif Robert e Biancamaria Frabotta: settant'anni verso il tempo delle donne', *Italica*, 69.4 (1992), 505–18, and my essay 'Guerre maschili/guerre femminili: corpi e corpus futuristi in azione/trasformazione', *Annali di italianistica,* 27 (2009), 125–38.
30. Marinetti and Robert, *Un ventre di donna*, p. 192.
31. Ibid., p. 75.
32. Ibid., p. 96.
33. Ibid., pp. 163–65.
34. Ibid., p. 217.
35. Rosa Rosà, 'Non c'è che te', in *Una donna con tre anime e altre novella* (Milan: Facchi, 1919). The quotations are taken from its recent publication in *L'arte futurista di piacere. Sintesi di tecniche di seduzione*, an illustrated collection edited by Barbara Meazzi (Cuneo: Nerosubianco, 2011), pp. 88–124.
36. Rosà, 'Non c'è che te', p. 107.
37. 'The inside of the house [. . .] No bedrooms, dining rooms, or living rooms but a shaping at will of all imaginable environments' (Filippo Tommaso Marinetti, Angiolo Mazzoni, and Mino Somenzi, 'Manifesto futurista dell'architettura aerea', *Sant'Elia*, 3.1 (1934), now on the website <http://www.futurismo.altervista.org/manifesti.htm>).

AN AFTERWORD WITH GÜNTER BERGHAUS

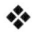

To scholars of Futurism Günter Berghaus needs no introduction. Born in 1953 near Cologne, the renowned German theatre historian and performance scholar has produced books on an impressive array of topics ranging from ritual in prehistorical art to twenty-first-century performance practices. Readers of this book will know him above all from his work on Italian Futurism. Reproducing a complete bibliography of his writings on Futurism would take up half of this book and could perhaps erroneously suggest that Berghaus has ceased to study the Italian avant-garde movement.[1] While it is true that today some of his books rank among classics in Futurism studies — including *Italian Futurist Theatre, 1909–1940* (1998), *Futurism and Politics: Between Anarchist Rebellion and Fascist Reaction, 1909–1944* (1996) — Berghaus continues to be at the forefront of his discipline, among others as the editor of the *International Yearbook of Futurism Studies*. The value of Berghaus's work, especially to the Anglophone world, can hardly be overstated, and very few people know the movement as readily and comprehensively as he does. It was not incidental, then, that the Marinetti family invited him to edit a new English-language edition of F. T. Marinetti's critical writings, which was published in 2006. Meticulous, ever-critical yet always open to new ideas and approaches, Berghaus to us seemed the ideal interlocutor with whom to close this book. On the occasion of his sixtieth birthday, we sat down with him to discuss his views on the history and historiography of Futurism.

How does your own experience as a historian of Futurism relate to the microhistorical approach which this book explores? Have there been, for example, minor or seemingly insignificant artefacts or details which in the longer run proved to have major implications for your historical understanding of Futurism?

GB: I would not say that in my own research I adhere to *microstoria*, but there are indeed certain artefacts that turned out to be rather vital to my work in Futurism studies. My first serious excursion into Futurist territory began in 1984, when I gave a paper on 'Dada Theatre as Anti-bourgeois Performance Art' at a conference in London, where I mentioned that scholars often considered Dada performance to have been modelled on the Futurist *serate*. But when I prepared that paper for publication in a Festschrift, I found next to no concrete evidence for my statement uncritically taken over from my sources. Everybody wrote the same formulaic phrases, and nobody offered substantial evidence for it. That is how I began

FIG. 1. Police file from the *Carteggio Riservato*.

researching Futurist performance art, which took me on a ten-year trail through dozens of archives and libraries.

What initially seemed like a real adventure soon turned into a nightmare. I had learned the spadework of archival research in several countries, but what I encountered in Italy was unlike anything I had experienced before. I shall give an example. On 16 September 1914, Marinetti, Boccioni, Carrà, Mazza, Russolo staged an anti-Austrian rally in the Galleria Vittorio Emanuele in Milan, distributed leaflets headed *The Futurist Synthesis of War*, and burned eight Austrian flags on a funeral pyre in the Piazza in front of the cathedral. They were arrested and charged with an 'attack on relations with a foreign State and burning of a foreign flag'. For six days, they stayed in the San Vittore prison in Milan. I was interested to see if the city archives still had the files relating to that incident and was told that the police file on Marinetti, compiled by the Prefect of Milan, had been transferred to Ministero dell'Interno, Direzione Generale della Pubblica Sicurezza. So I went to the Archivio Centrale dello Stato in Rome, found the archive number, but was told that the file was not in its designated place. The archivist alerted me to the fact that during his search for the file he discovered that there was another file in

the secluded section of the Segreteria Particolare del Duce, and that this Carteggio Riservato had now become available for research. I read that file, which was full of spy reports on Marinetti (see fig. 1), and while I was waiting to receive the police file, I discovered a vast collection of files on other Futurists that had been compiled for Mussolini by the secret police. When after three months the police file was found, I had written the bulk of my book, *Futurism and Politics*, which I published a year later, long before the volume on theatre had come to completion.

So, one coincidence led to another, nothing was planned, or much of what was planned could not be realised. My foray into Futurism, which so far has lasted thirty years, began with an aversion to simply accepting the judgements of dozens of eminent scholars, and indeed with valuing the small before moving to larger assertions.

The history of the history of Futurism is long and winding. It began with the Futurists' own histories of the movement. How did Futurists themselves depict their past? Both Marinetti and Boccioni, for example, liked to portray art or literary history in diagrams that came in the form of a genealogical tree, with Futurism as a rule showing itself as the tree's stem from which all later avant-gardes grow as branches. Marinetti at the same time also liked to pitch the idea of an endless generational conflict. What other models for history surface in Futurism? And which Futurist histories are still worth reading today?

GB: Most of Marinetti's own accounts were either autobiographical or mythological. They are of little historiographic value, as they suffer from the fading memory of an old man who at this point dictated most of his writings, or are conscious reinterpretations (that is, falsifications) of historical events. Similarly, the genealogical or family tree model in its various guises has to be seen in the context of the Futurist propagandistic project. Until 1945, some one-hundred book-length studies were published on Marinetti and Futurism, but seen from today's perspective their critical value is rather limited, perhaps with the exception of Fillìa's *Il futurismo* (1932), because this book sketches the movement's history in broad and interesting terms. Other histories by Futurists I find to be of less value. These include Remo Chiti's *I creatori del teatro futurista* (1915), Emilio Settimelli's *Marinetti: L'uomo e l'artista* (1921), and Bruno Sanzin's *Marinetti e il futurismo* (1924). They often take the form of simple narrative chronicles, as in Francesco Cangiullo's *Le serate futuriste* (1930). Sometimes they resemble hagiographies, as in the case of Alberto Viviani's *Il poeta Marinetti e il futurismo* (1940). In the post-war period, ex-Futurists undertook major efforts to keep the memory of Futurism alive against the adverse public view of Futurism as Fascist art. As they still considered themselves as Futurists, this effort was not altogether altruistic. They were also creating a platform on which they could promote a neo-Futurist art. On the whole, however, this endeavour found realisation in exhibitions rather than critical studies.

How does the post-Second World War reception and history of Futurism in Italy differ from that in the rest of Europe and beyond? It is often said that the political aspect of the movement made it a bête noire for a long time in Italy. But is that correct? What does the historiography of Futurism in Italian academia look like?

GB: It is true that on an international scale the factors determining post-war Futurism studies were substantially different from those in Italy. For example, post-war French scholars had to fight against the French enmity towards Italy, and in many cases they fell victim to this. German scholarship on Futurism was so minimal because of the general rejection of anything tainted with Fascism. In Anglo-Saxon countries Futurism was seen with quite neutral eyes, which meant that already in the fifties it could be exhibited and written about, while in Italy major ideological hurdles indeed prevented serious and objective approaches.

Those hurdles did not prevent people from writing about Futurism, however, and I must stress that it is a myth to say that Futurism in Italy was not studied or avoided in the immediate post-war period because of its political exploits. During my research into the critical reception of Futurism in the post-war period I have found some 650 publications for the period 1945–59. This is a considerable portion of what has been written on Futurism. (From a macro- rather than microhistorical perspective: my bibliographic research established that, between 1945 and 2009, more than 25,000 books and essays were published on Futurism.) Furthermore, Futurist art too continued to be exhibited after the war. For the period 1945–59, 392 exhibitions documented through catalogues were held that I know of. That said, it is certainly the case that in the fifties attempts to overcome the tainted image of Futurism as Fascist propaganda art made scholars and curators focus on the years 1909 to 1916, and there was a widely felt consensus that Futurism had come to an end with the death of Boccioni and Sant'Elia. Here, then, the phased history of Futurism took root: a first phase, before the Great War, which was supposedly neutral in political terms yet significant in artistic terms and full of ground-breaking aesthetic experimentation, and a subsequent second phase during which experiment died out and politics took over.

Italian views on Futurism have gone through many ups and downs. Each decade of Futurism scholarship evolved within a certain micro-climate — the reception of Futurism in Florence looks rather different from that in Naples. The major shifts and changes were therefore determined by Italian political and cultural history. In Italy, views on Futurism were influenced by three major groups: (1) scholars, (2) curators, gallerists, editors (that is, people who made money from marketing Futurism), (3) local politicians who sought to promote their city, region, or province through funding exhibitions, conferences, or archives concerned with regional Futurism.

When we limit ourselves to the group of scholars, it is rather clear that researchers from different generations have created a picture of Futurism with long-lasting consequences. These scholars include Paolo D'Ancona, Raffaele De Grada, Lionello Venturi, Enrico Falqui, Raffaele Carrieri, Fortunato Bellonzi, Giulio Carlo Argan, Carlo Ludovico Ragghianti, Carlo Bo, Umbro Apollonio, Guido Ballo, Mario Verdone, Ruggero Jacobbi, Maurizio Calvesi, Luciano De Maria, and of course Enrico Crispolti. Some of these critics were already established when Futurism thrived; others came much later and thus had a rather different view of the movement. I believe that it would be a most valuable task to investigate the manifold activities of these scholars, as it would give us important insights

into the manner in which Futurism came to be rediscovered and re-presented in the post-war period. Each of these historians pursued personal concerns and partisan interests. All of them had personal connections with Futurist artists and their views were greatly coloured by this. Of course, they were scholars and not propagators of Futurism. They recognized the historical significance of Futurism without necessarily agreeing to its agenda. But their views were strongly affected by personal experiences and contacts, which means that their studies must be critically analysed. I must stress that this has not yet happened, and the historiography of Futurism is a topic yet to be investigated.

Such an investigation would show, among other things, how strong the influence of the above-mentioned founding fathers of Futurism studies has been on later generations — and not just through their compilation of anthologies. Their influence can be gauged also by the fact that some of their erroneous histories got traded through the generations down to the present day. The views expressed by Verdone, Calvesi, Crispolti and others are not routinely questioned or critically examined, but rather accepted as historical truth. Take the example of Tristan Tzara's purported trip to Italy to gather material for a Dada album. The story about this journey was first set into the world by Vittorio Orazi, Prampolini's brother, who remembered in 1961 that 'Tristan Tzara ed Enrico Prampolini si erano conosciuti a Roma nel 1916.'[2] This statement was repeated by Palma Bucarelli in her catalogue of the first major Prampolini retrospective of 1961,[3] then by Enrico Crispolti in his essay 'Dada a Roma' (1966),[4] and finally by Filiberto Menna in his first comprehensive study of the painter (1967).[5] Daniela Palazzoli extended this assertion to include a visit to Ferrara (without any evidence for this).[6] As Orazi, Prampolini's brother, was writing from memory — and the memory of a seventy-year-old man can be faulty — we would need corroborating evidence before we can safely assume that Tzara ever visited Rome, Ferrara, and other places. However, Tzara's biographer François Buot has found no such evidence. When, a few years ago, I sifted the Futurist literature to find any verification of this journey, I could only trace a long list of scholars who had all repeated what their predecessors had written and then added accretions of their own invention. Having encountered many instances like this — some myths in Futurism studies die hard — I have also developed the habit of questioning *everything* I read, especially when a scholar adds a footnote without a detailed period source.

You talked about phases in Futurism's history, such as first and second Futurism. To what extent does it make sense to 'periodise' the history of Futurism following the many 'turning points' or 'capital moments' the overall historiography of the movement has produced?

GB: In my view, there is only one erroneous turning point in the popular mythology of Futurism: 1916. The death of Boccioni and Sant'Elia is always taken as the sign for the end of the heroic phase of Futurism. However, *primo futurismo* came to an end in 1914/15. During the First World War, Futurism more or less disappeared from the public mind. There were hardly any Futurist group activities, and the press fell silent on Futurism. Looking back, many more subsequent phases could

be and have been distinguished: there was political Futurism (1918–20), there was a post-war revival, with Marinetti, Benedetta, and Prampolini as the guiding lights (1920–23), then came *secondo futurismo* proper (1923–35), with a variety of directions such as mechanical Futurism, oneiric or para-Surrealist Futurism, *aeropittura*, cosmic Futurism and *arte sacra*, and, finally, *il terzo futurismo* (1935–44); here Futurism became a mere political vehicle devoid of true artistic merits (some exceptions notwithstanding). More than 1,000 artists acted under the Futurist umbrella in this final phase, but very few (e.g. Munari or Belloli) created anything of lasting value. Only in the 'minor arts', which were less politicized, can we discern some interesting experimental work or creations characterised by excellent craftsmanship (in interior design, fashion, decorative arts, graphic design). I can only think of a handful of works by Marinetti *accademico* that are still worth reading and studying (e.g. his 'Total Theatre' or 'Radia' manifestos).

Such periodisation has the advantage of creating order in the complex history of the movement. It also allows us to claim that the history of Futurism went beyond the Second World War. A new phase was that of Neo-Futurism (1945–60), guided by ex-Futurists who modestly updated the Futurist repertoire of expressive devices. And from 1960 to the present we have seen a continued Neo-Futurism by artists inspired by certain aspects of historical Futurism. So I have no problem with a basic grid of reference dates that indicate some major shifts and changes. Futurism evolved and metamorphosed over the decades. In my view, the changes were more significant than the continuities. The 'red threads' got extremely thin by the late twenties.

Futurism famously brought a lot of art forms together. To what extent have these various art forms received equal critical attention?

GB: Futurism's great feat is to have fused art forms so far separated, so to some extent it makes little sense to distinguish its different art forms. That said, literature and the fine arts clearly were the movement's preferred outlets, and these have been studied most widely. If we order Futurism's output in different art forms, then we do indeed see that not all of them have received equal attention. My bibliographic research suggests that, so far, there have been relatively few publications on Futurist cuisine (180), ceramics (290), fashion design (335), photography (335), radio and sound art (415), dance (450), furniture, decorative arts and interior design (465). Far more publications have been devoted to Futurist cinema (960), graphic design, typography and artist's books (1,580), music (1,730), architecture (1,770), theatre (2,880).

I cannot say much about the chronological order in which the different art forms practised by Futurists have been studied, which art forms received attention first, and which came later or late. What I can say is that the study of certain art forms and artists was very much tied to local or regional variations in Italian culture. MART in Rovereto pushes Fortunato Depero; Futurist ceramics has been a focal point in Liguria; and the proto-Surrealist tendencies in Futurism are intensely studied in Florence.

What is interesting about the study of Futurist performing arts is of course that these arts have also been brought to life by performances. This started off in the mid-sixties. In the seventies and eighties there were on average four or five theatre productions every year based on historical Futurism. Much less frequent were the attempts to recreate Futurist dance (only five or six significant attempts altogether that I know of). In the field of music, the revival of interest in Futurist compositions hinged on individuals such as Gianfranco Maffina and Rossana Maggia, Pietro Verardo, Daniele Lombardi, or Luciano Chessa, who showed major dedication and great continuity in their attempts to revive interest in Futurist music. I would even say that to this day, the concept of an art of noise is still widely discussed and always linked up with Futurism, also in popular media (see the essays in *The Wire*).

When you were active in the Drama Department of the University of Bristol, you yourself during the nineties engaged in several restagings of Futurist theatre (see figures 2 and 3). How has this helped you to come to terms with the complexity of Futurist performance in general?

GB: In the eighties, British drama departments mainly taught conventional theatre traditions, most notably Shakespeare and Realist or Naturalist drama. Modernist theatre and avant-garde performance were virtually absent from the curriculum. My first stagings (Expressionism, Dada, Bauhaus) were extracurricular activities that gave me the reputation of either being nutty or a rather wacky lecturer. I gave my first course on the historical avant-garde in 1988, and my first curricular productions of avant-garde and experimental theatre took place in the nineties. This allowed students to pursue in a coherent and structured manner their interests in non-verbal and physical theatre, performance art, modern, and postmodern dance. In all of this, I made the integration of theory and praxis a cornerstone of both my teaching and research. I channelled the results of my scholarly investigations into my teaching and, vice versa, I utilised the results of experimental work in the laboratory of workshops, rehearsals and performances in my publications. My two-volume history of avant-garde performance, published by Palgrave in 2005, would have been unthinkable without this setup in the Bristol Drama Department that allowed a tight interaction between theory and praxis.

Is there, perhaps likewise, a difference between how curators, through important exhibitions, on the one hand, and historians working more exclusively within academia on the other, have fleshed out the history of Futurism?

In general curators make the works themselves speak; scholars make their interpretation of those works speak. Curators come in two forms. They are either academically trained with serious cultural-historical interests or they are managers with purely commercial interests. In the fifties and sixties, there were around 150 major exhibitions of Futurist art, 90 per cent of them commercial. Between 1950 and 1970, some 100 ex-Futurists continued to produce work with Futurist features. Their work was exhibited in private galleries, sometimes in conjunction with non-Futurist work, sometimes in retrospectives with older Futurist work. In the fifties and sixties, there were also several group shows by ex-Futurists in commercial and in public galleries. The driving force behind them was Enzo Benedetti and his circle of Arte-Viva.

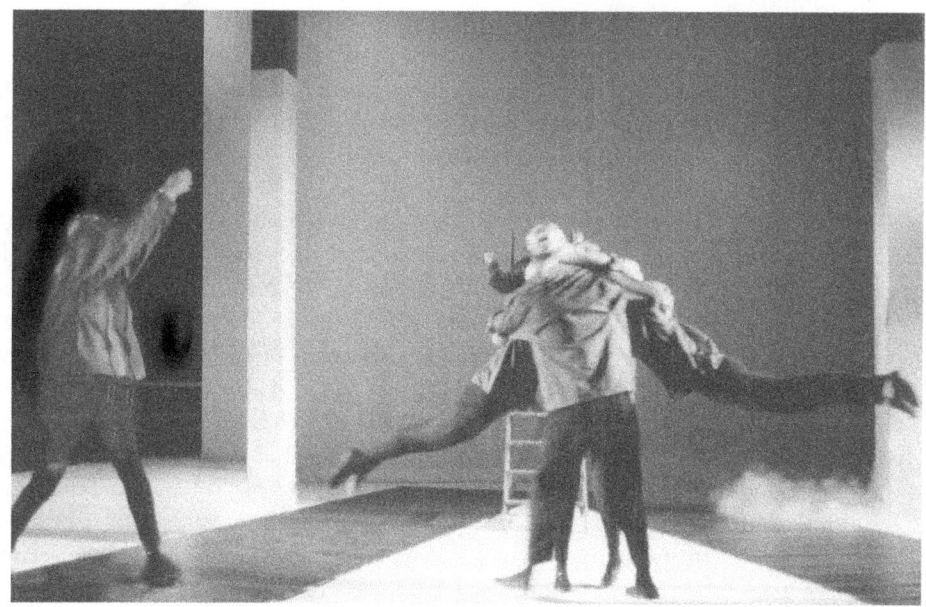

Fig. 2. The Aviatrix — Dance performance inspired by Giannina Censi's *Aerodanze* (1935). Presented as part of a programme of four mechanical dances, *Metal Monsters and Mechanical Mayhem* (Bristol, 1996).

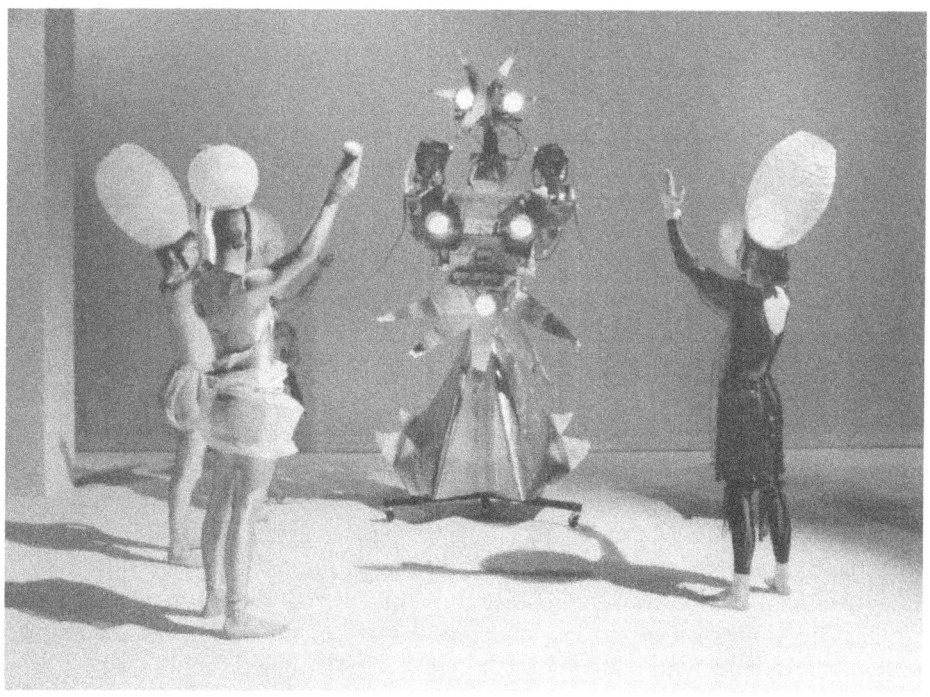

Fig. 3. Fortunato Depero, *Motolampade* (The Moving Lampshades, 1925). Presented as part of a programme of four mechanical dances, *Metal Monsters and Mechanical Mayhem* (Bristol, 1996).

In the fifties and sixties, there were only a handful of exhibitions curated by major public museums. This changed fundamentally in the seventies, when there were large-scale retrospectives for all important Futurist artists, and several group shows concerned with a revaluation of Futurism. These important and pathbreaking exhibitions were curated by scholars such as Crispolti, or academically trained curators in museums.

In the long term, private galleries profited from this revival. There were hundreds of sales exhibitions, and prices rose steeply. Once Futurism had become a profitable market proposition, the families of ex-Futurists started to clear out their cellars and attics. In the eighties and nineties there was a lively trade in Futurist art, so much so that fakes became a real problem. The other downside of the belated commercial success of Futurism was that too many lesser critics jumped on the bandwagon and produced an endless flow of insignificant publications. I have not done a precise statistical analysis, but a rough calculation shows that over the last twenty-five years, an average of 300 books and essays were published each year on Italian Futurism. Such an inundation of exhibitions and publications demonstrates that Futurism occupies in the Italian public mind the position of a major cultural asset. Curators and scholars have collaborated, and quite frequently have doubled up in their tasks (scholars curating shows, and curators publishing books).

How is Futurism today remembered among a wider public in Italy? What is the status of Futurism in cultural memory elsewhere? And has the 'popular' reception of Futurism evolved throughout the previous century?

In Italy, Futurism has become part of the cultural industry. It is widely considered to have been Italy's most important contribution to modern art. Futurism has become big business for museums, publishers, and private galleries. So, naturally, when the movement in 2009 had its centenary, they all wanted to draw maximum profit from the centenary bonanza. Yet, due to bad planning and curating in Italy and elsewhere, effectively, we had to wait for Vivien Greene to put forth the best 'centenary' exhibition, in 2014, at the Guggenheim in New York.

As far as the 'popular' reception of Futurism outside Italy is considered, little has changed over the past decades. The significance of Futurism within the historical avant-garde was first demonstrated in 1949 by James Thrall Soby and Alfred Hamilton Barr in their show, *Twentieth-Century Italian Art* (New York: Museum of Modern Art, 28 June–18 September 1949) and on a much grander scale in 1961 by Joshua C. Taylor (*Futurism*, New York: The Museum of Modern Art, 31 May–5 September 1961; Detroit: Institute of Arts, 18 October–19 December 1961; Los Angeles: County Museum, 14 January–19 February 1962). Also in 'neutral' Switzerland, Futurism was given an early airing, promoted by René Berger at the Musée cantonal des beaux-arts de Lausanne, and René Wehrli at the Kunsthaus Zürich. Other major exhibitions in the post-war period took place in Brussels, London, Paris, and Munich, but the curators or financiers behind these shows were all Italian (Paolo D'Ancona, Giorgio Castelfranco, Marco Valsecchi, Umbro Apollonio; Associazione degli Amici di Brera, Quadriennale/Ente Premi, Biennale di Venezia). Although the significance of these landmark exhibitions is not to be

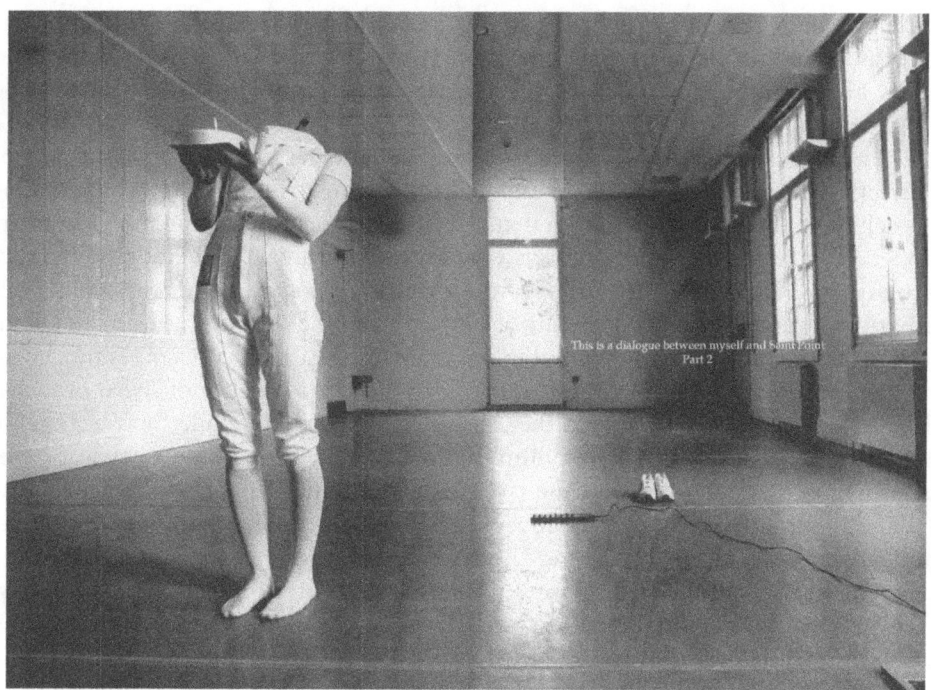

Fig. 4. Maria Sideri, *It Comes in Waves* (Dance performance, 2014).

underestimated, they remained isolated examples. Futurism — in both its Italian and Russian variety — only came to be widely recognized in the seventies, when dozens of major exhibitions and hundreds of books had seen the light of day. The grand picture that was established in these 'foundational years' has been fleshed out in subsequent decades, in a continuous and ever-expanding process.

Despite all this, the general public outside Italy still has very little awareness of Futurist art. If you ask an average visitor to a museum for the ten most important modern artists, no Futurist will appear on that list. If you ask a person with a dedicated interest in modern art, he or she will mention Futurism together with Dada, Surrealism, or Expressionism, but will be unable to say more than a few truisms about the movement (technophilia, machinolatry, interest in movement, Fascistic). Also in journalism old clichés prevail. Textbook opinions of the sixties and seventies are still endlessly repeated — especially the link between Futurism and Fascism. The major advances made in Futurism scholarship have simply not filtered down into the mainstream media.

What, then, has been or is the meaning and role of Futurism in the history of twentieth- and twenty-first-century art? In what art forms has the impact of Futurism been most significant? And are there still Futurist artists today?

Futurism was a major factor of renewal in twentieth-century art. Like other avant-garde movements, it introduced novel stylistic devices, but, more significantly, it overturned prevailing attitudes towards art through (1) its radical drive against all

traditions and conventions of the past, (2) its attempt to demolish art institutions (such as museums, libraries, or academies), (3) its attempt to fuse art and life, and (4) its understanding of art as a process (*arte-azione*) rather than an object to be contemplated.

These ideas had a major impact on subsequent art movements, directly or indirectly, also after 1945, also after 2000. However, an attitude behind a work of art is much more difficult to pin down than a stylistic device resurfacing in works of art produced by later generations. This is why Futurist influences are not always easily recognizable. Outside the fine arts, it was less the ideology and more the aesthetics of Futurism that left a mark. The impact varied from medium to medium and from decade to decade. It was probably the strongest in theatre: the *serate* resurfaced in the Happenings and Fluxus events of the sixties; the a-logicality of *sintesi* or *zaum'* plays influenced the Theatre of the Absurd; the idea of mobile, abstract scenic architectures, as devised by Prampolini, Balla, and Depero, became a key feature of experimental stage design from the twenties to the end of the century. Currently, BellaLuna Productions in Vancouver and a group called The Neo-Futurists, founded by Greg Allen in Chicago, offer interpretations of an updated Futurist theatre aesthetics. In the field of music, Russolo's Art of Noise has a lasting impact to this very day. In architecture, the term 'Futurism' is regularly used, although the link to historical Futurism is only made explicit in a limited number of cases. The same can be said about fashion design, where Futurism is regularly invoked but always metamorphosed into something decidedly contemporary. The restaging of Futurist banquets has become popular following the 1986 example set at the Palazzo Grassi and has led to the Italian reprints of *The Futurist Cookbook* and translations into English, French, German, Japanese, Norwegian, Portuguese, Slovenian, and Spanish. The impact on food design and gastronomy has been massive. Many artists of the Eat Art movement were directly inspired by Futurist food art, as was the design of numerous gastronomic events of the past decades, not to mention Ferran Adrià and molecular cuisine. Futurist radio and contemporary sound art are inextricably entwined. Graphic design, typography, and book art throughout the twentieth century profited from the liberation of the page and the complete rethinking of the book as a container and object by Futurists in East and West. Futurist furniture inspired Ettore Sottsass and the Memphis Group. And, leaving individual art media apart, references to Futurism abound in books on Cyberculture. In Italy, there is even a very active group called Net.futurismo, which organises conferences and performances, and publishes books.

In my view, there were three distinct phases of Neo-Futurism: first, there was the post-war period, which was dominated by ex-Futurists and only attracted a limited number of young artists; second, there were the seventies and eighties, when a new generation of artists rediscovered Futurism as a result of the flood of exhibitions and books published post-1968 (well documented by Renato Barilli); third, there were the post-2000 years, when a good fifty to sixty artists began producing work with direct references to historical Futurism. It also needs mentioning that, after 1989, Futurism enjoyed a major comeback in Russia. Several groups emerged on

the poetry scene and revived the traditions of *zaum'* and visual poetry, following a first but not particularly successful attempt in the fifties by the 'Philological School' in Leningrad. In the Fine Arts, Safar Gali proclaimed himself Grandmaster of Sur-Futurism, and Egor Popov formed in Moscow a group called Rossiiskaia assotsiatsiia futuristov, or Futurists of the Twenty-First Century. It would take several PhD dissertations to investigate these multifaceted revivals of Futurism.

Another interesting example of recent Futurism is Maria Sideri's *It Comes in Waves* (London: Bridge and Company Printers and Stationers, 2014, see fig. 4). This presents a dialogue between the dancer Maria Sideri and Valentine de Saint-Point, reporting on her research in various archives and presenting her recreations of Saint-Point's performances. This publication is the first in a planned series dedicated to an amalgamation of Futurism, feminism, body culture, and performance art.

So far we have looked at the history of Futurism and its historiography mainly within Italy. Perhaps it is time to expand our gaze somewhat and to look at what you call 'international Futurism', which has taken up a lot of your time in recent years. Could you start with saying what you mean by 'international Futurism'?

GB: By 'international Futurism' I mean an avant-garde version of modernism with a particularly future-oriented outlook, which seeks to overturn the restrictions of past traditions and to develop new artistic means to reflect the changes taking place in society. It thus creates the basis for an 'art of the future'. Such an endeavour was first formulated by Marinetti in Italy, but it also developed in other parts of the world — sometimes influenced by Italian Futurism, sometimes existing independently of it.

My interest in this field resulted from the utter frustration I experienced over ten years of research in Italian archives and libraries. I realised that I could investigate the impact Futurism had in other countries without having to travel to Italy. In fact, 90 per cent of all the books I needed I could find in London or Berlin, where in one month I could achieve more results than a year in Italy would produce. So, when in 1994, Laura Lepschy asked me to organise for the recently founded Institute of Romance Studies in London a conference on Futurism, I agreed under the condition that the event would investigate the movement in an international and interdisciplinary perspective. Out of that conference evolved a 650-page volume, *International Futurism in Arts and Literature*, published by De Gruyter in 2000 — the same company that in 2007 agreed to publish an update of my bibliography, *Futurism: A Bibliographic Reference Shelf* and in 2009 to issue a yearbook dedicated to international Futurism.

Defining 'international Futurism' as such is also opening an immense field of research. Is a single history of international Futurism possible?

GB: History is a construction based on the analysis of a plethora of phenomena. International Futurism Studies is in this respect at a very early stage. So far, Futurism has been studied nearly exclusively in a national perspective and has produced a massive amount of publications. Let me give you an indication of the number of studies on Futurism concerning different countries: Bulgaria (100),

Greece (110), Armenia (133), Hungary (150), Scandinavia (160), Georgia (215), Japan (220), the Baltic Countries (230), Belgium (230), Ukraine (290), Romania (330), Czechoslovakia (400), Yugoslavia (470), Brazil (500), Poland (570), USA (650), Germany (780), Portugal (790), Great Britain (1,010), France (1,200), Spain (1,260), Hispanic America (1,480), Russia (5,800). This count is still provisional until I have finally completed my bibliographic handbook of international Futurism. But it suggests the vast scale we are talking about. So, international Futurism studies exists and has, in fact, a history, but this tradition lacks a comparative perspective. Nearly all publications listed in my bibliography have an exclusively national outlook. The task for the future is to get out of this monolinguistic culture and to investigate the links between different forms of Futurism or para-Futurism or epi-Futurism, without falling into the trap of permanently looking for 'influences'.

The radiation of Futurist ideas from one culture to another was a process that could be extraordinarily complex and contradictory. Futurist manifestos and stylistic devices did not necessarily derive from Italian or Russian models. Futurist concepts migrated freely in the worldwide network of the avant-garde and were absorbed in a process of osmosis and creative adaptation. It is the task of international Futurism studies to follow this ebb and flow of ideas across national borders and investigate the reception-creation process, where Futurism was sublated in a range of works of art and literature that possessed a highly original character and were linked to both the stimulus received from outside and the prevailing conditions within a given country.

The historiography of international Futurism also begs the question of periodisation: perhaps a history that limits itself to, say, a year, or even a month, could say more about the functioning of international Futurism than one focusing on a decade?

GB: Perhaps. If we were to look at the history of international Futurism from an Italian perspective, an interesting year of course would be 1912, with the international touring exhibition of Futurism. The year 1920 would be another because then, in *Roma futurista* of 4 January, the 'Programma a sorpresa pel 1920' gets published. This signalled that, after four years of political activity, the Futurists were ready to return to their creative work. It established the basis for Futurism rising like a phoenix from the ashes and for claiming an eminent position in the international avant-garde (see the *Futurisme mondial* manifesto, 1924). The year 1929 might be another. In this year, Marinetti accepts his appointment as Accademico d'Italia and becomes an object of derision on the international scene. We could go on like this for quite a while.

And are there particular places or small items (such as magazines) that best allow us to grasp the tension between the global and the local in international Futurism, nodal points, so to speak?

GB: A good example would be the periodical *Vuoto totalo* [sic] (see fig. 5), a Neo-Futurist periodical published by a 'Ricostituito Movimento Futurista Napoletano', edited by Sergio Campana. It contains a manifesto, 'Distruzione totala' [sic], neo-Futurist graphic designs, and poems by Fillìa and Angelo Rognoni. The periodical

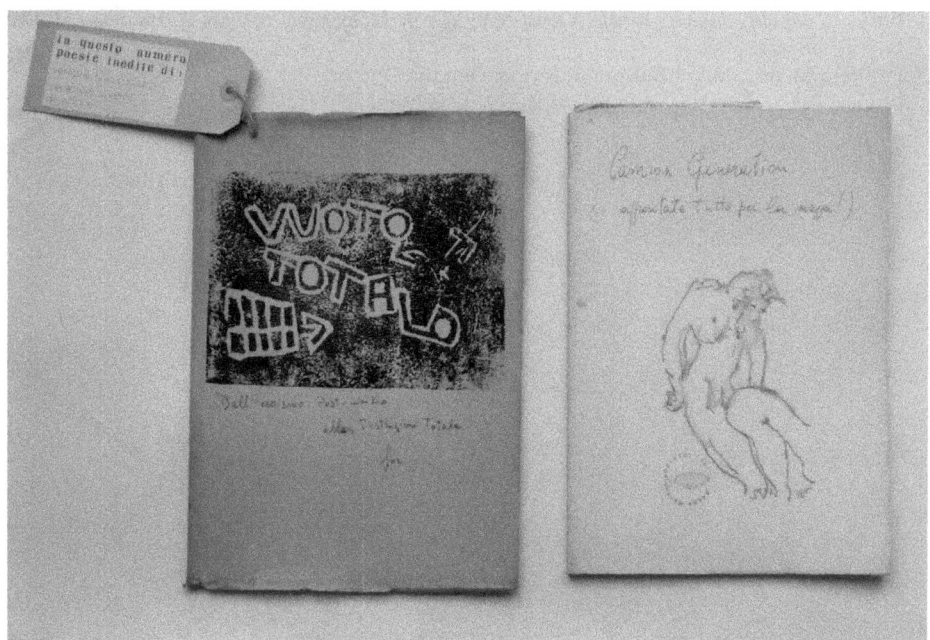

Fig. 5. *Vuoto totalo*, no. 1 (Paris & Pozzuoli: Pesce Nero Editore [Napoli: Tip. Fratelli Mazzanti], 1987).

was continued from September to December 1988 as *Camion: Rivista costruttivista & sfardista. Organo del dolce stile meccanico* and contained 'Il nuovo stile meccanico: Manifesto' by Sergio Campana and M. D. Cammarota, several 'Sparole [sic] in libertà', Aeropoems, para-Futurist poems by Latin American authors (Manuel Maples Arce, José Juan Tablada). *Camion: Rivista aperiodica stilmeccanica* of April 1989, called itself in its editorial 'Sendero Luminoso del futurismo', an allusion to the Partido Comunista del Perú. It further contains one 'Grande poema simultaneo collettivo nicaraguengo d'avanguardia totale'. Several contributions link Camionismo to Moana Pozzi and the porn actor John Holmes. Consequently, many of the pages are of a very explicit, pornographic nature and include some parodies of Giovanni Papini, Renato Guttuso, *Lacerba, Tema celeste* and *Marcatrè*. It also contains several *tavole parolibere* and the essay 'Neofuturismo a Napoli' by Domenico Cammarota. These magazines are small items, indeed, but the places and the history they open up are at the same time vast.

Notes to the Afterword

1. A full bibliography is available at <http://guenter-berghaus.com> (last consulted on 15 November 2015).
2. Vittorio Orazi, 'Per una storia delle avanguardie del 900: Tzara a Prampolini', *La fiera letteraria*, 15 (1961), 3.
3. *Enrico Prampolini*. Exhibition catalogue Rome: Galleria Nazionale d'Arte Moderna, 6 June 1961, ed. by Palma Bucarelli (Rome: De Luca, 1961).

4. Enrico Crispolti, 'Dada a Roma: Contributo alla partecipazione italiana al dadaismo', *Palatino* 10.3–4 (1966), 241–58.
5. Filiberto Menna, *Enrico Prampolini* (Rome: De Luca, 1967).
6. Daniela Palazzoli, 'Dada in Italia', *Marcatrè*, 23–25 (1966), 198–203.

INDEX

Academy 61
Accademia d'Italia 15, 40, 246
Acquaviva, Giovanni 177–78, 182 n. 85
 'Chicchi d'uva' 177
Acta Apostolicae Sedis 47 n. 80
Adamson, Walter 30, 44 n. 8
Adrià, Ferran 238
Agnoletti, Ferdinando 165 n. 33
Ago (Antonio Agostini) 175
Agostinelli, Alfred 49, 51
Albert-Birot, Pierre 220
 Matoum et Tévibar 220
Alighieri, Dante 17, 174, 176, 226
Alinari, Leopoldo, Giuseppe & Romualdo 164 n. 30
Allen, Greg 244
Allen, Woody 26
 Zelig 26
Amendola, Eva Kuhn 203
Amendola, Giorgio 162–63 n. 17
Andreoni, Cesare 181 n. 64
 'Pubblicità futurista' 181 n. 64
Angelini, Ettore 48
Apollinaire, Guillaume 60, 63, 67 n. 11, 112 n. 32, 113 n. 44, 165 n. 33
Apollonio, Umbro 78, 89 n. 43, 237, 242
'A proposito del discorso di F.T. Marinetti' 46 n. 66
Arcari, Paolo 110 n. 18
Ardita 211 n. 41
L'Ardito 38–39
Arditi / Arditismo 16, 19, 20–22, 38, 230
Argan, Giulio Carlo 237
Art galleries:
 Bernheim-Jeune (Paris) 60, 101, 113
 Doré (London) 64
 Marlborough (London) 59
 Sackville (London) 60, 61
 Sprovieri (Rome) 218
Arte Cristiana 42
Arte sacra 42, 47 n. 78, 79, 80 & 86
L'Asino 47 n. 71
Autori e scrittori 129 n. 53
Avanti! 21–22

Baer, Vico 59, 113 n. 45
Balla, Giacomo 3, 63, 74, 84, 88 n. 28, 100, 105, 113 n. 46, 114 n. 51, 124, 140 n. 5 & 13, 155, 162 n. 17, 165 n. 35, 203, 210 n. 17, 218, 219, 220, 244

manifestos and critical writing:
 and Fortunato Depero, 'Ricostruzione futurista dell'universo' 74, 219
drawings:
 Il pugno di Boccioni 105
theatre:
 Complessi plastici 219
 Macchina tipografica 218
Balbo, Italo 20
Baldessari, Iras 131, 139
 Giocatori di pallone 131
Baldissone, Giusi 217
Ballo, Guido 237
Banti, Alberto 1
Barbesti, Luciano 162 n. 21
Barbey D'Aurevilly, Jules-Amédée 183
Bargellini, Piero 160
Barilli, Renato 244
Barr, Alfred Hamilton 242
Bartók, Béla 219
Barzini, Luigi 49
 Da Pechino a Parigi 49
Bastianelli, Giannotto 164 n. 33
Baudelaire, Charles 24
Bauhaus 73, 75, 88 n. 26, 240
Baumeister, Willy 139
Bechhöfer, Carl 61
Behne, Adolf 69
Bellini, Giovanni 165 n. 33
Belloli, Carlo 239
Bellonzi, Fortunato 237
Beltramelli, Antonio 8, 13–15, 17, 23, 25
 I canti di Fauno 14
 La nascita del Fascismo 15
 Un tempio d'amore 14
 L'uomo nuovo 8, 13, 15
Benedetti, Enzo 240
Benedict XV, Pope 34
Benjamin, Walter 23–24, 28 n. 34, 28 n. 41, 78
 Das Kunstwerk im Zeitalter seiner technischen Reproduzierbarkeit 28 n. 34
Benn, Gottfried 24, 26
Berger, René 242
Berghaus, Günter 11–12, 24, 31, 38–39, 44 n. 11, 46 n. 51, 103, 112 n. 40, 216, 217, 218, 234–48
Bergson, Henri 203
Besant, Annie 211 n. 52

Betuda, Mario 34
 'Cane + buoi' 34
Bignami, Marino 109, 115 n. 55
Binazzi, Bino 164 n. 33
Binet, Alfred 201–02, 208, 212 n. 63
 Les altérations de la personnalité 201
Blavatsky, Helena Petrovna 211 n. 52
Blast 68
Bo, Carlo 237
Boccaccio, Giovanni 31
 Decameron 31
Boccioni, Umberto 1–3, 6, 9, 11, 55, 58 n. 19, 59, 66, 67 n. 13, 69, 71, 72–74, 78, 87 n. 5, 88 n. 18, 24, 28 & 30, 89 n. 42, 91, 104, 106–09, 111 n. 21 & 31, 112 n. 43, 113 n. 44 & 46, 114 n. 51, 115 n. 56, 124, 129 n. 50, 130–34, 139, 140 n. 5, 6 & 13, 154–55, 158–60, 161 n. 5, 163 n. 22, 164 n. 33, 165 n. 35, 192, 200, 209 n. 1, 210 n. 17, 225, 235, 236, 237, 238
 critical writing and manifestos:
 'Dinamismo plastico' 140 n. 6
 'I fondamenti plastici della scultura e della pittura futuriste' 161 n. 5
 'Manifesto' 72
 & Carlo Carrà, Luigi Russolo, Gino Severini [Aroldo Bonzagni, Romolo Romani, Giacomo Balla], 'Manifesto dei pittori futuristi' 67 n. 13, 73, 88 n. 28, 106, 113 n. 46, 114 n. 52
 'Manifesto tecnico della scultura futurista' 73, 107
 'Moto assoluto + moto relativo = dinamismo' 55
 Pittura scultura futuriste (dinamismo plastico) 66, 89 n. 42, 161 n. 5
 & Carlo Carrà, Luigi Russolo, Gino Severini [Aroldo Bonzagni, Romolo Romani, Giacomo Balla], 'La pittura futurista. Manifesto tecnico' 67 n. 13, 73, 88 n. 28, 113 n. 46, 114 n. 51, 131, 133, 140 n. 5 & 13, 155, 210 n. 17
 & Carlo Carrà, Luigi Russolo, Giacomo Balla, Gino Severini, 'Prefazione al Catalogo delle Esposizioni di Parigi, Londra, Berlino, Bruxelles, Monaco, Amburgo, Vienna, ecc.' ('The Exhibitors to the Public' / 'Les exposants au public') 63, 67 n. 13, 210 n. 13
 'Prefazione al Catalogo della Ia Esposizione di scultura futurista a Parigi' 209 n. 1
 'La scultura futurista' 73
 paintings and sculpture:
 La città che sale 88 n. 30
 Il corpo che sale 200, 211 n. 47
 Dinamismo di un ciclista 131
 Dinamismo di un corpo umano 131
 Dinamismo di un footballer 130–33
 Donna al caffè (compenetrazione di luci e piani) 155
 Forme uniche nella continuità dello spazio 88 n. 30, 133
 Gigante e pigmeo 88 n. 30
 Muscoli in velocità 88 n. 30
 Natura morta con bicchiere e sifone (Still Life: Glass and Siphon) 107, 108
 La risata 155
 Rissa in galleria 155
 La strada entra nella casa 1–3, 11
 Sviluppo di una bottiglia nello spazio 88 n. 30
 Visioni simultanee 1–3
 theatre:
 Il corpo che sale 200
Boethius, Anicius Manlius Severinus 17
Boine, Giovanni 160
Bolzon, Pietro 20
Bonsanti, Alessandro 159
Bontempelli, Massimo 199
 Nostra Dea 199
 La vita intensa 199
 La vita operosa 199
Bonzagni, Aroldo 106, 113 n. 46, 114 n. 51
Bottai, Giuseppe 20
Bowler, Anne 23, 28 n. 32 & 33
Bragaglia, Anton Giulio 163 n. 17, 192, 200
Braglia, Alberto 144
Breton, André 116
Brogi, Giacomo 164, n. 30
Brookfarmer, Charles (Carl Bechhöfer) 61
Bucarelli, Palma 238
Buot, François 238
Burliuk, David 116
 & Alexander Kruchenykh, Vladimir Mayakovsky, Victor Khlebnikov, *Slap in the Face of Public Taste (Poščëčina obščestvennomu vkùsu)* 116
Burzio, Eugenia 225
Buzzi, Paolo 100, 110 n. 18 & 19, 198, 200, 211 n. 48, 228
 Aeroplani 110 n. 18 & 19
 L'ellissè e la spirale. Film + parole in libertà 228–29
 L'esilio 110 n. 19
 Pesce d'aprile 200

Calvesi, Maurizio 237, 238
Camion: rivista costruttivista & sfardista 247
Cammarota, Domenico 247
Campana, Dino 160, 166 n. 44
 Canti orfici 160
Campana, Sergio 246–47
Campanile, Achille 190
Campari, Gaspare 155, 158
Campo di Marte 160
Campo grafico 181 n. 64
Cangiullo, Francesco 145–46, 156–57, 161 n. 4, 162 n. 8, 10, 12, 14, 17, 163 n. 22, 164 n. 33, 218, 236

Caffè-concerto: Alfabeto a sorpresa 156
Le serate futuriste. Romanzo storico vissuto 157,
 162 n. 8, 12, 14, 16 & 17, 163 n. 27, 164 n. 33,
 236
'Caffè Morgano' 162 n. 10
Caffè concerto 162 n. 14
'La ferita della rosa' 163 n. 22
La Maddalena del Caffè Fortunio: Pittoriche e pittoresche
 avventure galanti 162 n. 14
'Il mobilio futurista' 162 n. 14
Piedigrotta 218
Cannella, Guido 80, 89 n. 48
Cantucci, Ugo 34
 'Italia' 34
Cappa, Benedetta 184, 197–98, 204–05, 210 n. 29,
 212 n. 71, 72, 73 & 74, 239
 Spicologia di 1 uomo 197, 198
 Astra e il sottomarino. Vita trasognata 204–05
Capuana, Luigi 158, 163 n. 21 [as Luigi Capuano]
Caravaglios, Nino 111 n. 31
Cardonel, Louis Le 164 n. 33
Carli, Mario 19, 27 n. 25, 39, 46 n. 59
Carmelich, Giorgio 129 n. 55
Carocci, Alberto 159
Carrà, Carlo 11, 60, 88 n. 28, 106, 113 n. 47, 114 n. 51,
 140 n. 5 & 13, 154–56, 158–59, 163 n. 23, n. 26,
 164 n. 33, 165 n. 35, 198, 210 n. 17, 225, 235
 critical writing:
 La mia vita 156, 163 n. 23
 paintings and drawings:
 13 introspezioni 198
 Rapporto di un nottambulo milanese 198
 Quel che mi ha detto il tram 66
 Sintesi di un caffè concerto 154
 Caffè concerto 154
Carrieri, Raffaele 237
Carrugio, Gregorio 134
Caruso, Enrico 225
Casavola, Franco 135
Casella, Alfredo 219
Castelfranco, Giorgio 242
Castelli, Leone 20–21
Castello, Enrico 131, 139
 Calciatori 131
 Il portiere 131
Cavacchioli, Enrico 100, 110 n. 19
 L'incubo velato 110 n. 19
 Le ranocchie turchine 110 n. 19
Cavanna, Cesare 100, 112 n. 33
Caviglia, Enrico 21
Cavour, Camillo Benso di 15
Celant, Germano 60, 67 n. 6
Censi, Giannina 241
 Aerodanze 241
Il Centauro 212 n. 88
Chaucer, Geoffrey 17

Chessa, Luciano 240
Chiattone, Mario 73, 81–82, 84–85, 88 n. 22, 89 n. 53
 Costruzione di una metropoli moderna 81
Chiti, Remo 40, 47 n. 69, 236
 I creatori del teatro futurista 236
Cinti, Decio 33, 69, 87 n. 2
La Città futurista 87 n. 9, 129 n. 51
La Città nuova 41
La Civiltà Cattolica 37–38, 39–40
Clavel, Gilbert 219
Collodi, Carlo (Carlo Lorenzini) 214
 Le avventure di Pinocchio. Storia di un burattino 214
Comisso, Giovanni 189
Communism 13–14, 17, 20–21, 23, 24, 25, 27 n. 29,
 80, 129 n. 57, 189
Computer Poetry 116
Concrete Poetry 116
Congresses:
 Primo Congresso dei Fasci di Combattimento
 (Florence, 1919) 32, 38
 Secondo Congresso dei Fasci di Combattimento
 (Milan, May 1920) 16
 Primo Congresso Futurista (Milan, 1924) 39,
 112 n. 34
 Secondo Congresso Futurista (1933) 41
Constructivism 80, 124, 131
Conti, Primo 205, 212 n. 75, 76
 'Coscienze' 212 n. 75
 'Pagine sentimentali' 212 n. 76
Corbett, Harvey Wiley 74
Le Corbusier (Charles-Edouard Jeanneret) 24, 69, 73,
 74, 82, 84–85
 projects:
 Gratte-ciel Cartésien 85
 Plan voisin 85
 Ville contemporaine de trois millions d'habitants 85
 books:
 Vers une architecture (*Towards a New Architecture*) 69
Cork, Richard 61–62
Corona, Vittorio 133, 139
Corra, Bruno 36, 46 n. 40, 129 n. 55, 187, 191 n. 6,
 199, 200, 206–07, 209 n. 3, 212 n. 84, 85, 86 & 88
 Femmina bionda 191 n. 6
 & Arnaldo Ginna, *Alternazione di carattere* 199
 'Attimo' 212 n. 84
 'Per l'onnipotenza' 212 n. 85
 'Avventure' 212 n. 86
 'Chantaclar' 212 n. 88
Corriere della Sera 40, 163 n. 21
Craig, Edward Gordon 219
Crali, Tullio 84
Crispolti, Enrico 237, 238, 242, 248 n. 4
Cubism 1, 19, 60, 108, 109, 131, 154
Cucini, Dina 182 n. 85
Curci, Carlo Maria 37

Da Costa Meyer, Esther 70, 78, 80
Daily Express 62, 67, 67 n. 9
Daily Chronicle 61
Daily Graphic 66
Daily Mail 62
Daily Mirror 64
D'Alba Auro 53
 'Battute d'automobile' 53–54
D'Albisola, Tullio 128
Dal Co, Francesco 70
Dada (Dadaism) 88 n. 26, 116, 155, 238, 240, 243
Dalí, Salvador 24
Dalmasso, Giovanni 173
Dal Monte, Mario Guido 133
D'Ancona, Paolo 237, 242
D'Anna, Giulio 133, 139
 Calciatore 133
D'Annunzio, Gabriele 14, 21, 37, 46 n. 48, 159, 162 n. 17
Däubler, Theodor 164 n. 33
Da Verona, Guido 190
Da Vinci, Leonardo 116
De Chirico, Giorgio 218
Degas, Edgar 154
 Femmes à la terrasse d'un café le soir 154
 Dans un café, dit aussi L'absinthe 154
 Café-concert 154
 Le café-concert aux 'Ambassadeurs' 154
 Le chanteur avec le gant 154
De Grada, Raffaele 237
Delaunay, Robert 140 n. 4
Delle Site, Mino 134, 139, 199, 210 n. 35
 Sport 134
 Decorazioni per la palestra — Casa dello Studente Città universitaria 134
 'F.T. Marinetti, poeta e uomo d'azione' 210 n. 35
De Maria, Federico 110 n. 19
 La leggenda della vita 119 n. 19
De Maria, Luciano 194, 237
La Demolizione 33
La Dépêche de Toulouse 101
Depero, Fortunato 3, 8, 70, 74, 76, 82–84, 87 n. 8, 131–32, 139, 181 n. 64, 218, 219–20, 222 n. 39 & 44, 239, 241, 244
 critical writings and manifestos:
 'Il futurismo e l'arte pubblicitaria' 181 n. 64
 Un futurista a New York 82
 Numero Unico Futurista Campari 181 n. 64
 paintings:
 Giocatori di pallone 131–32
 Grattacieli e tunnel 8, 70, 76, 83–84
 I miei balli plastici 222 n. 44
 theatre:
 Anihccam del 300 218
 Balli plastici (Ombre, I pagliacci, L'uomo dai baffi, I selvaggi, L'orso azzurro) 219

Colori 219
 Motolampade 241
De Rochas, Albert 202
De Seta, Cesare 70
De Turris, Gianfranco 29, 43 n. 2 & 3
Deutsche Werkbund, *see* Werkbund
D'Harencourt, Anne 60, 67 n. 6
Diaghilev, Sergei 150
Diulgheroff, Nikolay 84
Dolfi, Mario 129 n. 55
Donizetti, Gaetano 176
 L'elisir d'amore 176
Dostoyevsky, Fyodor 199
 The Double 199
Dottori, Gerardo 19, 26, 132–34, 139
 Il Duce 19, 26
 Appunti allo stadio 132
 Partita di calcio 132–33
Duncan, Isadora 150

Einstein, Albert 126, 129 n. 57, 194
Ekstein, Modris 25
Epstein, Jakob 62
The Evening News 61, 63–66, 68 n. 31
Exhibitions:
 Les peintres futuristes italiens (Italian Futurist Painters) (Paris, Bernheim-Jeune; London, Sackville, ..., 1912) 60–61, 100, 101, 103–04, 113 n. 44, 246
 Mostra di pittura futurista (Florence, Caffè Giubbe Rosse, 1913) 159
 Exhibition of Works of the Italian Futurist Painters and Sculptors (London, Doré Galleries, 1914) 64
 Nuove Tendenze (Milan, 1914) 73, 81, 88 n. 24
 Biennale d'arte di Venezia (1924) 161
 Esposizione internazionale (Turin, Parco del Valentino, 1928) 84, 86
 Mostra internazionale di arte sacra (Rome, 1931) 41, 42
 Exposition Coloniale Internationale (Paris, 1931) 89 n. 56
 Prima mostra nazionale d'arte futurista (Rome, 1931) 141 n. 16
 Mostra futurista di aeropittura e scenografia (Milan, 1931), 140 n. 15
 Italienische Futuristische Luft- und Flugmalerei (Berlin, Galerie Lützowufer, 1934) 26
 XI Olympiade Berlin Kunstauschuss (1936) 135
 Prima mostra nazionale d'arte sportiva (Rome, Palazzo delle Esposizioni, 1936) 135
 Seconda mostra nazionale ispirata allo sport (Rome, 1940) 135
Expressionism 240, 243

Falqui, Enrico 237
Farfa 182 n. 83 & 85
Fascism 8, 13–26, 29, 32, 38–43, 69, 70, 84, 132, 133–36, 138, 139, 160, 174, 189, 228, 236–37, 243

Feininger, Lux 139
Fernandino, Beppe 84
Ferrall, Charles 24, 28 n. 37
Ferrer y Guàrdia, Francisco 45 n. 23
Ferretti, Lando 132
Ferris, Hugh 81
La Fiera letteraria 128 n. 44
Le Figaro 4, 48–49, 73
Filippi, Bruno 155
Fillìa (Luigi Colombo) 41, 47 n. 75, 70, 84, 86, 89 n. 53, 180 n. 54, 236, 246
 Il futurismo 236
 'Futurismo e fascismo' 87
 'Il naturismo futurista e la mostra del futurismo in Piemonte' 180 n. 54
 La nuova architettura 83
 'Spiritualità nuova' 41
Fiorini, Guido 84–86, 89 n. 54 & 55
 Grattacieli 'a radiatore' 85
 Grattacielo con tensistruttura 86
Fogazzaro, Antonio 37
Folgore, Luciano 53, 100–01, 110 n. 17, 111 n. 28, 158, 163 n. 25, 220
 critical writings:
 'Negli hangars del Futurismo' 163 n. 25
 poetry:
 'Automobile quasi te' 53
 Il canto dei motori 101, 110 n. 17
 theatre:
 Ombre + Fantocci + Uomini 220
 L'ora del fantoccio 220
Fort, Jeanne 155
Fort, Paul 155
Foschi, Italo 132
Il Frontespizio 160
Frülicht 73
Fuller, Loie 150
Il Futurismo 45 n. 17, 96–98, 110 n. 18, 19 & 21, 112 n. 34, 162 n. 12

Gali, Safar 245
Gambini, Ivanhoe 133, 139
Garibaldi, Giuseppe 33
Garnier, Tony 74, 80
 La cité industrielle 80
Gatto, Alfonso 160
Gazzetta del Popolo 41, 129 n. 51 & 53, 141 n. 19
Gentile, Emilio 172, 180 n. 47
Gentile, Giovanni 15
 Manifesto degli intellettuali fascisti 15
Gide, André 165 n. 33
Gilbert, Cass 73
Ginanni, Maria 207
Ginna, Arnaldo (Arnaldo Corradini) 172, 180 n. 49 & 50, 199, 200, 205, 211 n. 52,
 'Naturismo futurista' 180 n. 50

'Coltivare la pianta umana', 180 n. 49
Le locomotive con le calze 212 n. 79
Ginzburg, Carlo 1–4, 11, 12 n. 1 & 6, 224
Giolitti, Giovanni 15, 31
Giornale della libreria, della tipografia e delle arti e delle industrie affini 105, 111 n. 21, 113 n. 48
Giornale d'Italia 94–95
La Giovane Italia 31–33, 45 n. 16 & 21
Giuliotti, Domenico 36
Giuntini, Aldo 182 n. 83
Gleizes, Albert 140 n. 4
Godoli, Enzo 70, 90 n. 58
Goebbels, Joseph 26, 43
Gómez de la Serna, Ramón 33
Goretti, Maria 177, 182 n. 85
Gori, Fernando 47 n. 74
 Emilio Settimelli ovverosia l'eroe di stoppa 47 n. 74
Govoni, Corrado 198, 213
 'La fiera' 213
Gramsci, Antonio 14, 51
'Grande Serata Futurista. Firenze. Teatro Verdi. 12 dicembre 1913. Resoconto sintetico' 157
The Graphic 61
Greene, Vivien 242
Grendi, Edoardo 4, 12 n. 9
Gropius, Walter 24, 69, 75, 80
Guglielminetti, Amalia 109 n. 6, 110 n. 7, 8, 9, 11, 13 & 14
Guglielmi, Guido 174, 181 n. 62
Guttuso, Renato 247

Häring, Hugo 73
Härmänmaa, Marja 42, 47 n. 83
Haynau, Edith von 208
Heartfield, John 139
Henard, Eugène 74
Herf, Jeffrey 24, 28 n. 35
Hewitt, Andrew 24, 28 n. 36
Hitler, Adolf 17, 25, 73, 173
Hoffman, E.T.A. 216
 Der Sandmann 216
Holmes, John 247
Hoppe, Emil 80
Howard, Ebenezer 87 n. 3
Hradil, F.M. 135

Ialongo, Ernest 30, 44 n. 9
L'Illustrazione italiana 89 n. 41 & 45
L'Impero 39–40, 46 n. 62, 64 & 66, 47 n. 73, 210 n. 35
L'Incendiario 102, 104
L'Indipendente 157
Industrie Italiane Illustrate 211
L'Intransigeant 67 n. 11
L'Italia futurista 34, 36, 40, 45 n. 27, 28 & 29, 65, 212 n. 87

Jacobbi, Ruggero 237
Jacques-Dalcroze, Emile 150
Jahier, Piero 160
Jakobson, Roman 10, 116–18, 121
Jameson, Frederic 4, 12 n. 7
Janet, Paul 202, 208
Jarry, Alfred 215
 Ubu Roi 215
Jensen, Nicolas 105
Joyce, James 24
Joyner, Charles 3, 12 n. 2
Jünger, Ernst 17, 22, 24
 Der Arbeiter 22

Kafka, Franz 24
Kamensky, Vasilij 117
Kandinsky, Wassily 24
Keller, Guido 189
Khlebnikov, Velimir 10, 116–18, 127 n. 14, 16, 20 & 24
 'Bobéobi' 116
 'La conception mathématique de l'histoire' 126 n. 6
 Incantation by Laughter 126 n. 3
 Des nombres et des lettres 126 n. 4
 'Numbers' 126
Koch, Rudolph 111
Konody, Paul George 62, 67 n. 9
Kostelanetz, Richard 116
Kruchenykh, Aleksei 116, 118

Lacerba 34–37, 45 n. 25, 35 & 36, 59, 66, 69, 73, 108, 159–60, 165 n. 34, 36 & 39, 166 n. 46, 210 n. 28, 247
Ladovsky, Nikolai 80
Lambiase, Sergio 227
Lang, Fritz 81
 Metropolis 81
Lautréamont, Comte de (Isidore Lucien Ducasse) 116
Leadbeater, Charles 200, 201, 202, 211 n. 52
 The Astral Plane 200
Lebrecht, Danilo (Lorenzo Montano) 164 n. 33
Lenin, Vladimir 21
Leo XIII, Pope 38
 Officiorum ac munerum 38
Leonardo 35, 202
Lepschy, Laura 245
Letteratura 159
Lévi, Eliphas 211 n. 52
Levi, Giovanni 1–2, 4, 11, 12 n. 8
Lewis, Wyndham 62, 66
Lhote, André 140 n. 4
Libera, Adalberto 24, 82
Linati, Carlo 163 n. 27
Lissitzky, El 80, 139
Lista, Giovanni 98, 111 n. 23
Livshits, Benedikt:
 The One and a Half-Eyed Archer 127 n. 20

Lobachevsky, Nikolai Ivanovich 127 n. 16
Lombardi, Daniele 240
Lombroso, Cesare 211 n. 59
Loos, Adolf 80, 89 n. 39
Lucatello, Enrico 160
Lucini, Gian Pietro 91, 110 n. 18 & 19
 Revolverate 110 n. 18 & 19
 Il verso libero 110 n. 19
 Il carme di angoscia e di speranza 110 n. 19

Maassen, Henry 124
Macchi, Giacomo 20
Maeterlinck, Maurice 214–15, 218
 La Princesse Maleine 218
Maffina, Gianfranco 240
Maggia, Rossana 204
Malacrida, Arturo 105, 113 n. 49, 114 n. 50
 L'applicazione dei caratteri e dei fregi 114 n. 49
 Un nuovo rinascimento, studio comparativo dell'arte tipografica 114 n. 49
Malatesta, Sigismondo 14, 17
Malevich, Kazimir 139
Manchester Guardian 62
Manin, Daniele 112 n. 38
Manzoni, Alessandro 94
Maples Arce, Manuel 247
Marcatrè 247
Marchi, Virgilio 84
Marey, Etienne-Jules 132
Marinetti, Filippo Tommaso:
 critical writings:
 'Il 25. del futurismo festeggiato dai futuristi venticinquenni' 47 n. 83 & 91
 'Ad ogni uomo, ogni giorno un mestiere diverso! Inegualitarismo e Artecrazia' 39
 'Appendice' a *L'uomo nuovo* 13–20
 see also Beltramelli
 & Luigi Russolo, 'L'arte dei rumori' 111 n. 24, 153, 244
 'Come io vedo il mondo' 129 n. 57
 'Contro il matrimonino' 178 n. 2
 'Che cos'è il futurismo' 110, 151 n. 1
 'Contro il Papato e la mentalità cattolica, serbatoi di ogni passatismo' 29, 39
 'Contro Roma passatista' 88 n. 12
 & Umberto Boccioni, Carlo Carrà, Luigi Russolo, 'Contro Venezia passatista' 88 n. 12, 225
 'La declamazione dinamica e sinottica. Manifesto futurista' 222 n. 37
 'Distruzione della sintassi. Immaginazione senza fili. Parole di libertà' 95, 137, 151 n. 31, 33 & 36, 195, 209 n. 2, 210 n. 11, 12, 13, 20, 24 & 37, 218, 232 n. 8
 'Discorso di Firenze' 32, 38, 44 n. 14
 'Il discorso di Marinetti' 39–40, 46 n. 64

'Discours futuriste aux Anglais' 60, 66
'Discours futuriste aux Vénitiens' 97, 106,
 110 n. 20, 113 n. 46, 114 n. 52
'Elettori Futuristi!' 103
'Fondation et manifeste du Futurisme' /
 'Fondazione e manifesto del Futurismo' 4,
 15, 16, 22, 31, 48–49, 50, 52, 65, 73, 91–92,
 94, 110 n. 18, 111 n. 21, 145, 152 n. 37, 157,
 209 n. 5 & 9, 210 n. 38, 225
'Le futurisme mondial. Manifeste à Paris' 246
'Futurism Triumphs in London' 61
'Futurist Painting: Technical Manifesto' 67 n. 13
Futuristi e passatisti 110 n. 19
'The Futurist Manifesto against English Art' 59,
 63, 67 n. 13
'Ai giovani italiani. Proclama di F.T. Marinetti'
 112 n. 43
'In quest'anno futurista' 151 n. 8, 152 n. 38
'Italianità e originalità di Pirandello' 211 n. 55
'Lecture to the English on Futurism' 63, 64, 66,
 67 n. 13
'Lettera aperta dei futuristi italiani a Hitler'
 180 n. 45
'Manifeste des auteurs dramatiques futuristes'
 113 n. 46, 114 n. 52
'Manifesto dei drammaturghi futuristi' 113 n. 46,
 114 n. 52
'Manifesto della danza futurista' 150
'Manifesto dell'arte sacra futurista' 7, 30, 41,
 47 n. 75
& Mario Carli, Emilio Settimelli, 'Manifesto
 dell'Impero italiano' 46 n. 59
'Manifesto del partito politico futurista' 38, 143
& Emilio Settimelli, Bruno Corra, 'Manifesto del
 teatro futurista sintetico' 143, 151 n. 6 & 7,
 209 n. 3, 217
'Teatro totale per masse' 239
& Angiolo Mazzoni, Mino Somenzi, 'Manifesto
 futurista dell'architettura aerea' 233 n. 37
'Manifesto of the Futurist Painters' 67 n. 13,
 113 n. 46, 114 n. 52
'Manifesto tecnico della letteratura futurista' 33,
 53, 73, 108, 118, 128 n. 32, 146–48, 156, 195,
 209 n. 2, 7 & 8, 210 n. 16, 25 & 27, 218
'La matematica futurista' (*other titles*: 'La
 matematica futurista immaginativa
 qualitativa. Calcolo poetico delle battaglie';
 'Calcolo poetico delle battaglie d'oggi) 126,
 129 n. 53
'The Meaning of War for Futurism: interview
 with *L'avvenire*' 151 n. 8
'The Meaning of the Music-Hall' 62
'Mie proposte di nuovi sports' 135
'Misuratore di commedie' 129 n. 55
'Le mouvement poétique en Italie' 112 n. 41
'Nascita di un'estetica futurista' 88 n. 12

& Arnaldo Ginna, 'Il Naturismo futurista.
 Manifesto futurista' 172
'Noi rinneghiamo i nostri maestri simbolisti,
 ultimi amanti della luna' 210 n. 15
'Nuovi sports latini' 136
'La necessità della violenza' 33, 45 n. 23
'La nuova religione-morale della velocità' 7, 56,
 65, 68 n. 34, 194, 209 n. 6
'Orgoglio italiano rivoluzionario e libero amore'
 178 n. 2
'I poemi precisi' 124
'Primo manifesto politico futurista per le elezioni
 generali del 1909': 33
'Proclama futurista agli spagnoli' 33
'Programma a sorpresa pel 1920' 246
'Il proletariato dei geniali' 143, 151 n. 2
'Quarta dimensione di matematici e di artisti'
 (*other title*: 'Superare la matematica. Verso la
 quarta dimensione') 129 n. 51
'La radia' 239
'Rapporto sulla vittoria del Futurismo a Trieste'
 163 n. 21
'Il Re disse: che ha Marinetti?' 166 n. 47
'Risposte alle obiezioni' 151 n. 25, 207–08
'Rivoluzione futurista delle parole in libertà e
 tavole sinottiche di poesia pubblicitaria'
 181 n. 64
'I significati del Futurismo secondo Paolo Arcari
 del giornale clericale l'*Avvenire d'Italia*'
 110 n. 18
'La simultaneità in letteratura' 179 n. 18
'Simultaneità nello sport. Manifesto futurista' 136
'Lo splendore geometrico e meccanico e la
 sensibilità numerica' 10, 117–18, 120, 122,
 124, 127 n. 22, 128 n. 33, 34, 36, 38 & 39,
 146–47, 151 n. 34, 210 n. 23, 30 & 31
'Il tattilismo' 225
& Francesco Cangiullo, 'Il Teatro della Sorpresa'
 145–46, 156, 161 n. 4, 162 n. 12
'Il Teatro di Varietà' 62, 151 n. 11 & 18, 153, 156,
 161 n. 4, 191 n. 14
'Terzo manifesto-programma politico futurista'
 143
'Trieste, polveriera d'Italia' 32
'Trieste, la nostra bella polveriera' 45 n. 17
'Il trionfo dei Futuristi a Trieste' 110
'Uccidiamo il Chiaro di Luna' 179 n. 15,
 210 n. 15, 225
'L'uomo moltiplicato e il regno della macchina'
 55, 145, 217
'Vital English Art' 60
poetry:
 L'aeropoema di Gesù 43
 & Giovanni Acquaviva, 'Alla salute dell'Italia
 immortale — Cantare sparare e non morire'
 182 n. 85

'Après la Marne, Joffre visita le front en auto'
 128 n. 40
'Une assemblée tumultueuse (Sensibilité
 numérique)' 123–24, 128 n. 41
'Battaglia di Tripoli' 111 n. 28
'Battaglia peso + odore' 128 n. 35, 136, 145, 148
Canzoniere futurista amoroso e guerriero 176–78
'Carta sincrona dei suoni rumori colori immagini
 odori speranze voleri energie nostalgie' 198
'Cauccíù e Guttaperca' 229
'Decalogo della sensibilità motrice' 196, 198
Dune 54, 196, 198
'Dune. Parole in libertà' 210 n. 28
L'esercito italiano. Poesia armata 129 n. 53
'Manicure Faire les ongles à l'Italie' 198
Le monoplane du Pape (L'aeroplano del Papa) 33
Les mots en liberté futuristes 118, 124, 128 n. 30
 & 41
Originalità russa di masse distanze radio cuori 43
Parole in libertà futuriste tattili termiche olfattive 124–25
Il poema africano della divisione '28 ottobre' 43
Il poema non umano dei tecnicismi 138, 141 n. 31
'Poema preciso' 125
'Poetare e tracannare nella osteria dei soldati
 repubblicani alla salute dell'Italia immortale'
 177–78
'Velocità nel caos delle lave spente' 124
La ville charnelle 33
Zang Tumb Tumb 15, 100, 118, 121, 123,
 128 n. 29, 148, 210 n. 32, 229, 232 n. 7
prose:
 8 anime in una bomba. Romanzo esplosivo 34, 198,
 226
 L'alcova d'acciaio. Romanzo vissuto 227, 232 n. 16
 Gli amori futuristi 10, 179 n. 17, 183–90
 'La carne congelata' 188
 Come si seducono le donne 168, 171, 178 n. 2,
 179 n. 8, 9 & 14, 183, 186, 226–27, 228–29,
 232 n. 11
 'La domatrice di leoni' 180
 'Fa troppo caldo' 180
 & Alberto Viviani, *Firenze biondazzurra sposerebbe
 futurista morigerato* 173–76, 178 n. 3
 'La guancia' 180
 'La locomotiva blu' 169
 Mafarka il futurista (Mafarka le futuriste) 32, 36,
 168, 172, 203
 'Il negro' 188
 'Una notte bene impiegata' 187
 'Le notti di spazzavento' 189
 Novelle colle labbra tinte 179 n. 17, 190
 L'ottimismo artificiale 203
 'Rissa di bandiere' 188
 Scatole d'amore in conserva 179 n. 17, 232 n. 1
 & Enif Robert, *Un ventre di donna. Romanzo
 chirurgico*, see Robert, Enif

theatre:
 L'arresto 200
 Bianca e Rosso 200
 Cura di luce 200
 Un chiaro di luna 200
 Donna + amici = fronte 199
 Elettricità sessuale 200, 217
 Luci veloci 171, 178
 Poupées électriques 216–18
 Le Roi Bombance 31, 215–16, 221 n. 17 & 18
 Il tamburo di fuoco 170
 Il teatrino d'amore 213, 217
 Vengono 217
film:
 Vita futurista 144
volumes:
 Al di là del comunismo 189
 Collaudi futuristi 212 n. 70
 Democrazia futurista (dinamismo politico) 39, 144,
 152 n. 39, 178 n. 2
 Futurismo e fascismo 39
 *La grande Milano tradizionale e futurista. Una
 sensibilità italiana nata in Egitto* 110 n. 9
 Guerra sola igiene del mondo 45 n. 17, 88 n. 12
 Lussuria-velocità 68 n. 34
 I nuovi poeti futuristi 58 n. 23, 124, 128 n. 43
 I poeti futuristi 101, 110 n. 17, 112 n. 36 & 43
 Les remparts du passé 110 n. 19
 Taccuini 1915–1921 46 n. 53, 163 n. 21, 202–03
 La victoire du futurisme 110 n. 19
varia:
 & Fillía, *La cucina futurista* 11, 170, 181 n. 65,
 233 n. 22, 244
 Enquête internationale sur les Vers libre 110 n. 19
Mascagni, Pietro 176
 Cavalleria rusticana 176
Masnata, Pino 20, 129 n. 52, 204
 Anime sceneggiate 204
Matteotti, Giacomo 24
Mauclair, Camille 101
 *Il Futurismo e la giovane Italia (Le futurisme et la jeune
 Italie)* 101
Maupassant, Guy de 199
 Le Horla 199
Maurizio, Alberto 40, 47 n. 69
Mayakovsky, Vladimir 116–17, 127 n. 13
Mazza, Armando 157, 235
Mazzini, Giuseppe 31, 112 n. 38
McGuinness, Patrick 215
Meano, Cesare 180 n. 54
 'Colori e immagini del naturismo futurista'
 180 n. 54
 'La mostra del naturismo in Piemonte' 180 n. 54
Menna, Filiberto 238
Meyer, Adolf 75, 80
Michelangelo, Buonarroti 116

Mies van der Rohe, Ludwig 73
Migliorini, Bruno 159
Mix, Silvio 135
Moholy-Nagy, László 139
Montini, Giovanni Battista 42, 43
Morasso, Mario 49, 57 n. 6
 La nuova arma (la macchina) 49
Morel, Bénédict Augustin 167–68
Moretti, Marino 159
Mori, Marisa 133, 135
 Radiotrasmissione di una partita di calcio 135
Morris, William 103, 104, 105
Morselli, Enrico 208
Moscardelli, Nicola 165 n. 33
Munari, Bruno 133, 141 n. 18, 239
 Il tifoso 141 n. 18
Munch, Edvard 26
Mussolini, Benito 8, 13, 15–26, 30, 39, 40, 43 n. 2,
 44 n. 9, 46 n. 67, 132, 134–36, 139, 141 n. 23,
 160–61, 174, 236
 'Trincerocrazia' 22
Muthesius, Hermann 75, 89 n. 32
Muzi, Oscar 37

Nannetti, Vieri 34
 'Vignetta umoristica' 34
La Nazione 36, 45 n. 39
Nazzaro, Giambattista 226
Neal, Th. (Angelo Cecconi) 165 n. 33
Nelis, Jan 37
Nevinson, Christopher C. R. W. 59, 61–62, 64, 66–67,
 68 n. 19 & 21
 Arrival of the Wounded 66
 Bursting Shell 66
 The Circular Railway 66
 The Departure of the Train de Luxe 66
 Harvest of Battle 66
 The Non-Stop 64
 Road from Arras 66
 The Strand 62, 66
 Tum-Tiddly-Um-Tum-Pom-Pom 61
Nevison, H.W. 62
Nevinson, Margaret 66
New Age 61
The New Statesman 62
The Newcastle-on-Tyne Illustrated Chronicle 66
Nietzsche 14–15, 17
Nijinsky, Vaslav 150
Nike di Samothrace 52
Nitti, Francesco 15, 19
Notari, Umberto 30–33, 38, 44 n. 15, 45 n. 16, 18 &
 19
 Noi 32
 Quelle signore 31
Noi 88 n. 26
Notte, Emilio 131, 139

Partita di pallone 131
Novaro, Mario 164 n. 33
Il novissimo segretario galante. 400 lettere d'amore per ogni
 evenienza, 188–89
Nuova Antologia 201

Oberdan, Guglielmo 32
The Observer 61–62, 68 n. 26
Oggi e domani 129 n. 51
Orazi, Vittorio 238
Originalità 166 n. 47

Paladini, Vinicio 218
Palazzeschi, Aldo 3, 110 n. 19, 157, 159, 163 n. 21,
 165 n. 36, 205, 214–15
 I cavalli bianchi 214
 Il codice di Perelà 205
 L'incendiario 110 n. 19, 163 n. 21, 215
 Lanterna 215
Palazzoli, Daniela 238
Pannaggi, Ivo 84, 218, 232 n. 1
 & Vinicio Paladini, *Ballo meccanico futurista* 218
Paolieri, Ferdinando 36, 39, 46 n. 62
 'In difesa di Gesù' 36
 'Fascismo e Cattolicesimo. Le tenebre' 46 n. 62
Il Papa alla porta! Inchiesta e conclusioni per l'abolizione del
 Papato 32
Papini, Giovanni 34–38, 43, 45 n. 25, 36 & 38,
 156, 159–60, 164 n. 30 & 33, 165 n. 34 & 39,
 166 n. 44, 202, 247
 Polemiche religiose 45 n. 38
 'Gesù peccatore' 36
 'Chi non la vuole', 34
 'Contro Firenze passatista' ('Discorso di Firenze')
 165 n. 34
 L'esperienza futurista 165 n. 34
 'Il poeta pazzo' 166, n. 44
 Un uomo finito 159
Papus (Gérard Encausse) 211 n. 52
Le Papyrus 30, 44 n. 10
Paul, Saint 17
Perret, Auguste 74
Le Petit Bleu 67 n. 11
Petrarca, Francesco 17
Piccolo giornale d'Italia 73
Il Piccolo 113 n. 44
Pinna Berchet, Federico 20
Pius X, Pope 31
Pius XI, Pope 40, 47 n. 78, 81, 85 & 88
 Non abbiamo bisogno 40
Pirandello, Luigi 200–02, 208, 211 n. 51, 53 & 57
 Arte e scienza 201, 202
 Il fu Mattia Pascal 200, 201, 202
 'Personaggi' 200, 201, 202
Podhajska, Zdenka 135
Podrecca, Giulio 41, 47 n. 71

Poe, Edgar Allan 199
 'William Wilson' 199
Poelzig, Hans 73
Poesia, Rassegna Internazionale 8, 91, 94, 95–98, 101,
 104–05, 108, 110 n. 19, 111 n. 21, 113 n. 46
Poggi, Cesare Augusto 70, 85
 'Manifesto dell'architettura futurista' 70, 85
Pogni, Guido 166 n. 46
Il Popolo d'Italia 20–22
Il Popolo 40
Popov, Egor 245
Pound, Ezra 14–15, 24
 The Cantos 14
Pozzi, Moana 247
Pozzo, Ugo 84
Prampolini, Enrico 27 n. 26, 73–74, 84, 86, 88 n. 26,
 134–35, 139, 140 n. 15, 219–20, 222 n. 39, 238,
 239, 244
 manifesti:
 'Anche l'architettura futurista: E che è?' 73
 L'atmosferastruttura futurista. Basi per un'architettura
 73–74
 Nascita della simultaneità 84
 Divinizzazione dello spazio 84
 'Scenografia e coreografia futurista' 219
 paintings:
 Angeli della terra 134
 *La battaglia di Via Mercanti a Milano e l'incendio
 dell'Avanti e Arditismo e Futurismo* 27 n. 26
 theatre:
 Danza dell'elica 135, 218
 Danza del Foot-ball 135
 Le marchand de cœurs 220
 Tennis 135
 Vortice 135
Pratella, Francesco Balilla 61, 93, 106, 111 n. 26 & 31,
 113 n. 46, 135
 'Manifesto dei musicisti futuristi' 113 n. 46,
 114 n. 52
 '*La musica futurista. Manifesto tecnico* 106, 111 n. 26,
 114 n. 52
Pratolini, Vasco 160
Prezzolini, Giuseppe 14, 156, 159
'Primi scontri' 45 n. 35
Proust, Marcel 5–6, 49–52, 57
 À la recherche du temps perdu 49–50
 A l'ombre des jeunes filles en fleurs 50
 Du côté de chez Swann 50
 Du côté de Guermantes 57 n. 10
 'En mémoire des églises assassinées' 49–52
 'Impressions de route en automobile' (*other title* :
 'Les églises sauvées. Les clochers de Caen. La
 cathédrale de Lisieux. Journées en automobile')
 49–52
 La fugitive (Albertine disparue) 57 n. 10
 La prisonnière 57 n. 10

Pastiches et mélanges 49–50
Provinciali, Renzo 102, 104, 113 n. 47
Puma, Marcello 129 n. 52

Quarantotti Gambini, Pier Antonio 163 n. 21

Ragghianti, Carlo Ludovico 237
Raggio, Osvaldo 1
Ragusa, Enrico 136
Rainey, Lawrence 14
Ramella, Franco 1
Rancati, Gino 84
Rank, Otto 199, 208
 The Double 199, 208
Redondi, Pietro 1
Reed, Charles 74, 89 n. 45
Reghini, Arturo 165 n. 33
Richet, Charles 201, 211 n. 58
Ridolfi, Luigi 132
La Riviera ligure 164 n. 33
Rizzo, Pippo 133, 139
Robert, Enif 183, 229–31
 & Filippo Tommaso Marinetti, *Un ventre di donna.
 Romanzo chirurgico* 229–30
Rodchenko, Alexander 139
Rognoni, Angelo 246
Rolland, Romain 188
Rolls, Charles 66
Roma futurista 21, 38, 222 n. 49, 246
Romani, Romolo 106, 113 n. 46
Rosa, Desiderio 182 n. 85
Rosà, Rosa (Edith von Haynau) 208, 229, 230–31
 Una donna con tre anime 208
 'Non c'è che te' 230–31
Rosai, Bruno 40, 47 n. 69
Rosai, Ottone 40, 47 n. 69, 165 n. 33
Rosso, Medardo 156
Rosso, Mino 84
Rummel, Richard 87
Russian Futurism 10, 16, 116–29, 173, 243, 244–45,
 246
Russo, Ferdinando 163 n. 22
Russolo, Luigi 3, 62, 88 n. 28, 106, 113 n. 46,
 114 n. 51, 140 n. 5 & 13, 153, 155, 158, 165 n. 35,
 192–93, 210 n. 17, 225, 232 n. 10, 235, 244
 Incontro d'automobili e aeroplani 62
 Autoritratto (con doppio eterico) 192, 193

Saba, Umberto 137
 Cinque poesie sul gioco del calcio 137
Sade, Marquis de 116
Saint-Point, Valentine de 114 n. 52 & 53, 150, 168,
 179 n. 12, 245
 'Manifesto della donna futurista' 114 n. 52, 168–69
Salaris, Claudia 39, 45 n. 58, 70, 87 n. 11, 99, 100,
 111 n. 25 & 28

Sant'Elia, Antonio 8, 66, 69–70, 73, 76–85, 87 n. 2 & 10, 88 n. 24 & 25, 89 n. 31, 32, 33, 34, 37, 38, 39 & 44, 90 n. 57, 237, 238
　'Architettura futurista. Manifesto' ('Manifesto dell'architettura futurista') 69, 73, 87 n. 2, 88 n. 13 & 29, 89 n. 31, 32, 33, 34 & 37
　La città nuova 70, 73, 76–79, 88 n. 23
Sant'Elia 47 n. 83, 233 n. 37
Sanzin, Bruno 136–38, 141 n. 30, 176, 178, 236
　'Chianti Barbera Lambrusco' 176
　Goal 137–38
　Marinetti e il futurismo 236
Saussure, Ferdinand de 202
Sauvage, Henri 74
Saveli, Angelo 135
Savini, Virgilio 158
Schatz, Eveline 117
Scharoun, Hans 73
Schuré, Edouard 211 n. 52
Schwitters, Kurt 116
Seneca, Lucius Annaeus 17
Serrati, Giacinto 21, 27 n. 22
Settimelli, Emilio 36, 39–41, 43, 46 n. 40 & 59, 47 n. 69, 72–74, 88, 129 n. 55, 191 n. 4, 209 n. 3, 219, 236
　Aclericalismo 41
　Donna allo spiedo. Beffe bizzarrie avventure tutta la vena d'un fiorentino d'oltrarno 191 n. 4
　Marinetti: l'uomo e l'artista 236
　I processi al Futurismo per oltraggio al pudore 36
　Preti, adagio! 41
　& Ottone Rosai, Remo Chiti, Alberto Maurizio, Bruno Rosai, *Svaticanamento. Dichiarazione agli italiani* 40, 47 n. 69 & 88
Severini, Gino 11, 59–63, 66, 67 n. 7, 10, 11, 12 & 15, 68 n. 39, 88 n. 28, 91, 109 n. 5, 113 n. 45 & 46, 114 n. 51, 140 n. 5 & 13, 154–55, 161 n. 7, 165 n. 35, 198, 210 n. 17
　paintings:
　　Ballerina blu 154
　　Ballerina bianca 154
　　Ballerine al Monico 155
　　Ballerine spagnole al Monico 155
　　La danza del pan pan al Monico 154
　　Geroglifico dinamico del Bal Tabarin 154
　　Nord-Sud Métro (velocità + rumore) 65
　　Souvenirs de voyage 66
　　Le train dans la ville 66
　writing:
　　La vita di un pittore 67 n. 7, n. 10, n. 12, n. 15, 68 n. 39, 161 n. 7
Shackleton, Ernest 66
Shakespeare, William 240
Shklovsky Viktor B. 127 n. 8
Sideri, Maria 243, 245
Sintesi futurista della guerra 235

Sitte, Camillo 74
The Sketch 61
Slataper, Scipio 160
Soby, James Thrall 242
Soffici, Ardengo 35, 89 n. 52, 132, 155–57, 159–60, 161 n. 5, 162 n. 11, 164 n. 33, 165 n. 35, 36 & 39, 198, 213, 220 n. 3
　poetry:
　　'Caffè' 155
　　Statue e fantocci 213
　paintings:
　　Caffè Apollo 155
　　Caffè 162 n. 11
　　Compenetrazione di piani plastici 165, n. 35
　criticism:
　　'Arte libera e pittura futurista' 164, n. 33
　　'Il soggetto nella pittura futurista' 161 n. 5
Soggetti, Gino 108, 115 n. 54
Solaria 159, 160
Somenzi, Mino 84
Somigli, Luca 216
Sottsass, Ettore 244
Speer, Albert 24
Spiridigliozzi, Fernando 84, 206
　S. Francesco in aeroplano 206
Sport Fascista, Lo 132
Stalin, Joseph 24–25
Steiner, Giuseppe 20
Steiner, Rudolf 211 n. 52
Stem, Allen 74, 89 n. 45
Stevenson, Robert Louis 199
　The Strange Case of Dr. Jekyll and Mr. Hyde 199
Stewart, George R. 224
De Stijl 73, 116
Stile futurista 88 n. 26, 180 n. 49, 50, 53 & 54
Stravinsky, Igor 219
　Feu d'artifice 219
Stuparich, Giani 160, 166 n. 42
Der Sturm 114 n. 53
Sullivan, Louis 72
　The Tall Office Artistically Considered 72
Surrealism 116, 239, 243
Symbolism 9, 33, 190, 214–16

Tablada, José Juan 247
Tafuri, Manfredi 69
Tamaro, Attilio 157
Tamburri, Anthony 214, 212 n. 11
Tarrini, Cesare 133
Tastevin, Genrix Edmundovich 117
Tatlin, Vladimir 24, 80
Tato (Guglielmo Sansoni) 133, 135, 139
　Incontro calcistico di campionato 135
Taut, Bruno 69
Taveggia, Angelo 100–01, 104, 106–07, 112 n. 32, 33, 34 & 37, 114 n. 53

Tavolato, Italo 36–38, 160, 166 n. 46
 'Elogio della prostituzione' 36, 166 n. 46
 'Elogio del caffè', 166 n. 46
Taylor, Joshua 242
Tema celeste 247
Terragni, Giuseppe 82
La Testa di Ferro 21
Thayaht (Ernesto Michahelles) 133, 139
Theatres:
 Teatro Bellini (Palermo) 136
 Teatro Costanzi (Rome) 219
 Teatro Eden (Milan) 21
 Teatro La Fenice (Venice) 111 n. 21, 161
 Teatro delle Feste (Turin) 135
 Teatro degli Indipendenti (Rome) 200
 Teatro Lirico (Milan) 110 n. 18
 Théâtre de l'Oeuvre (Paris) 215
 Teatro dei Piccoli (Rome) 219
 Teatro Rossini (Pesaro) 112 n. 37
 Teatro alla Scala (Milan) 158
 Teatro Verdi (Firenze) 35, 157, 159
Tillis, Steve 213
Tittoni, Tommaso 31
Todorov, Tzvetan 126 n. 7
Tofani, Dino 164 n. 30
Tommei, Ugo 164 n. 33
La Torre 36, 46 n. 62
Toscanini, Arturo 155, 158
Town Topics 61
Tozzi, Federico 164 n. 33
Tschumi, Bernard 71
Tumiati, Gualtiero 217
Tynyanov, Yury 117, 127 n. 11 & 16
Tzara, Tristan 24, 238

Valsecchi, Marco 242
Van Alen, William 73
Van de Velde, Henry 75, 89 n. 32
Van Doesburg, Theo 88
Van Gogh, Vincent 26
Vannicola, Giuseppe 164 n. 33, 174–75
Vasari, Ruggero 218
 L'angoscia delle macchine 218
Vassalli, Sebastiano 37
 L'alcova elettrica. 1913: Il Futurismo processato per oltraggio al pudore 46 n. 41, 166 n. 46
Vecchi, Ferruccio 19–21
Il Ventesimo 211 n. 51
Venturi, Lionello 237
Verardo, Pietro 240
Verde e Azzurro 44 n. 15
Verdi, Giuseppe 155, 158, 160, 161, 176
 Aida 161
 La traviata 176
Verdone, Mario 237, 238
Verga, Giovanni 157, 158, 163 n. 21, 183
Vergani, Orio 163 n. 17
Veroli, Patrizia 150
Villiers de l'Isle-Adam, Auguste 216–17
 L'Eve future 216
Viola, Gianni Eugenio 30, 44 n. 5
Viva, Anna 182 n. 85
Viviani, Alberto 159, 164 n. 30, 164 n. 33, 165 n. 34, 166, n. 41 & 44, 173–75, 178 n. 3, 236
 Il poeta Marinetti e il futurismo 236
La Voce 14, 17, 35, 159–60, 164 n. 33
La Vogue 112 n. 41
Volt (Vincenzo Fani Ciotti) 29, 39, 44 n. 3, 89 n. 46
 La fine del mondo 29
 'Manifesto dell'architettura futurista' 89
Vorticism 60, 63
Vuoto totalo 246

Wagner, Otto 74, 80
Wagner, Richard 219
Wajda, Andrzej 27 n. 29
 Man of Marble 27 n. 29
Walsh, Michael 61–62, 67 n. 18, 68 n. 20, 21, 22, 25, 40 & 41
Warren, Whitney 74, 89 n. 45
Wedekind, Frank 183
Wees, William C. 61–62, 67 n. 18, 68 n. 24, 31 & 32
Wehrli, René 242
Werkbund (Deutsche Werkbund) 74, 75
Western Mail 61
Westminster Gazette 64, 66
Wetmore, Charles 74, 89 n. 45
Wiener Sezession 73, 80
White, John 7
Whyte, Iain Boyd 70
Wilde, Oscar 199
 The Picture of Dorian Gray 199
Wiley Corbert H. 89
Wilson, John 216–17
Wilson, Woodrow 88 n. 21
Wright, Wilbur 217

Zanini, Gigiotti 165 n. 33
Zanotto, Emilio 110 n. 19
 Giovanni Pascoli 110 n. 19
Lo Zar non è morto 190
Zevi, Bruno 69
Zucca, Giuseppe 190

www.ingramcontent.com/pod-product-compliance
Lightning Source LLC
Chambersburg PA
CBHW080912170426
43201CB00017B/2294